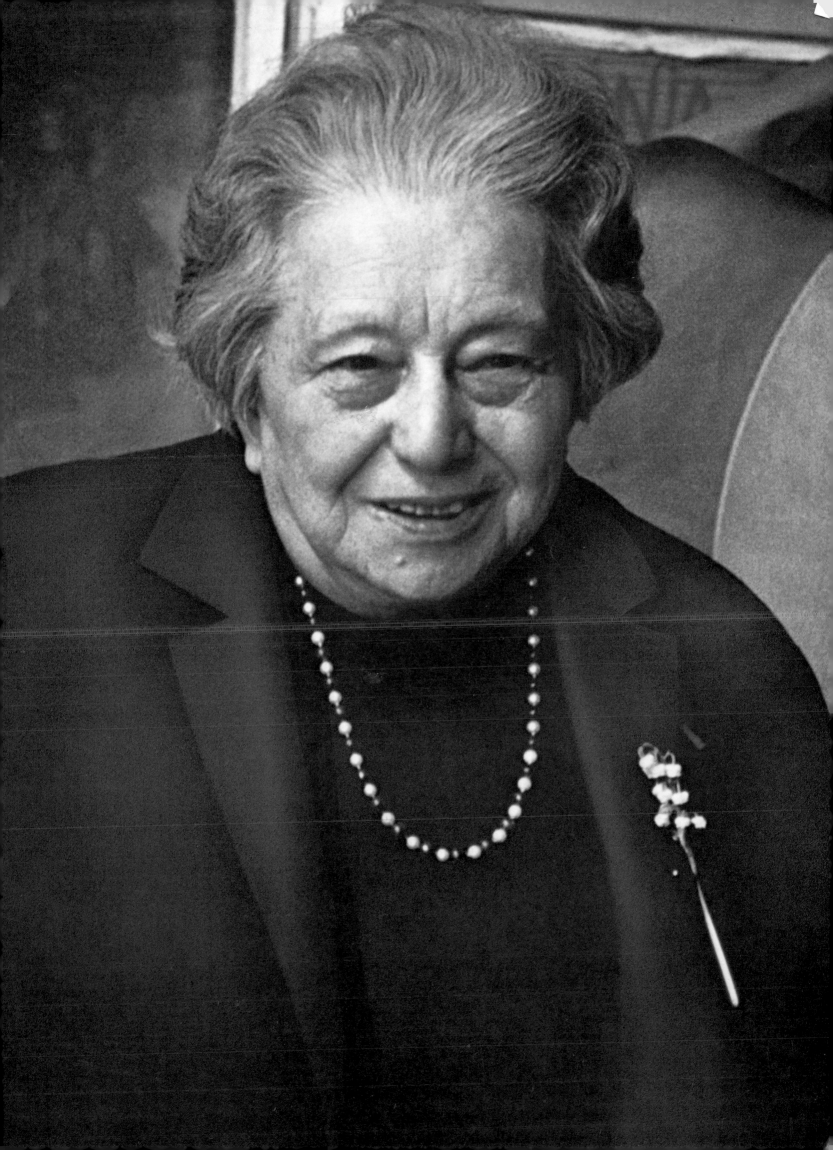

IN MEMORIAM

SONIA DELAUNAY
1885-1979

The designs for the front and back covers of this catalogue were painted by the artist, shortly before her death, for the Albright-Knox Art Gallery on the occasion of *Sonia Delaunay: A Retrospective*

Front Cover: Cat. 174. *Rhythm Color (Rythme couleur)*, 1979
No. 2096, gouache, 15-9/16 x 11-1/4 (39.5 x 28.5)
Collection Sonia Delaunay, Paris

Back Cover: Cat. 175. *Rhythm Color (Rythme couleur)*, 1979
No. 2095, gouache, 15-9/16 x 11-7/16 (39.5 x 29)
Collection Sonia Delaunay, Paris

Sonia Delaunay

A RETROSPECTIVE

FOREWORD BY ROBERT T. BUCK

ESSAYS BY SHERRY A. BUCKBERROUGH
CHRONOLOGY BY SUSAN KRANE

Albright-Knox Art Gallery
Buffalo, New York

This exhibition is supported by grants from the
National Endowment for the Arts, Washington,
D.C., a federal agency; the New York State
Council on the Arts and the Alcoa Foundation.
Sonia Delaunay: A Retrospective was orga-
nized by Robert T. Buck in cooperation with
Sherry Buckberrough, assisted by Susan Krane
and Douglas G. Schultz.

ALBRIGHT-KNOX ART GALLERY, BUFFALO, NEW YORK
February 2-March 16, 1980

MUSEUM OF ART, CARNEGIE INSTITUTE,
PITTSBURGH, PENNSYLVANIA
April 11-June 1, 1980

THE MUSEUM OF FINE ARTS, HOUSTON, TEXAS
June 27-August 31, 1980

THE HIGH MUSEUM OF ART, ATLANTA, GEORGIA
September 7-October 26, 1980

THE GREY ART GALLERY, NEW YORK UNIVERSITY,
NEW YORK, NEW YORK
November 15-December 27, 1980

ART INSTITUTE OF CHICAGO, CHICAGO, ILLINOIS
January 31-March 8, 1981

MUSEE D'ART CONTEMPORAIN, MONTREAL, CANADA
April 1-May 17, 1981

Library of Congress Cataloging in Publication Data

Delaunay, Sonia
 Sonia Delaunay, a retrospective.

 Bibliography: p.
 1. Delaunay, Sonia — Exhibitions. I. Buckberrough,
Sherry, 1945- II. Albright-Knox Art Gallery.
III. Title.
N6853.D347A4 1980 709'.2'4 79-57450
ISBN 0-914782-32-0

CONTENTS

Sonia Delaunay, who died recently in her ninety-fifth year, represented, with her fellow countryman Chagall, the last of a generation of modern artistic giants. Her formative years as an artist were spent in the unusually vital atmosphere of Paris just before World War I. She witnessed the rise of Fauvism, Cubism, and subsequently Dada, in which she became an enthusiastic participant. She was greatly esteemed by the members of her circle, which included many poets such as Apollinaire and Tzara who used their talents to express continuous admiration of her art. She gained recognition as "the artist couturier" and her impact on the field of fashion was considerable.

In 1925, she participated in the International Exhibition of Decorative Arts, in collaboration with couturier Jacques Heim. Together they designed a show boutique constructed on the Pont Alexandre III. The effect on the artistically knowledgeable section of the public was immediate. Sonia Delaunay had set her visual stamp on the event and, during the next five years, the dynamism and strength of her designs were to modernize and influence the decorative arts.

In the late 1930s, she again employed her organizational skills to aid her husband when they worked together on the completion of his ambitious projects at the 1937 International Exhibition of Arts and of Technics in Paris. Robert Delaunay had been commissioned to decorate the Air Pavilion and the Railroad Pavilion. In addition to her organizational work, Sonia Delaunay added three immense murals of her own design to the project in the Air Pavilion, based on aviation imagery, and a fourth monumental mural based on rail travel in the Railroad Pavilion.

After the death of her husband in 1941, Sonia Delaunay dedicated her time and energy to establishing his proper place in modern art history, subordinating her own career to this effort. In general, she exhibited her work infrequently in group shows and she was not the subject of a museum exhibition until 1958, when her work was displayed at the Kunsthalle in Bielefeld, West Germany. This exhibition, which led to the acquisition by the Bielefeld museum of three important works by the artist, was her first major one-artist show since 1916 in Stockholm. Little wonder then that Sonia Delaunay, otherwise preoccupied and reticent to promote herself, has been overlooked, if not ignored, save in her adopted city of Paris, where she lived from 1905 until her death on December 5, 1979. The purpose of the present exhibition, which now becomes the first since her death, and a memorial as well, is to offer art audiences in North America the opportunity to deepen their knowledge of this artist, whose major contributions to modern art have received scant and inadequate recognition on this continent.

This exhibition, the largest collection of her work ever assembled, consists of over two hundred items: paintings, gouaches, prints, books, fabrics, ceramics, tapestries, theatrical costumes, women's fashions and even carpets. As can be seen here, the artist's influence on modern applied design is still strong today; in many instances, its impact is still being felt several decades after the initial development of her ideas. The diversity of media in the work of Sonia Delaunay has in the past been misinterpreted as weakness instead of the strength that it is. Opinions change; works of art do not. With historical perspective and the gradual disappearance of prejudices emanating from various narrow definitions of artistic discipline, we may now view the surprisingly rich array in Sonia Delaunay's *oeuvre* for what it is — a consistent logic of aesthetic interaction without material limitation.

For Sonia Delaunay, the world was color and color was the world. Her fascination and concern for color, even at the expense of formalism, dominated her artistic obsessions and passions. The poet Blaise Cendrars, close friend and collaborator, must surely have been thinking of her when he wrote:

> "Colour is a sensuous element. The senses are reality. That is why the world is coloured. The senses build. Then intelligence arises. Colours sing. By neglecting colour the Cubists neglected the emotional grounds of a work of art — that sensuous, irrational, absurd, lyrical element which brings a painting to life surrealistically."[1]

A distinguished painter, professionally a close match to her more famous husband, Sonia Delaunay was nonetheless also wife and mother. Self-discipline enabled her to devote time to her art, but in the early years it seemed as if she was mostly creating privately for her own enjoyment and that of her husband and a small band of friends. Other artist-couples in modern art are noteworthy, especially Jean Arp and Sophie Taueber-Arp who were close friends of the Delaunays, but Robert and Sonia remain unique in that their artistic expression is really about the same things. Not that one should confuse the two artistically, for differences abound. Robert was first and foremost the theorist, pedant and promoter of ideas and concepts. Sonia's role during the often heated discussions among their friends was more restrained. She always viewed herself as "practical" in contrast to her husband's spirited and often illogical sense of spontaneity. However, as early as 1913, four years after they had met, she had matched his majesty of creativity with such works as *Electric Prisms* and *Bal Bullier*. There is no doubt whatsoever that her vivid sense of color deeply affected his work. From the time of their marriage, his palette changed dramatically from the somber influences of early Cubism to bright, even startling contrasts of hue, quite different from his earlier Fauve works.

At the same time that she painted *Bal Bullier*, Sonia Delaunay also illustrated Blaise Cendrar's *La Prose du Transsibérien* with her pochoir abstractions. It is a work which remains today a unique and advanced cooperative experiment of poet and artist. Furthermore, it demonstrates a significant departure into fields of expression very different from those of her husband and most other visual artists of the day. Her active interest in other media, such as the applied arts, fashion design and book design (considered by many as "the lesser arts") continued throughout her life. For those people whose artistic definitions fall within rigid confines, this has undoubtedly been a source of confusion. For the artist "there was no hiatus for me between my painting and my so-called 'decorative' works and the 'minor genre' had never been an artistic frustration but a free expansion, a new conquest of space, an application of the same research."[2]

In 1945, Sonia Delaunay described the social intent of her art as one of spiritual uplift:

> Besides, the invention of the atom bomb and the debates about it prove that life will change in every way and that the potential for destruction is so enormous that it can destroy everything and thus becomes absurd for humanity. All that proves and confirms my faith in a reconstruction full of joy, life advancing toward beauty, clarity and comfort for everyone. There is a lot to do in this area and it could keep humanity busy for years. In this world it is our art of clarity and joy which will triumph.[3]

She was, above all else, a determined optimist, even moralistic in her stance.

The artist mirrored this joy in her art on a personal level, too. A sometimes taxing number of visitors arrived to see her in Paris, but all came away enriched by the personal encounter. A quiet but powerful force emanated from her radiant personality. She was unceasing in her efforts to uplift the human condition through her art wherever and whenever possible. "I have always," she once said, "transformed everything that surrounds me."

Sonia Delaunay was a modern missionary of the human spirit.

ROBERT T. BUCK
Director
Albright-Knox Art Gallery
December, 1979

[1] Blaise Cendrars, quoted by Jacques Damase, *Sonia Delaunay: Rhythms and Colors* (Greenwich, Conn.: New York Graphic Society Ltd. and London: Thames & Hudson, 1972) p. 47.
[2] Sonia Delaunay, *Nous Irons Jusqu'au Soleil*, Paris: Editions Robert Laffont, 1978, p. 96.
[3] Ibid, p. 144.

ACKNOWLEDGMENTS

An exhibition of this scope necessarily involves the cooperation and interaction of many individuals. I would first like to convey an expression of my gratitude and admiration to Sherry Buckberrough, Assistant Professor of Art History, University of Hartford, who first suggested that we undertake the project and who has contributed a major critical study of Sonia Delaunay's work to the catalogue. It should be noted that Dr. Buckberrough's contribution was more than the normally expected one in aiding the organizational process, for she not only wrote many encouraging letters in seeking loans and aid for the exhibition and frequently visited private collectors and museums, but was in continuous contact with the Gallery staff in culling lists, in solving a myriad of unknowns and in affecting the final presentation and content of the exhibition.

Support of the exhibition and recognition of its significance have been gratifying, and I would like to express my thanks for major grants to the project from the National Endowment for the Arts, the New York State Council on the Arts, and the Alcoa Foundation, Charles L. Griswold, President. I would also like to acknowledge the contribution of the Chairman and Chief Executive Officer of the Aluminum Company of America, W. H. Krome George, who was instrumental in securing the major support for this exhibition.

The cooperation of the many lenders has been exceptional and chief among these, in addition to the artist's family and the Musée National d'Art Moderne in Paris, are Arthur and Elaine Cohen of New York.

A number of important works were lent by several institutions and I would like to express my thanks to Pontus Hulten, Director, and Germain Viatte, Chief Curator, Musée National d'Art Moderne, Paris; Dr. Ulrich Weisner, Director, Kunsthalle, Bielefeld, West Germany; Robert Littman, Director, Grey Art Gallery, New York University; and Richard A. Jacobs, Acting Director, Nixon Presidential Materials Project, National Archives and Records Services, Washington, D.C.

The organization of the exhibition could not have been undertaken without the cooperation of two individuals aiding the artist, Monique Schneider-Maunoury, Assistant to Sonia Delaunay, and Jacques Damase, Director of the Galerie de Varenne, Paris. Barbara Lyons of Harry N. Abrams, Inc., New York, has graciously provided a number of color photographs for the exhibition catalogue.

I would also like to express my thanks to directors and curators of the participating museums and galleries: Leon A. Arkus, Director, Museum of Art, Carnegie Institute, Pittsburgh; William C. Agee, Director, The Museum of Fine Arts, Houston: Gudmund Vigtel, Director, The High Museum of Art, Atlanta, Georgia; Robert Littman, Director, Grey Art Gallery, New York University; James Speyer, Curator, and Ann Rorimer, Associate Curator, 20th Century Painting and Sculpture, Art Institute of Chicago; and Louise Letocha, Director, Musée d'Art Contemporain, Montreal.

Members of the Gallery staff whose work has been indispensable to the success of the project are: Norma Bardo, Curatorial Secretary; William Buckley, Coordinator of Development; Elizabeth Burney, Administrative Assistant to the Director; Christopher Crosman, Associate Curator of Education; Susan Krane, Assistant Curator; John Kushner, Superintendent of the Building, and the Maintenance staff; Anne Marie Malachowski, Assistant to the Registrar; Annette Masling, Librarian; Jane Nitterauer, Registrar; Josephine Novak, Editor; Serena Rattazzi, Coordinator of Public Relations; Douglas G. Schultz, Chief Curator; Leta Stathacos, Gallery Shop Manager and Angela Tomei, Secretary. My thanks, also, to Sandra Ticen, who ably designed this catalogue.

The following individuals assisted Dr. Buckberrough's research: Susan Behrends, Timothy Benson, Vikki Berman, Martin Bush, Leslie Bussis, Judith Calvert, Jewell Chambers, Margaret Finch, Kay Gebhard, Ann Khan, Karen Lengyel, Paul Pelletier, and Arthur Shipee.

PREFACE

I would like to thank my wife, Nicole, and Jacqueline Holland, who worked on translating texts from the French and aided me with French correspondence. Mrs. Holland also worked with Gallery Shop Manager, Leta Stathacos, in producing a Delaunay line of reproductions for the shop.

Up to her death, Sonia Delaunay was unflagging in her efforts to obtain the important loans. She offered me great moral support; working with her for over three years on details of the exhibition was a great personal pleasure.

Finally, to the memory of the artist this effort is dedicated.

ROBERT T. BUCK
Director
Albright-Knox Art Gallery

Sponsorship of the Fine Arts is, at its best, a rewarding venture, and never more so than in this instance. In the person and in the work of Sonia Delaunay, there is a fusion of the artist's abstract vision and an ability to create art in terms of the practical world that represents human vitality at its finest. We at the Alcoa Foundation are proud to be associated with this exhibition and the effort of the Albright-Knox Art Gallery to bring the works of this artist to the attention of the American public. The Directors of the Alcoa Foundation hope that this exhibition will give great pleasure to audiences throughout North America and will establish Mme. Delaunay here as the significant figure in 20th century art we believe her to be.

CHARLES L. GRISWOLD, PRESIDENT
Alcoa Foundation

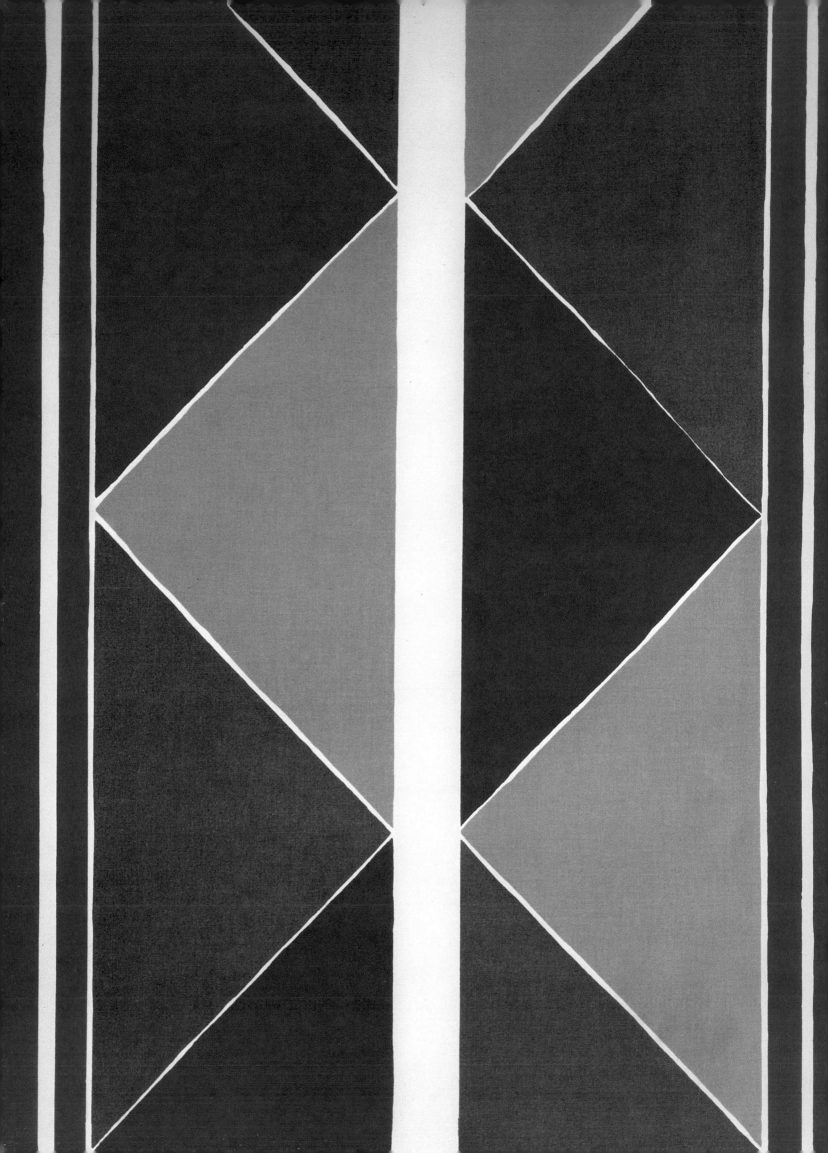

A BIOGRAPHICAL SKETCH:
EIGHTY YEARS OF CREATIVITY
BY SHERRY A. BUCKBERROUGH

CHILDHOOD IN RUSSIA

T he sunshine that streams through Paris windows is the same sunshine that guides days and seasons in the small Ukrainian village of Gradizhsk, where Sonia Delaunay was born in 1885. She recalled long Russian winters, endless landscapes of white mountains of snow lining the village street, all giving way to the springtime return of the sun and of color! Her earliest memories were of gay hues — tomatoes and watermelons, sunflowers against blue skies, the white snow on the black earth — colors of nature, steeped in solar light. Russian myth and literature are punctuated by a perpetual search for the sun. Sonia Delaunay discovered its richness long before her arrival in Paris.

Her father, whom she adored, was a factory worker. His generosity, honesty, and uncompromising spirit were absorbed into the character of his young daughter who attributed much of her inner strength to his presence during the first five years of her life. Her self-pitying mother on the other hand aroused in her a horror of pessimism and complaints. Sonia resolved to face life with a smile, generated by the confidence in life which the Russian countryside inspired in her. The family was poor, but with rich relatives; Sonia's uncle, Henri Terk, was a well-established lawyer in St. Petersburg. In a gesture of generosity, he offered to adopt Sonia and, in 1890, she moved from comparative poverty to extraordinary wealth. She met her father only once after this move, and never saw her mother again.

Sonia Delaunay was at ease from the start in St. Petersburg and in the large townhouse, complete with uniformed servants, which she soon considered her real home. Her childhood was one of splendid dreams and if her memories of the Ukrainian village were of magical colors rather than harsh realities, the experience of St. Petersburg was a village girl's fantasy brought into actuality. These events established her mode of understanding life, in which imagination and reality played equally important roles. Her later impulse toward creativity was an outgrowth of the flexibility developed during these early years.

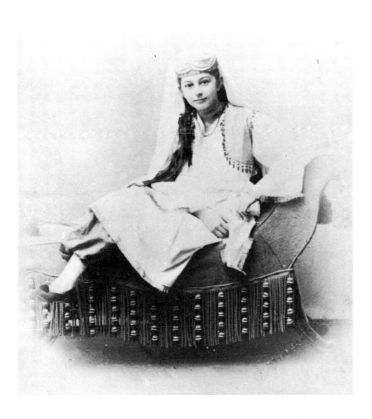

Fig. 1. *Sonia Terk, age 12, in Russian costume, 1897.*

Left: Cat. 219. *Harlequin (Arlequin),* 1977
149/900 (detail)
after c. 1925 design
fabric panel, 117-9/16 x 55-1/16 (300 x 140)
Issued by Artcurial, Paris

The Terk family was Jewish. If Sonia had remained in the village her character might have been more clearly marked by this aspect of her heritage. Wealthy Jewish families in St. Petersburg, however, were generally well assimilated. They profited intellectually and financially from the liberalizing periods of the 1860s and 1870s. Moves toward equality in Russia engendered a feeling of kinship between Jews and Russians and many Jews chose to absorb Russian culture fully. Although there was harsh repression of Jews again in the 1880s and 1890s, Henri Terk's household remained a product of that earlier liberal epoch.

Active in Franco-Russian relations, Terk practiced law among an international crowd. The Terks entertained with regularity in their St. Petersburg home and Sonia was raised with people all around her, both her own friends and those of her adopted parents. The family traveled periodically, to Italy, Switzerland and Germany. Her life in St. Petersburg was very fashionable and was conducted according to rigid proprieties. Restraints of social routine were contrary to Sonia's nature, which was atypically robust for a young girl of her era, and she was inclined to seek a more masculine kind of freedom. She preferred to play a Russian equivalent of cowboys and Indians than to play with dolls. Her models were her father and her uncle, both of whom were warmer personalities than her mother and her aunt. Thus, stereotypical oppositions of intellectual men and emotional women had little place in her upbringing. These influences led her to an unusually balanced sense of her potential, both as a woman and as a person with a career.

Raised with three governesses, from each of whom she acquired a language — French, German and English — Sonia was able to read the classics of western literature in the original. She read voraciously, and in school, philosophy and mathematics were important interests, although neither of these swept her imagination as did poetry and art. Albums of art reproductions, particularly from the Barbizon school, were the doorway to a private world in which she took

refuge during the long hours that the adults spent at lavish meals. While her uncle's friends spoke of Baudelaire and Verlaine, Sonia Terk established a mode of existence which, like that of the Symbolist poets, posed the dream world of art as equal and essential to the reality of daily life. Her fantasies were stimulated by the parks of St. Petersburg, which were filled with statues — escapes from the formalities of the parlor and of school. She evolved an interior life from her fantasies and reflections which remained her constant source of revitalization. It gave her a unique strength, an equilibrium, which carried her through many years of adventure, and many years of loneliness. Reflecting in the 1960s, she commented:

> I had never been weak enough to let anyone suspect my real inner self. Even for Delaunay, Apollinaire, Cendrars, I was an extremely energetic character, invulnerable, almost unreal, one who would smile at fate, never complaining and with an innate sense of happiness[2]

Sonia Terk received her first box of paints at the age of fourteen from the German painter Max Liebermann, who was a friend of her uncle. That she was serious about art, and learned from her classes in school, can be seen in a drawing she did in 1901 of a nude woman on the seashore. Techniques of chiaroscuro, crosshatching, and rhythmic balances of contours are

Fig. 2. *Sonia Terk in St. Petersburg, 1901.*

already well-developed. Furthermore, they have been put to the service of a unique device in which a cardboard palette, the painter's tool, is transformed into a seascape that extends infinitely and evokes a mood of sensual reverie. The thumbhole of the palette doubles as the sun under which the exotically extended nude delights in her basking. Although such images were a cliché of academic paintings of the period, this was a personal subject for Sonia Terk, who in her mid-teens spent hours each day sunbathing nude at her uncle's summer house in Finland[3] Sunbathing was not yet a custom for women[4]

I ler response to what she termed her "natural need" for the sun was one of open sensuality. This is not a characteristic which is normally associated with Russian culture, which, for almost a millenium, had been held firmly under the dominion of the conservative Eastern Church. The end of the century, however, brought about a sudden change of national attitude. Connections with the West, particularly with France, brought in new customs and ideas rooted in traditions of open sensual pleasure. The Russian backlash to this influx of western culture was an additional liberating stimulus for Sonia. Following on the heels of the Populist idealization of the Russian peasant, a revival of indigenous Russian customs and beliefs approached a zenith in the 1890s. In search of the most truly Russian cultural ideas, intellectuals turned to the old pagan myths, based on the sun god and mother earth. In some parts of the country ancient cult dances and rituals had been integrated into semi-Christian celebrations. The peasants, still tied to the land and the seasons, carried on these ancient traditions. Sonia remembered peasant weddings, and her memories again were images of movement and color — red and green dresses with numbers of ribbons flying through the air to the rhythms of the dance. Peasant crafts were later to become part of her own ideal of art.

As a result of contrasting and overlapping cultural forces, the seldom-exposed sensuality of Russian culture poured forth in the first decade of the century (particularly after the censorship repeals of 1905). It can best be seen in the costumes by Bakst for Diaghilev's Russian Ballet. It was a rising undercurrent in the cultural events and ideologies to which Sonia Terk was exposed, and one which she intuitively sensed. Like the great designers for the ballet, a circle of which she was to become a member in later years, she loved the fantasy involved in the experience of creating costumes. We see her dressed for costume balls at ages twelve and sixteen, first in peasant holiday attire and second as an Egyptian princess. Both ancient cultures and peasant cultures were sources of inspiration for her even in these early years.

Sonia Terk was lucky in having a sensitive drawing teacher, a woman who was later entrusted with founding a museum of popular art[5] Recognizing the young girl's talents, and probably her need for freedom as well, this teacher advised her adopted parents to send her abroad for further studies. In 1903, she left the opulence of St. Petersburg to assume the disciplined life of a university student in Karlsruhe, Germany. She studied under Schmidt-Reutter, a professor whom she admired and who trained her hand in the craft of drawing. The training was rigorous, and she found herself so thoroughly challenged that she even enrolled in anatomy courses for further analysis of the human skeleton and muscular system. Her undertakings out of class were almost exclusively portraits and self-portraits — studies of humanity which probe the exterior of the individual, seeking to express, in general plastic forms, the reality that is found within. These works are well within the tradition of German realism, but with a psychological intensity that reflects the Symbolist ambience which, by that time, had penetrated even the academies. The sitters are isolated figures, distanced from the spectator by the force of their own presence, the directness of their stares. There are few indications of their emotions or personalities. Instead, they reflect a collective neutrality, a sense of timelessness that would remain a part of Sonia Delaunay's art long after she had left the fashion of realism behind.

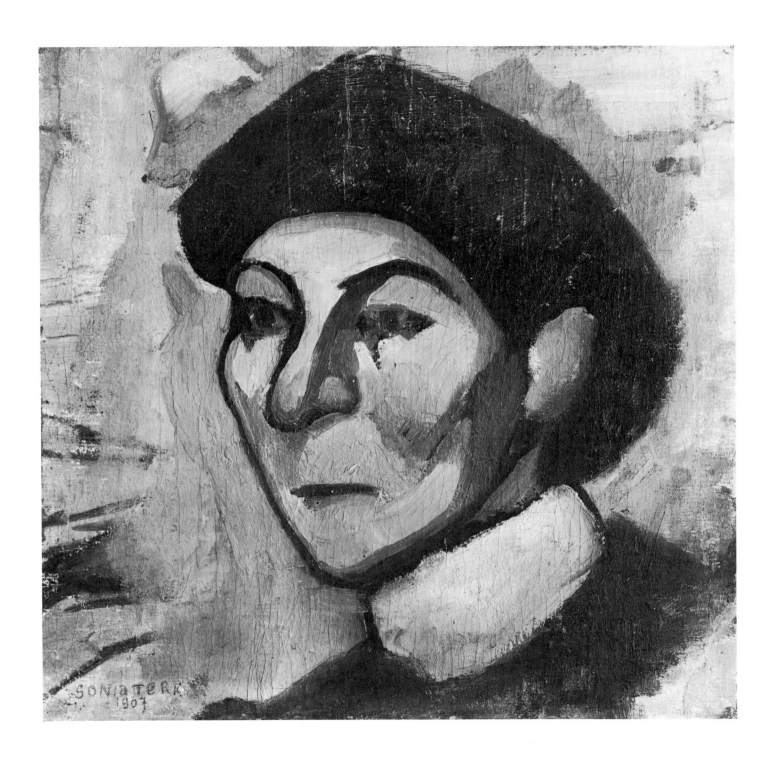

16

ARRIVAL IN PARIS — CONTACT WITH
IMPRESSIONISM, POST-IMPRESSIONISM AND
FAUVISM

S onia Terk's first real exposure to Impressionism came during her stay in Germany. This French contribution to the history of modern painting had made inroads into Germany during the 1890s, and was a well established countercurrent to academic tradition by the turn of the century. Sonia Terk bought three books on the French Impressionists while studying in Karlsruhe[6] and, sensing the nature-based sensuality of their canvases, decided that she wanted to live in their milieu, "near Sisley and Monet, near their airiness and lightness."[7] In 1905 she arrived in Paris.

She was twenty years old and committed to her avocation. She enrolled in courses at the Académie de la Palette, whose professors were as acquainted with the avant-garde of the 1890s as with the traditions of the academy. Cottet, Aman Jean, Desvallières, Simon and Jacques-Emile Blanche gave critiques in succession to each student. This was probably an attempt at thorough and nonbiased training, but the result was not at all positive for Sonia Terk, who guarded her need for a singular direction. As the confusion increased, she left the school to work on her own. She was to accept influences after that, but never again instruction. She set up a studio on the Rue Campagne-Première and worked alone.

Her social life, during this period, was far from lonesome. She lived with four other young Russian women in a *pension* in the Latin quarter and went out every night with a group of young friends. There was no lack of Russians to bring a feeling of home to this foreign environment. Among them were painters and poets of the future avant-garde. Sonia Terk found the ambience of art and friends much to her liking. Soon, however, she came under pressure to return to St. Petersburg and accept the responsibilities of adult bourgeois life — marriage and the establishment of a household. So determined was she to avoid such a fate, that she was willing to adjust to a nonemotional marriage in order to remain in France. She had been introduced to Wilhelm Uhde, a young German gallery owner, by a friend who was his neighbor. She admired his taste for the avant-garde and his understanding of the importance of painting. This appreciation was suf-

Cat. 41. *Study of a Young Girl (Etude de jeune fille),* c. 1905
No. 2039, pencil, 12-3/16 x 9-5/8 (31 x 24)
Collection Arthur A. and Elaine Lustig Cohen, New York

Left: Cat. 2. *Philomène,* 1907
No. 12, oil on canvas mounted on board, 15-15/16 x 16-9/16
 (40.5 x 42)
Collection Sonia Delaunay, Paris

ficient basis for her to suggest a "marriage of convenience" to him. He accepted willingly, and they were married in London in 1908.[8]

In the same year, Sonia Terk had her first solo show at Uhde's gallery on Notre-Dame-des-Champs. In it were exhibited such paintings as the *Young Finnish Girl (Jeune finlandaise)* and the *Yellow Nude (Nu jaune),* major canvases which mark the emergence of an individual style, divorced from the academy and in competition with the expressionist avant-garde of that period. Her years of solitary work had solidified her goals even within a deluge of contemporary influences.

As it was Impressionism which first brought her to Paris, it was to Impressionism that she turned when she left the academy. Watercolor and oil landscapes of Finland, where she returned each summer, record her confrontation with light in nature and her attempt to capture it with bold dabs of pure color. As with many artists of the period, Impressionism was the watershed which turned her toward the individual and imaginative forms of expression found in Gauguin, Van Gogh, Bonnard and Vuillard. Each of these artists could be seen in the galleries and at the salons, where they were in competition with the new group which rallied behind the leadership of Matisse.

The public controversy which eventually catapulted Fauvism as a movement evolved around the Salon d'Automne of 1905, the year that Sonia Terk arrived in Paris. Relying on pure color and spontaneous brushstrokes to establish their expression, the Fauves represented a vehement radicalism which was defended by the liberal critics as the advent of a completely new art, and vengefully attacked by the conservatives as naive, incoherent, and even anarchistic.[9] In 1906, their style assumed a relatively common language of flat planes and intense color. It was against this style that all modernist pretenders in Paris had necessarily to judge themselves, and it was a style which, like Gauguin's, was essentially decorative.

The Salon d'Automne of 1906 featured a retrospective of over 200 works by Gauguin. His emphasis on clearly defined contours, his concern with exotic patterning, and his evocative colors were of definite interest to Sonia Terk. The intensity of color, however, which marks her 1907 canvases can be traced to her admiration of Van Gogh. Like Vlaminck, she sought a purity and directness of emotional expression which only Van Gogh, among the Post-Impressionist masters, was able to communicate. Striving for an individual combination of the lessons learned from these two painters, she arrived at her own Fauvist breakthrough. It was as genuine as the outburst of Matisse in 1905, but it surpassed in vigor his paintings of 1907.

The group of Russian girls with whom Sonia Delaunay discussed painting, condemned Matisse for giving in to bourgeois tastes. His recent works showed a tendency toward calmness and refinement which nullified the effect of spontaneous expression. They were too acceptable. In Sonia Delaunay's own words: "It was from that very strong desire to go past Fauvism that my works of that epoch were born."[10]

Writing about his wife in 1938, Robert Delaunay assessed her early works in relation to contemporary style:

> ...these portraits have a slightly barbarous, slightly caricatured expression which contrasts with the academic flatness of the time and introduces a sort of spice into the art then existing in France. This was at the peak of fauvism and Gauguinism, when exoticism flourished at the Salon des Indépendants, for which Matisse carried the banner of French taste by channeling this whole avalanche of Slavic painting, mainly of oriental origin, and seasoning it to the Parisian literary taste of the time: the neo-Baudelairian period, the *Femme au Chapeau Vert,* the era of "everything is order and beauty..."[11]

His final reference is to the repeated line in Baudelaire's poem *L'Invitation au Voyage,* from which the title of Matisse's painting *Luxe, Calme et Volupté* was taken. Order and beauty were not sufficient for a more advanced taste, which sought greater freedom or perhaps, a truer form of expression. Robert Delaunay felt that truth of expression for Sonia Terk could not

help but include her Russian background:

> Like all artists or poets of the East, she grasps color at an atavistic level. From her first studies, done on her own or under the eye of some academic professor, one feels her lyricism, the need to express herself — though hesitantly in her timid beginnings — through dazzling color.
>
> This color sensitivity went far beyond academic and official instruction because of an innate need that was incompatible with established formulae, because of an anarchic spirit that would eventually be turned into a regulated force.[12]

Despite the improbability that there was anything "atavistic" in Sonia Delaunay's propensity for color, she enjoyed this comment by her second husband. She was quite willing to accept his stereotyping of Russians as inspired by color and surface decoration and as "classic mystics." Such links with the past fitted into her concept of the eternal. In expressing the part of her inner being that was Russian and fusing it with contemporary style, she could achieve the individuality which Robert saw as the "anarchic spirit" in her early oils. Moreover, in his opinion, much of Fauvism was reliant on the examples of Slavic artists. However absurd this statement may seem, it recalls the fact that such important figures as Kandinsky and Jawlensky were exhibited in the Salons of those years, and that the history of Russian painting had been made known to the Parisian public in Diaghilev's enormous exhibition at the Salon d'Automne of 1906. Elizabeth Epstein, one of the friends with whom Sonia lived, had studied in Munich and was acquainted with Kandinsky, Jawlensky and Marianne von Werefkin.[13] Thus, even with her submersion in French avant-garde art, Sonia

Terk was frequently in contact with ancient and contemporary Russian works of art.

In actual fact, the paintings of 1907 and 1908 present a dramatic synthesis of her training and her new interests. The contours are the result of calculated structuring, first before the model and second in the arrangement of the pictorial composition. The monumentality of the figures is reminiscent of the compressed images of Fauvism. The use of a thick black outline recalls Gauguin, and the background patterning brings to mind both Van Gogh and Matisse. The choice of colors is free, with blues, reds and yellows appearing in the faces and on the bodies. In the portraits such pure hues blend with flesh tones, producing images which are half-real, but also half-imagined. Like contemporary works by Kandinsky and Jawlensky, the brushstroke is loose and somewhat harsh. The term "harsh" is applicable as well to Terk's color, which, like that of the French, tends to focus on a limited number of primaries and secondaries, but which also, like that of the Russians in Munich, achieves intense tonal contrasts through oppositions of warm and cool. The backgrounds are often dark. Thus the glowing light of the colored bodies of nude models seems to radiate from an inner spirit, far from the presence of nature. It was this luminosity that caught the eye of Robert Delaunay, a young friend of Sonia's German husband and a painter also known for his explorations of color.

R obert Delaunay had met Sonia Terk through the Uhde circle as early as 1907. He then spent a year in the army, returning to Paris to find that Fauvism had lost its stamina, and that new Cézannesque inquiries were underway. Canvases by Braque and Derain in this new mode were displayed at Uhde's gallery and hanging on the walls of his home. Furthermore, Uhde had begun buying and showing works by Henri Rousseau, whose naive and direct images had brought forth Delaunay's admiration as early as 1906. Contact between Sonia Uhde and Robert Delaunay was quickly reestablished through these interests.

Delaunay arrived at the Uhde apartment one evening with his mother, the Countess Berthe-Félicie de Rose, who was a supporter of modern art. The salon was full of German painters and writers that evening, and before long Delaunay was launched into a violent argument with Rudolph Levy.[14] The force of his emotional outpourings in defense of artistic beliefs immediately attracted the hostess of the evening. As Sonia said, "I was carried away by the poet in him, the visionary, the fighter."[15] The two were soon deeply involved in stimulating conversations about the future of art.

During the summer of 1909, Delaunay accompanied his uncle to a summer house in Chaville, on the outskirts of Paris. Sonia and her husband took a room in a *pension* across the street.[16] The two artists of exactly the same age, spent time strolling together through the countryside and investigating the details of nature. Nature was the primary source of Delaunay's inspiration to create. Sonia watched him paint flowers in the garden: he returned from that month in the country with over eighteen small canvases. The two-dimensionality of these works, their intimate analysis of nature, the overall lushness and dominance of dark green are characteristics of the jungle paintings of Rousseau as well. Like Rousseau, Delaunay was apparently seeking a direct encounter with nature. The result was a careful investigation of the patterns produced by plant forms. Either at this time or upon return to Paris, Sonia Uhde began an embroidery of foliage which shows a

Cat. 4. *Portrait of Tchouiko (Portrait de Tchouiko),* 1907
No. 20, oil on canvas, 21-11/16 x 18-1/8 (55 x 46)
Collection Sonia Delaunay, Paris

close resemblance to Delaunay's flower studies, and which, she has admitted, was an attempt to emulate the color tonality of Rousseau![17]

Critics and historians have had difficulty understanding this sudden change in medium. She had already reached relative maturity in her painting and her exhibition at Uhde's had established her professionally, but there are no paintings extant from 1909. The major creation of the year was an embroidery. There are several facts which help to explain this deviation. First, it must be noted that Delaunay did not enjoy competition and became very nervous when anyone worked close to him. Second, Delaunay's mother was attempting to earn money at that time by designing floral motifs which were embroidered in wool. This may have inspired Sonia Uhde to explore the same medium. Third, satin stitch embroidery of stylized flowers and foliage was popular in both France and Russia at the turn of the century. The boldness of the stitch lent itself easily to the dramatic abstract force of Art Nouveau and proto-Expressionist designs. Almost all young girls of the period, even those of the upper classes, were taught needlework as a necessary part of their upbringing, so it can be assumed that Sonia Uhde was already reasonably skilled in the craft. By working in satin stitch embroidery, she could experiment in a medium which was both popular and modern without putting herself in direct competition with her new mentor. Yet, embroidery was not a retreat. A close look at the work and interests of both Sonia and Robert Delaunay during that period reveals a more fundamental purpose.

While seeking to acquire Rousseau's intuitive grasp of reality, Robert Delaunay had simultaneously begun to employ Cézanne's techniques for integrating the various sensations of nature. Two of these techniques were of particular importance: the use of repeated diagonal brushstrokes of neutral color providing a passage between spatially disconnected objects, and the conscious interruption of contours or *brisure,* which results from the use of *passage* in depicting the force of light. Using these methods,

Delaunay hoped to find an approach which would be both pure and constructive. The process, however, was difficult and required months of analysis. Consequently, during this period, Robert Delaunay's painting necessarily entered a destructive phase instead of proceeding directly to his constructive goal.

Academic schooling had taught Sonia a constructive approach that was not weakened by the bold expressionism of her Fauvist paintings. The process of destruction was alien to her. Delaunay advised her to break her carefully defined contours and to work with greater immediacy on the canvas. She found it very hard to achieve this in oil or even in pencil. In embroidery, however, she could experiment with an approach which, while destructive in terms of descriptive contours, was undeniably constructive in terms of pictorial form. The only lines in her 1909 embroidery are in the central scaffolding of stems. Visual interest is aroused by the directional intersections of the stitches and of the resulting forms. In this way, the embroidery recalls the tensional balances of brushstroke and form in a Cézanne painting![18] The directions, however, are less consistent than in a Cézanne. Angles of stitching are linked, changed slightly, or changed completely in a manner which denies the establishment of a recognizable pattern or rhythm. Forms develop with an independence which is purely expressive, and are connected intuitively within the confines of the medium. Those confines allow for varying colors, varying lengths and directions of stitches and forms, and either clarified or non-clarified edges. They do not, however, allow for an overlap of form. It is not possible to "stitch over" in such embroidery. Each stitch must be integrated with its neighbor in procedural sequence as well as in final effect. It is fundamentally an art concerned with the structure of surfaces. For Sonia Delaunay, these limitations were a challenge.

Robert Delaunay noted the surface orientation of Sonia's oils and later connected them with the traditions of the decorative arts:

> ...the colors are dazzling. They have the look of enamels or ceramics, of carpets — that is, there is

Cat. 46. *Study of Women (Etude de femmes)*, 1909
No. 2038, pencil on vellum, 12-3/16 x 9-7/16 (31 x 24)
Collection Sonia Delaunay, Paris

already a sense of surfaces that are being combined,
one might say, successively on the canvas.[19]
He was also convinced that it was through the medium
of embroidery that she learned to use color freely:

> Basically, color was handicapped by subservience to
> line: the latter limits color, paralyzes it, makes it rigid
> and sacrifices it, so to speak, to an archaic stability.
> The break, however, was to come in 1909.
> Delaunay-Terk made some satin-stitch wall hangings
> which, by means of their expressiveness, were to
> bring into view the prospect of liberation.[20]

Embroidery was a medium in which Sonia Delaunay
could work in a constructive manner while at the same
time disassembling the final restrictions of her
academic training. It was a medium in which she
could maintain both her individuality and the
decorative traditions of her Russian origin. It was also a
medium with which she could play, amusing herself
with the new problems it posed.

If the structural complexities of the embroidery
were resolutions to the issues posed by Cézanne in
painting, the color was inspired by Rousseau. Like
Robert, Sonia Delaunay was enamoured of the old
painter. Rousseau's appeal lay in the fact that he
remained forever a product of his provincial and
suburban roots, unsullied by the sophistication of Paris
or the avant-garde art world:

> Who was Rousseau? For us he was the typical
> French petit bourgeois, always correctly dressed,
> always standing on his dignity. He was extremely
> proud of being Monsieur Henri Rousseau, retired
> customs official. Yet painting was more than a hobby
> to him: it was his passion.[21]

For Sonia Delaunay as well, the embroidery that could
have been a mere hobby was in fact part of her passion
for creation. Moreover, Rousseau approached the art
of painting in a manner more closely related to that of
a traditional craftsperson. He was not an intellectual,
but a man of the people with a deep-seated need to
express his vision in pictorial form. In his own mind, he
was within the tradition of the great academic masters,
for whom the craft of painting was a serious concern.
In the minds of both Delaunays, he stood for the
primary creative spirit of the people. As Robert put it:

...Rousseau put together what might be called an
anonymous oeuvre, which was related in a thousand
ways to all popular art and which at the same time
bore the personal imprint of a strong will and of
stylistic purity — this is Rousseau's whole life and work.
 The type of painting you find in the suburbs, in
the country, in the small market towns; the naive and
direct expression of these artisans, paintings of fairs,
of amateur hairdressers, of milkmen, etc.... of all this
painting that springs directly from the abstruse ideas
of the people, Rousseau was the genius, its precious
flower.[22]

A fter the summer month in Chaville, Sonia Uhde and Robert Delaunay returned to Paris and continued seeing each other almost every day. Their time was spent exploring manifestations of the new modern spirit and of the ancient French spirit in the monuments of the city. Sonia recalls climbing eight flights of stairs to Robert's small studio where he enjoyed the company of plants and birds.

> From his window, one could see the Pont-Neuf, Notre Dame, the spire of the Sainte-Chapelle which he painted later on. These quays, these roofs of Paris were ingrained in his memory[23]

He took her to visit Saint-Germain-l'Auxerrois, which assimilates five centuries of French architectural style, and which holds the tombs of many of the artists whose works can be seen in the Louvre. In her old age, Sonia still adored the church. They also visited the Louvre, where they could explore cultures far older than those of France or Russia. They frequented the Egyptian, Chaldean and Assyrian rooms, which were not then the popular attractions they are today, admiring jewelry as much as sculpture, seeking to discover the "ancient sources of artistic form."[24] The magnet for them was probably the fact that the art of these cultures is primarily one of surface decoration.

Their friendship developed into love, and by the spring of 1910, Sonia Uhde resolved to ask her husband for a divorce. Uhde granted it without antagonism, and she immediately became engaged to Robert Delaunay. She still lived with her husband until the divorce became final, but she spent every waking hour with her fiancé. Her lawyer eventually advised her of the need to be more discreet and suggested that she and Delaunay move out of the city during the transitional period. They decided upon Nantua, which appealed to them because of its pastoral beauty, and they found temporary lodgings there. Shortly after they arrived Sonia fell ill but was unable to discover what was wrong. Robert, naturally disinclined to cope with the sickbed, wandered around the countryside on his bicycle poaching nests of baby birds in order to study their growth. He found young students to take care of Sonia while putting her in charge of tending some forty

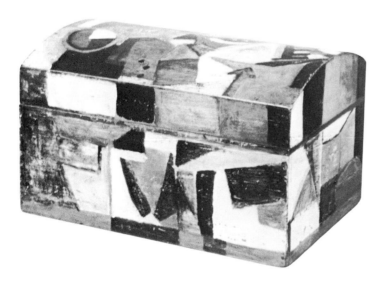

Cat. 195. Box (Coffret), 1913
oil on wood, 7-7/8 x 14-3/16 x 9-11/16 (20 x 36 x 24.5)
Collection Musée National d'Art Moderne, Paris

nests, which they eventually transported back to Paris. After they returned to Paris, Sonia saw a doctor and was informed, to her astonishment, that she was pregnant[25] The couple was married in November, 1910.

It is not difficult to imagine that Sonia Delaunay's energies were diverted from her work during this period, when her life was full of new adjustments. Coupled with the sudden surprise of learning that she was shortly to become a mother, was the fact that her pregnancy was a difficult one. She also had a new household to put in order, forty bird's nests to take care of and a husband who painted daily and was frequently so absorbed in his work that he forgot to bathe or shave. They moved into an apartment with a studio at 3, Rue des Grands-Augustins, and renovated it to accommodate their taste and needs. A bathroom was installed between the kitchen and the studio, the Empire furniture was moved out bit by bit and layers of wallpaper twenty centimeters thick were replaced by coverings of white calico. Charles Delaunay, the future jazz historian, was born in January, 1911. It was fortunate that he was an exceptionally calm baby. Robert was not given to child-care, and noise made him nervous. Sonia found a young girl to come in and look after Charles, and thus freed herself to work again. Her work, however, took a new direction.

Her first undertaking was a bed quilt for her son, composed of fragments of yardage and pieces of fur. The idea came from her recollections of quilts made by Russian peasants. In traditional Russian peasant households all of the domestic linens, furnishings, and utensils were decorated with time-honored designs. Young women were expected to take pride in their needlework and demonstrated this pride by embellishing towels, pillowcases and even dishcloths with brightly colored and active patterns. The colors were particularly vivid in southern Russia. Although folk art traditions were on the wane in the 19th century, the revival of interest in the Russian past brought these designs to light again in the 1890s.

It is difficult to surmise just how thorough Sonia

Delaunay's exposure to Russian folk art was, but she recalls as a young girl having entered a friend's house in the country and being overwhelmed by the colors of the various decorative motifs[26] Given her interest in "art of the people" and in the unique characteristics of her own heritage, one can assume that she took note of publications or exhibitions concerning these artifacts[27] The link was not tight for she did not use traditional stitching or traditional designs. Nonetheless, she considered her work to be in the manner of the Russian peasant, and she took pleasure in the thought that she was utilizing her heritage.

Russian needlework did not feature appliqué as one of its prize traditions, although the technique was employed for everyday or practical furniture coverings and apparel. For Sonia Delaunay, it was a simple device for experimentation in color, which had been released from the confinement of preconceived form in the earlier embroideries. Embroidery can easily become a painstaking and time-consuming task. Appliqué work of the sort which Sonia Delaunay undertook, however, used large straight-edged forms and was not particularly demanding in terms of technical skill. Her excitement with the quilt was an excitement with the arrangement of color on a surface. Technical proficiency in needlework was not her goal.

Redecorating the home in a pseudo-peasant manner served a practical as well as an aesthetic purpose. The Delaunays were living quite well during this period, but living beyond their means. Both had been promised incomes from their families, and had set up a household assuming a certain level of wealth. Robert's mother, however, habitually spent far more than the family earned and was never able to give the young couple the sum she had promised. Sonia was in the habit of spending freely, and found it very difficult to curb this style. She lent money to friends in need and opened the house each weekend to quantities of guests. Despite her extravagance, the purse strings were in her care, for practical considerations were quite beyond Robert's range of vision. One area in which Sonia later insisted that she economized was in the refurbishing of their home. Some of the unusual

materials that she employed in her collages or on which the two of them painted were, she recently stated, the result of lack of funds for buying proper supplies. But, despite financial worries, it was a happy time. It was a period in which the Delaunays played at life. For Sonia the ideal of peasant purity was integrated into the imaginative aspect of creative play.

The quilt for Charles' bed was made in 1911, before the collage experiments of Braque and Picasso. Later visitors to the house exclaimed that it looked Cubist, but it presented, instead, a timely coincidence of ideas. Robert Delaunay was involved during that year in his *City* and *Eiffel Tower* paintings which evolved ever more closely toward rectangular fragmentation and surface patterning. He was beginning the transition from his destructive to his constructive period. Sonia Delaunay commented:

> At the beginning of his constructive period, I didn't like what he was doing, but I felt that it was pleasant, striking. I understood and supported him before I got any actual pleasure from looking at his painting. I

learned to love his colors while remaining faithful to myself and very different[28]

Although the blossoming of color which we associate with Robert's work did not occur until the *Simultaneous Window* series of 1912, dramatic reds, yellows, and greens burst forth from the *Tower* paintings of late 1911, and corals, blues and greens bounce across the surface of the *City* paintings of the same date.

The colors which Sonia Delaunay chose for her appliqué project are far more intense, and far more varied — reds, yellows, greens, purples, pinks, beiges, whites and blacks. Their force equals that of her Fauvist canvases. Their interplay is far more extravagant. One senses that the beginning point for this creation was the placement of a certain patch of color, which determined the size, shape, and placement of its neighbor. The process continued, with adjustments, until the arrangement met the harmonic conception of her intuitive vision. It is balanced in

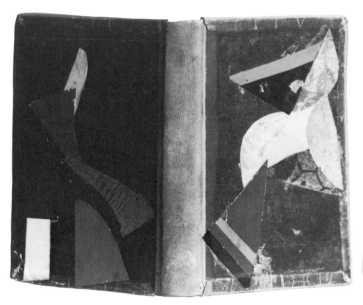 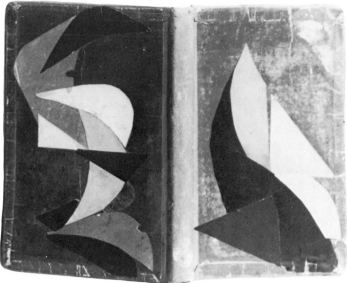

distribution of darks and lights, of complements and
related hues, of large and small fragments, and
probably of textures as well. (It is difficult to visualize
the original texture of the worn fur.) The effect is one of
syncopated visual activities — colors which project and
colors which recede, colors which relate and colors
which jar, areas that are simple and areas that are
complicated in formal and coloristic activity. Rectangles
dominate, but the potential monotony of their rhythm is
interrupted by occasional swinging diagonals and arcs
which carry the eye sweepingly from one corner to the
next. It is an arrangement whose rhythms were to
become very familiar as the format of Robert
Delaunay's *Windows.*

If the design was far ahead of its time, its
emergence may be explained by a confluence of
ideas. Early Cubist painting, with which Sonia
Delaunay was quite familiar, was concerned with such
spatial and rhythmic discontinuities. Both Robert
Delaunay and Fernand Léger, who were close friends
at the time, developed these concerns into theories of
contrast as the activating force in modern life and
modern painting. The contrasts of which they spoke in
painting were contrasts of color and form. Signac's

famous book, *D'Eugène Delacroix à Neo-Impres-
sionisme,* with its theories of simultaneous contrasts of
colors based on the principles of Chevreul and Rood,
was republished in mid-1911. This popular edition was
reviewed by Apollinaire, and certainly played its role in
the reintroduction of chromatic color into Robert
Delaunay's paintings[29] Although Sonia Delaunay was
not as intrigued by color theory as her husband, and
even he followed it loosely, she admits to having
learned from his example:

> …Delaunay began working with Chevreul's
> simultaneous contrasts, following, nevertheless, his
> own idea of it. And his construction in turn helped
> me. It was the backbone of my painting. It enabled
> me to arrange colors without drawing[30]

Turning her eye to textiles, Sonia simplified
her task by working with a limited number of related
shapes, allowing the vibrancy of the color contrasts
to dictate their extension. The decorative impulse
was already inherent in Cubist patterning of 1910
and 1911. It provided a structural substitute for the
representational form which Cubism was in the
process of destroying. Sonia Delaunay intuitively
developed this constructive aspect of analytical

Cat. 178. Bookbinding for (Reliure sur) Ricciotto Canudo's *Les Transplantés* (Paris: E. Fasquelle, 1913), 1913-14 (Dedicated to Sonia Delaunay)
fabric collage, 11-1/16 x 8-5/16 (28 x 21)
Collection Bibliothèque Nationale, Paris

Cubism to a final conclusion by combining its rhythms with a focused exploration of color in a medium which is constructive by its very nature.

It has frequently been stated that the quilt was both a springboard for future experiments in collage by the Delaunays and a catapult which launched their art into abstraction. Both statements are true with certain modifications. Sonia discovered that the decorative technique of appliqué was equivalent to the Cubist-inspired art of collage which emerged in 1912. She then began to work with colored paper rather than textiles as a basis for book covers, posters and paintings. Some of these designs are undeniably nonobjective. However, after the simple transition from appliqué to collage was accomplished, recognizable imagery reasserted itself in the designs, as it was reasserting itself in her oil paintings of 1913. Moreover, one wonders how fully abstract the quilt really was meant to be. It contains rectangles and triangles similar to those of the roof tops in Robert Delaunay's views of the city, and it contains a sweeping curve ending in the center which reflects the sweep of the *Eiffel Tower* paintings. The connections to Robert's

works cannot be ignored. Nonetheless, the appliqué called for simplification, solidification and flattening of his coloristic and spatial complexities. In the end it matters very little whether the work has vestiges of representation or is intentionally abstract. Representation was not an essential issue in such a decorative medium.

Sonia Delaunay moved from the quilt to other objects in her home, particularly cushion covers, lampshades, goblets and curtains. All of these objects are surface coverings of one or another sort; in several of them it is expected that the surfaces will be penetrated by light. Throughout 1912, Robert Delaunay was formulating his theory of simultaneity, which was based on the concept of light as the unifying force among contrasts. Sonia Delaunay's objects, composed of simultaneously contrasting colors, forced the theory to be demonstrated in the reality of the actual light of day and the gas lights of evening. These objects thus functioned as artificial prisms for the light which filtered through them. This concept was to become particularly important in the later works of 1913. By that time Sonia Delaunay's intimate creations had gained sufficient reputation among the friends who visited the apartment, that several had found their ways into other homes. Many had to be borrowed from collections in Paris, New York and Berlin for exhibition in the 1913 Herbstsalon at Der Sturm Gallery.[31]

n 1912, Sonia Delaunay was ready to return to painting. Her experiments in embroidery and textiles had allowed her to deal confidently with free color, and Robert was, by that time, working in a constructive manner with the colored facets of his *Simultaneous Windows.* In these, the Eiffel Tower and the city are joined, dissolved and simultaneously represented in rectangles and triangles of spectral color. Light from the sky had been the dissolving and unifying element of his works throughout 1911. It was the light of the sun, and, in the *City of Paris* of early 1912, it became the light of the moon as well. This light seemed always to fall from the upper right, and even in the *Window* series, the impact of its vibrating rays precipitated the evolution of radial pinwheel forms in that portion of the canvas. Sonia Delaunay's first oils of the period were called *Simultaneous Contrasts (Contrastes simultanés).* In them she clearly contrasts the multi-colored and ephemeral Eiffel Tower with the primary source of its illumination, the sun. In a comparison of one of her *Simultaneous Contrasts* with a typical *Window* by Robert, the individuality of Sonia's expressive style becomes readily apparent. Her geometry is far less disciplined and the pitch of her angles far more eccentric. The rhythms of triangles and rectangles seem to bend before the rhythm of circles, as though the pressure of intersection was one which occurred only on the two-dimensional surface. In Robert's works, the rhythms interconnect by sliding over and under one another. He remains traditionally interested in problems of spatial illusion. Sonia, who speaks of herself as "living in depth," is concerned primarily with the dynamics of the surface.

It is clear in *Simultaneous Contrasts* that Sonia Delaunay had learned to break contours. The triangles emanating upward from the side of the Eiffel Tower pierce directly through the rings of color which are representations of the expansion of the sun. This source of light, whose presence was made apparent in Robert's works by pinwheels, became in Sonia's, a dramatic, clarified doubling of colored rings, pushing with toppling force against the verticality of the tower. There is no precedent in Robert's work for such an image, nor can we find it in the paintings of

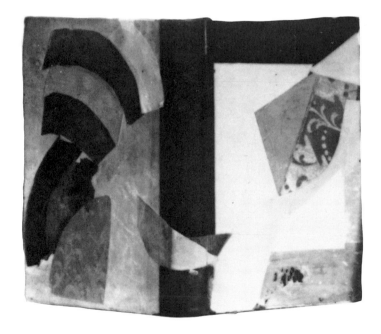

Cat. 177. Bookbinding for (Reliure sur) Guillaume Apollinaire's
L'Hérésiarque et Cie (Paris: Stock, 1911), 1913-14
(Dedicated to Robert Delaunay)
paper collage, 5-1/8 x 7-11/16 (13 x 19.5)
Collection Bibliothèque Nationale, Paris

contemporary Cubists or Futurists. It is, however, a ubiquitous motif in Russian folk art, and if Sonia Delaunay did not recall it from her youth, she was certainly reminded of it by its presence in the contemporary works of Chagall. This fellow countryman, who also hailed from a small Jewish village, arrived in Paris in 1910. By late 1912, he was in touch with the Delaunays and in 1913, he became one of the regulars at their home. For him the sun and the moon, and circular motifs in general, held a mystical significance which he associated with his Russian Jewish heritage[32] The motif of the sun as a combination of pinwheels and circular bands was, moreover, to be the subject of Robert Delaunay's major series of 1913, the *Circular Forms.*

It was during this time that Sonia began to delight in the effect of electric lighting on the streets of Paris:

> I liked electricity. Public lighting was a novelty. At night, during our walks, we entered the era of light, arm-in-arm.
> Rendez-vous at the St. Michel fountain. The municipality had substituted electric lamps for the old gas lights. The "Boul' Mich," highway to a new world, fascinated me. We would go and admire the neighborhood show. The halos made the colors and shadows swirl and vibrate around us as if unidentified objects were falling from the sky, beckoning our madness[33]

The typical rendez-vous to which she referred was a gathering of painters and poets, all of whom were excited by the rapid changes of the modern world and who were attempting to develop a literary or artistic parallel for its action. A primary figure among the group was Guillaume Apollinaire.

Apollinaire was a friend as early as 1911. Sonia told the story of how Robert cut short his summer vacation that year to intervene in the poet's unwarranted arrest for the theft of the Mona Lisa from the Louvre. Few of his friends remained at his side during that crisis, but the Delaunays, following their feelings as was their nature, remained faithful supporters. A year later Apollinaire was still stinging from the scandal and was thrown into depression by his separation from Marie Laurencin (which Sonia clearly saw as a step in the right direction). The Delaunays invited him to stay with them during this difficult period while he waited to move into his new apartment on Boulevard St. Germain-des-Prés. He was there for six weeks in November and December, 1912. During this time his famous poem *Zone* was published in *Les Soirées de Paris.*

Zone was his first truly modernist piece of writing. In it he consciously rejected the past by juxtaposing revered images of antiquity and Christianity to automobiles, airplanes, and, of course, the Eiffel Tower. With no punctuation to halt its progress, the poem slips from past to present, from distant exotic memory to the brash reality of modern Paris as though all were indivisible aspects of a dramatic but elusive continuum. The poem was the first literary exemplification of the Delaunay's theory of simultaneity. It stands to reason that Apollinaire should know this theory well as he had edited and published Robert's writings the previous summer[34] Moreover, *Zone* described a walking tour of Paris. It was a souvenir of the lifestyle of Apollinaire and the Delaunays during that exciting time.

In the poem, Apollinaire boldly defined the popular poetry of the modern age:

> You read prospectuses, catalogues, posters all loudly singing
> That is your poetry this morning, and for prose there are the newspapers[35]

During that very month Robert Delaunay began studies for his famous painting *The Cardiff Team,* in which he integrated several brightly-colored advertising posters. With this work, lettering in loud colors thus entered the realm of pictorial design in oil painting. Both the Cubists and the Futurists had made use of lettering much earlier. Its importance for them, however, was to provide linear structuring and nondescriptive clues to the painting's subject. Delaunay was the first to consider the concept of the poster as a total entity which could, through its coloristic arrangement, provide a structural unit essential to the painting's composition. Both Sonia and Robert Delaunay were primed for the integration of poetry and painting, of letter and color, into a simultaneous whole.

The intense and rewarding interchange between Apollinaire and Robert Delaunay was one of the more remarkable liaisons of early 20th-century art. It was a relationship, however, which only secondarily included Sonia. She supported Apollinaire's ideas and even made organdy curtains in simultaneous colors for his new apartment, but there was no direct collaboration between them on any specific project. Her true inspiration was to come from a different source, another poet. Sonia Delaunay describes her first encounter with Blaise Cendrars:

> On Wednesdays, Apollinaire would welcome his friends in his new apartment. On one of those evenings I noticed, sitting on the large sofa, a small young man, blond and frail. Blaise Cendrars. He had just written *Pâques à New York*. He lived two or three houses away from us. "Come and visit us in our studio." The next day he brought us a small booklet. *Les Pâques.*
>
> I read it first. Thrilled by the freshness of its ideas, I passed it on to Delaunay and rushed to my supplier, on Rue Dauphine, in order to get the materials for the cover and binding which I pictured for this poem. On suede I placed motifs of paper collage. Inside I did the same with big, colored paper squares. It was a tangible response to the beauty of the poem[36]

This was the beginning of a new year, of the one which was to give birth to so many creative ideas that Sonia Delaunay could return to them consistently for revitalization for the rest of her life[37] Many of them came directly from her collaboration with Cendrars. At his death she reiterated his importance:

> Cendrars represented to me one of the most luminous moments of my life. With his passing the shadows gather again.
>
> Little by little it will be realized that Cendrars was the truest and greatest poet of our time[38]

Les Pâques à New York was an even more brutal evocation of modernity than that posed by Apollinaire. With typography spread in nebulous order across the page, its juxtapositions of images and sounds disrupted the rhythmic flow of the traditional poetic stanza. The brashness of modern life imposed itself through rough contrasts of men and machines. Placement of words in the poem has to do with the force of the word, either as image or sound. As was the reverse case with colors and forms in Sonia Delaunay's *Simultaneous Contrasts,* disjunctive ordering in time compels an irregular arrangement in space. Nonetheless, movement flows from line to line, each line or group of lines serving as a rhythmic catapult for the next. Movement derives from the surface effect of the words. Depth of content or feeling is a quality of the words themselves and their intervals. Cendrars' poetry was the direct equivalent of Sonia Delaunay's style.

In Cendrars' presence in January, 1913, Sonia Delaunay attached stiffer boards to the paper cover of *Les Pâques,* covered them with suede, and glued on triangles of paper and fabric. The suede is a soft and rich beige. The papers range from bright red and yellow to deep blue, silver blue, and metallic gold. They distinguish themselves from their background like a cluster of exotic gems in a plushly lined case. One cannot help but be reminded of the long Russian tradition of finely covered books, replete with gold and jewels. The arrangement of the triangles, however, is far from traditional. On one side they are placed in such a way that they build a solid square. A duplicate square is begun at its side, but left incomplete. The missing triangles seem to have slipped below, where they anchor the floating form quite abruptly to the colored edge of the binding. On the other side, the triangles form three-quarter squares which double up to construct a diagonal axis. Once this pattern is established, the triangles then dissipate in various directions. Sonia Delaunay's technique of rhythm-breaking was already fully established. In the interior of the book, endpapers were created from a collage of rectangles in a quite regular vertical-horizontal arrangement. Rhythm-breaking here occurs in small overlappings and irregularities and in the sudden shift at top or bottom from tall rectangles to short rectangles. It is a subtle exploration of balances which relates to the rectangular rhythms of Robert Delaunay's *Windows* and which is an obvious precursor of Mondrian's compositions of the 1920s and 1930s.

The cover for *Les Pâques à New York* began Sonia Delaunay's special library of precious books.

Fig. 4. La Prose du Transsibérien, *unfolded.*

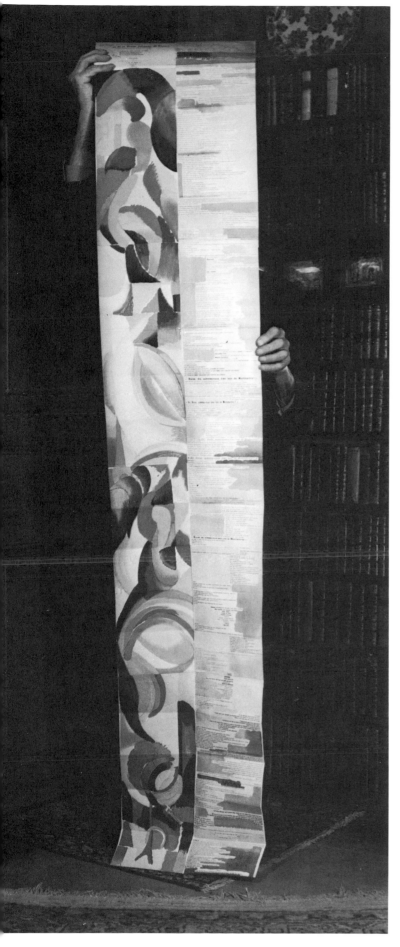

Other covers were made for the publications of all her favorite poets: Mallarmé, Rimbaud, Laforgue, Romains, Mercereau, Jaudon, Minsky, Canudo and, of course, Apollinaire. Several languages were represented in the collection. In their diversity, the connective link between these poets is their use of discontinuous rhythms, which, for Delaunay, put their works on that nebulous line between clarity and mystery. It was this quality that made them true poets for her. Other books were covered as well: three volumes of the periodical *Der Sturm,* the album which served as the catalogue for Robert Delaunay's exhibition at Der Sturm Gallery in 1913, and Kandinsky and Marc's famous publication. *Almanach der Blaue Reiter.* Clearly, the theorists who were sympathetic to simultaneity were accorded the same respect in Sonia Delaunay's library as were the poets. Their ideas were an extension of the poetic feeling.

The book covers vary in size, in type and color of covering, and of course, in color and style of collage. The designs range from rectangular to circular compositions and from simple abstraction to semi-representative images. It seems apparent that the covers were made over a period of time throughout 1913, for their styles can be linked to Sonia Delaunay's development in other art forms.

After the gift of *Les Pâques à New York,* Cendrars, who was desperately poor, came frequently to the Delaunays' home, both for the conversation and for the nourishment:

> From then onward he came to lunch nearly every day. He used to live close by at 4 Rue de Savoie in those days. He soon became part of our circle. His poetry was his life, and he lived for it, as Delaunay and myself lived for our painting. A few weeks later he wrote the *Transsibérien,* and, overwhelmed by the beauty of this poem, I undertook to illustrate it[39]

The poem to which she refers is *La Prose du Transsibérien et de la Petite Jehanne de France* which was probably written in February, 1913[40] It is a very long poem, evoking in its self-perpetuation the seemingly unending journey from Moscow to towns near the Sea of Japan. It is the tale of such a trip, similar to

the ones that Cendrars actually took.[41] It also tells the thoughts, memories, reflections and fantasies that pass through the mind of a young poet, accompanied by an even younger French prostitute, as they are propelled across the bleak Siberian landscape by the speed of a thundering train. It ends with a rousing ode to Paris, the hub of the world and of the poet's life.

A trip across Russia, from primitive village to major city, from childhood to adulthood, ending in Paris, where memories of the past join with the urgency of the present — such a theme was certain to strike a basic chord in Sonia Delaunay's heart.[42] Furthermore, and perhaps more importantly, the poem was rendered in simultaneous style. Robert Delaunay explained how it functioned:

> Literary simultaneism is perhaps achieved by contrasts of words.
> [La Prose du] Transsibérien [et de la petite] Jehanne de France is a simple contrast (a continuous contrast which is the only one that can reveal the profundity of living form).
> [La Prose du] Transsibérien [et de la petite] Jehanne de France permits a latitude to sensibility to substitute for one or more words, a movement of words, which forms the form, the life of the poem, the simultaneity.[43]

The contrasts in the poem are between past and present; Paris, Russia, and various other exotic locations in the world; revolutionary massacres and intimate lovers; anger and love. The images are combined in a form of writing which is neither traditional poetry nor normal prose. It has no metrical cadence nor tonal unity. On the other hand it does (unlike Apollinaire's Zone) have clarifying punctuation. The lyrical movement of certain lines and the abrupt interjection of certain words run counter, nevertheless, to the concept of prose. The two forms are blended into a simultaneous presentation that is guided by the quality of images. The images determine the poem's rhythm which changes freely according to the sensual impact of their associations and sounds.[44]

In the midst of his poverty, Cendrars suddenly inherited three thousand francs, and decided to spend it to print the Prose du Transsibérien. He had previous experience in such ventures with both La Légende de Novgorode, and Les Pâques à New York, published in very small editions by private presses.[45] With his new fortune, Cendrars could consider a major and luxurious edition for the Prose du Transsibérien. His delight with the Delaunays' art and particularly Sonia's cover for Les Pâques precipitated the suggestion that they collaborate on the printing project.

The genre of livres d'artiste had been growing since 1909 with the interest and support of Vollard and Kahnweiler.[46] In that tradition, however, the concept of the page-format, which necessarily fragments the flow of writing, was accepted. Images were arranged carefully in correspondence to the text, but within the limitations of the sequential interruptions that a series of pages provides.[47] If the project were to be simultaneous rather than sequential, even the format of the book had to be redesigned to enhance this final purpose. The result was a vertical paper panel two meters long, folded in half lengthwise and then accordion-style into twenty connected sections. In this way it could be stored in a normal book-size parchment cover, but could unfold to be experienced as a six and a half-foot continuum. Cendrars' text, using twelve different type faces in several colors, extends the length of the right vertical half. Delaunay's colored visual accompaniment runs the length of the text on the left and is interspersed with the text on the right in the open spaces created by the looseness of the nontraditional printing arrangement.

The format maintained a clear separation between the inventions of the artist and the poet while forcing the viewer to accept them as simultaneous. Arrangements of type connect with arrangements of color in such a way that they are intimately bound. Neither functions as a superfluous appendage; neither disrupts nor fragments the flow of the other. Sonia Delaunay helped choose the colors, faces and sizes of type which would allow this visual unity of presentation.

The visual image that still exists in its canvas original, created in response to the poem, has only one literal connection to the imagery in the text — the

Fig. 5. *Page detail of* La Prose du Transsibérien.

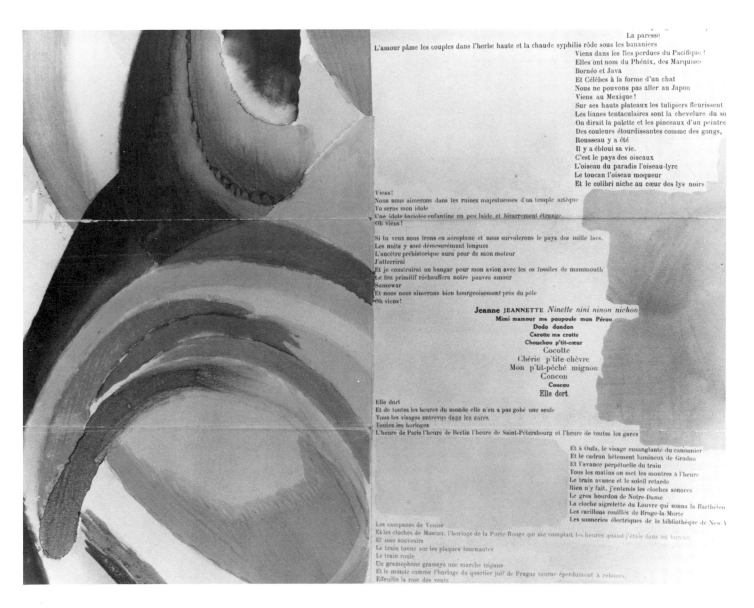

Eiffel Tower and ferris wheel at the very bottom. The poem ends with the cry:

> Paris
> City of the incomparable Tower of the Rack and the Wheel[48]

The Eiffel Tower had become an ultimate symbol of simultaneity for the Delaunays. It could be seen from all over the city and surrounding countryside. Its beacons, spotlights and radio equipment extended its range of influence far beyond normal visual limits. It had presided over two World's Fairs, bringing together nations from the entire surface of the earth to hover at its feet. It was the site of aerodynamic laboratories and meteorological studies and the half-way point for numerous balloon, dirigible, and airplane races. It was a central post for the development of international transportation and communication and of research in speed and space. It was the modern image par excellence.

Robert Delaunay had painted the Eiffel Tower over and over again in 1911 and 1912 and, by 1913, it had become a hallmark of his style and philosophy. Cendrars, absorbed in Robert's enthusiasm, wrote a poem about the Tower in August of that year. The edition of the *Prose du Transsibérien* was to total 150 copies. At two meters each, the entire edition, end to end, was calculated to rival the height of this great simultaneous monument. Sonia, who had included the Eiffel Tower in her *Simultaneous Contrasts* of 1912, was now prepared to solidify her conception of the image in clarified form and color.

She simplified the needle-like form to a single plane of solid color, broken by the ring of an accompanying wheel. This was the large ferris wheel which during that era stood at the opposite end of the Champs de Mars from the Tower. Like the Tower, it was a modern mechanical construction of immense proportions, a sensation-producing public toy projecting into space. Robert Delaunay had included it in his late *Window* paintings of 1912 and in *The Cardiff Team* of 1912-1913, where it facilitated his transition from rectangular to circular visual motion. Its form corresponds directly to that of Sonia's sun in her 1912 oils. She thus employed both the Eiffel Tower and the ferris wheel as components of the image which appears as the ending image of the poem and as her signature.[49]

The vast majority of the painted design for the *Prose du Transsibérien* is abstract. It is a syncopated combination of languid arcs and abrupt triangles, paisley pods and sturdy rectangles. Like the poem, it varies in rhythmic movements as consistently as it varies in hues, tones, and contrasts of colors. It develops freely, but with spontaneous discipline, from surface to surface, distinguishing the presence of imagined way-stations in the flux of transformed clouds of color. The steam of the train, the motion of its wheels, the change of the landscape, the voices of passengers are all images evoked but not stated by this unique combination of color and form.

The printing of the colored image was accomplished by a technique known as "pochoir." This method was inspired by the influx of Japanese stencil prints into Europe in the late 19th century and was frequently used in elegant fashion publications.[50] It requires stencils to be made for each separate color area; the stencils then control the placement of hand-applied watercolor or gouache. The mechanics of the procedure are simple, and it allows for the direct control of the artist over the color and texture of each print. Although pochoir stencils were made after a pre-established design, the process of cutting, then connecting colored form to colored form was one not far removed from that of appliqué or collage.[51] Pochoir was a printing technique in which Sonia Delaunay could maintain her unique interests in craft.

To ensure that her personal touch was apparent in each copy, color was allowed to bleed around the edges of the stencil. In places it appears that the brush was later applied to smooth over harsh transitions between color areas.[52] Sixty-two of the proposed one hundred and fifty copies were actually completed. Each is slightly different from the others. Each is a new expression, despite its repetition of a preconceived composition. The publication was at once an example of evocative and elusive poetry and of solid, hand-controlled craft.

T*he Prose du Transsibérien* was announced in October, 1913. Several months later Apollinaire commented in *Les Soirées de Paris:*

> Blaise Cendrars and Mme. Delaunay-Terk have realized a unique experiment in simultaneity, written in contrasts of colors in order to train the eye to read with one glance the whole of a poem, as an orchestra conductor reads with one glance the notes placed up and down the bar, as one sees with a single glance the plastic elements printed on a poster[53]

By that time, the concept of the poster was likely to have been connected in Apollinaire's mind with the *Prose du Transsibérien.* Several posters were designed to advertise the publication itself. In these images, Sonia Delaunay was faced with the challenge of creating the letters themselves, by her own hand, to be printed in various colors using the pochoir technique upon an equally multicolored surface. Words thus became part of the raw material which she could transform into a new simultaneous language of color.

The poster soon evolved in Delaunay's thinking into a means for advertising the concept of simultaneity itself. Alexandre Smirnoff, an old friend and former suitor of Sonia's from St. Petersburg, visited during the summers of 1912 and 1913 and spent considerable time at the Delaunays' country house in Louveciennes. He was so thoroughly enchanted by Robert Delaunay's discoveries that he returned to St. Petersburg determined to spread the news. In July, 1913, an evening was arranged at the artists' cabaret, The Stray Dog, dedicated to simultaneous contrasts. Smirnoff delivered a lecture on Robert Delaunay. The interior of the club was appropriately decorated with posters by Sonia, which lined the walls with colors and words. These were some of her first experiments in this applied art form, the first "poster-poems." In these early examples, placement of the letters is still dictated by the placement of the underlying forms. They are integrated with, but not yet equal in impact to, the abstract composition which organizes the movement of the colors.

The potential for the letters to play a far more dramatic role in the formal arrangement of the colors

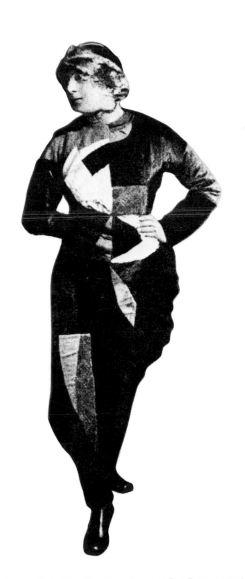

Fig. 6. *Delaunay in a simultaneous dress at Bal Bullier, 1912-13.*

provided the next challenge for Sonia Delaunay. A
sketch sheet for a poster for Apollinaire's poem *Zone*
illustrates how she played with these unfolding
possibilities. It was in this poem that posters
themselves were declared to be the poetry of modern
life. In the sketch, the *Z* and the *N* are broken into
angles capable of establishing planes. The *E* and *S* are
arranged as reciprocating curves, and the *O* becomes
a series of circles familiar from the *Simultaneous
Contrasts* of 1912. External angles and related planes
are then integrated with these forms. Thus, the letters
now take precedence in the primary ordering of
emerging compositions.

Eventually it occurred to Sonia Delaunay that
she might be able to earn some money from these
experiments by designing posters for major
companies. A project was begun for a Swiss watch
firm, Zénith, perhaps because of the appeal of the
letters, perhaps because the watch was a symbol of
sequential time, and certainly because Cendrars
offered to present the designs to the company. The
poet himself composed an "advertisement-poem"
which was incorporated into the poster:"Record! Noon
strikes its solar anvil with rays of light. Zénith."[54] The
contact with Zénith was never made, but the project
took on elaborate proportions as a theme for
experimentation in Sonia Delaunay's oeuvre. Crayon
sketches, water colors, collages and even an oil
painting are part of the assembly of remaining works.
Gathered together, they demonstrate several facts.
First, in the tradition of Art Nouveau posters, the clarity

of the word is far less important than the impact of the total image. Second, unlike Art Nouveau examples, the words are not accessories to a pictorial image but the basis of the composition. Third, although numerous formal motifs are repeated in all of the existing examples, no single composition appears to have been a finalized design. Instead, new directions are discovered in each version, giving rise to arrangements of very different flavors. The letters, like previously used pieces of fabric and paper, provided an endless supply of creative possibilities.

The *Zénith* series was produced throughout 1913 and continued into 1914. During that same period, Robert Delaunay was developing the *Circular Forms* paintings and clarifying his conception of the circles as the geometric counterpart to the simultaneous contrast of colors in terms of infinite movement. His works from these years are almost exclusively circular compositions. If Sonia Delaunay was to follow his lead and adhere strictly to his theories, she had to find a way to cause the linear and angular forms of the letters in the word "Zénith" to blend into a circular flow. The image of the watch, as centerpiece in the composition, provided the necessary focus. We see it either clearly or potentially defined in several of the sketches and in the collage. There is no *Zénith* sketch or painting that is without some device that creates circular movement. However, unlike her husband, Sonia Delaunay continued to explore the possibilities of rectangles and angles during this period, allowing them to disrupt, accelerate, or simply supply moments of tension within the circular flow. Her adherence to the *Zénith* theme was either the cause or the result of this anticircular inclination.

Other projects for advertising posters of these years can be more closely connected to the idea of the circles as an image of simultaneity. Pirelli tires were presented as juxtaposed concentric rings — two tires connected by a body of letters. Studies for a Bensdorf chocolate poster began in 1913. Here there was no problem: the word *chocolat* is composed primarily of circular or rounded letters. But Dubonnet, which

provided the subject for a major collage, was a challenge in that its letters are both angular and rounded. Sonia Delaunay met the challenge by placing the rounded letters upon a surface of rectangles and the angular letters on a surface of circles.

The shapes of letters are found transferred into other Delaunay compositions in which they have no referential significance. In a sketch for a simultaneous dress, an *L* becomes the bend of a sleeve and a *C* substitutes for a draping of fabric. Sonia Delaunay began making these dresses during the summer of 1913, when the group of friends who walked arm-in-arm through the streets of Paris established a custom of frequenting an evening spot called the Bal Bullier. It was a gathering place for students and artists, featuring the latest popular dances; the fox trot and the tango. These new movements, new rhythms on the dance floor, engendered an enthusiasm as rich as that brought forth by the electric lights on the street outside.

> The rhythms made us want to make the colors dance, too. Everyday wear as well as Sunday clothes were really monotonous and drab. We wanted to end this general state of mourning. It was up to us to find a way. I myself wore my first simultaneous dresses[55]

Apollinaire described this eye-catching apparel in a 1914 interview:

> M. and Mme. Delaunay are the innovators. They do not burden themselves with the limitation of antiquated fashion, and since they want to be of their own time, they don't innovate in the cut of clothing (in that they follow contemporary fashion), but rather seek to influence it by employing new fabrics which are infinitely varied with color. There is, for example, an outfit of M. Robert Delaunay: purple jacket, beige vest, black pants. Here is another: red coat with a blue collar, red socks, yellow and black shoes, black pants, green jacket, sky blue vest, tiny red tie.
> Here is a description of one of Mme. Sonia Delaunay's simultaneous dresses: purple dress, wide purple and green belt, and under the jacket, a corsage divided into brightly colored zones, delicate or faded where the following colors are mixed: antique rose, yellow-orange, Nattier blue, scarlet, etc., appearing on different materials, so that woolen cloth, taffeta, tulle, flannelette, watered silk, and peau de soie are juxtaposed.

He ended with a strong defense of these decidedly unusual combinations:

> So much variety cannot escape notice. It transforms fantasy into elegance[56]

Robert's coats were ordered in those combinations from a tailor. Sonia's dresses, however, were created by her own hand — assembled in collage as were the book covers. The arrangement of forms varied from arcs and circles to rectangles and triangles, but all were arranged not only to establish a movement of color, but to enhance the natural movement of the forms of the body. Cendrars was moved to compose a poem about these creations, which he felt expressed the woman's body as fully as did her skin:

> Designers have a stupid trade
> Just like phrenology!
> My eyes are weights that press down upon the
> sensuality of women.
>
> Anything that is a bump pushes into the depths.
> Stars dig into the sky
> Colors undress you through contrast
> "On her dress she wears her body"[57]

The concept of the emergence of the interior onto the exterior was one that entered Cendrars' writings as early as 1912[58] It was Bergsonian in origin and had made its way as well into Futurist thought, which stressed the need to interconnect the "internal plastic infinity" and the "external plastic infinity" through the proper use of color and light[59] Like the Delaunays, the Futurists were entranced by movement. Gino Severini, who was a resident of Paris and a friend of the Delaunays, had been interested in the colors and movements of nightclub interiors for several years. Interested as well in challenging the drabness of contemporary dress, he had daringly begun to wear different colored socks as early as 1911[60] Perhaps it was he who, according to Cendrars, saw the Delaunay ensemble at the Bal Bullier and:

> ...sent a telegram to Milan, describing our general getup and especially, very precisely and in detail, Mrs. Sonia Delaunay's "simultaneous dresses": Milan spread this information through the world as a Futurist manifestation, so that our behavior, gestures, and harlequin costumes...were known to the entire world, particularly to the avant-garde, which wanted to be up with the latest Paris fashions. Our extravaganzas especially influenced the Moscow Futurists, who modeled themselves after us[61]

Much to everyone's surprise, it was, in fact, the beginning of a new wave in fashion which rose to general popularity a decade later.

Severini had painted a series of nightclub dancers and café interiors in late 1912 and early 1913. The nightclub, as a hub of activity, a gathering spot for young people, was another appropriate symbol for modernity and for simultaneity. Sonia Delaunay was certainly not unaware of these ideas. Her personal enchantment alone with the Bal Bullier was sufficient inspiration for her major canvas of 1913, a thirteen-foot painting, on mattress ticking, depicting the entire dance floor complete with dancers and electric floodlights. As in the rendering for *Prose du*

Transsibérien, it presents a flowing and seemingly interminable length of colored forms, wafting from warm to cool, from delicate transition to sharp contrast of tone and hue. Despite its length, which almost rivals the traditional scale of murals, its horizontal format is more familiar than the vertical extension of the *Prose.* It is perhaps for this reason that it appears more balanced, certainly more integrated both in color and form.

Unlike Futurist renderings of dance halls, the *Bal Bullier* provides no central character. It is, rather, an image of group movement and interaction, very much within the philosophy of Jules Romains — the theory of Unanimism. Sonia Delaunay owned copies of Romains' writings and had covered her edition of his *Puissance de Paris.* In it he discusses various gathering spots in Paris, whose crowds create an energy which is distinct from that of the individuals involved. The group is transformed into a new life, a new organism with its own distinct rhythm. The scene which Sonia Delaunay has captured is precisely such a unity of individuals within a new state of existence. The individual is neither dominant nor the specific object of attention. The entire group formulates the interest and action of the painting.

Many of the dancers in the group that Delaunay painted were her friends. Their simultaneous movements were thus both metaphorically and actually the movements of the contemporary art world. Sonia did not often dance at the Bal Bullier, but as is apparent in the painting, she was fully absorbed in the energies of the Latin music, the reflections of the lights and the colors of the simultaneous costumes. She understood the action as fully as any of the dancers. She seldom took part in the intellectual discussions that stimulated the group. She was content to listen, to absorb their ideas and integrate them quietly into her own. She was one among many equal forces, working together in the development of a new art.

The movement of the crowd reflected in light had been a subject of study for Sonia Delaunay throughout the spring and summer of 1913[62] The

crowds which interested her most were those on the Boulevard Saint-Michel, seen under electric lights, reflected on the surfaces of windows or sidewalks. They were studies in the action of color and light as much as studies of people in movement. Yet, in these quickly rendered crayon sketches are found hat brims, extended arms, black ties and boots defining the presence of human forms. Areas of color result from the accumulation of long, bold hatches of color. They cease or continue, dependent on her observation of the street and her sense of balance in the color arrangement on the page. The unique definition of forms in the *Bal Bullier* is in part due to knowledge gained through these studies. The indivisible integration of reflection and actuality is directly a result of these pursuits. It is a primary facet of their expression of simultaneity.

The sketch technique employed in the crowd studies is also used, in a more controlled manner, for sketches of dancing couples which were preparatory to the *Bal Bullier.* A sketch for the central couple of the final painting explores the balance of red and green, yellow and purple, blue and orange and black and white contrasts. In some places these complementaries are in direct juxtaposition. More frequently they are connected by a corner, or across a narrow divider. Greens and reds dominate spatially in the sketch, as is also the case in the final painting. Sonia Delaunay was never particularly fond of either yellow or orange, especially in combination. This predilection for cooler contrasts separates her palette from that of her husband. Furthermore, unlike Robert, who was exploring contrasts of warm colors in his paintings of the sun and cool colors in his paintings of the moon, her canvases remain integrated presentations.

As Robert examined the sun and the moon for their optical effects, his paintings were more and more inclined toward centralized images radiating in centrifugal and centripetal motion. Sonia, in a continuing investigation of the dancing couple, translated it into a circular and centralized image in her cover for Ricciotto Canudo's book *Les Transplantés.*

By using collage, she was able to define a much bolder and more succinct combination of colors and forms, emphasizing the concentric circles which had been a part of her vocabulary for over a year. Robert had recently begun to employ such arrangements in his moon paintings. The circular composition fuses the two members of the couple even more intimately than in the *Bal Bullier.* Their individuality is apparent only through their contrasts. Again, Sonia's rendering of the dancing couple is not unlike her conception of the working relationship of herself and her husband:

> We were two moving forces. One made one thing and one made the other[63]
>
> Our temperaments were extreme opposites and clashed, but we needed to react together to the things of life and to communicate through our emotions. Strong and tonic delight in sharing all our disagreements. We were attracted by all that carried a spark of novelty. We became one with the avant-garde of the avant-garde[64]

In greater detail she describes the historical effect of their differences:

> My life was more physical. He would think a lot, while I would always be painting. We agreed in many ways, but there was a fundamental difference. His attitude was more scientific than mine when it came to pure painting, because he would search for justification of theories. From the day we started living together, I played second fiddle and I never put myself first until the '50s. Robert had brilliance, the flair of genius. As for myself, I lived in greater depth[65]

If his scientific interest in color theory aided her constructive approach to the use of color, her constant curiosity about new media provided inspiration for the formal development of their joint style.

The collage book cover for *Les Transplantés* with its clarity of form, was probably the basis for an oil sketch of the same image entitled *Tango-Magic-City.* The word "Magic" and the letters "Ci" are integrated into the composition in the manner of the contemporary poster projects. The concept of magic was one which wove its way ubiquitously through the writings of Apollinaire. The transcendent aspects of the philosophy of simultaneity were sometimes referred to as its magic. The word appears as well in a version of Robert's *The Cardiff Team* painted at the beginning of

the year. The word is in English, rather than in French, and it is probably the name of another Parisian dance hall that was popular at the time[66] The implications of the word extend from the modernity of contemporary life to the mysteriousness of the creative powers of poets and painters alike.

The forms of the letters are dramatically angular as they intersect languid arcs and discs. The roundness of the *c* is entangled with the severe right angle of the dancer's hat, resembling an *l* as much as a hat, and proving the constructive quality of letter and pictorial form. While the letters function as rhythm-breaking devices, the underlying composition has become the more stable in its circularity.

The idea of using simultaneous clothing in a painting carried over into Robert Delaunay's work of 1913. He began a series of canvases which exist under the titles of *Parisian Woman, Woman with a Parasol,* or *Simultaneous Dress.* The subject is clearly a model, perhaps Sonia herself, in multi-colored clothing against an assembly of radiating arcs and later, an elaborate ordering of concentric rings. In the earliest version, the woman carries a parasol which filters the light of the sun, separating it into cool and warm oppositions which play across the woman's head and dress. Both the parasol and the woman become prisms for the light of the sun, which is refracted into the surrounding space. The stylish pose of the model is reminiscent of the carefully captured stances of Sonia's tango dancers. Sonia was sufficiently intrigued with the image to begin her own version, in a collage, entitled *Solar Prism (Woman with a Parasol) (Prism solaire [Femme à l'ombrelle]).* It was a spontaneous undertaking that grew out of, or more precisely, on top of a sketch for a poster for chocolate. The *c* of *chocolat* became the outer definition of a parasol. Once again in this collage it is apparent how forcefully Sonia Delaunay retains her distance from her husband while simultaneously employing his themes. Her woman is all angles, brutally proliferated across the page, unique in the severe abstraction of the forms and in the quality of color contrasts. The concentric rings which had centered the image in the Canudo

Fig. 7. Electric Prisms, (Prismes électriques), *1914. Oil on canvas,*
93-3/4 x 98-3/4" (238 x 250.9). Musée National d'Art Moderne,
Paris.

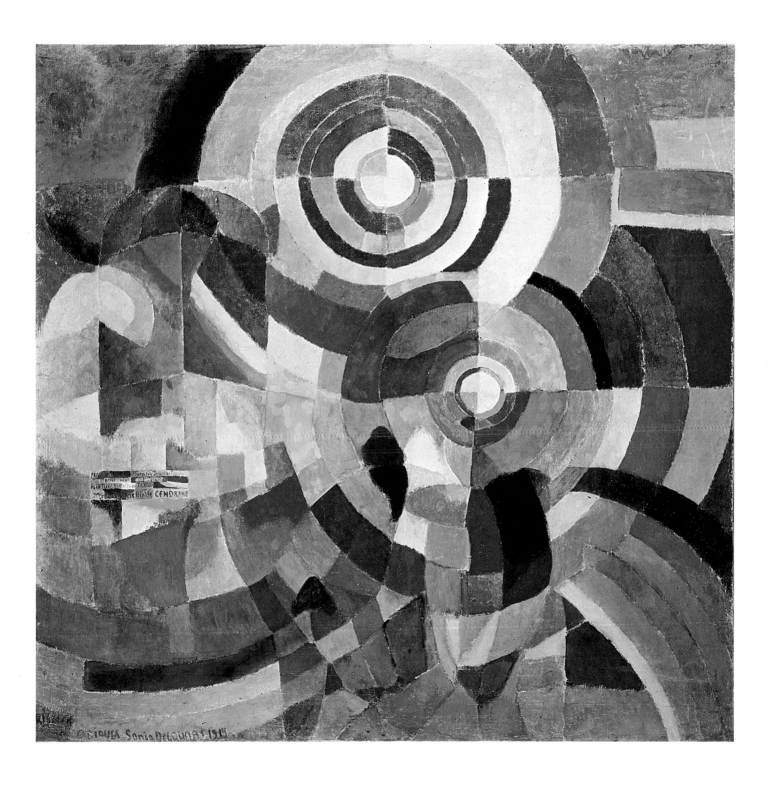

Fig. 8. Bal Bullier, *1913. Oil on canvas, 38-1/8 x 123-1/2"
(96.8 x 336.5). Musée National d'Art Moderne, Paris. Donation
Delaunay.*

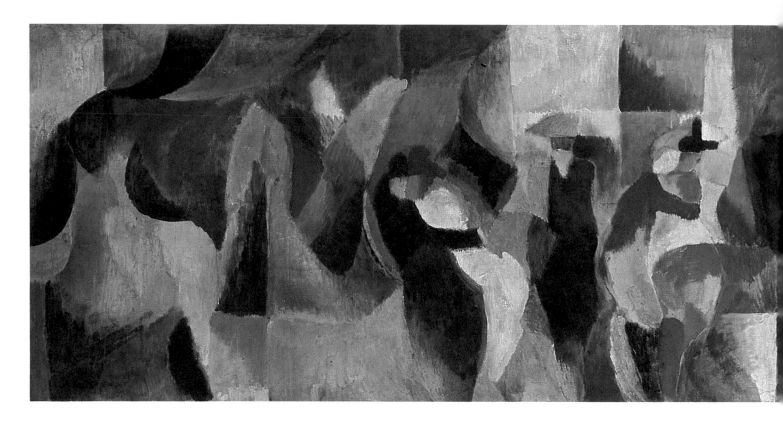

book cover are here relegated to the upper right corner, representing the sun, as they had in earlier works.

Robert, in the meantime, realized that concentric rings could represent prismatically separated light. In his paintings of the *Simultaneous Dress,* the concentric arcs of Sonia's sun are developed into fully formulated circles which provide the backdrop for the Parisian woman. Robert's accumulation of simultaneous images implies the presence of three-dimensional space. Sonia's is expressed through a collision of two-dimensional forms.

Both Sonia and Robert Delaunay were invited by Herwarth Walden to participate in the Erster Deutscher Herbstsalon, held in Berlin in the fall of 1913. Along with Robert's entire series of *Circular Forms* and major canvases, such as *The Cardiff Team* and the *Carousel of Pigs,* Sonia's paintings, bookcovers, lampshades, curtains, cushions, goblets and posters were put on display. If there had been any earlier doubt

as to the seriousness of Sonia's undertakings, it was dispelled by their presence in this major avant-garde exhibition. In fact, her involvement with three-dimensional objects was probably the inspiration for Robert to launch into the hitherto untried realm of sculpture. He exhibited three "simultaneous sculptures" in that fall exhibition. One was entitled *Parisian Woman, Electric Prism.*[67] Correlated to his interest in the light of the sun and the moon are the studies of the quality of light emerging from electric globes, which he integrated into his conception of the woman in the simultaneous dress. Electric light was also featured in his 1913 canvas of the *Carousel of Pigs.* Sonia, who had studied the effect of electric illumination far more thoroughly than she had that of the sun or the moon, developed this theme in *Electric Prisms (Prismes électriques),* a major canvas destined for the Salon des Indépendants of 1914.

In preparation for this painting, she resumed her studies of crowds on the Boulevard Saint-Michel, focusing on the arrangement of interlocking planes of color in which rectangular forms could become

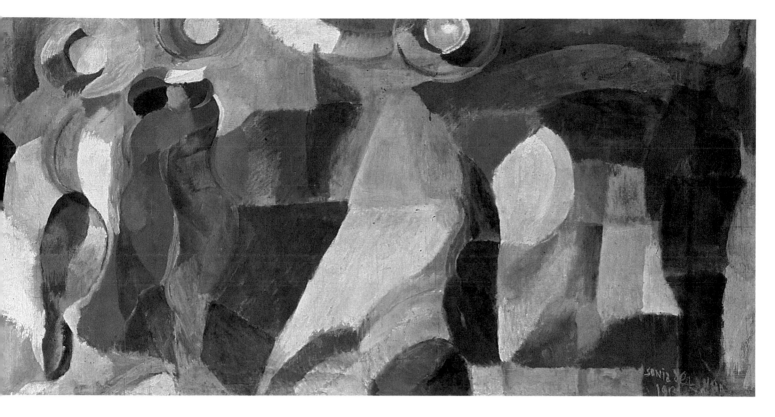

segments of expanding circular rings. Electric lights became central features, assuming the concentric arrangement of Robert Delaunay's *Disk*.

Robert was concurrently in the process of formulating his composition for the *Homage to Blériot* which included both studies of sunlight and of electric light. *Homage to Blériot* and *Electric Prisms* were meant as matching canvases of equal and enormous scale, developed in close collaboration.

Electric Prisms provides an appropriate conclusion for understanding Sonia Delaunay's development from the time of her marriage to Robert to the family's departure for Portugal in the spring of 1914. The surface is composed of interlocking planes of color, each sufficiently distinct to recall the origins of the style in collage. The image is defiantly two-dimensional, flattening even the ambiguous presence of human forms. The subject matter is both modern and popular — electric lights on the evening boulevard — yet it is in its style that the content of the painting is expressed. The style is founded on contrasting colors, luminously bouncing and balancing one another across whirls of circular forms. Concentric rings overlap and interlock, stabilized and interrupted by horizontal and vertical axes. The result is a play of rectangularity against circularity, color against form. The new style represents the concept of simultaneity, the Delaunays' new language of art. To prove the point, Sonia Delaunay balances enormous rings of electric light against the letters, words and colors of the poster for her first simultaneous book. The history of simultaneity and of Sonia Delaunay's development are thus fused with the present; poetry is fused with painting; color fused with light. The statement is complete.

Top: Fig. 9. Market at Minho (Marché au Minho), No. 57, *1916. Encaustic on canvas, 77-5/8 x 108-5/8" (196.8 x 276.3). Musée National d'Art Moderne, Paris. Donation Delaunay.*

Bottom: Cat. 75. *Market at Minho (Marché au Minho),* 1916
No. 457, gouache and crayon, 9 x 12 (22.9 x 30.5)
Collection Mr. and Mrs. Henry M. Reed, Montclair, New Jersey

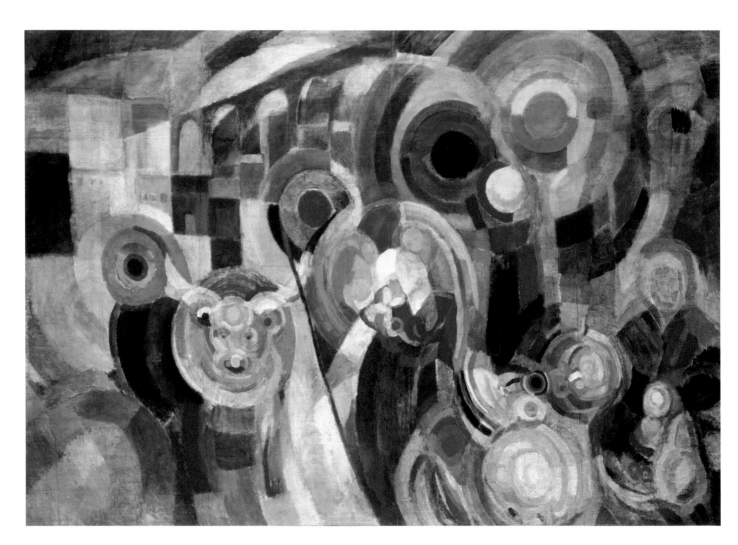

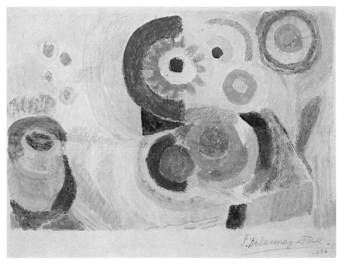

44

T he summer vacation of 1914 was to culminate in a long-term adventure of a very new sort for the Delaunay family. A hospitable friend invited them to Spain, suggesting that a change of air and the sun and sea of the south would be healthy for their small son Charles, who had contracted typhoid. Accordingly, they spent the summer in Fuenterrabia, where, in August, they learned of the outbreak of the war. Robert had fulfilled his military obligations in 1908 and was thus not required to return to France. The Delaunays decided to remain in the south until the situation in Paris was more stable.

They settled in the metropolitan center of Madrid for the winter and spring.[68] The summer's heat of the following year, however, drove them back to the seaside, this time to Portugal. Robert traveled first to Lisbon, where he made contact with a group of young architects and critics, Eduardo Vianna, José Pacheco, José de Almada Negreiros and Amadeo de Souza-Cardoso,[69] Portuguese artists whose interests were those of French modernism, and who already knew of Delaunay by reputation. Sonia arrived soon afterward, and the two were made thoroughly welcome by their new circle of friends. Sonia had felt that their lives in Madrid lacked the artistic and intellectual interchange to which they had been accustomed in Paris. It seemed that Portugal, however, could provide a charming new environment for a community of artists and ideas. They were persuaded to stay indefinitely, and following the advice of their friends, installed themselves in a villa on the shores of the Atlantic in Vila do Conde. They shared the house with the painters Vianna and Sam Halpert, an American whom Robert had known for many years. Life was inexpensive and peaceful, the company was agreeable and the environment dramatically inspiring for the specific orientation of the Delaunays' art. Sonia Delaunay recalls this period of her life as being a long and marvelous vacation:

> A dream life. We could work quietly from morning to night. The villa was perched on the sand dunes, facing the sea, with cacti blooming in the garden. I thought I was living a fairytale. As soon as we arrived, I fell in love with the village.[70]

Cat. 67. *Album No. 1*, 1916
No. 999, wax on paper, 8-1/2 x 8-3/4 (21.5 x 22.3)
Collection Tamar J. Cohen, New York

Portugal reminded Sonia Delaunay of her childhood home in Russia, the beauty of whose natural style of life was enhanced by the brilliant quality of the southern sun.

> The light was not intense, but it enhanced all the colors – the multicolor or dazzling white houses of sober design, the peasants in folk costumes, the materials, the ceramics that had amazingly pure lines of ancient beauty, amid the moving herd of hieratic, heavy-horned oxen.[71]

The peasant culture, with costumes and household objects, combined with the surrounding landscape to inspire a whole series of figure studies and still-lifes by both Sonia and Robert. The servants in the household, the vegetables, flowers and animals in the garden, and the pottery produced in local workshops supplied all of the imagery essential for new studies in color contrast. The roundness of forms characteristic of most of these objects, the vitality of their natural hues, radiating forth through the power of Portuguese light, allowed Sonia to test the conceptual and formal breakthroughs of the Paris period against what was observed in nature. The result was the development of a new, more intense palette, and more daring combinations than those generated by the semi-theoretical experiments before the war:

> The laws, scientifically discovered by Chevreul and verified by him in the experiment of practical colors, were observed by Robert and myself in nature, in Spain and Portugal. . . . The very quality of this light allowed us to go further than Chevreul. In addition to agreements based on contrast, we were able to find dissonances, that is to say, rapid vibrations which provoked a greater exaltation of color by juxtaposing certain warm and cool colors.[72]

With the base in observable reality, Sonia Delaunay's studies assumed a new seriousness.

The desire to capture the intensity of southern color extended the Delaunays' development of media as well as color contrast. The majority of the works from this period are painted in techniques employing wax or glue. They had learned the wax process in Paris from the Mexican painter Zaraga, using gelatin as a medium. Both processes were complicated and time-consuming, but had the reward of ensuring a long life to the vibrant hues:

> What counted were the greatest purity and impact of the color. Therefore the canvases have not changed, the colors are just as bright as they were from the start.[73]

The craftsmanship involved in such techniques was fully in keeping with both Sonia and Robert's belief in the necessity for the dedicated artist to develop original forms of creativity from the material at hand, or the material best suited for the artist's mode of expression. The traditional primacy of oil in the hierarchy of media in the fine arts was not relevant to their pursuits at that time, though both returned to oil after the Portuguese period. They attempted, with only limited success, to inspire their Portuguese colleagues in the wax process. The effort which it involved caused frequent dismay.

The same problem of time and effort was true of Sonia's attempt to involve the Portuguese group in pochoir projects. In their enthusiasm for the prospects of collaboration in a modernist artistic enterprise, they made plans for the formation of a group called *Corporation Nouvelle*. The purpose of this unofficial business group was to stimulate "artistic action" to publish collaborative albums of poetry and art, following the prototype of Sonia's undertaking with Cendrars, and to circulate exhibitions of the art of simultaneity throughout Europe. The Delaunays, their Portuguese friends, Daniel Rossiné (a Russian artist resident in Paris), Cendrars and Apollinaire formed the membership of the *Corporation*.

The albums were to be produced through the pochoir technique. Projects for the first album were begun at Vila do Conde, and continued throughout 1916 and 1917, with collages, watercolors and oils sent through the mail to the Delaunays from various members of the group. As time passed, both Vianna and Souza-Cardoso, who were given charge of translating poetic interpretations into pochoir, found the time and manual energy involved in the technique to be so cumbersome as to discourage creativity. Sonia Delaunay's perseverance in this tedious occupation set a model which few could follow.

Fig. 10. *Portuguese studio with decorated objects, 1915-18.*

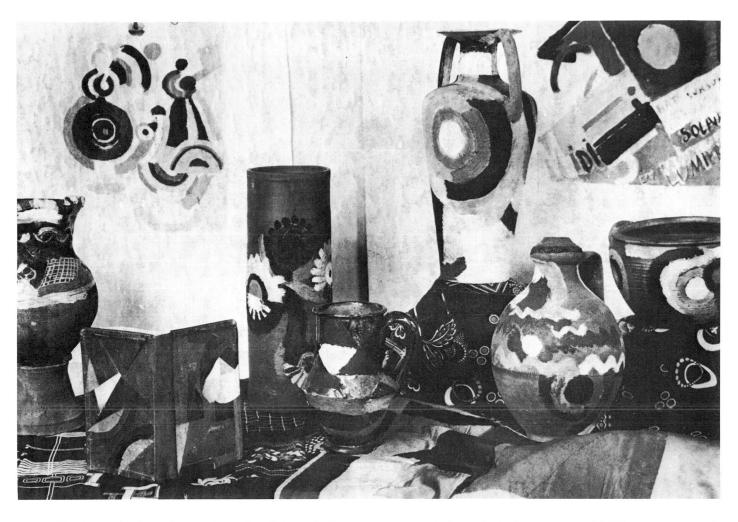

Sonia worked continuously during this period. With trusted help to manage the household and look after Charles, she produced at least sixteen complex images in wax or glue, most of which were preparatory to a large-scale canvas depicting the *Market at Minho (Marché au Minho)*.[74] Women and girls with pumpkins, watermelons, and assorted other ripe fruit and vegetables form the primary subject for this major canvas. The roundness of these images made them particularly attractive to her style. They produced arrangements of forms in which circles of different scales interlocked without the interruption of verticals and horizontals. Changes of rhythms resulted from the strategic placement of circles across and within other circles, giving full reign to the continuity of color contrast. Concentric rings were ideal for the representation of a bulky ox viewed full-face, integrated with the figural group by the continuum of colored arcs playing freely and abstractly through the background and foreground of areas of the composition. The slippery flow of sometimes languid, sometimes rapid curves and contrasts is, nonetheless, stabilized by the vertical arches of an ancient viaduct, the rectangles of a surrounding cityscape and the ghostly presence of standing forms.[75] The opposition of circularity and rectangularity is less dramatic in the *Market at Minho* than in the *Electric Prisms,* but remains an essential element in the fluctuation of forms.

Robert Delaunay's memories of Portugal were later summarized by his description of images found in

47

Sonia's painting:

> Immediately upon arrival in this country one felt
> enveloped by an atmosphere of dream and slowness:
> the rhythmic and casual movement of cattle in
> ancient harness with their giant horns, led by a little
> girl hidden in multicolored fabric; savage and strange
> were other visions of colors interlaced and exalted
> with a dizzying speed. The violent contrast of colored
> patches, women's clothes, shawls bursting with
> delicious and metallic greens, with watermelons.
> Forms, colors: women disappear in mountains of
> pumpkins, vegetables, in fairy-tale markets, with sun,
> intersected by a tall figure carrying an antique vase.
> The folk costumes of rare richness of color.[76]

Robert Delaunay's *Disk* from the early Paris
period was an image, divided into four parts, in which
both color and form were carefully controlled. In
Portugal, Sonia began her own experiments with
abstract disks of a very different sort. Placed in
contrasting relationship to their rectangular formats,
these simple presentations derived from her
observation of nature, and formed the basis for both
representative and abstract compositions. Her
absorption with the coloristic alphabet which the disks
produced, however, caused a problem of considerable
magnitude, one that she could have in no way
foreseen. In March of 1916 the Delaunays traveled to
Vigo, across the border in Spain, where Robert met
with the French consul concerning his military status.
Sonia returned early to Portugal on an errand, and
much to her surprise, was held in Porto on
accusations of espionage. It was thought that her
circular images had, in fact, been created for the
purpose of signalling to German submarines offshore.
It took weeks of investigation of all of the Delaunays'
correspondence with German artists and friends to
clear them of the charge. Although the incident was
absurd, it emphasizes the provocative power which
these mysterious new creations evoked. Sonia
eventually returned to Vigo, where the couple ended
the summer. Soon after, they decided to move to
Valença do Minho, a town directly on the
Spanish-Portuguese border.

Valença was a particularly fortunate choice for
Sonia Delaunay. The father-in-law of the mayor of the
town took a particular liking to the young couple and
facilitated arrangements for Sonia to design the
decoration, to be completed in tile, for the facade of a
local chapel. The building, which belonged to a Jesuit
monastery, thus became available to the Delaunays as
studio space during their year in the town. The
commission provided the first, long-awaited
opportunity to work on a monumental scale and to
unite the art of simultaneity with architectural forms.
The preparatory composition which Sonia evolved in
wax on canvas was based on the prototype of
Renaissance frescoes, in which numerous scenes of
both secular and religious significance were combined
in a series of panels, whose subjects related to their
architectural placement. The large design for the
facade itself portrayed the landscape of Valença, the
peasants of the surrounding countryside, the donor of
the chapel, whose brotherhood also sponsored an
orphanage, and, at the top, an apparition of the Virgin.
The composition inspired Robert Delaunay to issue a
long description and explanation of the conception:

> It is called: *La Misericordia au peuple du Minho par
> Apollinario, le donateur [The Misericordia [given] to
> the People of Minho by the Donor, Apollinario).…*
>
> The donor is in the middle of the picture.
> Behind him the background of the mountains of the
> country and, closer, two sister hills: Valença, the
> Portuguese, and Tuy, the Spanish, with their villages
> perched high up. He receives in his arms the children
> who come to him and places them in the
> Brotherhood of Misericordia which will bring them
> up. The men, dressed completely in black, are there.
> They have descended from the limpid blue-green sky
> of this country. On each side of the donor, groups of
> thoughtful peasants help — women in beautiful
> tessellated costumes of all colors, like birds in a
> bustling, bouncy group — and on the other side,
> directly in front of the Brotherhood, the men, serious,
> leaning on their tall mountain staffs. And above all
> this, in the transparent sky, an iridescent vision of the
> Virgin, with a sparkling cross, which, with hands
> joined, she uses to bless the charitable gesture of the
> donor.…
>
> This large composition unfolds into eight
> smaller panels where fruit, vegetables, toys, jars, and
> all the objects which are familiar in the life of the
> people (and which surround them) are depicted. The
> picture — the building for which it was destined.
> Nothing descriptive, nothing chiaroscuro, but

Fig. 11. *Preliminary design for* Homage to the Donor, *unrealized project in Jesuit monastery at Valença do Minho, Portugal, 1916. Encaustic on canvas, 51-1/8 x 128-5/8" (129.8 x 326.4). Musée National d'Art Moderne, Paris. Donation Delaunay.*

everything form in light....

The picture: a conscious balance of forms submitted to monumental expression in architectural harmony with the edifice. The overriding contrast of the sky to the group of men and the luminous form of the Virgin is, in turn, opposed to the deep and warm blackness of the Brotherhood. The large contrasts of forms: groups of men and groups of women subordinate to the general composition. As a consequence of these contrasts the women stand out in these great oppositions and vibrate simultaneously in the general movement of color. The disc. The tall staffs of the peasants, the banners of the Brotherhood interrupt and oppose the masses of colors, forming an architectural element which exalts the soaring ovals of the windows that frame the picture's base. These new techniques create pictures with *the formal and objective power* of nature through the very fact of their conception which is greater, more realistic, and, above all, anticonventional....

The *Misericordia,* a human feast to immortalize a dead man's beautiful gesture, enveloped by his great tranquility and contemplated religiously as before nature.[77]

The composition, which is now more simply called the *Homage to the Donor (Hommage au donateur),* was never realized in tile. The opportunity to conceive

designs for a public monument on such a large scale was not to arise again until 1937, when the Delaunays were asked to take charge of the interiors of several display buildings. It comes as no surprise, therefore, that one of the major murals which Sonia created at that later time evolved from the theme of Portuguese village life.

In the midst of these various adventures and endeavors, plans for the albums of the *Corporation Nouvelle* were still underway. Sonia produced several versions of the cover for *Album No. 1,* continuing her investigation into the collaborations of letter, color and form. Typical of her other works of the period, these projects emphasize the primacy of the circle, extending the interlocking letters around concentric disks resembling the earlier arrangement of the word "Zénith" around the face of a clock. Appropriately, designs for the word *chocolat* were begun again. The round forms of its letters allowed them to compose the circle itself, fusing denotative and nondenotative meaning into indivisible formal unity.

Cat. 80. *Self-portrait: Project for Exhibition in Stockholm
(Autoportrait: projet pour l'exposition de Stockholm)*, 1916
No. 962, wax on paper, 12-1/2 x 12-1/4 (31.8 x 31.1)
Collection Tamar J. Cohen, New York

The circle, symbol of the sun and of simultaneous action, was also the expression of Sonia Delaunay's self-image. A series of self-portraits accompany the designs for the album cover. They present an arrangement of colored disks as the upper part of the head, another for the eye, and a simple set of accessory curves to distinguish cheeks, chin and mouth. All vibrate dramatically in warm and cool color oppositions. The self-portraits were also created as cover designs for the catalogue of an exhibition of Sonia's work held in Oslo and Stockholm in April, 1916. This was one of the few occasions on which her works were seen during the war years. Exhibitions of the Portuguese group were planned for Lisbon and Barcelona, but due to complications of organization and disagreements among the members of the group, they never materialized. Similar disillusionments led to the abandonment of plans for the albums.

It may have been for purposes of arranging exhibitions that the Delaunays were in Barcelona in October, 1917, when they heard the news of the revolution in Russia. That faraway event marked the end of the Portuguese vacation, for it meant the end of the income on which they had relied. Commiserating with the plight of the Russian working class, peasants not unlike those who surrounded them in Portugal, the Delaunays actually celebrated the event. Despite the drastic change in lifestyle that the revolution meant for them, Sonia reflected on its positive results:

> It was a good thing. . . . Before, we lived like children. . . . After the Revolution, we were forced to make our own way.[78]

They moved again to Madrid, where the prospects for earning a living were more plentiful.

Although Robert's paintings had sold well during the early Paris period, there was little patronage for avant-garde art in Spain during the war years. Sonia thus resolved to find a market for her creations in the applied arts. The first opportunity came through another fortuitous encounter, this time with the founder and leader of the Russian Ballet, Serge Diaghilev. Also suffering from the elimination of French and English audiences, Diaghilev had established a successful

season for the troupe in Madrid in 1916, which was repeated the following year. Sonia made contact with her fellow countrymen, sharing with these professionals her abiding enthusiasm for the rhythms of dance.

The extraordinary combination of intricate rhythm and lyric passage which characterized Flamenco music had attracted her during the earlier stay in Madrid. Several canvases of Flamenco singers emerged from that period. In them, colored rings emanate from mysterious faces and full-bodied guitars. It was in these works that she first developed a vocabulary for translating the features of the human face into rhythms of simultaneous contrast. Conversely, the studies of disks from the Portuguese period were reintegrated in 1916 into images of musical performances — the whirling skirts of dancers that were much later to inspire an entire series of abstract canvases. On their return to Madrid in 1917, long evenings were spent with members of the ballet watching and listening to the best Flamenco artists.

Nijinsky was particularly attracted to the Delaunays' interests and to their work, and suggested that the three should compose a ballet together. It was Massine, however, who was absorbed into the flavor of Spanish music and dance, and who was to play the lead in the eventual collaborative effort of the Delaunays with the Russian troupe.

Despite tours of the United States and South America and successful new creative efforts with such artistic luminaries as Picasso and Cocteau, the Russian Ballet was foundering financially. Under duress, Diaghilev accepted a music-hall bill in London in which the ballet performed alongside an act of trained apes.[79] Perhaps to ensure the monetary success of the engagement, he decided to restage *Cléopâtre,* one of the most successful ballets in the company's repertoire. Originally choreographed by Fokine, to an assembly of music by Russian composers and featuring dancers Nijinsky, Pavlova, Karsavina and Ida Rubinstein, the ballet was the primary cause for the renown which the company established in Paris in 1909. The combination of erotic themes and outstanding virtuosity in dance had swept the audience with ecstatic enthusiasm. The sensuality and exotic appeal of the experience was fully enhanced by the sets and costumes of Leon Bakst, which, much to Diaghilev's dismay, were burned in a fire while the company was on tour in South America. Replacements that could rival the impact of Bakst's original designs were needed immediately. Diaghilev turned to the Delaunays for help.

Robert was asked to create the sets, and Sonia the costumes. It was a new experience for both artists, but one which they undertook with excitement. It provided Robert with the opportunity to work on a monumental, if not architectural, scale and Sonia with the chance to combine her interest in fashion with her love of music and dance.

Choreographed with an inclination toward the Egyptian origin of the theme, parts of the ballet stressed ritual processions with the repetitive, angular precision typical of Egyptian painting. Thus the two-dimensional orientation of Sonia Delaunay's style was appropriate to much of the staging. The dress for the character of Cleopatra herself posed the greatest challenge. Swathed as a mummy, she was to be carried on stage in a sarcophagus, lifted forth by slaves, then unwrapped from layers of colored veils to stand "with vacant eyes, pallid cheeks and open mouth . . . like a great pungent perfume of some exotic essence."[80] The scene gave Sonia Delaunay the opportunity to experiment with successive designs for lengths of fabric wrapped around the human form, and the liberty to design a boldly frontal costume less suited for the movement of a dancer than for iconic display. It was the visual movement of the costume, worn in London by Lubov Tchernicheva, that set the body into action.

The Cleopatra costume was an even more emphatic fulfillment of Cendrars' vision of the fusion of the female body with her clothing than were the early simultaneous dresses. His lines describe it perfectly:

> And the double conchshell of your bosom which passes
> under the bridge of the rainbows
> Belly!
> Disks!
> Sun!
> And the perpendicular shouts of color fall on your
> thighs[81]

Disks of sunlit colors, defined by rings of sequins and pearls, secured the breasts and belly for simultaneous presentation and protection, vying against the vertical and diagonal radiations of hues in the headdress complete with braided wool wig, and the skirt. Although the costumes had far more to do with the modern style of Delaunay's art than with any ancient source, she recalls finding disks, like those on her costume, on an Egyptian sarcophagus in the Louvre.

The London performance was a satisfying success for Diaghilev, who dispatched a telegram to the Delaunays in Madrid describing the ebullient reaction of the audience to the visual delight of the Cleopatra costume. The ballet established Sonia's reputation publicly as an innovator in both costume and fashion. In the next two years she received commissions from an opera company in Barcelona

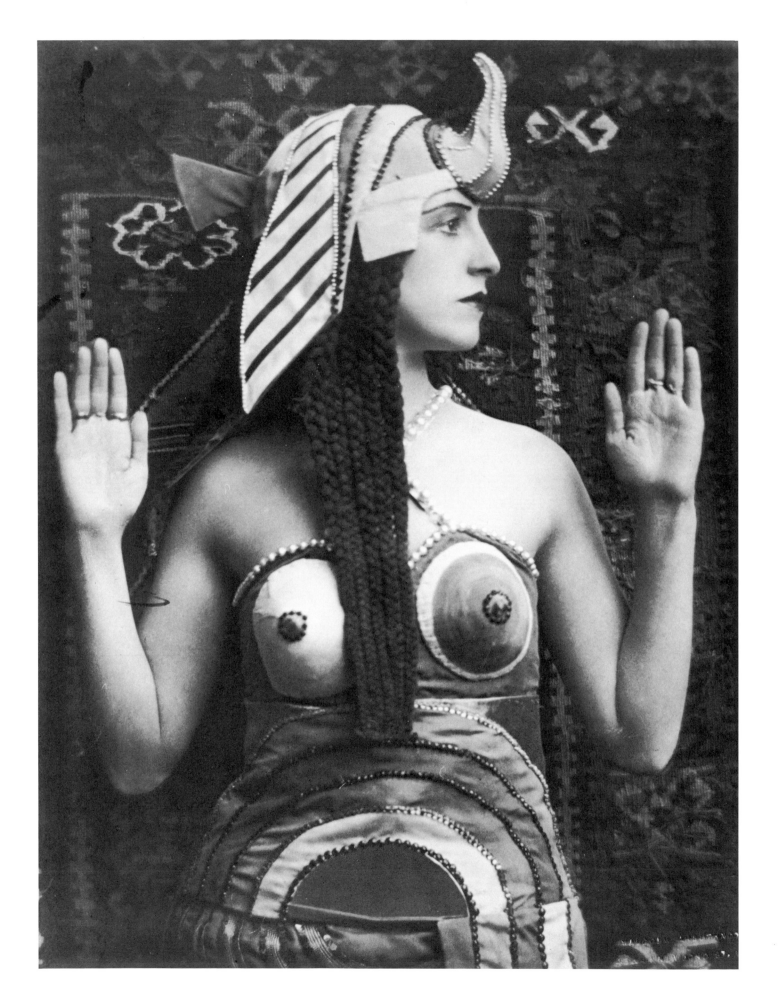

52

Left: Fig. 12. *Mme. Tchernicheva in Cleopatra dress, London, 1918.*

Below: Cat. 92 *Costume design (for Amneris in* Aida) *(Projet de costume [pour Amneris dans* Aida]), 1920
watercolor, gouache and pencil, 19-3/4 x 15 (50 x 38)
Collection Mississippi Museum of Art, Jackson, The Lobanov Collection

for costumes for *Aida,* and from the Marquis d'Urquijo to outfit his four daughters in modern style. Combining simultaneous colors with floral folk patterns and raffia with simple textiles, Sonia took this opportunity to influence the new freedom in fashion gained by short sleeves, short skirts and loose lines.

Through Diaghilev she was introduced to eminent members of Spanish society and, with backing from an English bank, was provided with space for a small shop in the best section of the city. The Casa Sonia was a revelation of modern interior design for the Spanish aristocracy. The walls were painted white, and the room furnished with raffia matting, small round tables and folding screens — simple materials and objects raised to the level of artistic refinement by the colors applied to their

surfaces. Throughout the stay in Portugal, Sonia had enlivened her home with designs applied to pottery, pillows and small wooden boxes which could enclose a new form of jewelry — simultaneous necklaces — made from large colored beads and shells. These were set for sale in the shop, along with experiments in lampshades, parasols, handbags, and various other accessories for home and dress. This introduction into the world of business gained her commissions for the interior decoration of wealthy homes and, on a much larger scale, for an entire theatre. The Petit Casino opened in 1919 with a dramatic color scheme: the entrance hall was in black, and the interior in sparkling red, yellow and white. Sonia designed the costumes for the first review staged in the new theatre, featuring the Spanish movie star Gaby.

Sonia Delaunay accepted her new undertakings with an attitude of amusement. Success came easily, and the artifacts she created spread the influence of the art of simultaneity out into the world. As Guillermo de Torre wrote a few years later:

> New art has descended to the streets . . . color is not trapped anymore between the four edges of a painting. It has come to earth, entered our sentimental pockets. clings to our clothes, dances on the walls, giggles under screens and peers down at us from the ceiling. The color is free and its prisoner, traditional decorative art, despairs and fades away[82]

Sonia's decorated objects were displayed along with Robert's canvases in Bilbao in 1919. After that time, however, it became apparent that the Spanish public was considerably less interested in modern art than in modern design. The Delaunays once again missed the stimulation of a life among painters and poets and a milieu appreciative of their interests. Despite the financial stability that Madrid offered, the Delaunays decided to return to Paris.

T he decade of the 1920s was one of multiple directions for Sonia Delaunay, from the intimacy of the home and a group of friends, to the spotlight of public stages and international exhibitions. It was a time when violently contrasting artistic styles and purposes could be experienced across Europe and a time of prompt and frequent communication between proponents of each new movement. Groups were reestablished after the forced dispersal and isolation of individual artists during the war years. Paris again became a fulminating center for the exchange of avant-garde ideas. By the end of the 1920s, the French economy was flourishing and national spirit soared. It was a decade of celebration, of confidence and of daring. In the midst of it, Sonia Delaunay communicated and collaborated with artists ranging from the most stalwart nihilists of the Dada movement to the most idealistic positivists of German and Dutch abstract art. Her activities included participation in the staging of outlandish theatrical performances and the administration of a textile workshop; her companions included poets and wealthy bourgeois patrons. She designed for an artistic and economic elite, while devising means to expand her creations to products for the public at large.

Contact with Dada artists and recognition in the world of decorative design evolved simultaneously in Sonia's life during the final years in Portugal and Spain. While she was exhibiting in Madrid with such fashion designers as Doucet and Zeim,[83] Robert was contributing to the second issue of the magazine *Dada,* begun in Zurich by the Rumanian poet Tristan Tzara. It was probably Apollinaire who forwarded to the *Corporation,* Tzara's writings, which appeared in several active avant-garde magazines[84] Tzara's extravagant development of word and sound contrast, his use of common language and contemporary themes, and his refusal to be constrained by accepted syntax or punctuation were all qualities which extended the liberating steps taken earlier by Apollinaire and Cendrars. It appealed to the Delaunays' sensibility as fully as did the visual concepts emanating from the Zurich group. In 1916, the poet Hugo Ball founded the Cabaret Voltaire in Zurich as a meeting and

Fig. 13. *Sonia Delaunay in her apartment on Boulevard Malesherbes, 1924. Note poems written by friends on door.*

performance center for a group of expatriate literary and artistic personalities who banded together in retaliation against the absurdity of war, logic, tradition, and bourgeois taste. They assumed the enigmatic appellation "Dada," which appropriately evoked their interests in direct and primitive expression. The technique employed in their early poetry readings and performances hailed from the inventions of the prewar avant-garde of Italy, France and Germany, including concerns with literary simultaneism and abstract art.

The most active visual artist of the Zurich group was the Alsatian painter Jean Arp, whose international interests had brought him in contact with the Delaunays' art on numerous occasions. He participated with them in the large showing at the 1913 Erster Deutscher Herbstsalon, and the following year looked them up in Paris before their departure for the south. He was thus well-acquainted with Sonia's use of collage and her activities in applied art forms. Upon arrival in Zurich in 1915, Arp himself undertook collaborative designs in embroidery and tapestry. The following year his famous collages "arranged according to the laws of chance" were begun. Along with Marcel Janco and Sophie Taeuber, he developed a sensitivity within the Zurich group for the need for art to rejoin life in the creation of new kinds of homes and new styles of everyday objects[85] The variety of media which Arp employed and his liberal attitude toward the distinctions between art and craft may well have been inspired by Sonia Delaunay's precedent[86]

The concern of the Dadaists with the importance of common objects was made clear in an essay by Tzara on Negro art published in the fall of 1917, and probably read by the Delaunays in Spain[87] In it he expounded the virtues of art produced by primitive peoples, created with the purity and spontaneity of an imaginative child, able to strip the object nude and reveal its essential truth. Spontaneous creativity was not only the method that Sonia Delaunay used instinctively to produce her initial designs, but the basis of a new style of life for both the Dadaists and the Delaunays, based on the fusion of poetic activity with common, everyday existence[88] With this underlying

belief that the power of art could free individual creativity, a core of positive philosophy arose through the thick shell of Dada nihilism. Marcel Janco developed the concept further by explaining that creative self-discovery could result from the exploration of new materials and from the collaboration of groups of artists. Collaboration could induce an expansion of power and a reduction of personal pride. Through these means a new plastic language, expressive of an international culture, could be constructed[89] Written language reconstituted in varying personal forms, was, moreover, fundamental to Dada expression. It was contrasted with abstract or nonobjective visual images throughout Dada publications in an intense effort at the fundamental collaboration of word and image. The goals of Zurich Dada were thus not far removed from those of the Delaunays, particularly those of Sonia. It is not surprising that a correspondence was established between them as early as 1918.

With the end of the war, Tzara, who had exchanged writings for little magazines with André Breton and Louis Aragon, joined those Dada-sympathizers in Paris. The years 1920 and 1921 were filled with demonstrations and publications, the news of which was reported in full to the Delaunays in Madrid. Eventually, the appeal of the communal excitement of the new Parisian avant-garde grew too strong for the Delaunays to resist. In 1921, the couple returned to Paris. Their social position among the prewar painters was not easily reestablished. It was only through Diaghilev's support that they were once more admitted into that artistic elite. However, they were immediately surrounded and celebrated by young poets, and they quickly assumed a participatory role in the development of the new artistic movement.

The enthusiastic acceptance of the Delaunays into the Dada circle is surprising when one considers that the philosophy of color simultaneity had not evolved radically since the years before the war. Tzara had emphatically rejected both Cubism and Futurism as outdated forms of art, yet he welcomed the collaboration of the Delaunays, complete with their theories. The quality which distinguished their work

from that of other prewar movements was simple enough to recognize: they lived their art in every aspect of their lives, particularly in the decoration of their home, which was totally the result of Sonia Delaunay's ingenuity.

The Delaunays spent several months looking for a new apartment. Eventually, they rented one with the help of people who were interested in Sonia's work. The new residence at 19, Boulevard Malesherbes was soon transformed into an environmental collage of simultaneous colors and participatory art. Although they had relatively much less money than before the war, and were forced to sell one of their prized possessions, Rousseau's *Snake Charmer*, in order to survive the move, Sonia immediately began hostessing Sunday gatherings of large groups of friends. Their apartment became the rallying point for adventure-filled evenings of demonstration and performance before the split in mid-1922 between Tzara's Dada followers and Breton's Surrealist offshoot. During and after that time, everyone who entered the house was invited to leave his mark. René Crevel describes his amazement at the effect of the interior:

> At the entrance to their apartment there was a surprise. The walls were covered with multicolored poems. Georges Auric, a pot of paint in one hand, was using the other to paint the notes of a marvelous treble clef. Beside him Pierre de Massot was drawing a greeting. The master of the house invited every new guest to go to work and made them admire the curtain of gray crepe de Chine on which his wife, Sonia Delaunay, had through a miracle of inexpressible harmonies deftly embroidered in linen arabesques the impulsive creation of Philippe Soupault with all his humor and poetry.
>
> Gaiety and high spirits are rare qualities. When they produce intelligent activity they cannot be honored too much. After five minutes at the home of Sonia Delaunay no one is surprised to find that it contains more than a certitude of its happiness. It is finally not a matter of conversation, sentences, the lure of discussion in which a bit of sophistry easily triumphs over directness; rather you enter the home of Sonia Delaunay and she shows you dresses, furniture, sketches for dresses, drawings for furniture. Nothing that she shows you resembles anything you

have ever seen at the couturier's or at furniture displays. They are really new things...[90]

The freshness and spontaneity of such creativity was no more impressive than the scope of community effort which it engaged. A drawing by Robert of the Eiffel Tower was inscribed with signatures during this boisterous period. They include: Tzara, Man Ray, Iliazd, Corpus Barga, Guillermo de Torre, Pierre de Massot, Jacques Baron, André Lhote, Gomez de la Serna, Leon Kroll, Joseph Delteil, Robert Desnos, André Breton, Louis Aragon, René Hilsum, Paul Guillaume, Marc Chagall, Ivan Goll, Vincent Huidobro, Boris Kochno, Waldemar George, Roger Vitrac, Nicolas Beauduin, Albert Gleizes, Ricciotto Canudo, Jean Arp, Arthur Frost, Patrick Henry Bruce and Blaise Cendrars.

Collaborative efforts were not limited to the decoration of the house. Tzara, Soupault and Delteil each wrote poems on Sonia Delaunay's creations. De Torre, Lhote, and Claire Goll wrote essays about her for publication. Tzara, Crevel and Aragon wore clothes that she made, and Gomez de la Serna devised a unique "fan-poem" which found its way onto one of her walls. Robert was not less active, recording the individuals of the group in numerous portraits and illustrating several books of their poetry. The Delaunays provided an exciting and comfortable physical setting for all of this activity. Their home was a rare combination of purely playful invention and revered style and fashion.[91]

The performances that the Dada group staged were frequently repetitions of evenings planned originally in Zurich. Although some new plans for the irritation of the bourgeois state of mind were assembled collaboratively during 1920 and 1921, it became more and more difficult for the group to devise unused techniques. By mid-1921, Breton saw the need for a different approach. He proposed a gathering of artists from all over Europe to discuss the direction of modern art and to agree on a constructive route for the future. A call for a congress in Paris appeared in January, 1922, in *Comoedia.* It was signed, among others, by Robert Delaunay. During this same month Delaunay painted Breton's portrait. Sonia later explained that Breton actually wanted Robert to be leader of the new movement[92] It was a short-term friendship, however, for differences arose rapidly, apparently over the issue of Breton's mistreatment of Tzara.

Breton's proposed congress was to observe parliamentary procedure with Breton behind the gavel, and to hold sessions under police protection. Tzara found such procedures too serious to reconcile with Dada philosophy, and was not in favor of opening the movement up to the integration of all styles. He declined to participate in the congress. Breton was infuriated, and published an indictment of Tzara as a fraud and a publicity-monger. The attack shocked the avant-garde, and caused most members of the congress committee, including Delaunay, to lose faith in Breton's leadership[93] The Paris Congress never materialized, but by the end of the year Breton had gathered around him a different group of friends, including Picabia, Aragon, Desnos and Vitrac. With Picabia in support of Breton's activities, the Delaunays became the dominating visual artists of Tzara's clan. The spirit of spontaneity, liberation and poetic action to which Tzara remained committed was more in keeping with the Delaunay's attitudes than Breton's more rigid intellectual pursuits.

In the meantime, the Delaunays continued to create and attempted to make a living. Robert exhibited paintings from the prewar and Portuguese periods at Paul Guillaume's gallery in May, 1922. Despite the supportive attendance of Dadaists and Surrealists alike, he sold very poorly. It was again left to Sonia to produce an income. Her reputation in interior design had preceded her from Madrid to Paris, and she was soon given a commission to decorate the bookstore Au Sans Pareil in Neuilly[94] The jarring rigor of the geometric designs which she applied there caused considerable reaction in the press and established her name in Paris business circles. During the same year, perhaps as an outgrowth of experiments with veils for *Cléopâtre,* she produced her first embroidered and appliquéd simultaneous scarves, which she sold to the wives of artists and fashion designers, who were in turn painted in their simultaneous attire by Robert. The integration of poetry with design was still Sonia's primary source of inspiration. This *mélange* was now directed toward the creation of fashion.

Cendrars' poem *Sur la Robe Elle a Un Corps* was finally published in Paris in 1919. It ended with the lines:

> And on the hip
> The poet's signature[95]

Sonia materialized Cendrars' image in the curtain-poem, mentioned by Crevel in his description of the apartment. Soupault had dedicated a poem to Sonia Delaunay:

> Upon the wind
> upon the earth
> remember
> red and green silences
> orange smiles
> Above all do not forget
> Sonia Delaunay
> her son and
> her husband ROBERT
> who SALUTE you[96]

She decided to embroider it on an elegant crepe curtain where, complete with *bonjour* and *bonsoir* and the signature of Soupault himself, it served as a greeting to guests who entered the house. It also doubled as a wrap for evening outings. Words were thus draped across the body, setting poetry into visual motion, imbuing it with the sensuality of the female

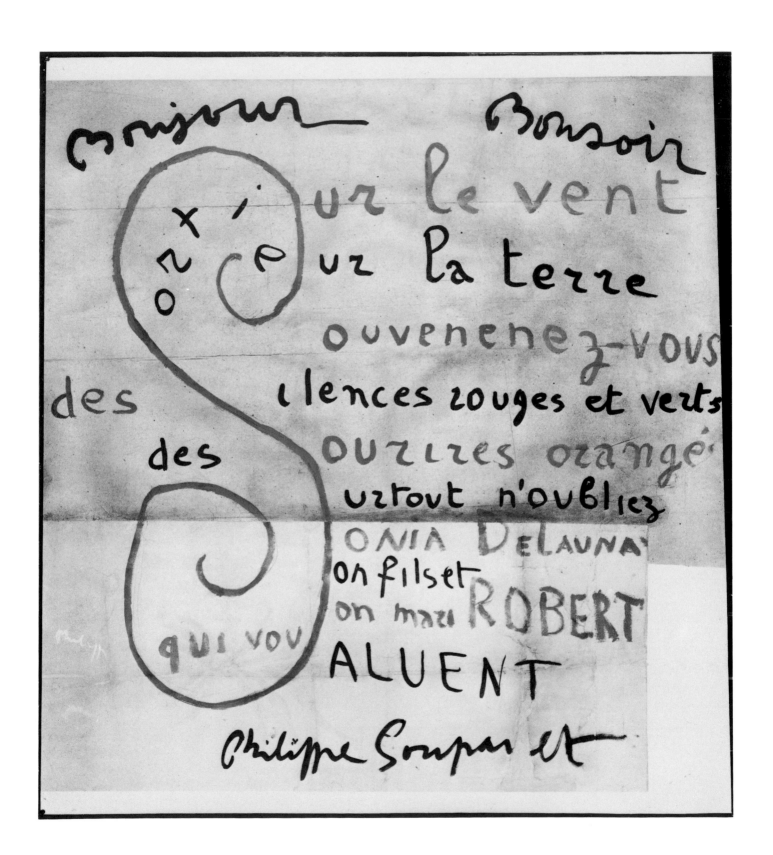

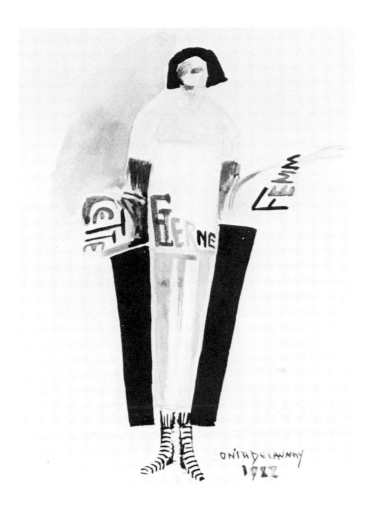

form. It fulfilled Cendrars' assertion:

> The woman's body is as bumpy as my brain
> Splendid
> If you become incarnate with spirit[97]

and gave rise to a whole new genre of activity — the "dress-poem."

The designs for "dress-poems" combine geometrically revolutionized fashion with pictorially arranged words, following the tradition of Apollinaire's *Calligrammes*. The design for a poem by Tzara is a particularly lucid combination. The poem reads:

> The fan turns in the heart of the head
> Flower of the cold serpent of chemical tenderness.

The words wind their way along the perimeter of two fan-like forms, connecting torso and skirt, right sleeve and left sleeve in a continuing play of radiating diagonals and curves. Dress designs were made for other poems of Tzara and for lines by the Chilean poet Vincente Huidobro. Louis Aragon preferred having his words associated with the masculine form and designed his own "vest-poems" which Sonia Delaunay then embroidered by hand.

Shortly after these "poem-fashions" were invented, Sonia Delaunay asked the poet Ramon Gomez de la Serna to collaborate with her on such a venture. He recorded his reaction to the suggestion in an essay published in 1922:

> If you would make a tiny poem for my next dress, says the adoring lady to the poet whom she admires and at whom she looks with lamb-like devotion, with a glance which penetrates out of the deep crevice of the eye as from the pilgrim's lantern.
>
> The poet, dazzled by the mock-solemn glance which has ravished the depths of his forehead, and has remained there, considers the woman, pondering the season of the poem which might suit her, and asks some questions about the dress: Brown? Of Velvet? With deep decolletage?[98]

He freed his imagination and produced a new vision:

> ...I would write the poem spirally surrounding and twisting like a serpent of words around the body of the victim. The necessity of showing off so that drawing-room curiosity can decipher this poem will oblige the focal figure to make two or three rhythmic, halting turns which would create what might be called "the dance of the poem."
>
> Yet one can think of a more complete poem whose long text would require two or three dresses superimposed and voluminous, finishing the poem at the inevitable limitation, and, further, it is possible, for a major poem of great substance, that at the end of the dress, one might be able to write a popular-magazine "to be continued" series — making one wait from Thursday salon to Thursday salon — at which time the new dress could be read as the interesting continuation[99]

For Gomez de la Serna, the undertaking was apparently filled with greater responsibility, greater seriousness, than any previous challenge.

The Russian poet Ilia Zdanevitch, called Iliazd, followed Sonia Delaunay's lead by creating a design from a poem, for a dress to be worn by Vera Soudeikine, the wife of Stravinsky. Sonia Delaunay had been introduced to the composer and his wife through Diaghilev, and had once again assumed the role of hostess for expatriate Russians in Paris. Iliazd had been active in the Russian avant-garde before and throughout the war years. He had published a book on Larionov and Goncharova as early as 1913, and was a friend of the Russian Futurist poets Mayakovsky and Klebnikov. With other members of the group *41°*, which he organized in 1917, several performance

pieces called "dra's" were invented in the new language of *Zaoum*. All words in this language were pronounced with tongue in the cheek, reducing the vocabulary to elemental noises charged with multiple meaning. In 1921 Iliazd arrived in Paris on a Georgian government grant, and fell in quickly with the Delaunays and the spirit of Parisian Dada. He sided with Tzara from the beginning of the Dada-Surrealist split![100]

Sonia created a sewn-leather cover for Iliazd's book of poems. Matching in style her cover for Tzara's *De Nos Oiseaux* of 1922, it exhibits a far more thoughtful, controlled and craftsmanly approach to the problems posed by book-binding than did her earlier attempts. The design is limited to the basic, clarified forms of the circle and the square, concentrically placed in balanced relationship to the rectangle of the cover. Front and back are repeated images, both animated by the dramatic angles of the letters *I* and *Z*. The style is abstract and harshly geometric as were her designs for the interior of Au Sans Pareil. The gay patterns of Portuguese decorative design were abandoned for an even more reductive use of color and form. The style is almost brutal in its directness, but forcefully constructive. It is probably the result of Iliazd's communication to her of the latest ideas developed in Russian Constructivism — the use of primary geometric forms as building blocks for functional art.

Early in 1923 an evening of dance, performance and exhibition was organized by the Union of Russian Artists to raise money for their relief fund. It was held at the familiar Bal Bullier and called the *Grand Bal Travesti-Transmental*. Iliazd who was an expert at the creation of "transmental" poems, was a primary figure in the organization of the evening. The program announcement read as follows:

> This is going to be a vast fun fair. There will be chariots, traffic jams, competitions to choose beauty queens, gigolos and gigolettes, bearded women, pigs' merry-go-rounds, fake massacres, a four-headed foetus, mermaids and mythological dances, and oddities made of flesh and unbreakable wire, which are at the same time fire-proof, insured against accidents and safe for children of all ages. Delaunay

> will be there with his transatlantic troupe of pickpockets, Goncharova with her boutique of masks, Larionov with his "rayonism," Léger and his *orchestre-décor,* André Levinson and his all-star company, Marie Vassilieff and her babies, Tristan Tzara and his fat birds, Nina Peyne and her jazz band, Pascin and his original belly dancers, Codreano with her choreography, Iliazd and his bouts of fever reaching a temperature of 106, and many other attractions. The ball-rooms will be decorated by the best artists of today![101]

The members of the Delaunay circle were all represented. Robert decorated two stands, the Poets' Booth and the Booth for a Company of Transatlantic Pickpockets, and his famous painting *Carousel of Pigs,* which included a portrait of Tzara, was on exhibition. Sonia designed a booth of modern fashions, which displayed her scarves, ballet costumes, embroidered vests, and newly-created coats. Live models donned the simultaneous designs, but were integrated as colored physical entities into the geometric arrangement of the entire booth. It was her first presentation of clothing and design in a fully unified exhibition setting. In later reflection she saw it as an outgrowth of her well-established use of the principles of collage: "total *papier collé* since everything was collage, from the floor covering to the ceiling, and through it all walked the costumed models."[102]

Several costumes for a fancy dress ball were designed during this period, probably with the *Bal*

Transmental in mind.[103] Their presentation of spinning
swirls and violent zigzags reflects a far greater
inclination toward abstraction than her previous
fashions. The forms dictate rather than correspond to
the shapes or movements of the body. The dance
which these images could perform would resemble
that of an intricately mechanized theatre of toys,
jumping and spinning to whims of impulse based on
the fury of their color vibrations.

It was just such a dance that Sonia Delaunay
asked the Rumanian dancer Lizica Codreano to
perform to the music of Francis Poulenc at another
evening organized by Iliazd. Held in April at the
Licorne, the program featured presentations by the
Tcherez troupe, a group of Russian performers
assembled under Iliazd's leadership. In their midst,
Sonia introduced her conception *The Dancer with
Disks (La Danseuse au disques),* in which the color
and form of the costume directed the dancer's every
move:

> ... Codreano magnificently danced the color. Her
> costume, made very simply, was composed of three
> elements: a large cardboard disc, covered with
> fabrics of different material in different colors, orange
> and green, fastened around the face of the dancer
> and completely covering the upper part of her body.
> A half-circle where two reds and blues were arranged
> formed her short skirt. Finally, a black circle was
> attached to her right hand and a white circle to her left.
> The rigidity of the costume imposed its
> obedience. The dancer was obliged to move frontally
> and her movements had to respect the plane. With
> great feeling, while altering the position of the plane,
> Codreano created and unceasingly transformed the
> relations of the colors.
> In this manner a new language of color was
> achieved from which all description had been
> banished. The imagination played free.[104]

The inspiration for this kind of dance had evolved in
Portugal and Spain with studies of the colors and
rhythms of Flamenco performers. In 1913, the
costume compositions were inspired by color
movement itself. Imagination, guided by a formal
understanding of the craft of simultaneity, took
precedence over observation. The result was the
subjugation of the human form to a world of action
based on a universal order whose infinite movement
transcended the limitations of ordinary physical time
and space. It was an attempt to transform the mystical
power of two-dimensional surfaces into the realm of
three-dimensional activity.

> In 1923, this was a first attempt, a try. If the
> opportunity had been offered me to pursue this
> experiment, I am certain that I would have found
> other means of amplifying the idea, making it more
> supple, and diversifying the possibilities of its
> expression by the use of the machine, electricity, etc.,
> which would have helped me accessorily. ... The
> terrain would have become immense.[105]

The integration of mechanically controlled
motion in dance and the stage, in support of
ideological concepts emerging from poetry and
painting, had already become a part of constructivist
theatre in Russia, and was being explored
contemporaneously at the Bauhaus in Oscar
Schlemmer's *Triadic Ballet.* Sonia Delaunay's theatrical
pursuits never realized that level of mechanization, but
her designs for *The Dancer with Disks* confirmed the
concept of *Rhythm without End (Rythme sans fin)*
which both she and her husband would pursue at
length in painting a decade later.

The next major event on the Delaunay calendar
was one that was to rock both the art world and the
general public of Paris. Tzara was still actively insisting
on the priority of Dada as the leading movement of the
avant-garde. He thus proposed an evening of
performance in an auditorium large enough to hold a
Dada "super-demonstration." Unfortunately, his
reputation as a dangerous producer had put him on
the blacklist of most auditorium managers. He was
forced into new business alliances, both for this reason
and because of the new well-defined split in the Dada
ranks. It was fortunate for Tzara that Iliazd had entered
the Parisian art world and had established a relatively
respected reputation among theater management.
Iliazd was able to procure the Théâtre Michel for the
evening of July 6, 1923, and plans were made for an
elaborate evening to be called *La Soirée du Coeur à
Barbe (The Evening of the Bearded Heart).*[106]

Cat. 103. *Miss Mouth and Mr. Eye for* Le Coeur à Gaz, 1923
watercolor and pencil, 12-3/4 x 9-3/8 (32.4 x 24.5)
Collection The Museum of Modern Art, New York: The Joan and
Lester Avent Collection

Tzara then had the problem of devising the program for the soirée. Deprived of the group on which he had previously counted for inventive collaboration, he decided to restage a play which had been written and presented two years earlier. It was appropriately entitled *Le Coeur à Gaz (The Gas-Operated Heart)*. The play, originally acted by Soupault, Ribemont-Dessaignes, Fraenkel, Aragon, Péret, and Tzara himself, consisted of tedious intercourse between various characters, each of whom represented a different feature of the human face. Described by Tzara himself, it was:

> ...the greatest swindle of the century, it will bring luck only to industrialized imbeciles who believe in the existence of geniuses. The performers are asked to give the play the attention due a masterpiece of the force of Macbeth and Chanticler, but to treat the author, who is not a genius, with little respect and to take note of the lack of seriousness in the text which brings no innovation to the technique of the theatre.[107]

It has been classified as a "repetition of the affirmation of boredom"[108] and as "something dashed off with no pretension other than to be aggressive and written in a few days entirely in Dadaist euphoria."[109] It was meant to take an unsuspecting audience off-guard, and its effect could not easily be achieved if its shock value were already recognized. The restaging of the play, just two years after its original introduction, took that risk.[110] Tzara evidently counted on new costumes, actors and staging to achieve the desired shocking effect.

The performance fell under the management of Iliazd. It was staged by technicians of the Tcherez troupe and performed by professional actors from the Odéon theatre. Costumes were devised by Sonia Delaunay. Much to Tzara's amazement, Iliazd actually discovered coherent action in the play, and its production assumed the demeanor of a proper stage presentation. Sonia's designs for the new presentation achieved the merger of costume with relief sculpture, for which Picasso's creations for Cocteau's *Parade* had provided a precedent. The characters were not meant to dance, but simply to present themselves in banal interaction.[111] Accordingly, Sonia's inventions spoofed the formality of bourgeois apparel, by exaggerating its forms and rendering it in

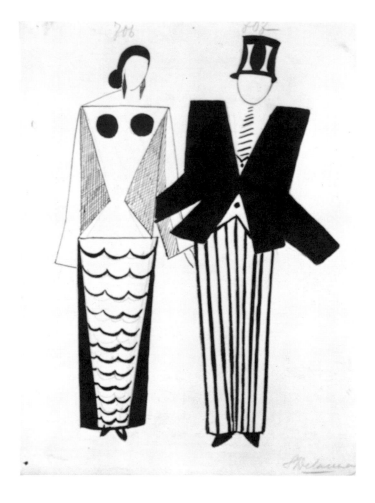

simultaneous colors. As with the designs for Codreano's dance, the costumes were confiningly frontal. They allowed only for changes of facial expression and for the gestural action of hands. This limitation of physical action would certainly have contributed to the effect of boredom which the play was intended to evoke.

Despite the relatively tame quality of the 1923 production, the very fact that Tzara chose to restage the play in the midst of the battle of Dada and Surrealism provoked organized reaction from the opposing camp. A wave of shouting was set off by the Surrealists during the reading of a poem by Soupault. As the play began, Breton and Aragon appeared in the orchestra and heckled the actors. Breton then jumped on stage and, swinging his cane, broke the arm of

Fig. 16. *Poet René Crevel and novelist Mme. X (Jacqueline Chaumont) wearing costumes designed by Sonia Delaunay for Tristan Tzara's* Le Coeur à Gaz.

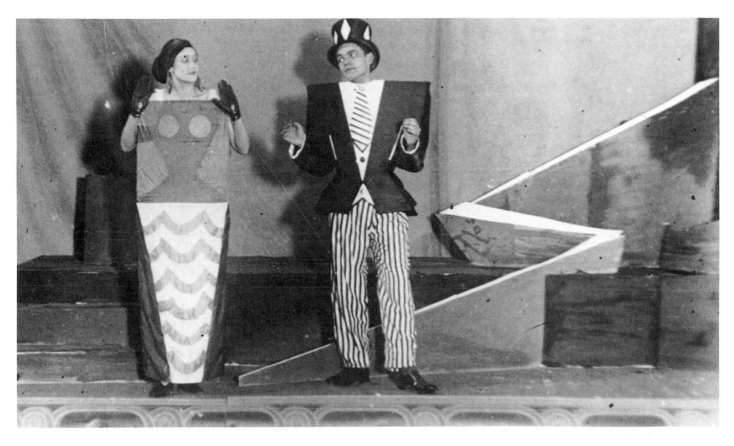

Pierre de Massot, who played the role of Nose. The actor was unable to protect himself, being completely encased in Sonia Delaunay's cardboard costume. Tzara rushed to the rescue, and he and Breton battled hand-to-hand. Finally, the police arrived and tossed the trouble-makers into the street. As things quieted down, however, Paul Eluard, infuriated by the presentation of his enemy Cocteau, leaped at the actors, exploding footlights and gaining himself a considerable bill from the management of the theatre![112]

A month later, the critic Roger Vitrac discussed the evening:

> If Mr. Tristan Tzara felt obligated to dress this play with costumes by Mme. Delaunay and Cubist stage set, if he wanted to present it to the public in a pot-pourri of works by so-called "modern" celebrities, it was with an indisputable artistic purpose to which his former friends could not be party. They had only one means at their disposal: not only to sabotage the performance but to make their dissent public and irremediable. The best way was to put DADA in the auditorium and to provoke the author and actors systematically. This is what they did![113]

His comment not only proves the respectability which Sonia Delaunay's creations demanded and had attained, but points out the confused ideological ends to which both groups aspired during that period of disassociation. The Delaunays remained faithful to Tzara, and Sonia enjoyed his friendship long after her husband's death.

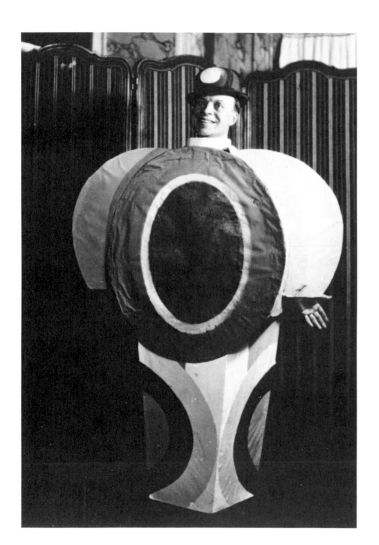

Fig. 17. *Costume for gala held at the Hôtel Claridge in Paris, 1923.*

he costumes for *Le Coeur à Gaz* served aptly as a tongue-in-cheek arena for experimentation in the serious transformation of modern bourgeois fashion. The following year, cardboard costumes exhibiting the same frontal, abstract conception as those from the play (and perhaps based on its designs), were paraded before the high society of Paris. An evening was organized by the collector Laurent Monnier at the Hotel Claridge to raise money for the treasury of the Organization of Russian Pages, whose charitable concerns were directed toward the influx of Russian refugees into France from the Bolshevik regime. Marshal Foch was the honored guest of the evening, which featured Russian folk dancers and an elaborate parade of fashions from the past, present, and future. The future was appropriately represented by Sonia Delaunay's inventions.

The Delaunays had, in the meantime, accepted another young poet, Joseph Delteil, into their band of close friends. In preparation for the event at the Hotel Claridge, Delteil wrote a lengthy poem, intended for recitation, *La Mode qui Vient*. A man dressed in black began the description:

> The coming fashion is profound and mysterious, to speak of it gives rhythm to my tongue and I feel myself caught up in its flow.[114]

As the text progressed, models appeared draped in veil-like lengths of fabric designed by Sonia:

> For cloth is ideal and divine,
> Cloth which is elusive as swallows,
> Cloth which has a thousand names and origins
> From that which is born at a ewe's udder
> And that which a paradisal worm creates in a sunny mood…[115]

Eventually, four male models in extravagant cardboard encasements made their way on stage as the poet stressed the collaboration of body and fashionable form:

> All lines lead to the heart.
> The sleeves are the wings of the heart.
> The socks the color of the heart.
> The trousers climb the heart.
> The waistcoat is the knave of the heart.
> The necktie is the knot of the heart.
> The buttonhole is the flower of the heart.
> All lines lead to the heart,

All lines lead to the heart!
Round speed maddens our tissues and our legs.
Blood gallops in our veins to the rhythm of the Universe![116]

Delteil later clarified the diverse types of men who would be transformed by this new apparel:

And these same men, see them clad in the triangular mode
The one who is no doubt a businessman and perhaps a man of feeling.
He has no awareness of wearing a miracle on his torso:
Well, he is a consequence of the choicest astronomical theories;
And this other whose pince-nez are a bicycle rolling rolling across his pupils,
And this one has on his soft hat
Showered torrents of stick!
And that one, who has abandoned the straight line and the short linear conception.
And the paltry rules of silhouette of single material and flat color.
To leap at last into the wide virgin expanses,
The region of fashion round
Like the world[117]

Finally, female models appeared in both cardboard contraptions and soft cloth creations:

A dress is no longer a little, flat closed thing,
But begins in the open sky and mingles with the courses of the stars,
So that she who wears it carries the world on her back.
The Universe is at Woman's beck and call. [118]

To end the presentation, all of the simultaneous figures gathered around the reciter, covering him with color and abstract form.

The prophecy that Sonia Delaunay's creations would point the direction of future fashion was well-considered. Shortly after the display of her fashion booth at the *Bal Transmental* in 1923, a textile manufacturer in Lyons asked her for a set of fabric designs. The fabric industry was one of the few in France to revive quickly after the economic depression and loss of manpower caused by the war. Traditionally sensitive to stylistic directions set by Parisian couturiers, textile producers had learned to keep a careful watch on images evolving in the realm of avant-garde art. An important precedent had been set by the employment of Raoul Dufy to design printed textiles before the war, in Paul Poiret's studio, and later to work with new weaving techniques in creations for a major fabric firm. Sonia Delaunay respected Dufy's revolutionary approach to the medium,[119] but took giant strides beyond him by substituting pure geometry for exotic imagery. The discipline of textile studies perfected her control of color interaction while integrating the playfulness of her inherent creative approach with the planar geometry more typical of Constructivism.

The production of textiles proved to be a natural extension of Sonia Delaunay's theatre designs and handmade simultaneous fashions. To achieve perfection in this fusion of art and craft, however, she found it necessary to establish her own printing workshop, the Atelier Simultané, where the precise qualities of color gradation which she envisaged could be carefully supervised.[120] The designs were most frequently printed on silk. In exploration of textural as well as color contrast, however, she employed workers to embroider in a stitch resembling *point d' Hongrie,* combinations of wool and silk on cotton. By the fall of 1924 her new business was in full swing, and her fabrics were presented "cinematically" at the Salon d' Automne in a display of moving coils devised by her husband.[121]

The colors of Sonia Delaunay's fabrics were limited to four, occasionally five or six, in each design. Many retained the violent contrast of hues found in her Portuguese paintings. Others expanded into softer combinations of browns, beiges, greens and quiet yellows. Frequently the designs were created with the possibility of interchanging sets of colors to allow an infinite variety which could be accommodated to personal tastes. For elegance and excitement, threads of gold and silver, catering to the tastes of the day, were integrated into the intricate patchwork of forms. Squares, triangles, diamonds and stripes dominated the designs, appearing far more often than the ubiquitous circles of her earlier dance costumes. The practical demands of actual daily clothing stimulated a renewed investigation of a wide geometric vocabulary.

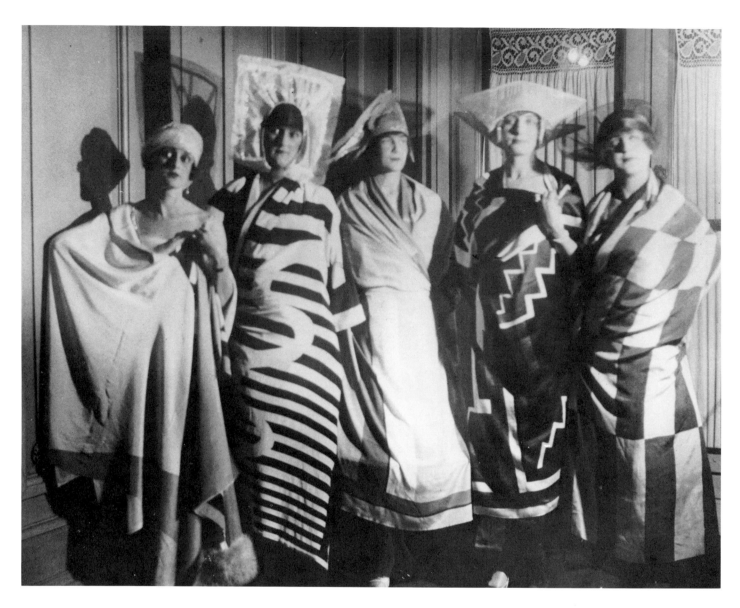

The new "simultaneous" fabrics were the most dramatic extension of the Delaunays' concept of modernity into the world at large. As Robert commented in a later essay:

> No exoticism, no neostylization. It's truly the rhythm of the modern city, its prism, its illumination, the colors, its river. In short, the surface of the fabric, intimate with the surroundings of everyday life, presents something like visual movements comparable to chords in music, but it provides the body of the material with a definite signifier that gives the objective feeling that the fabric has attained its maximum vitality. The fabric becomes a principal element of composition. One would like to shape it, to use it in such a way as to give the suggested model its greatest effect...[122]

It was precisely this desire to give the fabric shape that inspired Sonia's creations, as early as 1924, of meticulously embroidered and appliquéd coats that quickly brought in a bevy of commissions from the wives of fashion designers, of artists, of such architects as Gropius, Mendelsohn, and Breuer, and from no

less a celebrity than Gloria Swanson. America looked to its film stars to set fashion style, and soon Sonia Delaunay was sending textile designs to this country for manufacture.

An international exhibition was planned to be held in Paris in 1925. Unlike earlier exhibitions, which had featured developments in science and industry, this was to exalt the fusion of art and commercial enterprise in decorative design. It was also meant to reaffirm the primacy of France in the realm of taste and fashion. Pavilions from all the major European industrial countries, except Germany, were erected across the Esplanade des Invalides and small boutiques, displaying the creations of luxury fashion houses, lined the sides of the Pont d'Alexandre III. Sonia Delaunay was asked to participate, whereupon she outfitted a shop, the Boutique Simultanée, in collaboration with the furrier Jacques Heim. Fabrics, coats, dresses, handbags and assorted other

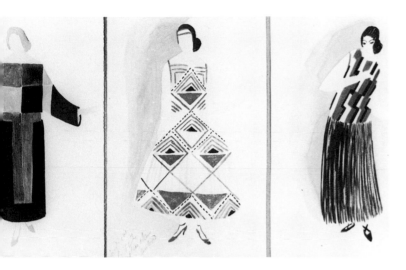

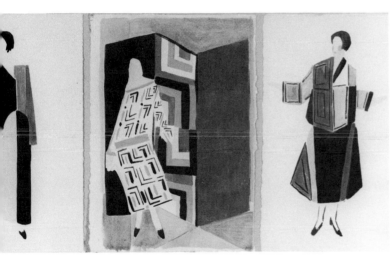

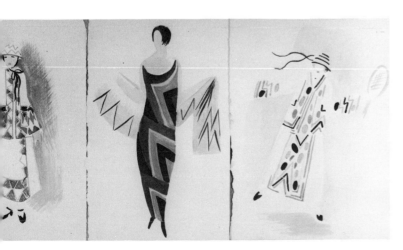

accessories were distributed against folding screens of simultaneous design in the most elaborate display arrangement that she had produced to date. In marked contrast to the elaborate floral and oriental motifs of French Art Deco (a mixture of borrowed style reshaped by Cubist form), the Delaunay display provided a dramatic challenge. Simplified design and striking color stated the mood of the mechanized postwar culture far more effectively than the nostalgic lingerings of more conservative decorators. After the 1925 exhibition the "modern style," typified by Sonia Delaunay's creations, was to take precedence in the French decorative arts. Armand Lanoux summarized the popular response to her work:

> The journalists have unanimously proclaimed Sonia Delaunay's boutique on the Pont Alexandre III as outstanding. There we can feast our eyes on her "simultaneous" materials and fabulous embroidery, executed as always with great care for harmony of color. These magnificent coats in graduated tints, delicate as morning mists or reflections of autumnal splendours, must have been made for regal shoulders. Sonia Delaunay also works in furs with unsurpassed virtuosity, and she knows how to play off neutral shades of skins against one another. She combines fur with embroidery, metal with wool or silk — but the metals she uses are always dull in color, thus creating a certain rich discreet elegance.[123]

To document her contribution to the development of decorative arts in France, an album with twenty portfolio plates of fashion designs and poetry by Cendrars, Tzara, Delteil and Soupault, was published that year by the Librarie des Arts Décoratifs.

Part of the cause of Sonia's success was the fact that her fashions were consciously in keeping with the liberating aspects of female clothing that had developed of necessity during the First World War. Many important fashion houses, run by men, had closed during the war when they and their workers had been conscripted into the army, and when, in any case, their buying public had dwindled to a handful. There was little interest in elaborate appearances during that era of forced practicality. Skirts rose from the floor to ankle length, and expanded from hobbled hemlines to full skirts geared toward easy walking.

Right: Fig. 19. *Mannequins modeling beachwear, 1928.*

Far right: Cat. 125. *Three Bathers, (Trois baigneuses),* 1928
No. 1376, watercolor and pencil, 7-3/4 x 10-1/2 (19.6 x 26.7)
Collection Museum of Art, Rhode Island School of Design,
 Providence

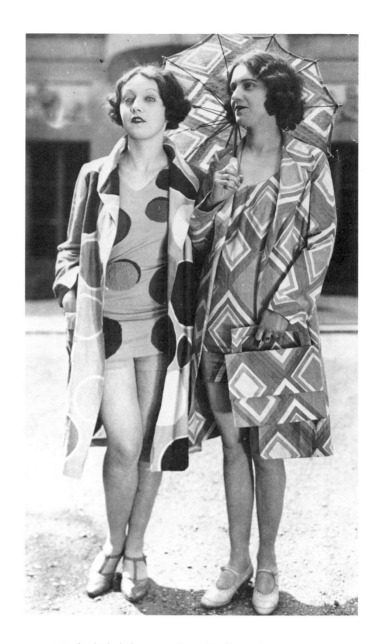

Bodices were loose and waistlines released from restraint and impractical placement. After the war, Paris found that many of its top designers were women. Attempts to reinstate the period designs of earlier years, including their confining layers of nonfunctional folds and gathers, met with resistance from the postwar female public. Designers who were sympathetic to this new attitude, made efforts toward the reintegration of a feeling for femininity with comfortable fabrics and liberating cuts.

The effect of Sonia Delaunay's designs depended upon the presence of uninterrupted surfaces and the elimination of applied ornamentation. The modern cut enhanced the display of her geometric forms, which in turn accelerated the turn of fashion toward greater freedom for the female figure. She took advantage of full skirts and tunic cuts, of a variety of lengths and shapes of hemlines, and of the advent of sportswear into the female wardrobe. Shawls, scarves and flowing wraps were still in vogue for evening wear. This allowed Sonia Delaunay to develop a complete repertoire of products based on the priority of the two-dimensional design.

Claire Goll, wife of the editor of the new magazine *Surréalisme,* described the effect of Sonia Delaunay's early fashion designs:

> ...the woman here is radiantly reflecting in her colorful dress. The black, white, and red stripe runs down her almost like a new meander, giving her movements a rhythm of their own. And when she goes out, she dons the delightful mole-coat, which is covered with wool embroidery, so that it almost looks woven. Its harmonic lines are filled in all nuances of brown, rusty red, and violet. When receiving her friends, she wears a tea gown, in which a gaudy triangle cheerfully keeps recurring. But in the evening she wears the coat that is worthy of the moon and that was born of a poem; for the geometric forms of the alphabet were used by Sonia Delaunay as an unexpected ornament, so that now instead of saying that a dress is a poem we can say: This poem is a dress. Sometimes she even weaves a verse in large letters inside an evening cape, or the wearer can openly acknowledge her favorite poet by wearing a quotation from his work, delicately embroidered in wool on a sash. For Sonia Delaunay not only uses the strangest material, she

particularly brings out its spirit. Thus, through her daring colors and forms she not only gives us sensual pleasures, she also and especially educates us toward a new style.[129]

She created unique "poetry-fashion" for her friends in the world of art, elegant and expensive clothing for the new, extravagant bourgeoisie and she considered as well the plight of the everyday woman, whose pocketbook did not permit such individualized care. She devised an invention called the "fabric pattern" *(tissu-patron),* in which the cut of the dress was sold in a package with the length of fabric for which it was created. The idea, patented by Robert Delaunay, was to insure the artistic unity of the design of the fabric and the design of the dress, and to allow the general public to choose among a variety of her creations, which could then be made with minimal expense. She discovered, however, that few purchasers were content to have the dress made without personal

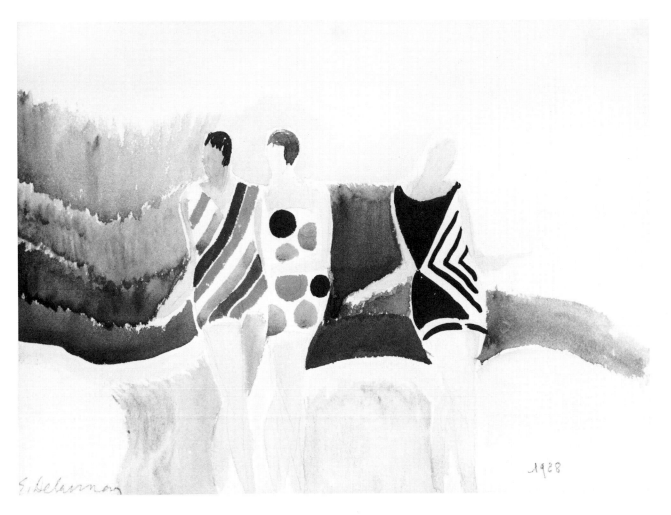

alteration, which destroyed the purity of the artist's original conception. As a result she soon abandoned the "fabric-pattern" and returned to textiles and individual commissions.

She was, nonetheless, kept fully occupied by the work, not all of which she enjoyed:

> I was capable of being a woman manager, but I had other purposes in life. I have always felt horror and disgust for the business world...the heap of orders, the mundane intrigues, the business problems — in the end I was employing thirty workers — all of it devoured me. I used to lead three lives in one at an insane pace and, during the thirties, I would suffer not of what I was doing but of not being able to fight on all fronts at once...[125]

Robert Delaunay, who considered himself to be far more practical than Sonia, helped her capitalize on the potential of her business by establishing important liaisons:

> He knew very well how to place me in the way of large orders; he would invite home anyone who exercised influence at that time. Once I reproached him, as a joke, for trying to sell me. When success literally assailed me, he pretended to be envious of my luck and to believe that the money was easily earned. "You don't realize, you are not doing

anything, you don't make the slightest effort and people climb up five flights of stairs to come and buy."[126]

The great age of Delaunay fashion, however, ended almost as quickly as it had begun, much to the artist's relief:

> The great depression of 1929 saved me from business. The orders had stopped. America was withdrawing into its economic wreckage. I was eating my heart out wondering what work I was going to give to my employees, how I was going to pay my expenses while hardly working. The answer came in a flash. Robert and I were sitting at a cafe across from the Dôme. I noticed on the other side of the boulevard a quiet individual smoking his pipe in the sunshine. This serene philosopher — it was Vantongerloo, the painter — was telling me what to do. ...We are crazy to try to maintain our enterprise at all costs. Let's act like Vantongerloo, who is dreaming in the sun. Let's drop everything and go back to painting.[127]

Fig. 20. *Model draped in simultaneous fabric.*

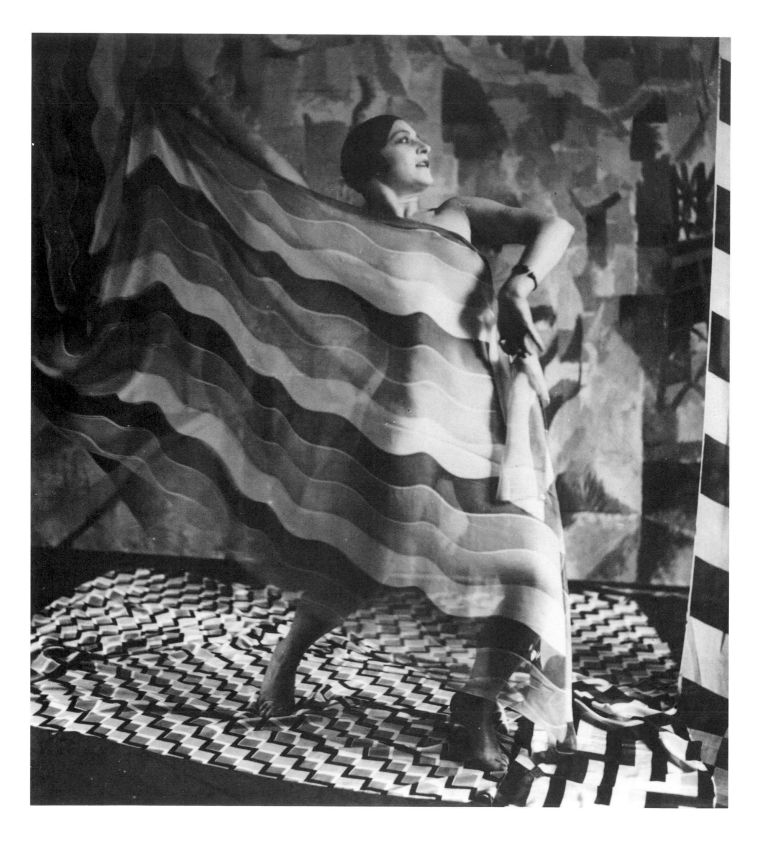

Clockwise from top: Figs. 21-25: *Boutique Simultanée at International Exhibition of Decorative Arts, Paris, 1925; Sonia Delaunay wearing a dress of her own design, 1925; advertisement for the Boutique Simultanée; model wearing Delaunay pajamas, 1925; the architect Golfinger wearing a robe and pajamas designed by the artist, 1930.*

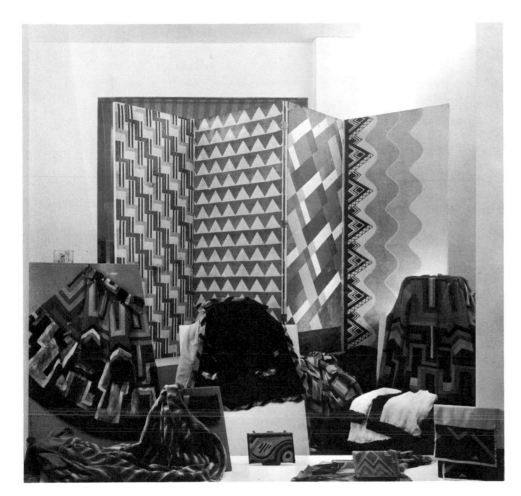

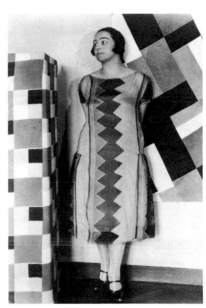

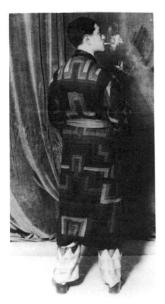

boutique
« simultané »
n° 16
pont alexandre III
aux
arts décoratifs

1925

sonia delaunay

tissus simultanés brevetés
modèles art simultané
modes broderie déposées

PARIS : 19, boulevard malesherbes, tél. élysées 10-88
LONDON : PARIS - trades, 20 a, berkeley street
RIO de JANEIRO casa de aladin rua 15 de maio 52

850

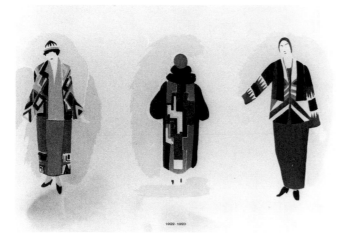

1922-1923

Top, left: Cat. 94. *Group of Women (Groupe de femmes),* 1922-23
No. 1454, china ink and pencil, 8-1/4 x 10-5/8 (21 x 27)
Collection Sonia Delaunay, Paris

Bottom, left: Cat. 183. Page from *Sonia Delaunay, ses peintures, ses objets, ses tissus simultanés,* (Paris: Librairie des Arts Décoratifs), 1925
Collection Sonia Delaunay, Paris

Bottom, right: Cat. 116. *Group of Women (Groupe de femmes),* 1925
No. 115, pen and ink, 10-5/8 x 7-7/8 (27 x 20)
Collection Sonia Delaunay, Paris

Below: Fig. 26. Three Women in Simultaneous Dress (Trois femmes en robes simultanées), *1925. Oil on canvas. 57 x 44-1/2" (144.8 x 113). Private collection.*

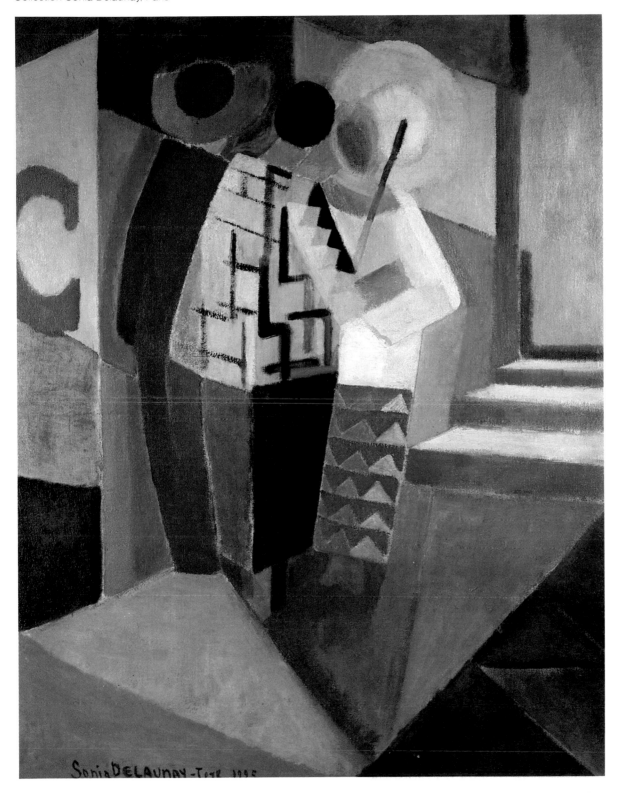

Upper, left to right: Cat. 221. *Losanges,* 1977
fabric panel
Cat. 215. *Damiers,* 1977, fabric panel
Cat. 213. *Black Magic,* 1977, velvet panel

All issued by Artcurial, Paris

Middle, left to right: Cat. 212. *Black Magic,* 1977
velvet on 3-panel screen: Issued by Artcurial, Paris
Cat. 203. *Coat,* 1924, wool and silk
Collection Union Française des Arts du Costume, Paris

Cat. 228. *The Serpent,* 1978 (after 1922 design)
crepe de Chine scarf: Issued by Artcurial, Paris
Cat. 214. *Checks,* 1977
wool muslin shawl: Issued by Artcurial, Paris

Lower, left to right: Cat. 201. *Parasol* (ombrelle), 1922-23, canvas
Cat. 200. *Handbag,* 1922-23, canvas
Cat. 202. *Printed Scarf,* 1922-23, crepe de Chine
All collection Union Française des Arts du Costume

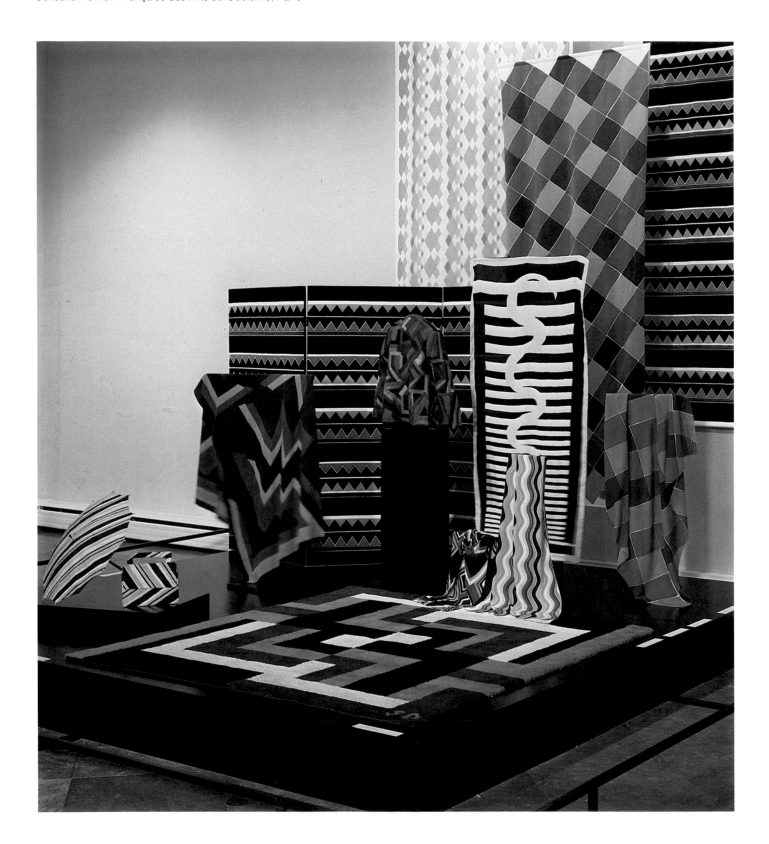

Cat. 199. *Scarf,* 1922, silk
Collection Tamar J. Cohen, New York

Cat. 222. *Rythmes,* 1977, crepe de Chine scarf
Cat. 209. *Rug,* (Tapis), 1967 (reedition of Rug, 1925)
Both issued by Artcurial, Paris

Top, left: Fig. 27. *Sketch of dining room of the Delaunays'
apartment on Boulevard Malesherbes, Paris, 1924. Gouache on
paper. 11-3/8 x 16-1/2" (29.2 x 41.9). Collection Sonia Delaunay,
Paris.*

Bottom, left: Fig. 28. *Salon of the Delaunays' apartment on
Boulevard Malesherbes, Paris, 1925.*

Top, right: Fig. 29. *Sycamore buffet, 1923.*

Bottom, right: Fig. 30. *Sycamore table, 1923.*

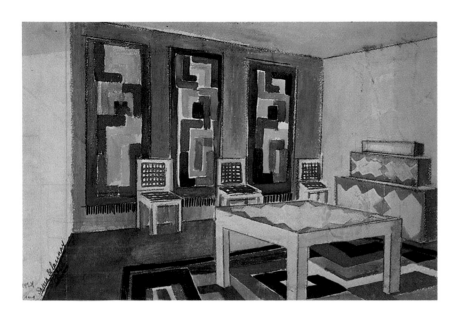

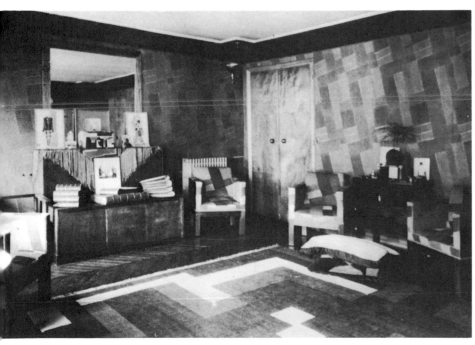

75

Top: Cat. 102. *Fabric Design No. 6 (Projet de tissu no. 6)*, 1923
No. 1809, gouache, 12-7/16 x 18-15/16 (31.5 x 48)
Collection Sonia Delaunay, Paris

Bottom: Cat. 91. *Costume Studies*, 1919-23
Three works in one frame, left to right:
 1. *Costume*, 1919
 No. 1540, china ink, 10-1/16 x 6-1/2 (25.5 x 16.5)
 2. *Simultaneous Dress, Rhythm Without End (Robe simultanée,*
 rythme sans fin), 1923
 No. 510, watercolor, 11-7/16 x 7-1/2 (29 x 19)
 3. *Costume*, 1923
 No. 1539, watercolor, 10-1/16 x 5-15/16 (25.5 x 15)
Collection Sonia Delaunay, Paris

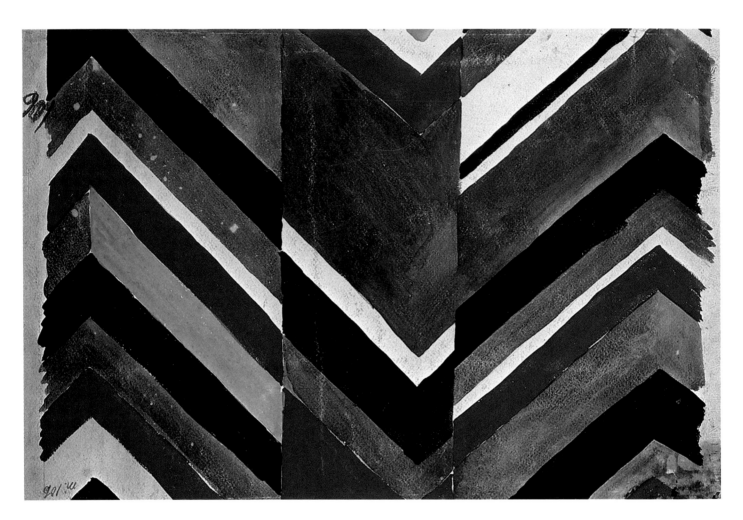

T he 1925 International Exhibition of Decorative Arts effectively reestablished France as a country that actively supported new movements in both art and design, with an economy sufficiently sound to provide artists with work. Foreigners who had spent time in Germany during the early part of the decade, profiting from the devaluation of the mark, later made their way to Paris in great numbers. The ideologies which they brought with them were, for the most part, ones which held as a goal the fusion of architecture, fine art, and decorative design. Sonia Delaunay's Boutique Simultanée which displayed not only female fashions, but interior furnishings, was a perfect example of this combination.

In outfitting the new apartment on Boulevard Malesherbes, Sonia Delaunay had not been satisfied simply with simultaneous curtains, wall hangings, and decorative accessories. She began designing armchairs to be covered in upholstery of her own creation; tables, sideboards, and commodes in which the contrasts of carefully patterned wood grains achieved the desired simultaneous effect; and carpets manufactured according to specific stipulations which would ensure the perfect integration of all of the other furnishings of the room.

A reviewer of the 1925 exhibition discussed Delaunay's experiments with wood:

> Wood, such a beautiful material, was bound to tempt our artist. Always attracted by color, her only requirement was that the shading of the wood should please her. With her grand scale of vision, she went quickly from small works to robust enterprises; she began to work on furniture; always neat, practical and convenient, her interiors are charming. In the same way that she designs a hat, a dress, a garment or a bag for a specific person, she adores creating a suite of furniture in keeping with the color, the life and the profession of each person.[128]

Her fusion of simplicity, functionalism, and an orientation toward individual taste struck a point of balance between the anonymity of Russian and German design, and the unique elegance of Art Deco creations. The French buying public was ready for a change, but not yet willing to accept the severity of

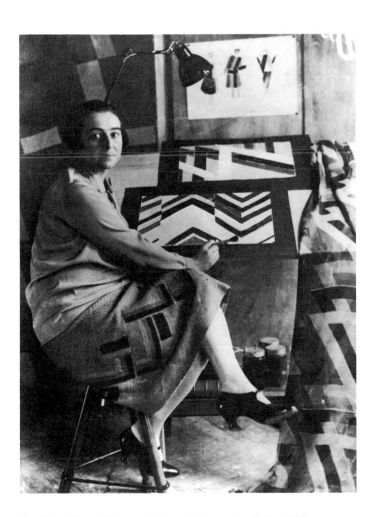

Fig. 31. *Sonia Delaunay in her design studio, Paris, 1920s.*

more radical abstract styles. Her work heralded a turn toward the style known as "modernism" in furniture as well as in fashion and textiles.

Martin Battersby, in his book *The Decorative Twenties,* submits that the anti-decorative preference in design in France after 1925 resulted from the influence of new approaches to photography and mobile cameras providing movement and eccentrically-angled shots, in German and Russian films; a preoccupation with the presence of the machine in modern life, inspiring the organization of a major Machine Age Exhibition; and the development of new materials which could allow the production of simply designed furniture at low cost[129] Although it is not likely that any of these cultural phenomena were directly influential on Sonia Delaunay's style of the 1920s, she did participate in the cinema, accepted a commission to decorate a car (a 1925 Citroën B 12), and acknowledged the concept of standardization as necessary to the extension of her style to the general public.

Two film producers approached her in 1926 to create costumes, fabrics and set designs. In Marcel l'Herbier's production of *Le Vertige,* the modernity of her abstract lines and color contrasts emphasizes the attitude of control and seriousness which characterized the drama. In René Le Somptier's film *Le P'tit Parigot* on the other hand, the assembly of patterns, colors, and abstract movements produced an atmosphere of gaiety suited to the spectacle in which crowds of performers took part. The latter film featured another dance by Lizica Codreano in a Delaunay costume that now stressed the interaction of angles with disks and allowed for the free movement of the human form[130] The experience in coordinating costume with furniture and wall decoration for the creation of a total interior matured her vision in the realm of theatre sets. In 1928 she collaborated with Léonide Massine in the creation of a new ballet, *Les Quatre Saisons,* designing a unified combination of set and costume for each season. Although the ballet was never staged, the sketches display a synthesis of approach surpassing that of any of her previous

involvements with the theater. Günter Metkin, writing on the merger of art and the stage, assessed the designs for *Les Quatre Saisons* as follows:

> As may be seen from the designs — costumes, flats, and backdrop would here have been interrelated to present a gay and optimistic festival of athletic modernity. The backgrounds consist of undulating parallel lines using the well-tried rhythm of color contrasts, as well as slanting patterns that act as a stimulus to the eye by refracting at an acute angle with the patterns on the wings. Like the costumes, colored balls are intended to underline the bright gaiety of the simultaneous contrasts[131]

Sonia Delaunay was engaged for several other small film or theatre productions prior to 1930, each of which employed her understanding of numerous aspects of the decorative arts.

By the end of the decade it was apparent to Sonia Delaunay that the general aesthetics of her style had become international. She was asked to assemble a portfolio of reproductions of contemporary examples of textiles and rugs, which was published by Charles Moreau in 1929[132] The striking point of similarity among the selections, which included French,

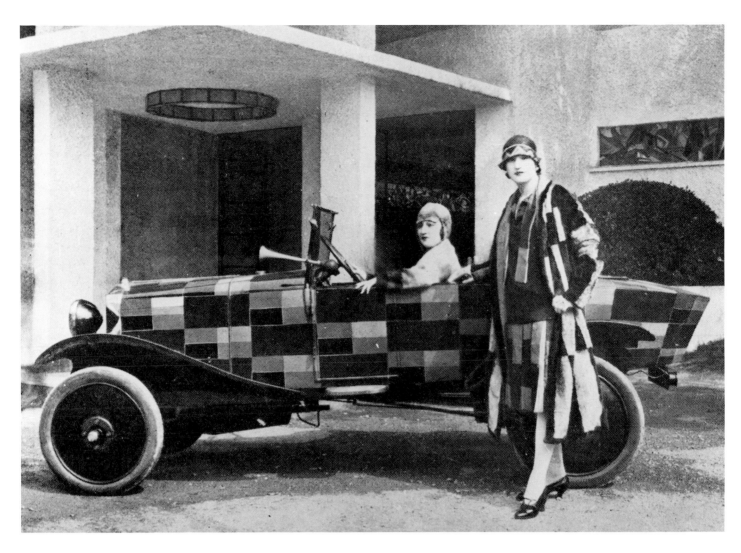

Austrian, Dutch, Belgian, German, Polish, and Russian examples, was the use of planes of pure color and abstract geometric form. The style was one which Sonia Delaunay could justifiably consider essential as an expression of her epoch. In the essay which she published to accompany the album, she emphasized the importance of style as a manifestation of the spirit of the time:

> Style is the synthesis of practical necessities and the spiritual condition of an epoch. We want to examine the sources from which this selection proceeds and the more serious movements of our life to which it is connected.
>
> Our era is above all mechanical, dynamic and visual. The mechanical and the dynamic are the essential elements of the practical dimension of our time. The visual element is the spiritual characteristic of it![133]

She acknowledged the importance of the machine and of functional concerns in the creation of useful objects. She did not, however, condone ideologies that put pragmatism before aesthetics:

> The dynamism and speed of modern life requires a synthesis. The example of mechanical achievements demonstrates that the true beauty of an object is not an effect of taste but is intimately tied to its function. Even this principle has been pushed to the absurd by theoreticians who proclaim the supremacy of utility while forgetting that the spiritual element has always been indispensible to man and that we owe to it the most beautiful human creations![134]

Sonia Delaunay's understanding of the use of textiles had expanded by 1929. She now saw them as material naturally suited to cover full wall surfaces with compositions that were structurally, and thus functionally, related to the concept of architecture itself. A fabric with rectangular designs set on a diagonal was attached to the walls that enclosed her living room on Boulevard Malesherbes. It simultaneously complemented and contrasted with the furniture, the carpeting and the rectangularity of the wall surfaces themselves. This orientation toward the structural fusion of decoration and architecture led naturally to a consideration of wall hangings and of murals.

> The simplicity of the forms and surfaces of objects leads to an inquiry into materials and the decorative dimension of surfaces. It is for this reason that we

Cat. 121. *Dance Costume for* P'tit Parigot *(Costume de danse du P'tit Parigot)*, 1926
No. 675, watercolor, 8-7/8 x 7-1/2 (22.5 x 19)
Collection Musée National d'Art Moderne, Paris

take part in the renaissance of the decorative dimension of cloth, fabric, and, in the near future, of mural painting.

Great plain surfaces, without any relief decoration, suggest an element of fantasy which is provided by textiles, wall hangings, etc. Small tables placed against walls do not go with architecture. Only wall decoration in its architectural form is impressive.[135]

A renewed inclination toward monumentality accompanied this theoretical focus on the entire wall surface. The transformative power of a painting was traditionally limited to the area contained within its frame. What Delaunay was saying in her discussion of fiber arts was that the Renaissance concept of the fusion of painting with wall surface, best exemplified, according to her, by Veronese's enormous *Marriage at Cana* in the Louvre, or by the precedent of frescoes and carvings from ancient cultures, was by far the most appropriate use of artistic form. Panel paintings should achieve a scale suited to their setting. The general implication found in this concept is that they should be large. Smaller images, on the other hand, could be employed successfully in the arrangement of a wall surface, if the composition of the entire surface were structurally integrated according to the dictates of the architecture, of color and of form. In 1930, Robert Delaunay began a series of large-scale reliefs, his own synthesis of painting, architecture and sculpture, designed to extend from ceiling to floor and from one corner to the next, in the rooms for which they were intended. Most of his works from that time until his death in 1941 were completely abstract, or to use his word, "inobjective."

Abstraction had been just as present in Paris during the 1920s as were Dada and Surrealism. Piet Mondrian returned to Paris from Holland in 1919, bringing with him the fully established theory of abstraction known as De Stijl. Other important members of this group, Vantongerloo and Van Doesburg, came to France later in the decade. Russian Constructivists, including Pevsner and Pougny, added fuel to the abstractionist fire, as did numerous influential Polish and Hungarian artists. By

the beginning of the 1920s, arguments were beginning to arise between those artists who adhered rigidly to the tenets of nonobjectivity with a geometric basis, those who favored abstraction but were tolerant of the occasional appearance of a natural image and the Surrealists, whose dream-imagery ranged from abstraction to hyper-realism.

In 1931, Van Doesburg gathered together a group of artists — Hélion, Tutundjian, Arp, Herbin, Kupka, Gleizes, Valmier and Robert Delaunay — to form a new movement which was to pose the primacy of nonfiguration, but with a liberal view toward the principles by which the image was created. The new association gave itself the title *Abstraction-Création,* proving its acceptance both of artists whose images derived from observation and of those for whom pure geometry formed the sole basis:

Abstraction because some artists have arrived at the concept of nonfiguration by means of the progressive

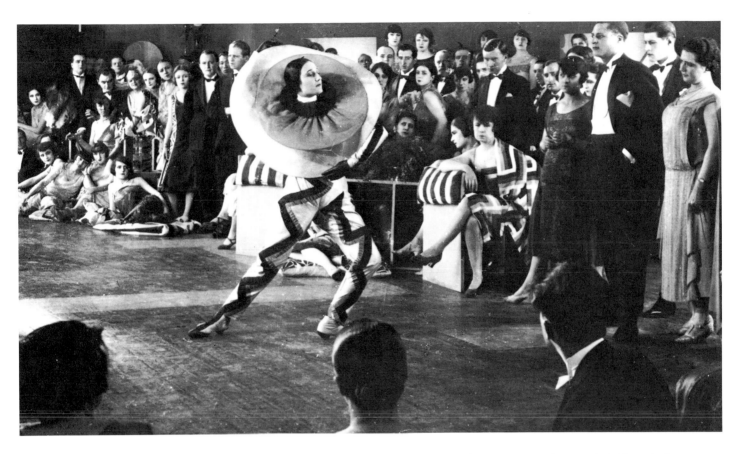

abstraction of the forms of nature.

Creation because other artists have directly reached nonfiguration by a concept of purely geometric order or by the exclusive use of elements usually called abstract, such as circles, planes, bars, lines, etc.[136]

Herbin, and later Vantongerloo, were the most stringent of the association. Their refusal of numerous good paintings on the grounds that one could detect a natural image and the admission of several mediocre works because they were nonfigurative caused argument and dismay among several members, Delaunay included. In 1934, he, together with Arp, Sophie Taeuber-Arp, Pevsner, Gabo, Freundlich, Valmier and Hélion, dropped his membership. Nonetheless, the involvement with *Abstraction-Création* either began or reconfirmed a set of friendships between the Delaunays and a strong faction of abstract artists.

Jean Arp and Sophie Taeuber-Arp had become close friends with the Delaunays during this period,

traveling with them on vacation and visiting their household, which still offered frequent hospitality to artists and poets active at the high point of Paris Dada. Arp and Taeuber-Arp were both defenders of abstraction, but like Sonia and Robert, found it essential to incorporate a level of imagination, fantasy or even dream into their creations. Arp had been affiliated with the Surrealist group as well, and developed a philosophy of Concrete Art which combined the "automatic" techniques of Surrealism with the goal of anonymity to which many of the abstractionists adhered. It was a fusion of the appreciation of pure form and pure color with individualized expression, and was a philosophy that struck a chord of agreement with the Delaunays. Sonia later depended on that friendship, with its concordance of ideas, to support her through a time of grief. Her only effort at one-to-one collaboration with another painter was for a lithograph which she created jointly with Jean Arp.

Fig. 35. *Project for illuminated sign, Zig Zag, 1936.*

Unlike her husband, Sonia Delaunay also looked with interest to the work of more rigid abstractionists. Assessing whether or not their creations exhibited the quality of rhythmic excitement that she sought in her own, she at times opened herself to their influence. Mondrian was an artist whom she greatly appreciated:

> I've always looked to see what was happening around me. Later I also looked at Mondrian's work because I like the square. I introduced the square into my own work, while Delaunay still worked with circles.[137]

Robert Delaunay had begun his series of paintings, *Rhythm Without End* in 1930, shortly before the creation of the *Abstraction-Création* group. Their halved circles, joined on a diagonal axis, were a direct offshoot of Sonia's earlier images of dancers. This borrowing of motifs prompted an interchange on the activity of colors that they both employed:

> He would ask me at the end of the day: "Are the colors exact?" We worked a lot together on these rhythms since they were closer to me. Robert's work is more scientifically simplified than my painting. I used to tell him at the time that it was too dry. Over the years, I realize that it was done on purpose to approach pure movement.
>
> Our discussions were productive....I would tell him: "There is too much of this or not enough of that. You use too much of it or not enough." I would reproach him for using orange which I hate. Yellow and orange are colors that I always avoid, but in fact, it was really our two temperaments expressing themselves differently.[138]

The Delaunay style, which approaches anonymity in the use of pure form, pure color and a mutual agreement of syntax, was, nonetheless, the result of distinctly individual expressions by two divergent personalities. Like Arp, Sonia was inclined toward the unexpected and intentionally incorporated the quality of the dream in her work.

While Robert returned to abstract oils, which he was beginning to sell in sufficient quantity to contribute significantly to the family income, Sonia continued diverse activities even after the close of her business.

> My life was very complicated, divided, fragmented between the private orders I was still getting from couturiers, especially Jacques Heim; the publishing of albums, the printing of articles in magazines, some shop window projects and posters — we were interested in electric advertising — meetings with architects, engineers, prospective underwriters. And, with all that, Robert never finished his paintings or classified anything. I had to store them, keep notes, assemble information for a catalogue in anticipation of future exhibitions, sales or bequests to museums..[139]

To rest her mind and sort out her ideas in the midst of all these demands, she began again to keep a journal. In combination with the scrapbooks of newspaper clippings, exhibition announcements and other pieces of documentation, her daily entries provide a full account of creations, collaborations and business ventures, as well as of thoughts and fantasies.[140]

Her artistic activities during these years ventured into the use of electric advertising, particularly neon.

Cat. 135. *Projects for "Mica-tube,"* 1936
Two works in one frame, top to bottom:
 1. *Design for neon sign for "Mica-tube, a Ribbon of Light" (Projet d'affiche lumineuse pour "Mica-tube, un ruban de lumière")*
 No. 799, gouache, 8-1/8 x 12-1/4 (20.7 x 3.9)
 2. *Poster design for "Mica-tube" neon lighting (Projet d'affiche pour les lampes "Mica-tube")*
 No. 5087, gouache, 7-9/16 x 15-3/16 (19.2 x 38.6)
Collection Bibliothèque Nationale, Paris

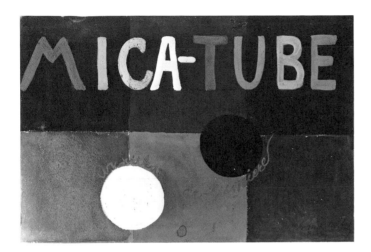

Poster projects were created for the light bulb and neon manufacturer Mica-tube, and an illuminated relief promoting Zig-Zag cigarette papers was actually completed in 1936. This combination of colored line and light on a two-dimensional surface won first prize in a competition for publicity murals sponsored by the Société d'Electricité de France.

Integrating electric lighting into a work of art was as natural to Sonia Delaunay as the creation of an appliquéd quilt. She had been entranced with the effect of electric lighting for over twenty years, and had sought to capture the quality of that light in the colors of her canvases. Posters for popular commercial products had continued to provide an outlet for playful creativity during a time when many of her other pursuits assumed the seriousness of functional design. After the close of her textile business, the flavor of her fabric designs acquired a new freedom. Examples in

black and white from 1933 push the concept of contrast to the limits of optical adjustment. The patterns assault the eye with a force that deceives a normal understanding of the stability of the two-dimensional surface. The spectator's vision is jostled up and down the composition, in a manner as aggressive as the products of the Op Art movement of the 1960s. The use of electricity was no more dramatic as a visual device than those designs. Electric posters combined all of these interests, and, moreover, provided the opportunity to work again on the scale of the mural.

With all of the collaboration necessary for the production of works of art that would make their way to the public by means of a commercial market, Sonia Delaunay still guarded the purity of her personal approach:

> In rereading my diary, I realize how hungry I was for spiritual exchanges with others, and yet, at the same time, exclusive in friendship and collaboration. I demanded an ascetic way of life, sacrificed to work and art and some kind of equivalent to the vow of courtly love. I explained this to A...with brutal candor. It is true that I was defending a private domain, my inner life, into which I had until then allowed no intrusion, and that I would hide behind a wall of good humor and optimism. No one could claim to read my inner emotions![141]

n 1935 the Delaunays moved from their apartment on Boulevard Malesherbes to the studio-apartment combination on Rue Saint Simon which Sonia occupied until her death. At the same time, they gave up the studio which Robert had kept over the years on Rue des Grands-Augustins. The new quarters were modern in design and filled with sunlight. Sonia, however, was hesitant at the thought that she would no longer have a private space in which to work. The problem was resolved by a young friend who offered the Delaunays the use of his spacious garden in Neuilly as their working quarters. They spent most of their time in this setting. It was here that they were finally located one day by a patron who informed them that they were being sought by architects who were planning the pavilions for the 1937 Paris World's Fair.

In contrast to the fair of 1925, which focused on decorative arts and private industry, the 1937 assembly was titled the International Exhibition of Arts and of Technics, with emphasis on public and communal production. Organized just six years after a major financial crisis in France, the exhibition rose in the midst of widespread unemployment, economic uncertainty and the outbreak of civil war in Spain. Like most other workers of the period, artists had begun to form unions that could bargain for large scale commissions, spreading both the work and the remuneration among their members. As they considered the vulnerability of their financial position in society, most artists abandoned easel painting, which was prey to the whims of the affluent buying public, and looked toward the more permanent and financially secure realm of public murals[142] The Delaunays' previously established inclination toward the mural put them in direct sympathy with this philosophy.

The concept of public art, however, posed the problem of seriously considering art which the common people would both appreciate aesthetically and comprehend intellectually. Despite the universal goals of most of the abstract movements, few members of the working class found meaning or took much pleasure in nonobjective images in painting, sculpture, or mural composition. Louis Aragon

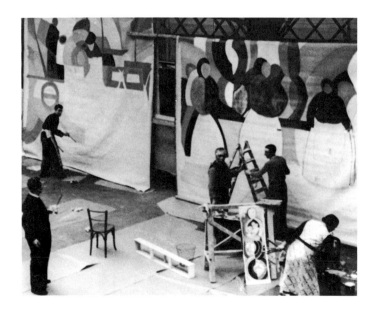

Fig. 36. *Sonia Delaunay (right foreground) and assistants working on a panel of her mural* Portugal *for the Railroad Pavilion at the 1937 Exhibition. Watching (left foreground) is Robert Delaunay.*

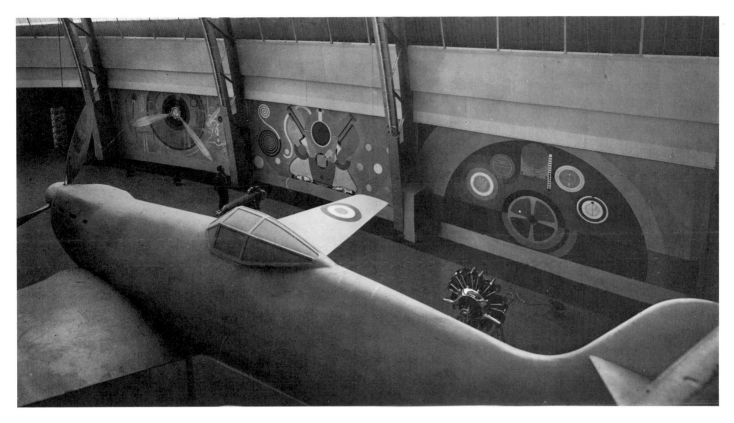

championed a revival of traditional figuration, which could not be misunderstood and which could effectively represent the national spirit of working class France. His "socialist realism" remained at loggerheads with the "new realism" defined by Léger and Le Corbusier — a realism discovered in the interior spirit, sensitive to the everyday objects of the modern world.[143] The beauty and harmony of the machine, the focus of contemporary working life, could provide the inspiration for their future-oriented reality. The mechanical theme of the International Exhibition, and the communal efforts that it necessarily involved, provided an atmosphere in which the "new realism" could flourish. Even firm abstractionists such as Herbin and Valmier produced murals on the theme of mechanical movement.

Robert Delaunay was given a commission for 2,500 square meters of interior and exterior surface to compose for two of the major pavilions, the Air Pavilion and the Railroad Pavilion. The task was enormous, but

one which he accepted with enthusiasm, as did Sonia, whose role in the final plans was far from small. Robert Delaunay had been inspired by the airplane from the time of its invention. He collected numerous postcards of early models, several of which were included in his prewar paintings. In 1913, the young couple had regularly made their way to the airport at Saint-Cloud to watch landings and take-offs in the raking light of the setting sun. Years later, they were present for Lindbergh's arrival in France after the first transatlantic flight. Sonia was the one who suggested to her husband that he should take greater advantage of his interest in aviation by incorporating it into his painting. The result was his famous *Homage to Blériot,* the counterpart to her *Electric Prisms.*

For the 1937 Air Pavilion, Robert proposed a major architectural-sculptural assemblage of concentric three-dimensional loops in simultaneous colors that would fly through the vast open space enclosed by glass that would house the most recent

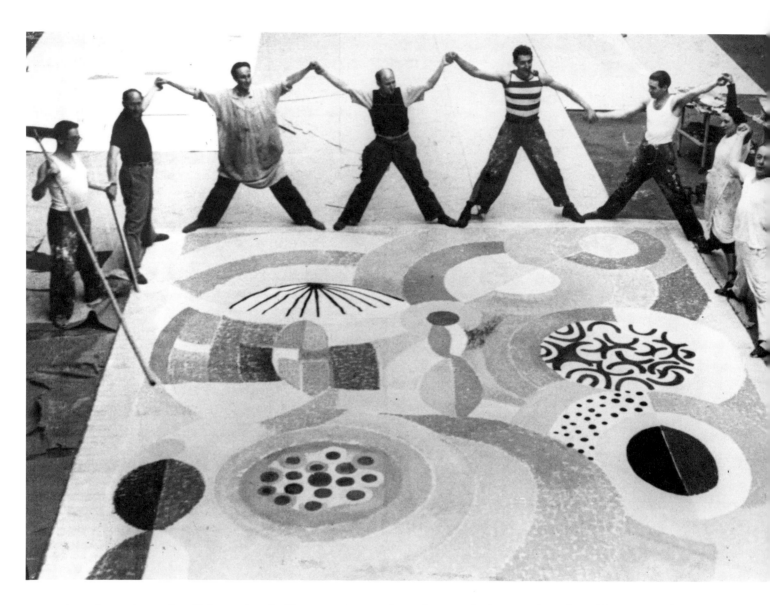

examples of aerodynamic efficiency. Louis Cheronnet
described the effect:

> Walking through the Aeronautical Pavilion we finally
> arrive in a vast hall which resembles the cockpit of an
> over-sized aeroplane ready to soar up into space.
> Within the convex, luminous cockpit one observes
> several planes which seem to float among the spirals
> of a celestial yet half real staircase. How could one
> better express the exaltation of one of Man's latest
> conquests?[144]

Flanking the lower level of this pavilion were
monumental murals created by a variety of artists on
the theme of the airplane and its flight. Sonia produced

three images that were placed next to one another
between the architectural supports of the light-filled
enclosure. All three examined essential parts of the
airplane — the propeller, the motor, and the control
panel. Whether or not her understanding of the
mechanical functioning of the airplane was clear, she
diligently investigated its forms, its movements, and the
connections and rhythms of its component parts.
Once examined, the parts appear to have been
funneled through her imagination, emerging onto the
wall surface in an order of spatial and coloristic activity
having little to do with their actual function. The

Fig. 39. Distant Voyages (Voyages lointains), 1937. *Gouache, 13-1/8 x 36-1/4 (34 x 92). Collection Musée National d'Art Moderne, Paris.*

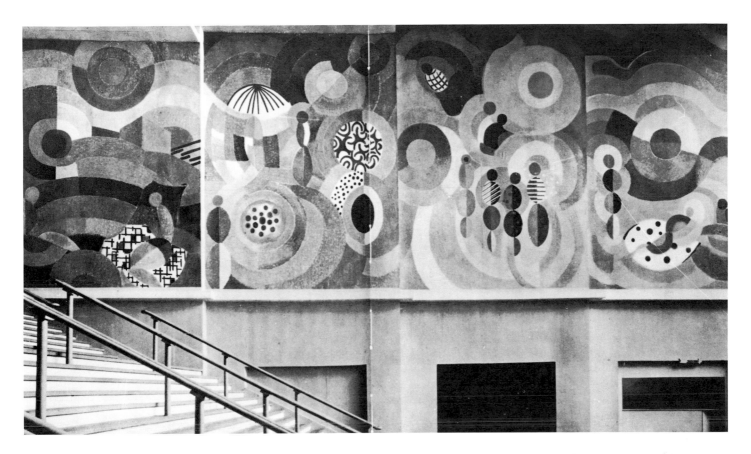

machine, joined to the spirit of the mind, assumed its own artistic life. The results were reminiscent of the carefully considered fantasy machines of Picabia or Max Ernst, with the difference that her visual action was substituted for their intellectual irony. In the gouache design for the airplane motor, one finds the organically developing spirals that would later typify the style of Alexander Calder and which he used in the early 1970s to decorate a Braniff Airlines passenger plane.

Although written in 1920, the poem dedicated to Sonia Delaunay by Isaac de Vando-Villar is too appropriate to ignore in a discussion of the 1937 murals:

> The aeroplane shall bring you in his beak
> the ribbon of the rainbow
> and the immaculate compass-rose.
> Your amphora is filled from the warmth of our gazes.
> The soft tips of your fingers diffuse rays of light,
> puzzles, carnivals and village fairs.

> The green serpentine of your cigarette
> hung from the simultaneist lamp
> like a rattlesnake.
> Your coloured-feather words
> to fill my pillow of memories.
> In the mirror of your face
> Modern art smiles upon us.
> Within the dome of your hat
> tamed aeroplanes shall alight![145]

Sonia Delaunay's art of simultaneous surfaces, which had earlier domesticated the airplane, now celebrated its phenomenal capacities in qualifying the cultural life of its times and indicating the directions of the future.

For the interior of the Railroad Pavilion, Sonia created two murals, entitled *Portugal* and *Distant Voyages* [*Les Voyages lointains*], of even larger proportions. The architecture of this building was designed to resemble a train station, complete with ticket booth, café, and magazine and cigarette stand.

Robert Delaunay's abstract reliefs were applied to interior and exterior surfaces, spanning massive distances and directing the eye toward entrances and exits, which were further enlivened by his figurative frescoes. Monumental stairways poured into the large concourse, whose interior surfaces were illuminated by skylights and elaborated by giant pylons. The volumetric presence of the architectural vocabulary asserted itself in distinctly contrasting cadence against the colors of the Delaunays' murals. Robert's *Air, Iron and Water* accosted the stairway from the opposite end of the hall, while Sonia's sets of interlocking circular rhythms propelled spectators to and from points of arrival and departure for imaginary journeys. The borrowing of motifs between the Delaunays in these projects was open and reciprocal. Decorative angles and triangles entered Robert's compositions as Sonia turned again to circles in continuous patterns of movement, indebted both to her earlier Portuguese creations and to Robert's *Rhythm Without End* series. Louis Cheronnet commented as well on Sonia's contributions:

> Sonia Delaunay for her part, leads us into a wondrous land, among the magical spheres of optical illusion and invisible electrical currents. The idea of the infinitely small and the infinitely big makes us quite dizzy. We are surrounded by a magical play of light diffractions and electrical interferences, of fissions and fusions. A realm of illusion where time can only be a dream....[146]

The mural *Distant Voyages* earned the artist a medal.

To complete this immense task, the Delaunays were assigned a corps of unemployed painters to work under their direction.[147] They rented a large garage near Levallois, and arranged makeshift lodgings in it in order to dedicate the greatest amount of time to the undertaking at hand. A journalist from the newspaper *Petit Parisien* visited the sprawling studio and reported with surprise:

> I cannot explain why I had imagined these workshops of abstract art as mysterious laboratories where reigned a half-light favourable to the creation of obscure and somewhat incomprehensible works. Instead of an alchemist's den, I discovered, in an immense garage and amid makeshift arrangements, an outburst of enthusiasm, of light, of springtime....A

group of young artists — men and women together — were feverishly working to complete the murals intended for the Railways and Aeronautics pavilions. Here, dressed in bright yellow trousers and light brown sweater, Robert Delaunay was busy putting the finishing touches to a folded canvas ready to be sent to the Exhibition — I could only appreciate the freshness and harmony of the tones from the model....There, Sonia Delaunay was completing another canvas for the Railways pavilion — a composition displaying numerous stylized, yet both picturesque and evocative characters....

> It is really quite exceptional to come across such a homogeneous team where each one has sacrificed his own individuality to a single aesthetic inspiration, and gives the best of himself, of his ardour and of his talent to a common work. And it is not to devote themselves to the occult practices of abstract art, as I had secretly hoped, but to celebrate the joy they find in working together, the sincere fellowship which unites them. This, in their view, is "tomorrow's formula," something quite new in social as well as artistic terms, an experiment with worldwide implications, and one which must succeed. They speak with smiling conviction![148]

Despite appearances, the collaboration was not always smooth, neither between artists nor between artists and architects:

> All was not well in our commune. We fired the architect who had used poor materials. And we got on with our work under tremendous difficulties, because there were continuous obstacles created by painters, the *peintres-pompiers* who wanted to prevent the realization of this work. Finally, however, we reached the end of our enterprise.[149]

With these difficulties, the exhibition halls did not open when expected and many visitors missed the spectacle that they presented. Nonetheless, the response after the official opening was overwhelmingly positive. Americans, in particular, were impressed by the assembly of architecture, painting, sculpture and modern engineering. The Delaunays were invited to participate in the next American World's Fair, but the war and the death of Robert prevented the realization of this project.

fter the triumph of 1937 the Delaunays enjoyed a period of exaltation in the acceptance and appreciation of their art. Robert gathered numerous students around him, all of whom met weekly at their apartment, and he began assembling notebooks on the development of his art and his theories. It was a time when both members of the team were able to return calmly to painting and earn a living thereby. Albert Gleizes, a friend from early Cubist days, became a strong proponent of the philosophy of simultaneity and invited them to exhibit in the room which he organized in the 1937 Salon d'Automne. The following year, Orthon Friez was in charge of a section of the Salon des Tuileries, in which all participants were to submit panels measuring five meters by five meters. Sonia's entry, unlike her compositions for the International Exhibition, was totally abstract. Based on the concept developed in the series, *Rhythm Without End,* it presents full disks and semi-disks in an arrangement that gives the impression of being axially aligned, but which manages to tilt, bend and break its primary order, allowing color contrasts and concordances to compensate for the disconcerting effect of its geometry. In the midst of massive swings of concentric arcs, a tiny pattern of diamonds provides a stable horizontal support for the compelling action of blues and oranges, reds and greens, blacks and whites, and occasional intermediaries in the potentials of the palette.

The members of *Abstraction-Création* were reunited in 1939 in an exhibition called the Salon des Réalités Nouvelles, indivisibly allying the concept of "new-realism" with that of nonobjectivity. Fredo Sidès was asked to be president of this new organization, and Nelly van Doesburg to be its secretary. Both were habitués of the Delaunays' numerous social functions. Sonia comments that the formation of this group after the 1937 exhibition marked the end of the "Surrealist racket."[150] The organization assembled for a second salon in 1946, having lost several of its members to illness or to the war. Sonia Delaunay created a poster design for that exhibition in which she listed the movements represented within the group: Abstract Art, Concrete Art, Inobjective Art, Orphism and

Cat. 137. *Design for Poster for Delaunay Aperitif: "A Delaunay is good at all times." (Projet d'affiche pour l'aperitif Delaunay: "Un Delaunay est bon a toute heure"),* c. 1937
No. 5067, gouache, 19-5/16 x 12-5/8 (49 x 32)
Collection Bibliothèque Nationale, Paris

Constructivism. An attitude of acceptance of any style that captured the spirit of modernity typified Sonia Delaunay's interrelations with other artists as much in 1946 as it had in 1922.

Shortly after the completion of the 1937 exhibition projects Robert Delaunay began to show signs of illness. Although this did not effect the activities of his daily life or his plans for the future, by the outbreak of war in 1939 it was clear that he would fare better in a calmer environment and warmer climate than those of Paris. The Delaunays packed up the belongings that would fit into their multi-colored Talbot, and departed for the south. After an initial stay in the Auvergne, they decided to continue on to the Midi where they knew that the Arps, the Magnellis and other artists had already found lodgings. Their arrival has been best described by Alberto Magnelli:

> One day, in Cannes, I was sitting waiting for my wife outside a café just in front of the railway station, when there suddenly appeared a large car packed full of heavy rolls of canvas; who did I see inside it but the Delaunays! We all gestured wildly in greeting. They immediately parked and came to join me at the café to celebrate their arrival and our chance meeting.
> They managed to find a flat at Mougins, and, as we were all staying within a relatively small radius of each other, we had no difficulty in meeting frequently. The first time we went to visit them at Mougins, we were met by the most extraordinary sight. Robert Delaunay had unpacked all his rolls of canvases, comprising works from all periods, and he had literally covered all the walls and even the floors with them. In order to pass from one room to the next, there was no other way but to walk over the paintings. We were somewhat abashed, but Delaunay assured us that it did them no harm at all to walk on them. The effect of this fantastic Delaunay museum was indeed astounding.[151]

Perhaps the lack of proper Delaunay carpeting and the experience of working with paintings on the floor for the 1937 murals contributed to this carefree attitude toward the preservation of the artifacts. Whatever the explanation, it is apparent that the Delaunays were able to continue their work in high spirits despite the war, increasing lack of supplies and Robert's illness.

By 1941, however, the state of Robert's health could not be ignored. In October, the Delaunays departed for a location with better facilities. Robert was hospitalized in Montpellier, where he succumbed to cancer on the twenty-fifth of the month. He was never aware of the seriousness of his illness and continued to make plans for new works of art until the very end. Sonia Delaunay contacted her son Charles, who joined her in Lyons, and the poet Joseph Delteil, who composed an obituary that was published in Paris. With her belongings packed in boxes and bags and deposited in various locations in France, and with no permanent lodging, Sonia Delaunay resolved immediately to bury herself in drawing, an occupation which she knew would restabilize her direction in life during this time of extraordinary confusion. The drawings materialized, but paintings did not. Delteil advised her to return to painting for therapy, but by then a serious decision had become firm and her direction for the next several years established:

> I told him that if I did it, it would be for me because I did not want to be used as a tool to destroy Robert's work. When it has been fully appreciated, there will be time enough to take care of myself. Perhaps now I shall be able to achieve what Robert had demanded from me: to gain the recognition for his work that his exuberant personality had hindered.[152]

She planned a book on the life and work of her husband, for which she would supply the documentation and ask Delteil to write the text. This project was not completed until 1957,[153] and the text was then written by Pierre Francastel, but the concept was a primary concern for fifteen years following Robert's death.

Reading the announcement by Delteil, the Arps contacted Sonia Delaunay and invited her to stay with them in Grasse. They lived in a picturesque villa, surrounded by olive trees, called the Château Folie. She accepted, thankful for the opportunity of interchange with artists whom she respected and for the pleasure of the beautiful countryside. The Magnellis were close by, and with artists Ferdinand Springer and François Stahly, a small community was formed, meeting at various homes and gathering at a favorite

café. In this manner an atmosphere conducive to work was again established. Arp produced sculptures and reliefs, Magnelli a large series of collage canvases, Sophie Taeuber-Arp an important group of paintings, and Sonia Delaunay a collection of small-scale gouaches which continued her experiments in color and form in the quiet manner that characterized her mood. Many works were exchanged between the artists, as there was almost no purchasing public to be found during those difficult times. Several years later the remaining members of this intimate group produced an album of collaboratively created prints in memory of the years in Grasse.

Sonia Delaunay's journal records a typical day in early 1943:

> In the morning I went to the hotel, picked up letters from Switzerland and a visiting card. From there, called the Chenus and the Magnellis after lunch. Then read the newspapers which I brought back, took the cat for an outing in the garden. Then worked. I have three color drawings in the sketch book. Then read Balzac as a break. Afterwards made a resumé of the inventory of my paintings and watercolors in the Big Exercise book and in the Little Notebook. Also worked on that after dinner, until 11 p.m. Then read Balzac again. Listened to the news but could only get Russia and Africa.[154]

The group was soon forced to disperse by the successive occupations of the area by the Italians and the Germans. Sonia decided to remain despite the risks, at which time her concerns for the future of the art works in her care became issues of preservation, and extended to the creations of her friends as well:

> I stayed on in Grasse with my Persian cat, whom I would take everywhere with me in my open shopping bag.
>
> The paintings, luggage that we had left in Mougins, when we had to leave in a hurry because of Robert's illness, I stored in crates and suitcases, keeping only a bare minimum.
>
> After the Arp drama, the death of Sophie in Switzerland, I packed all their belongings.
>
> At the hasty departure of the Magnellis for Paris, I did the same thing with theirs.
>
> I had only one obsession, how to protect the crates of paintings belonging to the three of us from the bombing raids. Some friends had a semi-underground garage. I had everything stored there. We put bags of plaster in front of the boxes.[155]

The works were saved from potential damage and later shipped by truck to Paris.

After the departure of the Arps, Sonia moved to the Grand Hotel in Grasse. From her window she enjoyed a full view of the town and the surrounding countryside and recorded it in sketches meant to render the image as it was seen. They are reminiscent of the structured realism of her student years, but activated by more carefully considered patterns of geometric form. With the German occupation, she was invited to stay at a villa rented by the English owners of the hotel, where she remained until it was possible to return to Paris.

O nce again on Rue Saint Simon, after the war, Sonia Delaunay could continue her life of work surrounded by her library, her works of art, and many friends. Her routine was punctuated by visits to galleries, museums, evenings of poetry and social gatherings. The flavor of the art world, however, had changed. Groups of artists with ideologies similar to hers were not as close and her mood no longer lent itself so frequently to hostessing large gatherings. During the first years after the war, she was occupied with a singular purpose:

> My *raison d'être* is to promote Robert's work which was not fully appreciated during his lifetime.[156]

She spent considerable time talking with gallery owners and potential buyers, disliking the essential considerations of finances that took precedence in that realm over thoughts of creativity in life. Her belief in the validity of the art of simultaneity assumed even stronger proportions during these discouraging years:

> Besides, the invention of the atom bomb and the debates about it prove that life will change in every way and that the potential for destruction is so enormous that it can destroy everything and thus becomes absurd for humanity. All that proves and confirms my faith in a reconstruction full of joy, life advancing toward beauty, clarity and comfort for everyone. There is a lot to do in this area and it could keep humanity busy for years. In this world it is our art of clarity and joy which will triumph.[157]

Memories of the past, preserved in documents, gave her needed support:

> I read the beautiful letters that Robert wrote to me. I had never reread them before. I am surprised how poetic they are, how much he loved me and lived for me. It has been good for me to find all this again because, having suffered a great deal, I had had moments of doubt. Had it not been for the everlasting fights and the money problems, I would have had a very beautiful life. Despite these difficulties, it really was beautiful and I am happy to have lived it and to have maintained it with my patience and constructiveness.[158]

At the end of 1946, Louis Carré presented a major retrospective exhibition of Robert Delaunay's work, which effectively marked his place in history, and which was followed in the next decade by major showings both in Paris and abroad. Thus, Sonia's

Cat. 187. Sonia Delaunay, *Sonia Delaunay,* Six planches, gravées à l'eau-forte avec un texte préliminaire de l'auteur (Milan: Schwartz), 1966
Collection Sonia Delaunay, Paris

ambitions on her late husband's behalf were fulfilled, and by the end of the following year she was prepared to pursue her own work with full devotion:

> On coming home at night, I have been thinking. How to eliminate from my life all those who prevent me from living only for my work. I have a lot of time to catch up with. Having had too much strength, I did not economize enough for the one thing I cherish: painting. Robert was right when he used to tell me that I was too talented and did not work enough. I must catch up and devote my time to that one purpose.[159]

She had already returned to oils and to large formats, employing a varied palette of subtle hues that adjusted and readjusted the geometric schema of broken and interlocking disks. After 1948, she began dramatic new experiments in the interconnection of color and form. Black dominates her famous *Colored Rhythm No. 616 (Rythme coloré No. 616)* of this year, in strong contrast to the subtleties of 1946, the oranges of 1938, or the clash of primaries typifying numerous other periods.[160] Forms float in space, or are cut with disturbing angles or distributed with compelling irregularity, but all are connected by invisible tensions.

Both the irregularities and the tensions increase in her paintings of the 1950s. Checkerboards break into circles, angles cut across squares, dark greens play against brilliant yellows, blues and reds against blacks and whites. Expectations are confounded by the surprise of new elements, confronting one another in continuing oppositions, agreements violently disrupted and disagreements passionately resolved. The unity of the composition perseveres regardless. It is a unity of rhythmic interchange, comparable to that produced in the writings of her favorite poets.

As the years passed, her love for poetry deepened and her ability to discern good from bad became more refined.

> I got out the book of Arp's poems which I much prefer to Eluard's. Eluard is too descriptive and lacks rhythm. I feel this very clearly — it is all in the rhythm. Robert used to say it about painting. I already knew that and it is the same thing that pleases me in poetry: the musicality of the rhythm and words. It is the same thing with music. When I fumble with the radio, I am attracted by rhythm and I shun the descriptive.[161]

Although her opinions were firm concerning the state of the art, she remained open to new possibilities until her death. She described an evening in 1949:

> Listened to the UNESCO Festival of Poetry. Breton very surrealistic, resembles their painting. I prefer Lautréamont. From Eluard, a poem not as dusty as Breton, clearer structurally but ordinary. From Aragon *La Rose et le Réseda*. God knows I don't like Aragon and his attitude to life, but this poem is so French in its construction, classical as well as modern, that I was struck with wonder, it was the most remarkable of the evening. I truly enjoy listening to it again. After, there was Prévert — nil for me, Claudel — it sounded good but it was shallow, Saint-John-Perse too dense and alien to our time. There was an unknown poet at the beginning, considered by the commentator to be the poet of the future — zero — communistic....During Valéry I fell asleep. What was true with Mallarmé is wrong with Valéry.[162]

Her favorites remained the friends of her younger days, Cendrars, Tzara and those mysterious figures, the Symbolists, whose words had made their way into conversations during her childhood in St. Petersburg. As late as 1973 she published an album of pochoir prints to accompany several of Rimbaud's poems from the series *Les Illuminations*. Even in translation, Rimbaud's use of contrast, surprise, contradiction, agreement, and rhythm come through clearly:

> Children's laughter, discretion of slaves, austerity of virgins, horror of the faces and objects of this place, hallowed be you by the memory of this vigil. It began with all boorishness, behold it ends with angels of flame and ice.[163]

Rimbaud's words become Delaunay's colors, his imagery her forms, and his syntax her compositions, filled with problems that can only be resolved in the imagination, understanding that remains personal to the reader or the viewer. The confrontation with the unknown, which is the confrontation with the self, remains fundamental:

> ...I liked reading in English because some words escape me and that allows my imagination to create pictures. I am bored when I read in a language I completely understand. In painting also, I am capable of technical expression but I would like to achieve more humanity. That is what I am looking for.[164]

Inspiration for creativity emerges from such experiences.

In January of 1960 Sonia Delaunay again reconsidered the direction of her work:

> I took my canvases out to see what to give to the museum. Nothing satisfies me; I find all the last canvases incomplete. One should be able to work like in Portugal, blending into the canvas, but the awakenings are hard, life does not permit it. Decided to make a canvas from an old gouache and to put two gouaches together so that they could hold their own with the rest![165]

Returning to a previous style for revitalization, her palette suddenly assumed the bright, pure colors of a gayer, more carefree time. The compositions from the 1960s, nonetheless, exhibit the daring and technical control gained by her further years of experience. As inspiration returned, the scale of the canvases increased to monumental proportions. At the age of eighty-two, she could be found working on canvases over eight feet in length or seven feet in diameter. It was during this time of renewed public appreciation, with several touring retrospective exhibitions of work by both Delaunays, that her painting inspired its own flamboyant renaissance.

Inspiration came as well from collaboration with another poet. A friendship developed some time in the early 1960s between Sonia Delaunay and Jacques Damase. She soon discovered in him an appreciation of life and art that ran parallel to her own:

> Jacques' great sensitivity matches mine and there we agree. I have yet to find it anywhere else and I have missed it all my life. This slightly cerebral hypersensitivity translates into painting within me. I told him that it was this hypersensitivity which made me feel close to him, that there is a spiritual pleasure which spurs one on to creation and the rest to emptiness and destruction, so..[166]

In 1966 they published a collaborative album of poetry and prints; the poetry of Damase is a response to Sonia Delaunay's art of a new epoch, which still sought to fulfill the goals she established before the First World War:

> MAGIC of the sign, of form,
> magic of rhythm.
> ETERNAL MARK OF THE PRESENT.
> "A work of art is required
> both to conceal and reveal
> at one and the same time
> the presence of its creator."
> All the interest lies in the
> REVELATION.
>
> ALL
> great works
> are static, simple,
> mysterious,
> profoundly, incalculably
> EVOCATIVE, even when
> their external appearance seems
> limited to the present day.
> STATICS is the BALANCE
> of forces. The emotional
> power which emanates from
> this balance of values is the
> DYNAMICS
> of all art![167]

The decade was full of other albums as well, some with appreciative texts, some with collaborative poetry, and, in 1970, a group of etchings in dark, quiet hues presented under the title *Avec Moi-Même (With Myself).*

Damase has been particularly active in the promotion of Sonia Delaunay's work during the last two decades. Through his galleries and his publications, considerable numbers of images from the past and the present have been made available to the public at small expense. His support was parallel to that of several museum and gallery directors. Works by Sonia Delaunay have been exhibited in Paris, Lisbon, Milan, Geneva, Zurich, London, and several cities in Canada and the United States. There have been several major retrospectives. The decade of the 1970s ended with a large showing in Tokyo, and the 1980s begin with the present exhibition in America.

In her last years the work continued to expand. Inspired by the high quality of Gobelin tapestry production, she returned to designs for soft textures. Both Gobelin and Aubusson have woven numbers of her creations on a scale rivaling that of her earlier

Middle row, left: Cat. 171. *Drawing to my Friends the Poets (Dessin à mes amis poètes),* 1976
No. 2067, ink, 7-5/16 x 5-5/16 (18.5 x 13.5)
Collection Sonia Delaunay, Paris

Center: Cat. 172. *Drawing (Dessin),* 1977
No. 2063, ink, 7-5/16 x 5-1/8 (18.5 x 13)
Collection Sonia Delaunay, Paris

Right: Cat. 164. *Drawing (Dessin),* c. 1970
No. 1478, ink, 7-7/8 x 5-1/2 (20 x 14)
Collection Sonia Delaunay, Paris

Bottom: Cat. 170. *Drawing (Dessin),* 1976
No. 2074, crayon on card, 8-11/16 x 8-1/4 (22 x 21)
Collection Sonia Delaunay, Paris

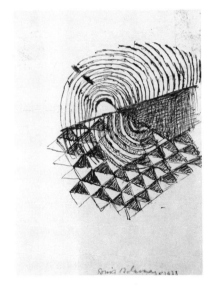

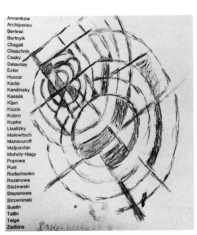

murals. Carpets, mosaics, and ceramic plates complemented the development of prints and books. She received commissions for stained glass windows and even one for the exterior design of a sports car — a Matra B 530 — appropriate to her continuing enthusiasm for the speed and excitement of modern life. A style that struck a contemporary chord once again achieved full appreciation.

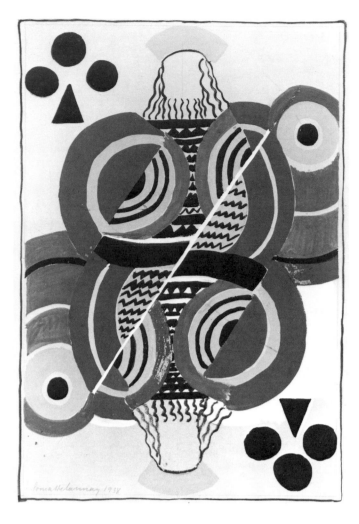

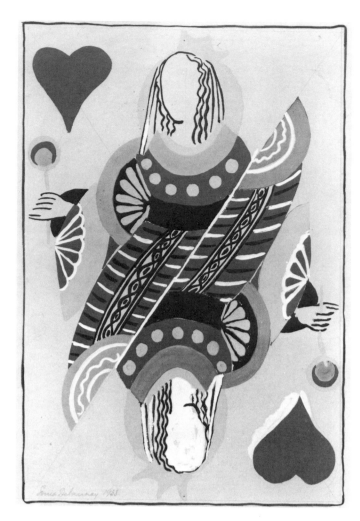

Even in the difficult years after the Second World War, there was a segment of the population that continued to react to her art with the naive and immediate delight for which purpose it was created:

> I especially like young people and I get a response from them.[168]

Youngsters still revel in the gaiety of the colors, comprehending the poetry that they evoke through unhampered intuition. For their benefit, she produced an alphabet of colors, as a series of prints and as a book, accompanied by the poetry of Damase. The publication is a favorite among adults as well. The play-world of color and form, encompassing feelings and thoughts, language and love, is as present in an alphabet as in an oil painting. For more complex minds, however, she applied the elaborate and fluctuating rules of her own games to the traditional format of a deck of playing cards, a project that interested her as early as 1938.

Until her death in December, 1979 Sonia Delaunay's studio was still filled with visitors. Few were invited to leave their mark on the walls, but all emerged with a smile on their lips. Sonia Delaunay's enthusiasm for life and for art permeated her surroundings, the home of a "revolutionary and a conservator," who is still guided by the necessities of her inner being:

> I have never confided to anyone what I tell myself…this language of the private self. My diary is, in a way, the companion of my inner life. At the heart of my research, as in my work concerning fashion, show business and decorative art, I have always had to progress alone.[169]

Alone but surrounded by people, she inspired yet a new generation. Past and present met and agreed, prophesying the future of a philosophy and a style that surpassed even the expectations of its own creator:

> The authenticity of a work is in the contribution of a new creation expressing almost organically the personality of the creator.
>
> Freedom in the artistic domain is independence from all subjection to an order different from the creative purpose determined by the artist.[170]

Artistic liberty was Sonia Delaunay's complementary offering to the eternal quality of vital existence.

Far left: Cat. 140. *First Design for King of Clubs (Premier projet pour le roi de trèfle)*, 1938
No. 628, gouache, 25-1/8 x 19-1/8 (63.7 x 48.5)

Left: Cat. 141. *First Design for Queen of Hearts (Premier projet pour la reine de coeur)*, 1938
No. 629, gouache, 25-1/8 x 19-1/8 (63.7 x 48.5)

Both collection Kunsthalle, Bielefeld, West Germany

Top: Fig. 40. *Matra B. 530, 1967, decorated by Sonia Delaunay.*

Bottom, left: Cat. 151. *King of Spades Design for Playing Cards (Roi de pique. Projet pour jeu de cartes)*, 1960
No. 1067F, gouache 7-3/16 x 4-15/16 (18.3 x 12.5)
Collection Sonia Delaunay, Paris

Bottom, right: Cat. 190. Sonia Delaunay, *Avec moi-même*, (Paris: Editions Société Internationale d'Art XXe Siecle), 1970
Collection Sonia Delaunay, Paris

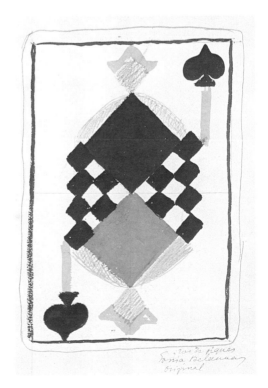

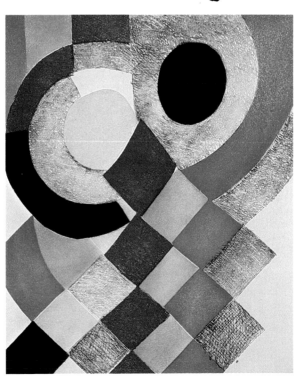

Clockwise (from top): Cat. 216. *Circular Rhythms,* 1977
Cat. 224. *Signal,* 1977
Cat. 227. *Carnival,* 1978
Limoges porcelain plates, issued by Artcurial, Paris

Cat. 230. *Yellow Dancer,* 1978
Cat. 226. *Windsor,* 1977
Limoges porcelain plates
Issued by Artcurial, Paris

Cat. 210. Plate, 1969
Cat. 211. Plate, 1969
Issued by Jacques Damase, Paris
Collection Tamar J. Cohen, New York

Center: Cat. 229. *Venise,* 1978
Limoges porcelain vase
Issued by Artcurial, Paris

Bottom, left: Cat. 217. *Claridge,* 1977
281/900
fabric place mats, 13-3/4 x 17-3/4 (35 x 45)
Issued by Artcurial, Paris

Bottom, right: Cat. 223. *Signal,* 1977
252/900
tablecloth, 55-1/4 x 55-1/4 (140 x 140)
Issued by Artcurial, Paris

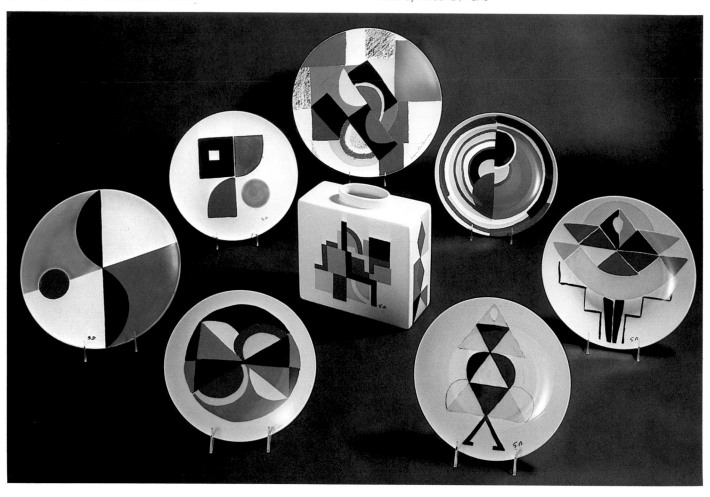

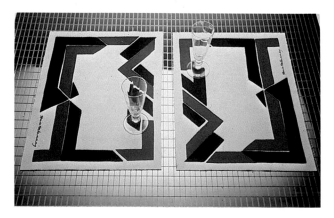

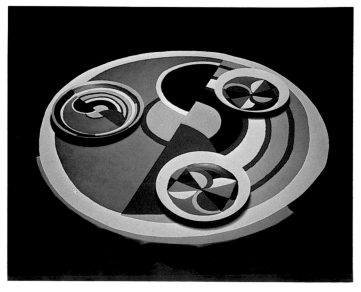

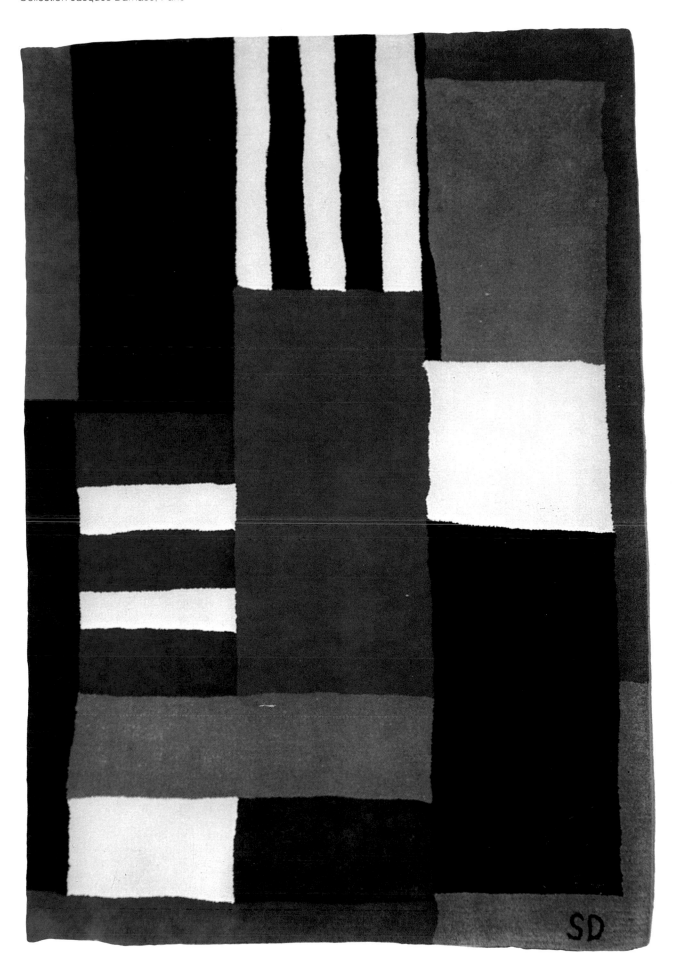

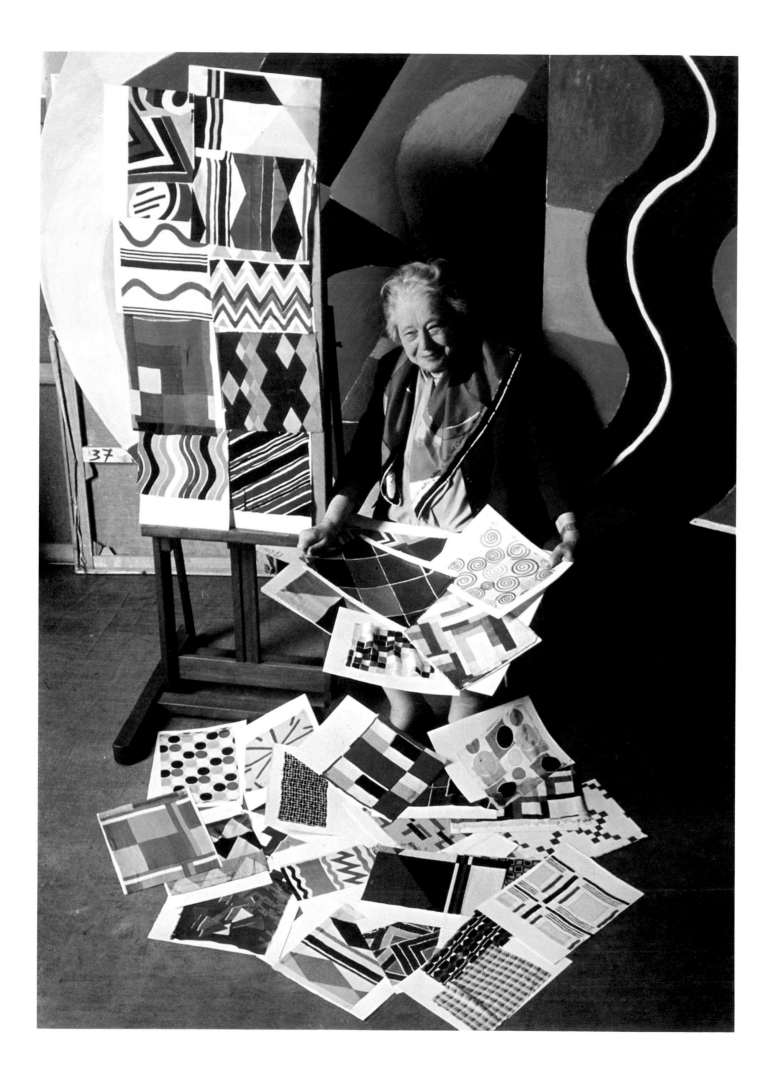

AN ART OF UNEXPECTED CONTRASTS
BY SHERRY A. BUCKBERROUGH

"Upon awakening, the Delaunays talk painting."
Apollinaire wasn't exaggerating; he could have
added: they breathe, live painting and he could have
even said they paint on their bed sheets. It was
true. We loved each other in art as other couples are
united in faith, in crime, in alcohol, in political
ambition. The passion of painting was our main tie. It
was mingled with the love of life!

T heir love of life and their love of art intertwined in an
everchanging pattern that by its very complexity
excited new inspirations and new insights. This state
of being produced the creative impulse that ruled the
Delaunay house for almost seventy years. It was the
basis of the love and marriage of Sonia Terk and
Robert Delaunay in 1910, and it was the source of
emotional and spiritual support for Sonia Delaunay
after the death of her husband in 1941. Until the day
of her death at age ninety-four she inhabited the same
apartment and studio in Paris that she and Robert
had occupied in the 1930s. She worked with the same
pigments and enjoyed the same resplendent
sunlight of the Ile de France, streaming through tall
walls of glass and softened as it slipped past towers
of meandering philodendron. She continued to create.
Some of her most brilliant works in oil, gouache,
lithography, ceramic and tapestry were produced
within the past twenty years. Her palette turned
toward mixtures of brilliant orange, yellow, pink and
purple, interspersed with her more frequent blues,
reds, greens, whites and blacks. The carefully
balanced combinations of color recreate the
enlivening energy of the sunlight that flowed through
her studio.

In my most recent research, I have had the feeling of
being very close to touching what Robert had felt
and what was the "solar source" of his work. I still
stumble over obstacles....But I am sure that there
is, behind it all, something fundamental, which will be
the basis of painting of the future.
The sun rises at midnight?

These are the closing lines of her recently
published autobiography entitled, appropriately, *Nous
Irons Jusqu'au Soleil* (*We Will Go all the Way to the*

Fig. 42. *Sonia Delaunay draped in a scarf of her own design.*

Left: Fig. 41. *Delaunay with a selection of her fabric designs, c. 1970.*

Sun). It would be wrong to interpret this passage as meaning that Sonia Delaunay was a "late-bloomer." One need only glance at the works of her formative years, the earliest dating from 1901, to recognize innate talent and competent training, giving substance to individual invention. Her first solo exhibition in Paris was in 1908 when she was just twenty-three. By 1910, her works had been seen in Germany, Russia, Portugal, Sweden, Norway and the United States. In the 1920s her textile and fashion designs were sold throughout Europe and America, and dramatically affected the style of contemporary design in each of the countries where they were imported. She was acclaimed by both the commercial world and the artistic avant-garde. Her reputation was widespread. After that time, however, her accomplishments were largely overlooked. It is only in recent years that her name has again become well-known and the significance of her art established.

> There is really a flagrant injustice toward us two. I was classified in the decorative arts and they didn't want to admit me as a fully fledged painter[3]

In the 1930s and 1940s, the role that Robert Delaunay had played in the emergence of modern art in the 20th century was generally ignored, overshadowed by the enormous fame of Picasso, of Braque, and some of the Surrealists. Upon Robert's death, Sonia Delaunay resolved to dedicate her life to the establishment of his place among those luminaries by organizing his paintings and his notebooks and encouraging the rising interest of museum directors and historians in his work. In 1946, the Galerie Louis Carré hung a major retrospective exhibition of Robert Delaunay's paintings, and Sonia at last relaxed her campaign on his behalf. She began, at age sixty-one, to consider both the depths of her own potential and her own right to recognition for past creations.

Sonia Delaunay's work has posed difficult problems for traditional critics who, accepting the model of such artists as Robert Delaunay, have assumed that serious art of the early modern era was found only in painting or sculpture, and that it was necessarily supported by copious theorizing. Sonia Delaunay never ceased to paint, but she explored just as significantly all forms of fashion, textile and interior design. For a female painter of that epoch, an interest in such realms of creation easily left the door open for both the art establishment and textbooks of art history to label her a "decorative artist" — one who is not really concerned with the metaphysical problems that serious art struggles to encompass. Furthermore, Sonia Delaunay has provided very little theory that could elucidate a metaphysical purpose. The writings which were published prior to the last two years were either semi-poetic statements concerning the process of creation and the magic of art or short essays in which the theory of simultaneity, stated originally by her husband, was applied to various functional media. She deferred to Robert in the realm of theory, which raised questions for many years concerning the originality of her own work.

Nous Irons Jusqu'au Soleil is composed primarily of extracts from the journals that she kept daily from 1902 to 1906 and 1933 to 1970. In them she recorded the events of her life in detail and her thoughts and feelings about people and ideas. Reading through this year by year account, one is struck above all by the depth of her dedication to two interconnected loves — her husband and her art.

> I have a crazy desire to work and I must do it even if it shortens my life. I love creation more than life, and I must express myself before disappearing[4]

The need to create extended itself to all aspects of her environment. The art of the Delaunays was an art of pure color, experienced in the light of the sun, evoking both the rhythms of the universe and the vibrations of the inner soul. The constructive power of color was discovered in the years just prior to the First World War. Sonia Delaunay described the effect of this revelation:

> 12, 13, 14, what rich and explosive years for Robert and me! Robert was prophesying and could not

be stopped. Before the outbreak of the war, Robert had been shooting off rockets in all directions — Back on earth I had gathered the falling sparks of the fireworks. I tended the more intimate and transient fires of everyday life, while silently continuing the important work. Robert was already dreaming of large-scale works, collaborations between painter and architect. He was aiming at monumentality and I stood behind him, also loving the vastness of it. In the sky we had rediscovered the moving principle of any work of art: the light, the movement of color. In neglecting it, the cubists, like surrealists later on, dried, disincarnated and stiffened everything. That "unreasonable, absurd, lyric" element, necessary for human creations, is the sensual song of color. We celebrated it on the roofs and walls of the city; I wanted to see it everywhere, not to leave it by going out of the studio; it has its place everywhere, in every circumstance of life. It makes homes habitable, bodies alive, mysterious or truly naked; it can be the jacket of a book, the surface of objects, the harlequin driving away ugliness, the sadness and the sclerosis of all academies, of all schools, of all barracks, all the prisons of the world where poetry is locked up[5]

The movement of color was the gaiety and the glory of life, but also its depth and its mystery. It was a means of liberation from the pettiness and emptiness of everyday existence, a means of transformation, of elevation of the spirit.

> Talked…of those sciences of man, of those wise men of India who spread their beliefs in Europe. They want to transform mankind above everything else, and that is exactly my idea. One cannot go further as long as man isn't changed within[6]

The assumption that art can actually change mankind implies that art is imbued with a certain kind of power and magic. Both its creation and its contemplation are fundamentally mystical activities. Sonia Delaunay's mysticism, like that of her contemporaries Kandinsky, Jawlensky, Malevitch and Chagall, can be traced back to her Russian origins. The icons that she adored as a child, for their beauty rather than their religious significance, evoked, nonetheless, the transcendental mood which she strove thereafter to recapture. The history of Russian art is dominated by such images, which are almost totally two-dimensional, intense in their coloration, and animated by an expressive play of line and form. Despite the flourishing of western illusionistic techniques in the 18th and 19th centuries, the icons remained the most venerated form of Russian artistry.

If Russians may be more inclined than westerners to seek spiritual transformation in art, the purpose of that transformation remains elusive when the art object is abstract and there is no common symbolism. This problem precipitated the reams of theory that accompanied most early 20th-century abstract art. Sonia Delaunay's art requires an explanation to clarify its purpose. The complete explanation comes only by combing the notes and essays left by her husband, Robert.

Although Robert Delaunay's writings have been organized and edited, and even translated into English, they create problematic reading. He chooses certain key words to express complicated ideas and reiterates them frequently. The words, however, are often ambiguous in their inherent meanings, in their context within the theories, or in relation to the works of art. This ambiguity is so consistent that it sems to have been an essential element in the ideology of both the Delaunays. In Robert's art we are confused by such terms as "simultaneity," "craft," "languages," "rhythm," and "descriptive." These words apply to Sonia Delaunay's art as well, where they are further complicated by her own comments concerning the importance of "play" and of "poetry," and her critics' description of her work as "decorative." Before grasping her purpose on an intellectual level, one must work through the issues that these terms provoke.

The word "simultaneity" became almost synonymous with the name Delaunay even before the First World War. It was used as well by the Futurists — in particular, the poet Henri Barzun and poet-critic Guillaume Apollinaire — with the result that the origin and meaning of the word were disputed throughout western Europe. Generally speaking, it referred to the excitement and dynamism of the

modern era. With the invention of time-saving and space-conquering machines, with the influx of strange and exotic cultures into Europe, with new languages, new images, new sensations of touch and sight, and, above all, with new life-styles based on action and speed, it became apparent to Robert Delaunay in particular that the complexities of life were not sequential but were all present within the instant.

Sonia was the first to comprehend the significance of this idea, that only by accepting the activity of the world as simultaneous could one experience the fullness of life and define one's own role within it. Only by employing a simultaneous form of expression could art stimulate this realization. The Delaunays found that color provided the means in the form of its simultaneous contrasts. Colors are the constituent components of light, which clarifies our understanding of reality. Simultaneous contrasts are a part of that process of clarification. The activity of colors in combination transforms them from separate entities, experienced successively, into pulsating unities whose structure disallows separation in either time or space. The experience of this activity, which is visual energy, could actually reveal the concept of simultaneity to the viewer. The profundity of the revelation, experienced at its fullest, could transform man's conception of reality and himself. Blaise Cendrars, a poet with whom Sonia Delaunay felt a strong sympathy and with whom she collaborated on the first "simultaneous book," assessed the significance of the concept of simultaneity in the following way:

> The word "simultaneous" is a term of the trade, like "reinforced concrete" in building, like "sublimated" in medicine. Delaunay uses it when he works with tower, door, house, man, woman, toy, eye, window, book, when he is in Paris, New York, Moscow, in bed, or in the air. The "simultaneous" is a technique. The technique works the primary material, universal material, the world?[7]

"A term of the trade" — within this statement the term "trade" becomes as problematic as the term "simultaneity." In French it is *métier,* which means "trade," but also "profession," "vocation," or "craft."

The fact that the word has so many implications is probably why it appealed so greatly to Robert Delaunay. He used the word as frequently in his theories as he used any given color in his paintings, and at times he tied it down to more specific interpretations:

> For painting is a craft *(métier),* a manual craft *(métier)*[8]

Sonia Delaunay clearly agreed with him:

> Art is a craft like any other and one must work that way without bothering oneself about exterior contingencies[9]

When *métier* is interpreted as "craft" it becomes particularly pertinent and difficult to define in relation to Sonia Delaunay's art which falls frequently into the realms of traditional crafts. Robert insisted on the need for a craftsmanly approach to the art of painting. Sonia approached some of the traditional crafts with a similar attitude. How then is one to classify her creations? Like many artists of the 1970s, she stretched the boundaries of both the terms "art" and "craft." Her purpose, however, was not to render the concepts useless, but, like her husband, to present them as simultaneous.

The concept of craft usually presupposes that a certain material, already existent in some tangible form, is worked upon by a craftsperson with a set of technical skills and transformed into another tangible product. The form of the final product is preconceived before the physical material is worked. It is assumed that the product will serve some functional purpose and probably have a marketable value. When one attempts to apply this concept to Sonia Delaunay's art, the discrepancies are immediately apparent. The sheer quantity of materials with which she worked is enough to exhaust the talents of any true craftsperson. She explored materials wherever they could be found — curtains and mattress covers included — less for the sake of producing a curtain or mattress cover than for the sake of "materializing" the simultaneous image.

Robert Delaunay insists that the artist must

consider "...the role of the material,...the direction one should give to the material."[10] His concept of material extends, however, beyond the realms of oil and canvas. It includes color, form, and as Cendrars informed us, the entire visible world. Everything that could be perceived with the eyes became for the Delaunays the raw material that could then be transformed by the artist through his or her craft. Thus we find that the important aspect of the term "craft" in the Delaunays' work is that of technical skill, the process by which the world is transformed. That technical skill, which the Delaunays refer to as their *moyens,* is both very simple and very complicated.[11] It is simple in that it is merely the recreation of the visual sensations of the world into rhythmic contrasts of colors. It is complicated in that it requires a consciousness of these rhythms, both in the world being perceived and in the work of art being created.

The sense of sight was the physical route for metaphysical understanding in the Delaunays' philosophy. Impressions converge upon the eye in undifferentiated simultaneity and succession. In the process of perception one distinguishes separate features among these impressions, at which point one can speak of specific sensations — sensations of light which, when distinguished further, are actually sensations of colors in movement. The colors are in movement because impressions, by their very nature, are fleeting. The perception of these colors is necessarily a synthesis in the mind. By making the realization that what is perceived cannot be separated from the process of perception, one distinguishes oneself from one's surroundings — one becomes conscious both of the self and of the world.

The world is not stable. It moves with the energy of universal forces. The self moves with the energy of ideas and emotions. Colors on canvas, or on any other surface, move with the energy which they generate in their contrasts. This energy takes the form of vibrations that have certain rhythms. The technique of painting requires the ability to distinguish the rhythms of the world, which are revealed

through visual perception, and to express these rhythms through color contrasts. Robert Delaunay complained that this is what many people "forget or to which they remain insensible: life, observation, vision, eye, evolve and the only evolution in painting is that of craft, which renews itself in balance with our faculties."[12] Thus, the technical skill of the Delaunays' craft was far more than physical work on a tangible object. It necessitated an expansion of consciousness, both in its sensory and intellectual realms.

The technical process was the same for Sonia Delaunay when approaching a canvas or when creating a costume design, a new piece of furniture, a scarf or a book cover. Each of these items served a practical purpose, and many were clearly marketable. Sonia's designs for textiles and fashions supported the couple throughout the decade of the 1920s. In the early 1930s, the economic situation in France was such that she was faced with the decision of lowering the quality of her products in order to make a profit. Unwilling to make such a compromise in a product which she considered to be art, she closed her business and returned to painting. There was no hierarchy in her mind concerning either the function or the marketable value of the end product. The process of creation took precedence over both.

Sonia Delaunay's entry into the textile and fashion industry was the eventual and practical result of her activities during the first years of marriage when homemaking was an important aspect of her life. With a new apartment and studio, with a new husband whose nature was totally impractical and with a new baby, the years 1911, 1912, 1913, were filled with household obligations. Surprisingly, these were not impositions on her artistic spirit. She integrated the realms of home and art without questioning the distinction. An appliquéd quilt for her son Charles, brightly colored dresses for herself, cushions for the sofa and covers for best-loved books — "I do all that to entertain myself...color excites me, I am not aware of what I'm doing."[13]

She admitted freely that while Robert was breaking through Cubism and experimenting with the principles of simultaneity, she remained in the background. This temporary removal from "professional competition" gave her the freedom to play — with her home, her dress, various materials, and, above all, colors.

> We lived like children. We had a regular income and we played at life like others play with dolls.[14]

Having sufficient money before the First World War to live without "working," both Sonia and Robert Delaunay were able to spend as much time as they wished at their art. Art-making and art-talk absorbed almost every hour of the day.

As a child Sonia Terk was raised in an extremely stable bourgeois home, a serious milieu which did not suit her nature. She spent her days escaping into dreams and fantasies. In Paris and with Robert, she found and relished the opportunity to transpose the "extraordinary" mood of her fantasies and dreams into the realities of daily existence. Her husband taught her how to do it. What Sonia loved in him was his propensity for ignoring the pragmatic concerns of everyday existence and treating the world as stimulus for creation. Even in the face of serious financial dilemmas, when Robert's crazy business sense was no help to their income, she admired and respected his ability to play with life. She also admired the seriousness with which he approached his painting.

Johan Huizinga has described play as being fundamentally an activity of the mind, for it has far less to do with matter than with images and their manipulation.[15] It is this quality which allows play, like fantasies and dreams, to create an "extraordinary" world existing parallel to real life. This "make-believe" world is limited in time and space, having a time for beginning and a time for ending and material or ideal boundaries which mark its place. The activity that evolves within these limits is movement composed of change, alternation, succession, association, and separation. As Huizinga observes, this description of play does not easily allow the term to apply to the process of creativity in the plastic arts. The fact that art objects are bound by matter and form forbids them absolute free play.[16] In considering traditional art forms of the nineteenth century, one must admit that Huizinga is essentially correct. It was precisely those static creations, however, that Sonia Delaunay was striving to replace with art that "moves," that creates its own visible action and thus transcends the traditional limitations of matter and form. Some would argue that this can only be accomplished through kinetic art. The Delaunays argued that it was in fact more profound in its effect through the employment of color. When movement is produced by color, the art object expresses the process of its own creation.

Huizinga makes the further point that however playful the plastic artist's creative impulse might be, because he is concerned with physical matter, he must in the end work like a craftsman, "seriously and intently, always testing and correcting himself."[17] Robert Delaunay would have agreed with him. Painting is a craft which is absolutely serious. Sonia's attitude toward painting was equally serious, but her attitude toward artistic creation in general was playful, and in her early years the playfulness emerged more directly when she worked in other media. Robert noticed the freedom that she exhibited in her non-oil, non-canvas objects and remarked on the fact that it released her innate instinct for color. The purity of her color sense left him somewhat in awe. By exploring other media she was better able to break through the restrictions of line and form which she had been trained to consider primary in the craft of painting.

Even in reference to painting, Sonia Delaunay quipped: "If you play at something, you don't think why you do it."[18] We tend to think of play as diametrically opposed to seriousness. Actually the line between them is never clear. By her insistence on the integration of life and art, Sonia Delaunay grasped the concept that creativity necessitates a flexible flow between playful and serious intentions. Eventually she was able to equalize the process of her approach in

all media, but the equalization took time and thoughtful energy.

Intuitive rules of color, geometry and rhythm guided the form of Sonia Delaunay's play on every object that she approached — lampshades and jewelry boxes included. As with an absorbing game, these limitations provided the challenge against which she pitted her mind. When the desire to win the game is strong enough, the play becomes very serious. The compelling quality of the play of simultaneous colors brought Sonia Delaunay to an awareness of this seriousness during the early years of the First World War while the couple was living in Portugal. The light and the colors of that region inspired her to begin making "studies" after nature according to the rules of her prior adventures in color. Free play was heightened and refined to become inquiry and experimentation. All of these "studies" centered around concerns of painting. She still considered the decorative arts a freer realm.

Sonia Delaunay's income had come from an apartment building in St. Petersburg. The Russian Revolution of 1917 eliminated that resource and left the couple penniless. Given the sudden importance of having to make a living, Sonia decided to turn her escapades in the decorative arts toward a profitable end. This meant quite simply that the rules which guided her creative process became more strictly defined and the seriousness of her color studies was enhanced by commissions for work. She later described the importance of this period in her art:

> In 1923, I was commissioned by a fabric house in Lyons to design some textiles. I made fifty designs — colored patterns with geometric forms, pure rhythms. For me they were and remained color scales, which were ultimately the purified conception underlying our painting. My studies were completely pictorial, and, from a plastic point of view, a discovery that helped both of us in our painting...
> Having passed through this stage of inquiry which was never theoretical but based solely on my own sensibility, I acquired a freedom of expression that can be found everywhere in my recent work, in all the gouaches, which are expressions of states of soul;...[19]

When she returned to painting, it was with a new ease. The freedom of creativity which had always marked her approach to her home and her dress was maintained even when painting. Play and seriousness were thoroughly integrated and comfortably resolved. As she says:

> The game is included in the work as technique, but if it provokes a raise of visual attention, a concentration to win, to succeed, to touch, to shift, to throw, to pull, it also provokes a shifting of attention and reflection toward carelessness, and of the effort toward release.[20]

Jacques Damase, a poet, gallery owner, and good friend of Sonia Delaunay's, has offered an intimate view of her working method in recent years:

> I had the good fortune to see these "syncopated rhythms" born, to follow them from the small gouaches with which the artist sometimes helps herself, from the first sketch in charcoal, a sort of first skeleton. I saw the first colors, the first marks, present themselves.
> Sometimes Sonia Delaunay doesn't know right away how to resolve her equations and she searches with tenacity, with calm or with rage. Sometimes, to give another scenario, the picture becomes a battle. There are hostile camps, an enemy that will be a too tenacious yellow or green. Sometimes the painting becomes a game of checkers: if one moves a piece, a color, everything is again questionable. It is a fascinating story to follow[21]

The battleground of the canvas absorbed her completely, and it was a battle which she inevitably won. She won by imposing an order on the chaotic energies of color and form, but an order which recorded the tensions of the battle. Without those tensions, carefully balanced, engendering movement through their varieties and contrasts, the painting would not live. It would not express the creativity of life, which emerges from the soul. It would not be art.

Sonia Delaunay had a clear understanding of what art is, though she found it difficult to define the art that she created:

> The authentic work of art is the expression of interior life, it is the poetry of the Creator[22]

> I don't know how to define my painting.
> That's not a bad thing, since I mistrust
> classifications and systems. How and why
> define that which comes directly from the guts?[23]

The problem arose in the fact that each work of art was different. Each had its own inspirations, its own development in the imagination and in materials, and its own quality of expression. Nonetheless, one recognizes a Sonia Delaunay painting at a glance. Despite their differences, each work communicates through a consistent language — the language of color.

> Color became for us a vital means of expression,
> like speech. We play with colors as with a new
> means of expression[24]

Throughout Robert Delaunay's writings one finds discussions of the need to develop a language of art which is pure — pure in the sense that it is free from cliché, free from description, and direct in its ability to express. The new language of color is the activity of the craft, the *métier* of simultaneity. As such, it is more than a simple tool. It is a means of expression that develops in the process of creation.

R. G. Collingwood, writing in the 1930s when abstract art dominated the avant-garde, proposed that the essence of artistic creativity is the creation of language, which is never a tool but a pure activity[25] His theories explain the Delaunays' ideas about art quite well. Part of the urge for expression begins in the realm of emotions. Facial and body gestures are its most basic forms, but those forms of expression are often automatic. They require no conscious creativity. The activity of language is conscious. Consciousness alone can constellate primary emotions, which have made themselves evident to the mind, and can give them a form for presentation to the exterior world[26] Thus, a continuous discovery and awareness of the self are necessary for the creation and use of language. This is the second step in the craft of simultaneity — one perceives the simultaneous either in nature or on the canvas, then develops a language to express it. The language is developed when the awareness is complete.

Huizinga argues that the creation of language is, in fact, a primary form of cultural play — it is "the spirit…continually 'sparking' between matter and mind"[27] in the process of naming, distinguishing, and absorbing the world.

It is appropriate that Sonia Delaunay should have found poetry to be analogous to her own artistic product, for poets are particularly conscious of the creativity involved in the process of expression in language. Choice of words is important to poets, but an extensive vocabulary is not. Ordering of words is important, but rules of syntax are not. The poet's purpose is not to describe his emotions and thoughts through clearly defined words and logical grammar, but to individualize his expression by avoiding the dead body of such previously understood language[28] Thought and emotion are communicated by their differentiation from the logical and descriptive, by the exposition of their own creative evolution. As Sonia Delaunay said, there must be a certain mystery:

> As with written poetry, it's not the combination of
> words that counts, it's the mystery of creation that
> either gives or doesn't give emotion.
> The same with colors, it's the poetry, the
> mystery of an interior life which breaks loose, radiates
> and communicates itself.
> From that point on one can freely create a new
> language[29]

Description could not be poetry for her.

Throughout Robert Delaunay's writings one finds emphatic rejections of "descriptive" art. As early as 1912 he insisted on this:

> If art is attached *to the Object,* it becomes *descriptive,*
> *divisive, literary.*
> It stoops to imperfect modes of expression, it
> condemns itself of its own free will, it is its own
> negation, *it does not liberate itself from mimesis*[30]

Considering that he, nonetheless, included recognizable objects in his paintings for many years after his breakthrough into simultaneity, we must assume that the nondescriptive art which he applauded was not necessarily nonobjective (although by the 1930s he concluded that all pure art should be "inobjective"). If an object is represented so completely

that it leaves nothing to the imagination, then it is thoroughly described. This is accomplished when its form and color are apparent, but also its weight, texture, and position in space. A thorough description of this sort creates an illusion of the object with which one is completely comfortable; it corresponds to one's general conception of such objects in the world. Nothing is learned from the experience of viewing such description. The consciousness is not broadened.

The Delaunays were clearly reacting to academic art of the late 19th century in this battle against description. The refined technical illusions of academic realism satisfied very little purpose beyond simple amusement provided by the technique itself. By eliminating such illusionism, the artist could avoid the potential for art to fall to such depths. The first step was to eliminate such specifics as texture and local color, replacing them with surfaces of light. The second step was to eliminate chiaroscuro, which produced illusionistic space. The third was to eliminate line, which was too finite in its definition of form. What remained was color on canvas, creating its own non-illusionistic space, defining its own flexible limits and announcing its own form. Recognizable objects could be represented through such means, but their representation came through expression rather than description.

The poets, of course, understood this new language of color first. To quote Sonia Delaunay:

> The poets who surrounded me, Apollinaire and above all Cendrars, understood what I wanted to do. Not to reduce abstract art to an intellectual set purpose, to simply calculated geometry, not to let it impoverish itself, but to return to the sources of the primitives, to ally order and lyricism. Abstract and sensual had to merge for me. To break with descriptive line didn't mean to sterilize. I'm willing to accept the priority given me — very late — in that which concerns abstract art. But I add immediately that the "abstracts" haven't followed me; they are cut off from life and from their natural rhythms. They have forgotten that the abstract is no big thing if it is only a mannerism, a simplistic reaction; it is most important when one demands that it be a complete art, a complex art.[31]

The mystery of creation involves the sensual as much as the intellectual; matter as well as mind. It plays between the two with rhythms which vary according to the situation and the mood. If the work of art does not express this play, these rhythms, it reduces itself to the mechanical.

One of Sonia Delaunay's favorite quotations is from Plato: "Rhythm is the ordering of movement." Movement of colors expresses the creative play of life. The ordering of that movement into rhythms corresponds to the order which nature imposes on its own processes — natural rhythms. Sonia Delaunay tried to unite such order with lyricism, poetic expression, which is not natural but parallel to nature in the imagination. This could only be accomplished by understanding rhythms as completely as possible.

In her studies for textiles, her stage of inquiry, Sonia Delaunay gained total control of this problem:

> Rhythm is based on numbers because color can be measured by its vibrations. This was a completely new concept that opened infinite horizons for painting and could be used by anyone who felt and understood it.[32]

Actually, the concept was not completely new. It had been discussed thoroughly by Ogden Rood in the late 1870s.[33] Robert, more readily than Sonia, accepted Rood's scientific approach. Sonia's predilection for mathematics, an interest which she developed even as a child, brought her to the discovery of her own intuitive system of calculation — according numbers to the intensity of a color vibration, multiplying them by the addition of colors or the division of forms. The mathematics of the painting could never be resolved into a closed system because the numbers are based on colors, which are infinite in variety and infinite in the rhythms they produce. The order which such numbers produce is an order that is flexible — it shifts before the will of color.

E. H. Gombrich has proposed that artistic orders are based on the laws of geometry.[34] Color can influence the effect of an order through contrast of brightness, but it remains secondary to problems of line and shape. His assertions are posed in the context

of an analysis of the decorative arts in which the concept of an artistic order is connected to the concept of the pattern. A decorative pattern projects a certain rhythm, a counterpart to the organic rhythms which guide our heartbeat, our breathing, or our locomotion. It is by this rhythm that we become aware of a pattern. Once it is recognized and assimilated, it disappears from our consciousness. A pattern may pose complexities far beyond the calculability of the average spectator, but if its rhythm is recognized through a focussed analysis of certain key areas, the repetitive continuation of that rhythm will assure the eye and the mind that the pattern is complete. Consistent rhythms, however complicated, satisfy our sense of order which, in temporal terms, allows us to project a certain continuity of events in life from the past and present into the future. The successful decorative pattern fuses temporal and spatial orders in a like reassuring continuum.

Once the order of a certain pattern is recognized, any breaks in the order or changes in the degree of order attract attention and call for fresh alertness until a new pattern of order is established. This is the way in which the mind adjusts to changes in patterns of life as well as changes in patterns of decoration. If the order in a given visual pattern is too familiar, it will be considered dull. If it is too unfamiliar or contains too many breaks from an order that is considered normal, it will be found confusing. The successful pattern falls on the line between dullness and confusion,[35] or between familiarity and change, allowing the mind to assimilate the new into the arena of the old.

The rhythmic orders with which Sonia Delaunay was concerned are of exactly this sort. The word "pattern," however, is not an accurate label for her finished designs, for one never senses that any recognizable order of geometry is completed. Concentric circles, checkerboards, alternating diamonds, triangles, and rectangles each set up an order which the eye is allowed to follow just long enough to assimilate the rhythm. The order is then broken and a new pattern begun. The mind is never allowed to fall out of awareness, for the pattern changes come too quickly. No order of geometry rules the completed composition. Instead, the confusion of pattern is resolved by the order of color, in the energy of its contrasts, which was Sonia Delaunay's original guide for the placement of color, the establishment of form and the adjustments of changing patterns. The final effect is one that frequently seems far from any sense of order. As Germain Viatte expresses it:

> But it is here that everything seems to fall down, that a new complexity turns the affirmed imbalances to account, suddenly evoking the mechanical disorder of energies in primordial or final chaos[36]

Such disturbing effects are seldom associated with successful patterns of decoration. They are, however, very much a part of revealing works of art. They are found as well in the clash of abstract forms in ancient Russian icons. Both order and disorder govern the development of our lives, and the more rapidly our cultures change, the more the strife between order and disorder becomes apparent. Damase has observed this strife in Sonia Delaunay's rhythms:

> That sometimes oblique rhythm, that almost Dionysiac magic which enlivens the surface, are cut by counter rhythms, counter currents: those syncopated rhythms in short, a living representation of our chaotic and organized epoch[37]

Our sanity frequently rests on that tensional line between chaos and organization, disorder and order. People who live creatively have generally brought that line to consciousness.

The textiles that were produced under Sonia Delaunay's direction are perhaps her only creations which provide the observer with patterns whose order can be grasped and assimilated. By the nature of the product, designs for textiles must be repeatable, and the consistency of their repetition establishes its own comprehensible order. When one examines the designs themselves, however, it is apparent that the phenomenon one might call "rhythm-breaking" is still a primary source of their disturbing interest. The breaks are simply calculated in such a way as to let the motif be extended rather than contained.

In Sonia Delaunay's fashion and costume designs, the patterns and breaks were considered

either in correspondence to or in contrast to the rhythmic movements of the human body. The forms produced by this confluence of rhythms were never three-dimensional, despite the three-dimensionality of the body. They remained firmly attached to that two-dimensional surface which separates interior from exterior, adjusting the visual effect of that surface to its ambiguous position in space. By adhering to two dimensions, these works met the requirements of late 19th- and early 20th-century decorative design. Illusionistic designs were assumed to be inappropriate to surfaces whose function necessitated clear spatial definition. Sonia Delaunay took this trend of thinking one step further by insisting that such typical decorative motifs as flower and foliage, even in two dimensions, had no particular purpose on a functional object and served only to confuse it. The limitations of the preconceived shapes inherent in such motifs destroyed the vitality of a design based on color.

Color asserts its own rhythms. Designing with color, allowing its rhythms to be primary, has little to do with traditional decoration or the term "decorative." Sonia Delaunay insisted that it had, instead, to do with construction. Her coloristic orders were constructed and dissolved and reconstructed in different forms, even on the surface of a pocketbook or beach jacket, and in each instance the process of construction provided a new awareness. For the designer, it was an awareness which became a building block for the next stage of construction. For the observer, the mental reconstruction of the design is an awareness that could be extended to the world at large.

Sonia Delaunay creates objects that are not aptly defined as "decorative," but because of her adherence to the surface, they can be described as "decorated." The decorated object is a fundamentally ambiguous entity. Gombrich places it somewhere between a regular body (a cube or a sphere) and a piece of coal. The regular body allows us to anticipate its complete shape correctly from a single view. The backside of a lump of coal, however, remains somewhat hypothetical in our minds until we have actually seen it.[38] The decorated object provides us with an overall form which corresponds to our expectations, but the design may change drastically from side to side. Part of it remains elusive. Decoration transforms an object by transforming its surface. It does not, however, really change it. The object remains the object, whether it is a painting, a wall, a rug, or a lampshade. Decoration stimulates the joy and delight of imagining the object as something else.[39] Implicit in all of Sonia Delaunay' ideas about art is the assumption that activation of the imagination is essential to the process of creation. It is only by nurturing such active imagination that works of art can be created, decorated, or designed in such a way that they approximate poetry and elevate the spirit.

> ...The child is a poet, poetry is the art of keeping this child's imagination by basing it on a construction, on a craft of expression.[40]

Sonia Delaunay would have us appreciate, perhaps treasure, and try to recapture the spirit of free imagining which occupies so much of a child's life. It is in that play between reality and non-reality that new languages are produced and in the play between what is understood and what is not understood that the consciousness is activated and the soul transformed. The craft of simultaneity concerns itself with that play in all of its seriousness. The concept of simultaneity would not exist if one could not imagine the existence of a second or third reality parallel to the one that is immediate. Imagination is at the core of the craft. Sonia Delaunay's simultaneous colors capture the imagination between the beats of changing rhythmic orders. Yet, those colors present far more than the imaginings of a single mind. Her art expresses the fullness and complexity of creation and of life.

A BIOGRAPHICAL SKETCH: EIGHTY YEARS OF CREATIVITY

1. Biographical information and memories of Sonia Delaunay's childhood are found in Sonia Delaunay, *Nous Irons Jusqu'au Soleil* (Paris: Editions Robert Laffont, 1978), passim.

2. Ibid., p. 196.

3. Viatte first made this connection. Viatte, preface in *Sonia Delaunay: Dessins, Noirs et Blancs* (Paris: Jacques Damase, Artcurial Editeurs, 1978), p. 6 and note 1.

4. Looking back, Sonia Delaunay surmised that she introduced naturism into Russia. See Sonia Delaunay, *Nous Irons Jusqu'au Soleil*, p. 15.

5. Ibid., p. 16.

6. One of these was Julius Meier-Graefe's famous *Der Moderne Impressionismus* (Berlin: J. Bard, n.d. [1903-04]).

7. Sonia Delaunay quoted in Jean Clay, "The Golden Years of Visual Jazz: Sonia Delaunay's Life and Times," *Réalités* (Eng. ed., Paris), 1965, p. 42.

8. There are discrepancies in the information concerning this date. Some say they were married in 1909. The latest publications, however, Sonia Delaunay, *Nous Irons Jusqu'au Soleil*, p. 20 and the catalogue *Sonia et Robert Delaunay* (Paris: Bibliothèque Nationale, 1977), p. 3, both indicate that the ceremony was in 1908.

9. For a discussion of the criticism of the 1905 Salon d'Automne and of the actual anarchistic leanings of some of the Fauvist painters, see John Elderfield, *The "Wild Beasts," Fauvism and Its Affinities*, exhib. cat. (New York: The Museum of Modern Art, 1976), pp. 38-44.

10. Sonia Delaunay, *Nous Irons Jusqu'au Soleil*, p. 20. Years later, when Matisse began his colored *découpages*, Sonia Delaunay developed a new appreciation for his art. Her comments about him were thus inconsistent. She either loved him or thoroughly disliked him, depending on the period of his art to which she was referring.

11. Robert Delaunay in Arthur A. Cohen, ed., *The New Art of Color: The Writings of Robert and Sonia Delaunay*, The Documents of 20th Century Art (New York: Viking Press, 1978), p. 133, essay on "Sonia Delaunay-Terk (1938)."

12. Ibid.

13. Arthur A. Cohen, *Sonia Delaunay* (New York: Harry N. Abrams, Inc., 1975), p. 42.

14. Gustav Vriesen and Max Imdahl, *Robert Delaunay: Light and Color* (New York: Harry N. Abrams, Inc., 1967), p. 24.

15. Sonia Delaunay, quoted in Clay, "The Golden Years of Visual Jazz," p. 42.

16. Sonia Delaunay, *Nous Irons Jusqu'au Soleil*, p. 23. Previously published accounts of this period imply that Sonia Uhde and Robert Delaunay saw one another frequently during the winter and spring of 1908-09 and that Sonia went alone to the pension in Chaville.

17. Ibid., pp. 20-21 (information supplied by the editors Jacques Damase and Patrick Raynaud).

18. Still-life drawings by Sonia Delaunay from this same period are in the style of Cézanne.

19. Robert Delaunay in Cohen, *The New Art of Color*, p. 133, essay on "Sonia Delaunay-Terk (1938)." He stated in this passage that there were several embroidered wall hangings made during this period. It is unfortunate that only one example is still extant.

20. Ibid., p. 134.

21. Jacques Damase, *Sonia Delaunay, Rhythms and Colors* (Greenwich, Conn.: New York Graphic Society and London: Thames & Hudson, 1972), p. 45.

22. Robert Delaunay in Cohen, *The New Art of Color*, p. 126, text and footnote, from "Notes on Rousseau (1911)."

23. Sonia Delaunay, *Nous Irons Jusqu'au Soleil*, p. 23.

24. Vriesen and Imdahl, *Robert Delaunay: Light and Color*, p. 24.

25. She had taken no contraceptive precautions since she had had scarlet fever and assumed that she could not have children. See Sonia Delaunay, *Nous Irons Jusqu'au Soleil*, p. 39.

26. Michael Peppiatt, "Sonia Delaunay: A Life in Color," *Art News* (New York), vol. 74, no. 3, Mar. 1975, p. 88.

27. In July 1911, there was an exhibition in Paris of modern Russian folk art from the Talachkino workshop. Although these works bore no resemblance to Sonia Delaunay's quilt, their presence proves a contemporary interest in Russian folk art. See Louis Vauxcelles, "Les Arts . . . : Broderies Russes," *Gil Blas* (Paris), July 26, 1911.

28. Sonia Delaunay, *Nous Irons Jusqu'au Soleil*, p. 39.

29. LeRoy C. Breunig, ed., *Apollinaire on Art*, The Documents of 20th Century Art (New York: Viking Press, 1972), pp. 176-77 from *L'Intransigeant*, Aug. 7, 1911. For the impact of this publication on Robert Delaunay, see an article by this author, "The Simultaneous Content of Robert Delaunay's *Windows*," *Arts Magazine* (New York), vol. 54, no. 1, Sept. 1979, p. 108.

30. Sonia Delaunay, quoted in Cohen, *The New Art of Color*, p. 215, from an interview with Cohen in 1970.

31. Galerie der Sturm, *Erster Deutscher Herbstsalon*, exhib. cat. (Berlin: Galerie der Sturm, Oct. 1913). Most of these objects were probably given as gifts to such people as Robert's mother and aunt.

32. Franz Meyer, *Marc Chagall* (New York: Harry N. Abrams, Inc., 1963), pp. 149-65, passim.

33. Sonia Delaunay, *Nous Irons Jusqu'au Soleil*, p. 43.

34. Apollinaire edited Delaunay's "Note sur la Construction de la Réalité de la Peinture Pure," published as "Réalité, Peinture Pure," in *Der Sturm* (Berlin), Dec. 1912. See Breunig, *Apollinaire on Art*, pp. 262-65.

35. Roger Shattuck, ed., *Selected Writings of Apollinaire* (New York: New Directions Publishing Corporation, 1970), p. 119. Apollinaire also discussed this concept in an article in *Les Soirées de Paris* (Paris), no. 9, Oct. 1, 1912.

36. Sonia Delaunay, *Nous Irons Jusqu'au Soleil*, pp. 53-54.

37. There is some debate among scholars about the date of Sonia Delaunay's encounter with Cendrars. Her latest recollection was that it took place on Jan. 1, 1913. This date fits well with other existing evidence. The problem is discussed fully in Sue Behrends, "An Experiment in Literature and the Arts: Sonia Delaunay, Blaise Cendrars and *Le Premier Livre Simultané (La Prose du Transsibérien et de la Petite Jehanne de France)*, (unpublished paper, Iowa City: University of Iowa, 1976), pp. 1-2 and note 6. Much of my understanding of the specific collaboration of Sonia Delaunay and Blaise Cendrars is the result of information presented in Behrends' paper.

38. Sonia Delaunay, quoted in Cohen, *The New Art of Color*, p. 198, from the essay "The Poem *Easter in New York* (1962)."

39. Damase, *Sonia Delaunay: Rhythms and Colors*, pp. 48-49.

40. This dating has been ascertained by Pär Bergman in *"Modernolatria" et "Simultaneità," Recherches Sur Deux Tendances dans l'Avant-Garde Litteraire en Italie et en France à la Veille de la Première Guerre* (Stockholm: Bonnier, 1962), p. 314.

41. Cendrars traveled in Russia from 1904 to 1907 and again from St. Petersburg to Lisbon in 1911.

42. Noted by Behrends in "An Experiment in Literature and the Arts," p. 9.

43. Robert Delaunay, in Cohen, *The New Art of Color*, p. 51 from "Simultaneism in Contemporary Modern Art, Painting and Poetry (October 1913)."

44. The structure and style of the *Prose du Transsibérien* are interpreted adeptly in the introduction to *Blaise Cendrars, Selected Writings*, Walter Albert, ed. (New York: New Directions Publishing Corporation, 1966), pp. 15-23.

45. *La Légende de Novgorod* was purportedly published in an edition of 14 in 1909. As no copies remain extant, Cohen suspects that the project may have been fabrication on Cendrars' part. Cohen, *Sonia Delaunay*, p. 23 and note 9. *Les Pâques à New York* was published by a secret anarchist press. See Blaise Cendrars, *Oeuvres Complètes* (Paris: Denoël, 1961), vol. 8, p. 652.

46. See Eleanor M. Garvey, "Cubist and Fauve Illustrated Books," *Gazette des Beaux-Arts* (Paris), vol. LXIII, Jan. 1964, pp. 37-50.

47. See Jacques Damase, *Révolution Typographique Depuis Stéphane Mallarmé* (Geneva: Galerie Motte, 1966), n.p. and Behrends, "An Experiment in Literature and the Arts," p. 13.

48. Quoted from Albert, *Blaise Cendrars: Selected Writings*, p. 333.

49. Bergman, *"Modernolatria et Simultaneità,"* p. 316.

50. For a thorough discussion of the technique and its history, see Burr Wallen, "Sonia Delaunay and Pochoir," *Arts Magazine* (New York), vol. 54, no. 1, Sept. 1979, pp. 96-101.

51. Wallen explains the artist's attraction to the medium admirably. Ibid., pp. 98-99.

52. Ibid., p. 99.

53. Guillaume Apollinaire, commentary in *Les Soirées de Paris* (Paris), June 15, 1914, translated in Cohen, *Sonia Delaunay*, p. 35.

54. Blaise Cendrars, translated in Cohen, *Sonia Delaunay*, p. 73.

55. Sonia Delaunay, *Nous Irons Jusqu'au Soleil*, p. 36.

56. Guillaume Apollinaire in Cohen, *The New Art of Color*, p. 180, from "The Seated Woman (1914)."

57. Blaise Cendrars, *On Her Dress She Wears a Body*, translated by Madeleine Mathiot.

58. The concept of an inner core of a woman being revealed, joining with the exterior forces of the universe, was fundamental to a poem entitled *The Wheel*, that Cendrars wrote in 1912. Sonia Delaunay provided him with a visual analogy to his evocation of the revelation of female rhythms.

59. See Umberto Boccioni, "Technical Manifesto of Futurist Sculpture," published in April 1912 and translated in Umberto Apollonio, ed., *Futurist Manifestoes*, The Documents of 20th Century Art (New York: Viking Press, 1973), pp. 51-65.

60. According to Apollinaire, "La Vie Anecdotique, Peintres Futuristes," *Mercure de France* (Paris), vol. 94, Nov. 16, 1911, p. 346, partially quoted in Bergman, *"Modernolatria" et "Simultaneità,"* pp. 272, 350.

61. Blaise Cendrars, quoted in Vriesen and Imdahl, *Robert Delaunay: Light and Color*, p. 60 from *Blaise Cendrars vous parle*, "Entretiens de la Radiodiffusion Française" series (Paris: M. Mannoll, 1952), pp. 141-42. This work is included in Cendrars, *Oeuvres Complètes*, vol. 8. As a direct interview, it seems to relate Cendrars' actual memories, as opposed to the truth-fantasy interweaving of many of his writings.

62. The studies of light on the Boulevard Saint-Michel were, according to Sonia Delaunay, done after Robert's studies of circular forms. See Sonia Delaunay, *Nous Irons Jusqu'au Soleil*, pp. 44-45. This places them in 1913, during or after the summer at Louveciennes. Studies of moving crowds, however, may have been done earlier.

63. Cindy Nemser, *Art Talk: Conversations with 12 Women Artists* (New York: Charles Scribner's Sons, 1975), p. 38.

64. Sonia Delaunay, *Nous Irons Jusqu'au Soleil*, p. 39.

65. Ibid., p. 67.

66. Gustav Vriesen states forthrightly that the word "magic" refers to a dance hall, though when questioned in recent years, Sonia Delaunay could no longer recall the place. *Sonia Delaunay* (Bielefeld: Städtisches Kunsthaus, 1958), p. 44. (For ease of reference, in the text the Bielefeld museum is referred to by its post-1969 title "Kunsthalle.")

67. The listing of this and two other sculptures in the catalogue for the *Erster Deutscher Herbstsalon* poses numerous questions. Only one of the sculptures, *Horse, Prism, Sun, Moon*, is preserved in reproduction. The photograph shows a small, painted hobby horse against the backdrop of Robert's famous *Disk*. This does not, however, confirm that either the horse or the other sculptures were exhibited in front of *Disk* in the Herbstsalon. The horse was probably displayed in such an arrangement in an exhibition at the Mánes gallery in Prague in February 1914, where it was to be listed as "Art de l'espace, *Disques* contraste couleur simultanée. *Cheval. Prisme. Soleil. Lune.*" See Donald E. Gordon, *Modern Art Exhibitions, 1900-1916* (Munich: Prestel Verlag, 1974), vol. II, p. 789, and Robert Delaunay, *Du Cubisme à l'Art Abstrait*, p. 139. Robert gives a July-August 1913 date to the horse-disk assemblage. Nonetheless, it seems unlikely that the *Disk* now in the Tremain collection in Meriden, Conn. was used in the Herbstsalon. None of Robert's other paintings on exhibition contain the formalized concentric rings of the *Disk*. Even the *Carousel of Pigs*, now destroyed, appears (from the poor photograph printed of it in *Comoedia* in 1914) to have the looseness of the *Circular Forms*. It is quite possible that the formula of colored concentric rings, which was to become the highlight of Robert Delaunay's style, was an outgrowth of Sonia's experiments in collage.

68. There is some confusion about this chronology. In *Nous Irons Jusqu'au Soleil*, p. 72, Sonia Delaunay implies that they went first to Madrid, then to Fuentarrabia, where Robert ceased temporarily to paint. Because his change of behavior worried her, she suggested that they join friends in Portugal. Most other sources, however, record Fuentarrabia as the first stop, and Madrid as the winter and spring, 1914-15, place of habitation. See especially Cohen, *Sonia Delaunay*, p. 69; Paulo Ferreira, *Correspondance de Quatre Artistes Portugais, Almada Negreiros, José Pacheco, Souza-Cardoso, Eduardo Vianna avec Robert et Sonia Delaunay* (Paris: Presses Universitaires de France, 1972), p. 40 and Charles Goerg, "Les Marchés au Minho de Sonia Delaunay," *Bulletin du Musée d'Art et d'Histoire de Genève* (Geneva), n.s., vol. 13, 1965, p. 204.

69. Amadeo de Souza-Cardoso had known the Delaunays in Paris in 1913. He had returned to Portugal at the outbreak of the war and was living in his parents' home in Menhufe. The Delaunays contacted him upon arrival in Portugal.

70. Sonia Delaunay, *Nous Irons Jusqu'au Soleil*, p. 37.

71. Sonia Delaunay quoted in Ferreira, *Correspondance de Quatre Artistes Portugais*, p. 44.

72. Sonia Delaunay, *Nous Irons Jusqu'au Soleil*, pp. 75-76. It is interesting to note that Sonia Delaunay mentions Chevreul, but never Rood, in her reference to color theorists. Chevreul's concepts were applied to fibers, textiles and wallpapers. Rood's were purely theoretical analyses of light and color.

73. Sonia Delaunay, quoted in Ferreira, *Correspondance de Quatre Artistes Portugais*, p. 42.

74. See Goerg for a full listing of the known works related to the *Market at Minho*.

75. Goerg points out that the market place is at Valença do Minho, the viaduct at Vila do Conde and the seated market woman, a servant from the Delaunays' villa. See Goerg, "Les Marchés au Minho," pp. 212-13. The Delaunays moved to Valença do Minho in September 1916. There are photographs, however, of Sonia working on a large canvas of the *Market at Minho* in Vila do Conde. Thus it may be that the image is a composite of scenes from the market at Vila do Conde and at Valença do Minho, and that the series was completed late in the year, after the change of residence.

76. Robert Delaunay, quoted in Cohen, *Sonia Delaunay*, p. 68.

77. Robert Delaunay in Cohen, *The New Art of Color*, pp. 67-69, passim, from a letter to Maximovitch Minsky written around 1918.

78. Sonia Delaunay, quoted in Peppiatt, "Sonia Delaunay: A Life in Color," p. 88.

79. Charles Spenser, *The World of Serge Diaghilev* (New York: Penguin Books, 1979), p. 107.

80. Valerien Svietlov describing Ida Rubinstein in the 1909 performance of *Cléopâtre*, quoted in Spenser, *The World of Serge Diaghilev*, p. 54.

81. Blaise Cendrars, *On Her Dress She Wears a Body*, translated by Madeleine Mathiot.

82. Guillermo de Torre, "El Arte Decorativo de Sonia Delaunay-Terk," *Alfar* (Montevideo), no. 35, Dec. 1923, quoted in Sonia Delaunay, *Nous Irons Jusqu'au Soleil*, pp. 80-81.

83. Sonia Delaunay was invited to participate in a conference on modern fashion designers at the Ritz Hotel in Madrid in 1918.

84. Apollinaire was himself promoting Tzara's poems in *Nord-Sud* in 1917.

85. See Willy Verkauf, "Dada—Cause & Effect," in Willy Verkauf, ed., *DADA, Monograph of a Movement* (New York: George Wittenborn, 1957), p. 14; and Janco's essay in Verkauf, *DADA, Monograph of a Movement*, pp. 18-30.

86. Behrends, unpublished research.

87. Tristan Tzara, "Note 6 sur l'art nègre," *SIC* (Paris), Sept.-Oct. 1917.

88. Years later Tzara explained that his purpose in exploring primitive art and sponsoring Negro soirées was to recapture "in the depths of consciousness the exalting sources of the function of poetry." See Tzara's essay "L'Art Océanien," *A.P.A.M.*, 1951, translated in Elmer Peterson, *Tristan Tzara, Dada and Surrational Theorist* (New Brunswick: Rutgers University Press, 1971), pp. 46-47.

89. See Janco, "Creative Dada," in Verkauf, *DADA, Monograph of a Movement,* passim.

90. René Crevel in Cohen, *The New Art of Color,* p. 186 from the essay "Visite à Sonia Delaunay (1920?)."

91. Behrends has noted the Parisian Dadaist preoccupation with style and fashion: Tzara's elaborate clothes and use of a monocle; Breton's use of a cane.

92. Sonia Delaunay, *Nous Irons Jusqu'au Soleil,* p. 84.

93. A meeting of the entire Parisian avant-garde was held at the Closerie de Lilas on February 17, 1922, at which Breton was called to account for his actions. Several of Breton's close friends expressed their disapproval, with Aragon standing behind him and Soupault attempting to reconcile the warring factions. Delaunay was present at a small meeting after this quasi-trial, at which Satie wrote a majority resolution in condemnation of Breton. Delaunay, however, did not sign the document. See Mathew Josephson, *Life Among the Surrealists* (New York: Holt, Reinhart and Winston, 1962), pp. 147-50. As late as May 1922, the Breton-Delaunay relations were still apparently intact. By the following year they had disintegrated entirely.

94. The contact was probably made through Cendrars, who published with this company's press.

95. Cendrars in Cohen, *The New Art of Color,* p. 181. *Sur la Robe Elle A Un Corps* was published in Blaise Cendrars, *Dix-Neuf Poèmes Elastiques* (Paris: Au Sans Pareil, 1919).

96. The Soupault poem was later given the title *Manteau du Soir de Mme Delaunay.*

97. The first lines of Cendrars' *Sur la Robe Elle a Un Corps* in Cohen, *The New Art of Color,* p. 180.

98. Ramón Gómez de la Serna, "Los Trajes Poemáticos," *La Voz de Guipuzcoa* (Bilbao), 1920, Martin Bush, trans.

99. Ibid.

100. See Françoise Woimant and Marcelle Elgrishi, "Iliazd, Tériade et Pierre Lecuire, Trois Grands Editeurs de Notre Temps," *Nouvelles de l'Estampe* (Paris), no. 15, May-June 1974, p. 18 for a biography of Iliazd.

101. Quoted in Damase, *Sonia Delaunay,* pp.135-36.

102. Sonia Delaunay in Cohen, *The New Art of Color,* p. 211, from "Collages of Sonia and Robert Delaunay (1956)."

103. It is possible that her inventions of fashions for a carnival in Rio de Janeiro were begun at this time.

104. Sonia Delaunay in Cohen, *The New Art of Color,* p. 212 from "The Color Danced (1958)."

105. Ibid.

106. See Annabelle Henkin, *From Dada Performance to the Surrealist Sketch,* (unpublished Ph.D. dissertation, New York: Columbia University, 1973), p. 211, and Michel Sanouillet, *Dada à Paris* (Paris: Jean-Jacques Pauvert, 1965), pp. 380-81.

107. Quoted in J. H. Mathews, *Theatre in Dada and Surrealism* (Syracuse: Syracuse University Press, 1974), p. 31.

108. Ibid., p. 41.

109. Sanouillet, *Dada à Paris,* p. 383.

110. It is not clear whether Tzara or Iliazd was in control of the planning of the evening, nor how aware Tzara was of Iliazd's plans for the staging and direction of the *Coeur à Gaz.* See Mathews, *Theatre in Dada and Surrealism,* p. 36 and Sanouillet, *Dada à Paris,* p. 380.

111. The 1921 performance of the *Coeur à Gaz* included a dancer. This character was not listed among the 1923 cast.

112. Josephson, *Life Among the Surrealists,* p. 152.

113. Quoted in Mathews, *Theatre in Dada and Surrealism,* pp. 37-38, from an article published in *Les Hommes du Jour* (Paris), Aug. 4, 1923.

114. Joseph Delteil, *The Coming Fashion,* translated in Damase, *Sonia Delaunay,* p. 167.

115. Ibid.

116. Ibid., p. 168.

117. Delteil, *Poem for the Dress of the Future,* translated in Damase, *Sonia Delaunay,* pp. 177-78. This poem is a readaptation of *The Coming Fashion* and was published in Sonia Delaunay's 1925 album, *Sonia Delaunay: Ses Peintures, Ses Objets, Ses Tissus Simultanés, Ses Modes* (Paris: Librairie des Arts Decoratifs, 1925).

118. Delteil, *The Coming Fashion* in Damase, *Sonia Delaunay,* p. 168.

119. Sonia Delaunay in Cohen, *The New Art of Color,* pp. 205-06 from "The Influence of Painting on Fashion Design (1926)."

120. Martin Battersby, *The Decorative Twenties* (New York: Walker and Company, 1969), p. 92.

121. Robert Delaunay in Cohen, *The New Art of Color,* p. 139, from "The Art of Movement (1938)."

122. Robert Delaunay in Cohen, *The New Art of Color,* pp. 137-38, from "The 'Simultaneous' Fabrics of Sonia Delaunay (second version) (1938)."

123. Quoted in Damase, *Sonia Delaunay,* pp.157-58.

124. Claire Goll in Cohen, *The New Art of Color,* p. 185, quoted from "Simultaneous Clothing (1924)."

125. Sonia Delaunay, *Nous Irons Jusqu'au Soleil,* p. 96.

126. Ibid., p. 97.

127. Ibid., p. 102.

128. Thérèse Jung-Clemenceau, "La Boutique Simultanée," *Les Arts Plastiques* (Paris), no. 2, 1925, n.p.

129. Battersby, *The Decorative Twenties,* p. 52.

130. Codreano had danced in Sonia Delaunay's designs in 1924 and 1925 as well as in the 1923 soirée organized by Iliazd.

131. Günter Metkin, "The Delaunay's [sic] Theater," in Henning Rischbieter, ed., *Art and the Stage in the 20th Century: Painters and Sculptors Work for the Theater* (Greenwich, Conn.: New York Graphic Society, 1970), p. 106.

132. Sonia Delaunay, ed., *Tapis et Tissus* (Paris: Editeur Charles Moreau, 1929).

133. Sonia Delaunay in Cohen, *The New Art of Color,* p. 199, from "Rugs and Textiles," dated 1925 but not published until 1929.

134. Ibid., p. 200.

135. Ibid.

136. Quoted by Gladys C. Fabre in *Abstraction-Création 1931-1936* (Munich: Westfälisches Landesmuseum für Kunst und Kulturgeschichte and Paris: Musée d'Art Moderne de la Ville de Paris, 1978), p. 11.

137. Sonia Delaunay in Cohen, *The New Art of Color,* p. 216, in interview with Cohen in 1970.

138. Sonia Delaunay, *Nous Irons Jusqu'au Soleil,* p. 107.

139. Ibid., pp. 108-09.

140. Sonia Delaunay also preserved all of the correspondence received from poets and artists throughout her life. These have recently been catalogued by the Bibliothèque Nationale, Paris.

141. Sonia Delaunay, *Nous Irons Jusqu'au Soleil,* pp. 110-11.

142. Patrick Weiser, *1937 Exposition Internationale des Arts et des Techniques,* exhib. cat. (Paris: Centre Georges Pompidou, 1979), p. 4.

143. Ibid., pp. 4-5.

144. Louis Cheronnet, quoted in Damase, *Sonia Delaunay: Rhythms and Colors,* p. 237.

145. Isaac del Vando-Villar, quoted in Damase, *Sonia Delaunay: Rhythms and Colors,* p. 245.

146. Louis Cheronnet, quoted in Damase, *Sonia Delaunay: Rhythms and Colors,* p. 237.

147. Sonia Delaunay, *Nous Irons Jusqu'au Soleil,* p. 114. The architect promised them 50 artists, but then selected 25 for his own use. Sonia Delaunay, in the end, had only 3 helpers, one of whom was the artist Estève.

148. Jean Maréchal in *Petit Parisien* (Paris), May 30, 1937, quoted in Sonia Delaunay, *Nous Irons Jusqu'au Soleil,* pp.114-15.

149. Sonia Delaunay, *Nous Irons Jusqu'au Soleil,* p. 116.

150. Ibid., p. 120.

151. Alberto Magnelli translated in Damase, *Sonia Delaunay: Rhythms and Colors,* pp. 253-54, from a statement by the artist in *Six Artistes à Grasse 1940-1943,* exhib. cat. (Grasse: Société du Musée Fragonard, Musée Regional d'Art et d'Histoire, 1967), n.p.

152. Sonia Delaunay, *Nous Irons Jusqu'au Soleil,* p. 129.

153. Robert Delaunay, *Du Cubisme à l'Art Abstrait.*

154. Sonia Delaunay, *Nous Irons Jusqu'au Soleil,* p. 136.

155. Sonia Delaunay, in *Six Artistes à Grasse 1940-1943,* n.p.

156. Sonia Delaunay, *Nous Irons Jusqu'au Soleil,* p. 139.

157. Ibid., p. 144.

158. Ibid., p. 151.

159. Ibid., p. 162.

160. Cohen, *Sonia Delaunay,* p. 87.

161. Sonia Delaunay, *Nous Irons Jusqu'au Soleil,* pp. 134-35.

162. Ibid., pp. 167-68.

163. Arthur Rimbaud, from *Morning of Drunkenness,* translated in Oliver Bernard, ed., *Rimbaud, Collected Poems* (Baltimore: Penguin Books, 1962), p. 250.

164. Sonia Delaunay, *Nous Irons Jusqu'au Soleil,* p. 138.

165. Ibid., p. 185.

166. Ibid., pp. 198-99.

167. Jacques Damase in Damase, *Sonia Delaunay: Rhythms and Colors,* p. 284.

168. Sonia Delaunay, *Nous Irons Jusqu'au Soleil,* p. 163.

169. Ibid., p. 185.

170. Ibid., p. 205.

THE ART OF UNEXPECTED CONTRASTS

1. Sonia Delaunay, *Nous Irons Jusqu'au Soleil* (Paris: Editions Robert Laffont, 1978), p. 34.

2. Ibid., p. 206.

3. Ibid., p. 165.

4. Ibid., p. 158.

5. Ibid., p. 45.

6. Ibid., p. 158.

7. Blaise Cendrars, *Aujourd'hui* (Paris: Bernard Grasset Editions, 1931), pp. 127-28 from *Le Contraste Simultané,* written in July 1914.

8. Arthur A. Cohen, ed., *The New Art of Color: The Writings of Robert and Sonia Delaunay,* The Documents of 20th Century Art (New York: Viking Press, 1978), p. 21 and Robert Delaunay, *Du Cubisme à l'Art Abstrait* (Paris: S.E.V.P.E.N., 1957), p. 79, quoted from Robert Delaunay's first notebook, 1939.

9. Sonia Delaunay, *Nous Irons Jusqu'au Soleil,* p. 152.

10. Robert Delaunay in Cohen, *The New Art of Color,* p. 70, quoted from a letter of 1917.

11. Cohen has chosen to translate *moyens* generally as "technique." Cohen, *The New Art of Color,* passim. This is certainly what Robert Delaunay implied, but once again, the term is unclear. It is more frequently and more loosely translated as "ways" or "means."

12. Robert Delaunay in Cohen, *The New Art of Color,* pp. 70-71, quoted from a letter of 1917.

13. Sonia Delaunay, *Nous Irons Jusqu'au Soleil,* p. 35.

14. Ibid., p. 31.

15. Johan Huizinga, *Homo Ludens, A Study of the Play-Element in Culture* (Boston: Beacon Press, 1955), pp. 1-27, passim.

16. Ibid., pp. 165-72, passim.

17. Ibid., p. 166.

18. Cindy Nemser, *Art Talk: Conversations with 12 Women Artists* (New York: Charles Scribner's Sons, 1975), p. 42.

19. Sonia Delaunay in Cohen, *The New Art of Color,* p. 197, quoted from "Sonia Delaunay on Sonia Delaunay," written in 1967.

20. Quoted from Sonia Delaunay in *Sonia Delaunay,* exhib. cat. (New York: Denise René Gallery, 1968), n.p.

21. Jacques Damase, "Sonia Delaunay: 60 Ans de recherches et d'innovations," in *Sonia Delaunay,* exhib. cat. (La Rochelle: Musée des Beaux-Arts de la Rochelle, Maison de la Culture, 1973), n.p.

22. Sonia Delaunay quoted in 1968 Denise René Gallery catalogue, n.p.

23. Sonia Delaunay, *Nous Irons Jusqu'au Soleil,* p. 206.

24. Sonia Delaunay quoted in 1968 Denise René Gallery catalogue, n.p.

25. R. G. Collingwood, *The Principles of Art* (London, Oxford, New York: Oxford University Press, 1958), p. 275.

26. Ibid., pp. 225-41, passim.

27. Huizinga, *Homo Ludens,* p. 4.

28. Collingwood, *The Principles of Art,* passim.

29. Sonia Delaunay quoted in 1968 Denise René Gallery catalogue, n.p.

30. Robert Delaunay in Cohen, *The New Art of Color,* p. 82 from "Light."

31. Sonia Delaunay, *Nous Irons Jusqu'au Soleil,* pp. 45-46.

32. Sonia Delaunay in Cohen, *The New Art of Color,* p. 197, quoted from "Sonia Delaunay on Sonia Delaunay."

33. Ogden N. Rood, *Modern Chromatics, Student Text-book of Color with Applications to Art and Industry* (New York: Van Nostrand Reinhold Company, 1973), first published in 1879.

34. E. H. Gombrich, *The Sense of Order, A Study in the Psychology of Decorative Art* (Ithaca: Cornell University Press, 1979), p. 117.

35. Ibid., passim.

36. Germain Viatte, preface in *Sonia Delaunay: Dessins, Noirs et Blancs* (Paris: Jacques Damase, Artcurial Editeurs, 1978), p. 6.

37. Damase in 1973 La Rochelle catalogue, n.p.

38. Gombrich, *The Sense of Order,* p. 10.

39. Ibid., p. 166.

40. Sonia Delaunay, *Nous Irons Jusqu'au Soleil,* p. 141.

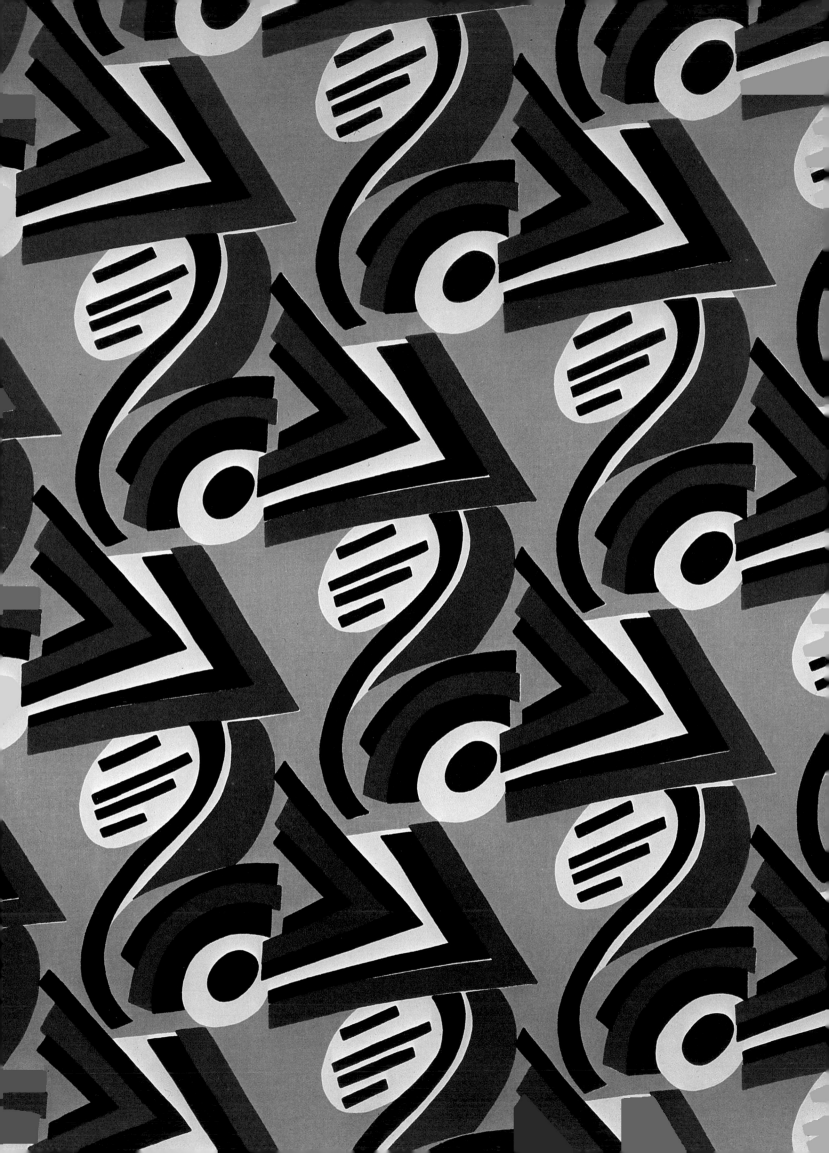

CATALOGUE OF THE EXHIBITION

Dimensions are given in inches followed by centimeters in parentheses. Height precedes width. Page numbers for illustrations are indicated in parentheses at end of each entry.

PAINTINGS

1. *Self-portrait (Autoportrait)*, c. 1904
 No. 2022, sepia ink on canvas, 18-1/8 x 12-3/8 (46 x 31.5)
 Collection Sonia Delaunay, Paris (p. 124)

2. *Philomène*, 1907
 No. 12, oil on canvas mounted on board,
 15-15/16 x 16-9/16 (40.5 x 42)
 Collection Sonia Delaunay, Paris (p. 16)

3. *Philomène*, 1907
 oil on canvas, 16-1/8 x 13 (41 x 33)
 Collection Edythe and Saul Klinow, Muttontown, New York
 (p. 127)

4. *Portrait of Tchouiko (Portrait de Tchouiko)*, 1907
 No. 20, oil on canvas, 21-11/16 x 18-1/8 (55 x 46)
 Collection Sonia Delaunay, Paris (p. 20)

5. *Young Finnish Woman (Jeune finlandaise)*, 1907
 oil on canvas, 31-1/2 x 25-3/16 (80 x 64)
 Collection Musée National d'Art Moderne, Paris (p. 128)

6. *Landscape at the Water's Edge (Paysage au bord de l'eau)*, 1908
 No. 1078, oil on canvas, 29-1/8 x 36-1/4 (74 x 92)
 Collection Sonia Delaunay, Paris (p. 129)

7. *Portrait of Tchouiko (Portrait de Tchouiko)*, 1908
 No. 19, oil on canvas, 21-11/16 x 18-1/8 (55 x 46)
 Collection Sonia Delaunay, Paris (p. 130)

8. *Yellow Nude (Nu jaune)*, 1908
 No. 1405, oil on canvas, 25-5/8 x 38-5/8 (65 x 98)
 Collection Jacques Damase, Paris (p. 131)

9. *Simultaneous contrasts (Contrastes simultanés)*, 1912
 No. 659, oil on canvas, 17-15/16 x 21-11/16 (45.5 x 55)
 Collection Musée National d'Art Moderne, Paris (p. 134)

10. *Bal Bullier (Le Bal Bullier)*, 1913
 oil on canvas, 38-3/16 x 51-15/16 (97 x 132)
 Collection Kunsthalle, Bielefeld, West Germany (p. 138)
 (will travel to Buffalo only)

11. La Prose du Transsibérien et de la petite Jehanne
 de France *by Blaise Cendrars (par Blaise Cendrars)*, 1913
 oil on canvas, 76-1/4 x 7-1/2 (193.6 x 19)
 Collection Musée National d'Art Moderne, Paris (p. 137)

12. *Tango-Magic-City*, 1913
 oil on canvas, 21-13/16 x 18-1/8 (55.4 x 46)
 Collection Kunsthalle, Bielefeld, West Germany (p. 140)

13. *Zénith*, 1913
 No. 890, oil on canvas, 12 x 14-15/16 (30.5 x 38)
 Collection Sonia Delaunay, Paris (p. 142)

14. *Dubonnet*, 1914
 oil on canvas, 39-3/4 x 52 (101 x 132)
 Collection Mrs. Rachel Adler, New York (p. 144)

15. *Dubonnet*, 1914
 No. 797, oil on canvas, 24 x 30 (60.9 x 76.2)
 Collection Tamar J. Cohen, New York (p. 145)

16. *Portuguese Still Life (Nature morte portugaise)*, 1916
 No. 863, encaustic on canvas, 14-15/16 x 22-1/16 (38 x 56)
 Collection Mme. Georges Pompidou, Paris (p. 154)

17. *Young Girl with Pumpkin (Jeune fille au potiron)*, 1916
 oil on canvas, 21-1/2 x 25-1/4 (54.6 x 64.1)
 Collection Leonard Hutton Galleries, New York (p. 153)
 (will not travel to Chicago or Montreal)

18. *Rhythm (Rythme)*, 1938
 No. 123A, oil on canvas, 70-7/8 x 58-11/16 (180 x 149)
 Collection Musée National d'Art Moderne, Paris (p. 179)

19. *Rhythm (Rythme)*, 1945
 oil on canvas, 51 x 34-7/8 (129.5 x 88.6)
 Collection The Grey Art Gallery and Study Center,
 New York University Art Collection, gift of
 Mr. and Mrs. Myles Perrin (p. 182)

20. *Rhythm (Rythme)*, 1946
 oil on canvas, 69 x 59 (175.2 x 149.8)
 Collection Tamar J. Cohen, New York (p. 183)

21. *Colored Rhythm (Rythme coloré)*, 1948
 No. 616, oil on canvas, 40-15/16 x 57-1/8 (104 x 145)
 Collection Sonia Delaunay, Paris (p. 186)

22. *Colored Rhythm (Rythme coloré)*, 1953
 No. 175, oil on canvas, 39-3/8 x 86-5/8 (100 x 220)
 Collection Sonia Delaunay, Paris (pp. 188-189)

23. *Rhythm-Color (Rythme-couleur)*, 1953
 No. 132, oil on canvas, 44-1/2 x 57-1/2 ((113 x 146)
 Collection Sonia Delaunay, Paris (p. 185)

24. *Composition, Rhythm (Composition, rythme)*, 1955-58
 oil on canvas, 63-3/16 x 85-7/8 (160.2 x 218.1)
 Collection Musée National d'Art Moderne, Paris (pp. 190-191)

25. *Colored Rhythm (Rythme coloré)*, 1958
 No. 698, oil on canvas, 45 x 34 1/4 (114.3 x 87)
 Collection Albright-Knox Art Gallery, Buffalo, New York, gift of
 Seymour H. Knox (p. 192)

26. *Rhythm-Color (Rythme-couleur)*, 1959-60
 No. 894, oil on canvas, 49 x 64 (124.5 x 162.5)
 Collection Kunsthalle, Bielefeld, West Germany (pp. 194-195)

27. *Rhythm Without End — Dance (Rythme sans fin — danse)*,
 1964 (after 1923 watercolor)
 No. 1154, oil on canvas, 63-3/4 x 51-3/16 (162 x 130)
 Collection Sonia Delaunay, Paris (p. 196)

28. *Design for Stained Glass Window, (Projet pour vitrail)*, 1967
 gouache on panel, 45 x 13-1/2 (114.3 x 34.3)
 Collection Tamar J. Cohen, New York (p. 199)

29. *Rhythm-Color (Rythme-couleur)*, 1967
 No. 1229, oil on canvas, 78-3/4 x 59-1/16 (200 x 150)
 Collection Sonia Delaunay, Paris (p. 200)

30. *Rhythm-Color (Rythme-couleur)*, 1967
 No. 1234, oil on canvas, 63-3/8 x 51-3/16 (161 x 130)
 Collection Sonia Delaunay, Paris (p. 201)

31. *Rhythm-Color Called "Large Round Painting"
 (Rythme-couleur dit "grand tableau rond")*, 1967
 No. 1541, oil on canvas, diameter 88 5/8 (225)
 Collection Sonia Delaunay, Paris (p. 202)

32. *Rhythm-Color (Rythme-couleur)*, 1967
 No. 1554, oil on canvas, 78-3/8 x 59-1/16 (199 x 150)
 Collection Sonia Delaunay, Paris (p. 203)

33. *Syncopated Rhythm called "Black Serpent"
 (Rythme syncopé dit "Serpent noir")*, 1967
 No. 1532, oil on canvas, 49-1/4 x 98-9/16 (125 x 250)
 Collection Sonia Delaunay, Paris (pp. 204-205)

34. *Rhythm-Color (Rythme-couleur)*, 1970
 No. 1633, oil on canvas, 52-1/2 x 39-1/2 (133.4 x 100)
 The National Archives of the United States,
 Washington, D. C. (p. 207)

WORKS ON PAPER

35. *Nude Lying on the Beach (Nu étendu au bord de la mer)*, 1901
 No. 2030, pencil, 5-15/16 x 9-1/16 (15 x 23)
 Collection Patrick Raynaud, Paris (p. 124)

36. *Aunt (Tante)*, 1904
 No. 523, charcoal and chalk, 18-7/8 x 11-13/16 (48 x 30)
 Collection Sonia Delaunay, Paris (p. 124)

37. *Study, People Around a Table (Etude, personnages
 autour d'une table)*, c. 1904
 No. 2033, gouache, 8-11/16 x 14-9/16 (22.1 x 37)
 Collection Sonia Delaunay, Paris (p. 125)

38. *Two Male Heads (Deux têtes d'hommes)*, 1904
No. 2018, charcoal and chalk, 14-3/4 x 22-1/16 (37.5 x 56)
Collection Sonia Delaunay, Paris (p. 125)

39. *"Chez Maurice," Place Blanche*, c. 1905
No. 2031, pencil on vellum, 9-15/16 x 13-15/16 (25.3 x 35.5)
Collection Sonia Delaunay, Paris (p. 126)

40. *Seated Nude (Nu assis)*, c. 1905
pencil on vellum, 12-3/16 x 9-7/16 (31 x 24)
Collection Sonia Delaunay, Paris (p. 126)

41. *Study of a Young Girl (Etude de jeune fille)*, c. 1905
No. 2039, pencil 12-3/16 x 9-5/8 (31 x 24)
Collection Arthur A. and Elaine Lustig Cohen, New York (p. 17)

42. *Study of a Young Girl (Etude de jeune fille)*, c. 1905
No. 2042, pencil, 12-3/16 x 9-7/16 (31 x 24)
Collection Sonia Delaunay, Paris (p. 126)

43. *Study of nude from back (Etude de nu de dos)*, c. 1905
No. 2045, pencil, 12-3/16 x 9-7/16 (31 x 24)
Collection Sonia Delaunay, Paris (p. 126)

44. *Ile St. Louis*, 1906
No. 606, etching, 9-7/8 x 12-7/8 (25 x 32.7)
Collection Sonia Delaunay, Paris (p. 19)

45. *Reclining Nude (Nu couché)*, 1909
No. 2034, pencil on vellum, 9-7/16 x 12-3/16 (24 x 31)
Collection Sonia Delaunay, Paris (p. 131)

46. *Study of Women (Etude de femmes)*, 1909
No. 2038, pencil on vellum, 12-3/16 x 9-7/16 (31 x 24)
Collection Sonia Delaunay, Paris (p. 22)

47. *Simultaneous contrast (Contraste simultané)*, 1912-13
No. 1152, collage and gouache, 13 x 9-11/16 (33 x 24.5)
Collection Sonia Delaunay, Paris (p. 135)

48. *Zone*, 1912-13
No. 1456, china ink and crayon, 12-5/8 x 19-11/16 (32 x 50)
Collection Sonia Delaunay, Paris (p. 36)

49. *Dancing Couple, Study for Bal Bullier (Danseurs, étude pour le
Bal Bullier)*, 1913
pastel, 11 x 7-5/8 (27.9 x19.6)
Collection André Emmerich, New York (p. 141)

50. *Design for Pirelli Poster (Projet d'affiche Pirelli)*, 1913
No. 214, pastel, 7-7/8 x 10-1/4 (19.7 x 27)
Collection Sonia Delaunay, Paris (p. 141)

51. *Simultaneous Contrasts: Poster for Smirnoff Lecture (Contrastes
simultanés: affiche conférence Smirnoff)*, 1913
No. 471, watercolor, 25-3/16 x 19-3/8 (64 x 49.2)
Collection Sonia Delaunay, Paris (p. 136)

52. *Studies of colors (Etudes de couleurs)*, 1913
No. 204, crayon, 6-7/16 x 7-11/16 (16.4 x 19.5)
Collection Sonia Delaunay, Paris (p. 135)

53. *Studies of Light — Boulevard St. Michel (Etudes de lumière —
Boulevard St. Michel)*, 1913
No. 203, crayon, 5-3/16 x 5-13/16 (13.3 x 14.7)
Collection Sonia Delaunay, Paris (p. 135)

54. *Studies of Light — Boulevard St. Michel (Etudes de lumière —
Boulevard St. Michel)*, 1913
No. 205, crayon, 6-1/2 x 11 (16.5 x 27.9)
Collection Sonia Delaunay, Paris (p. 135)

55. *Zénith*, 1913-14
No. 483, crayon, 7-1/4 x 8-5/16 (18.4 x 21.7)
Collection Sonia Delaunay, Paris (p. 143)

56. *Zénith*, 1913-14
No. 5031, watercolor, 7-11/16 x 9-7/8 (19.5 x 25)
Collection Sonia Delaunay, Paris (p. 141)

57. *Crowd Movement, Electric Prisms (Mouvement de foule,
prismes électriques)*, 1914
No. C409, crayon, 9-7/8 x 7-1/2 (25 x 19)
Collection Kunsthalle, Bielefeld, West Germany (p. 147)

58. *Electric Prisms (Prismes électriques)*, 1914
No. 32, crayon, 10-1/16 x 7-9/16 (25.6 x 19.2)
Collection Sonia Delaunay, Paris (p. 38)

59. *Electric Prisms (Prismes électriques)*, 1914
No. 841, crayon, 9-5/8 x 8-1/2 (24.5 x 21.5)
Collection Sonia Delaunay, Paris (p. 147)

60. *Electric Prisms (Prismes électriques)*, 1914
No. 40, collage and crayon, 11-5/8 x 7-5/16 (29.5 x 18.5)
Collection Sonia Delaunay, Paris (p. 147)

61. *Solar Prism (Woman with parasol) (Prisme Solaire [Femme à
l'ombrelle])*, 1914
collage and crayon, 19-1/2 x 13 (49.5 x 33)
Private collection, New York (p. 146)

62. *Zénith*, 1914
No. 495, gouache, 13-3/4 x 12 (34.9 x 30.5)
Collection Tamar J. Cohen, New York (p. 143)

63. *Zénith*, 1914
No. 495A, gouache, 23-1/2 x 19-1/2 (59.7 x 49.5)
Collection Tamar J. Cohen, New York (p.143)

64. *Circles (Cercles)*, 1915
gouache, 18-1/2 x 17 (47 x 43.2)
Collection André Emmerich, New York (p. 148)

65. *Disks (Disques)*, 1915
Two works in one frame, l to r.
 1. *Disk (Disque)*, 1915
 No. 155, sizing on paper, 7-1/8 x 8-1/2 (18 x 21.5)
 2. *Disk (Disque)*, 1915
 No. 153, sizing on paper, 7-3/4 x 5-11/16 (19.7 x 14.4)
Collection Sonia Delaunay, Paris (p. 148)

66. *Portuguese Toys (Jouets portugais)*, 1915
No. 467, gouache and wax on paper, 11-3/16 x 8-15/16
(28 x 22.7)
Collection Musée National d'Art Moderne, Paris (p. 149)

67. *Album, No. 1*, 1916
No. 999, wax on paper, 8-1/2 x 8-3/4 (21.5 x 22.3)
Collection Tamar J. Cohen, New York (p. 45)

68. *Album, No. 1*, 1916
No. F1001, wax on paper, 9-1/8 x 9-1/4 (23 x 23.5)
Collection Arthur A. and Elaine Lustig Cohen, New York (p. 149)

69. *Catalogue for Stockholm Exhibition — Self-portrait and
Announcement of Exhibition (Catalogue pour l'exposition de
Stockholm — Autoportrait et annonce de l'exposition)*, 1916
pochoir, 12-5/8 x 16-15/16 (32 x 43)
Collection Sonia Delaunay, Paris (p. 150)

70. *Chocolate (Chocolat)*, 1916
No. 582, pastel, 9-3/4 x 7-3/4 (24.7 x 19.7)
Collection Arthur A. and Elaine Lustig Cohen, New York (p. 151)

71. *Chocolate (Chocolat)*, 1916
No. 1011, gouache, 9-1/4 x 9-1/2 (23.5 x 24.1)
Collection Mrs. Kay Hillman, New York (p. 151)
(will not travel to Montreal)

72. *Dancer (Danseuse)*, 1916
No. 416, watercolor and gouache on paper mounted on board,
14-3/16 x 9-5/16 (35.8 x 23.7)
Collection Musée National d'Art Moderne, Paris (p. 152)

73. *Dancer, Second Version (Danseuse, deuxième version)*, 1916
No. 110, gouache, crayon and watercolor, 22-7/16 x 18-7/8
(57.2 x 48)
Collection Albright-Knox Art Gallery, Buffalo, New York. General
Purchase Funds. (p. 152)

74. *Disk (Disque)*, 1916
No. 154, sizing on paper, 10-1/2 x 8-1/16 (26.6 x 20.5)
Collection Sonia Delaunay, Paris (p. 148)

75. *Market at Minho (Marché au Minho)*, 1916
No. 457, gouache and crayon, 9 x 12 (22.9 x 30.5)
Collection Mr. and Mrs. Henry M. Reed, Montclair, New Jersey
(p. 44)

76. *Portuguese Still Life (Nature morte portugaise)*, 1916
 wax on paper mounted on board, 27-9/16 x 37-7/16 (68.5 x 95)
 Collection Musée National d'Art Moderne, Paris (p. 155)

77. *Self-portrait (Autoportrait)*, 1916
 No. 28, gouache, 11-5/8 x 8-11/16 (29.5 x 22)
 Collection Sonia Delaunay, Paris (p. 149)

78. *Self-portrait (Autoportrait)*, 1916
 No. 380, wax on paper, 13-1/4 x 19 (33.7 x 48.3)
 Collection Tamar J. Cohen, New York (p. 150)

79. *Studies for the Poster "Chocolate" (Etudes d'affiche
 "chocolat")*, 1916
 Three works in one frame, top to bottom:
 1. 1047A, 5-11/16 x 10-1/16 (14.5 x 25.5)
 2. 1047, 3-7/8 x 9-11/16 (10 x 25)
 3. 3-5/8 x 7-5/16 (9.7 x 18.8)
 Collection Bibliothèque Nationale, Paris (p. 151)

80. *Self-portrait: Project for Exhibition in Stockholm (Autoportrait:
 projet pour l'exposition de Stockholm)*, 1916
 No. 962, wax on paper, 12-1/2 x 12-1/4 (31.8 x 31.1)
 Collection Tamar J. Cohen, New York (p. 50)

81. *Cleopatra as Mummy (Cléopâtre comme momie)*, 1918
 No. 189, gouache, 12-7/16 x 9-5/8 (31.5 x 24.5)
 Collection Sonia Delaunay, Paris (p. 157)

82. *Costume for Cleopatra (Costume pour Cléopâtre)*, 1918
 No. 693, watercolor, 22-7/16 x 14-3/8 (57 x 36.5),
 incorrect inscription added at later date
 Collection Sonia Delaunay, Paris (p. 156)

83. *Costumes for* Cléopâtre *(Costumes pour* Cléopâtre*)*, 1918
 No. 68, watercolor, 10-3/4 x 20-1/8 (27.3 x 51.1)
 Collection Sonia Delaunay, Paris (p. 158)

84. *Costumes for* Cléopâtre, *Project for four shawls (Costumes
 pour* Cléopâtre, *Projet pour quatre châles)*, 1918
 No. 754, watercolor, four works in one frame, each
 12-1/4 x 3-3/4 (31 x 9.5)
 Collection Sonia Delaunay, Paris (p. 157)

85. *Design for fabric for* Cléopâtre *No. 1, (Projet de tissu pour*
 Cléopâtre *No. 1)*, 1918
 watercolor and ink, 4-3/4 x 13-9/16 (12 x 34.5)
 Collection Mr. and Mrs. N. Lobanov-Rostovsky, London (p. 156)

86. *Design for fabric for* Cléopâtre *No. 2, (Projet de tissu pour*
 Cléopâtre *No. 2)*, 1918
 gouache and ink, 5-1/16 x 12-3/16 (12.7 x 31)
 Collection Mr. and Mrs. N. Lobanov-Rostovsky, London (p. 156)

87. *Design for fabric for* Cléopâtre *No. 3, (Projet de tissu pour*
 Cléopâtre *No. 3)*, 1918
 gouache and ink, 4-3/4 x 12-3/16 (12 x 31)
 Collection Mr. and Mrs. N. Lobanov-Rostovsky, London (p. 156)

88. *Stage Design, Mummy for Screen for* Cléopâtre, *(Projet de
 décors, momie pour l'écran pour* Cléopâtre*)*, 1918
 watercolor and ink, 12-5/8 x 9-5/8 (32 x 24.4)
 Collection Mr. and Mrs. N. Lobanov-Rostovsky, London (p. 157)

89. *Stage Design, Mummy for* Cléopâtre, *(Projet de décors, momie
 pour* Cléopâtre*)*, 1918
 No. 17, gouache, watercolor and ink, 12-1/2 x 9-3/8
 (31.8 x 23.8)
 Collection Mr. and Mrs. N. Lobanov-Rostovsky, London (p. 158)

90. *Studies for* Cléopâtre *(Etudes pour* Cléopâtre*)*, 1918
 Two works in one frame, left to right:
 1. No. 1676, ink, 9-1/2 x 6-3/4 (24 x 17)
 2. No. 1676a, watercolor, 8-1/4 x 6-1/8 (21 x 15.5)
 Collection Sonia Delaunay, Paris (p. 158)

91. *Costume Studies*, 1919-23
 Three works in one frame, l. to r.
 1. *Costume*, 1919
 No. 1540, china ink, 10-1/16 x 6-1/2 (25.5 x 16.5)
 2. *Simultaneous Dress, Rhythm Without End (Robe
 simultanée, rythme sans fin)*, 1923

No. 510, watercolor, 11-7/16 x 7-1/2 (29 x 19)
 3. *Costume*, 1923
 No. 1539, watercolor, 10-1/16 x 5-15/16 (25.5 x 15)
 Collection Sonia Delaunay, Paris (p. 76)

92. *Costume design (for Amneris in* Aida*), (Projet de costume
 [pour Amneris dans* Aida*])*, 1920
 watercolor, gouache and pencil, 19-3/4 x 15 (50 x 38)
 Collection Mississippi Museum of Art, Jackson, The Lobanov
 Collection (p. 53)

93. *Maquette for Curtain-poem by Philippe Soupault (Maquette
 pour le rideau-poème de Philippe Soupault)*, 1922
 gouache, 57-7/8 x 57-1/16 (147 x 145)
 Collection Bibliothèque Nationale, Paris (p. 58)

94. *Group of Women (Groupe de femmes)*, 1922-23
 No. 1454, china ink and pencil, 8-1/4 x 10-5/8 (21 x 27)
 Collection Sonia Delaunay, Paris (p. 72)

95. *Panel of Costumes (Panneau de costumes)*, eight drawings,
 1922-25
 No. 1473, 24-13/16 x 60-1/4 (63 x 153)
 l. to r. 1. No. 405, 1922, watercolor and china ink,
 12-1/4 x 8-7/8 (31 x 22.5)
 2. No. 518, 1925, watercolor, 12-5/8 x 9-7/8 (32 x 25)
 3. No. c, 1924, china ink and watercolor, 10-5/8 x 7-1/8
 (27 x 18)
 4. No. d, 1925, watercolor, 12-5/8 x 10-1/16 (32 x 25.5)
 5. No. e, 1925, watercolor and china ink,
 9-5/8 x 6-15/16 (24.1 x 17.1)
 6. No. f, 1923, watercolor and china ink, 12-1/4 x 7-7/8
 (31 x 20)
 7. No. g, 1923, watercolor and china ink, 12-1/4 x 7-7/8
 (31 x 20)
 8. No. 804, 1922, watercolor and china ink,
 12-5/8 x 9-1/16 (32 x 23)
 Collection Sonia Delaunay, Paris (pp. 162-163)

96. *Panel of Costumes (Panneau de costumes)*, nine drawings,
 1922-26
 No. 1474, 26-7/16 x 60-1/4 (62.7 x 153)
 l. to r. 1. No. 63, 1922, watercolor, 12-1/4 x 8-7/8 (31 x 22.5)
 2. No. 65, 1923, watercolor, 9-7/8 x 5-15/16 (25 x 14.8)
 3. Dress, watercolor, 13-13/16 x 9-7/8 (35 x 25)
 4. Dress, No. L, watercolor, 12-5/8 x 7-1/2 (32 x 19)
 5. Dress, No. M, watercolor, 13-13/16 x 9-7/8 (35 x 25)
 6. Dress, No. N, 1926, watercolor, 13-13/16 x 9-7/8
 (35 x 25)
 7. Dress, No. O, 1923, watercolor, 12-1/4 x 9-1/16
 (31 x 23)
 8. Dress, No. P44, watercolor, 13-13/16 x 9-7/16
 (35 x 24)
 9. Dress, No. Q523, 1923, watercolor, 12-1/4 x 9-7/8
 (31 x 25)
 Collection Sonia Delaunay, Paris (pp. 162-163)

97. *Design for Female Costume for* Le Coeur à Gaz *(Projet de
 costume de femme pour* Le Coeur à Gaz*)*, 1923
 No. 677, watercolor, 15-7/8 x 11-7/16 (40.2 x 29)
 Collection Sonia Delaunay, Paris (p.161)

98. *Design for Male Costume for* Le Coeur à Gaz *(Projet de
 costume d'homme pour* Le Coeur à Gaz*)*, 1923
 No. 277, watercolor, 16-15/16 x 11-7/16 (43 x 29)
 Collection Sonia Delaunay, Paris (p. 161)

99. *Dress (Robe)*, 1923
 No. 5348, china ink, 10-7/16 x 8-1/4 (26.5 x 21)
 Collection Sonia Delaunay, Paris (p. 166)

100. *Dress, Rhythm Without End (Robe, rythme sans fin)*, 1923
 No. 602a, china ink, 9 x 4-15/16 (22.9 x 12.6)
 Collection Sonia Delaunay, Paris (p. 167)

101. *Dress-poèm by Tzara (Robe-poème par Tzara)*, 1923
 gouache, 12 x 7-1/2 (30.5 x 19)
 Collection Tamar J. Cohen, New York (p. 166)

130. *Graphic Research (Recherche graphique)*, 1933
No. 1439, china ink, 6-1/2 x 5-15/16 (16.5 x 15)
Collection Bibliothèque Nationale, Paris (p. 176)

131. *Graphic Research (Recherche graphique)*, 1933
No. 1440, china ink, 7-1/8 x 6-1/2 (18 x 16.5)
Collection Bibliothèque Nationale, Paris (p. 176)

132. *Design for Panel for the Air Pavilion: Airplane Motor (Projet de panneau pour le Palais de l'Air: moteur d'avion)*, 1936
No. 701, gouache, 9-1/2 x 22-1/16 (24 x 56)
Collection Sonia Delaunay, Paris (p. 177)

133. *Design for Panel for the Air Pavilion: Control Panel (Projet de panneau pour le Palais de l'Air: tableau de bord)*, 1936
No. 702, gouache, 9-1/2 x 22-1/16 (24 x 56)
Collection Sonia Delaunay, Paris (p. 177)

134. *Design for Panel for the Air Pavilion: Propeller (Projet de panneau pour le Palais de l'Air: l'hélice)*, 1936
No. 703, gouache, 9-1/2 x 22-1/16 (24 x 56)
Collection Sonia Delaunay, Paris (p. 177)

135. *Projects for "Mica-tube,"* 1936
Two works in one frame, top to bottom:
1. *Design for neon sign for "Mica-tube, a Ribbon of Light" (Projet d'affiche lumineuse pour "Mica-tube, un ruban de lumière")* No. 799, gouache, 8-1/8 x 12-1/4 (20.7 x 30.9)
2. *Poster design for "Mica-tube" neon lighting (Projet d'affiche pour les lampes "Mica-tube")* No. 5087, gouache, 7-9/16 x 15-3/16 (19.2 x 38.6)
Collection Bibliothèque Nationale, Paris (p. 83)

136. *Project for Distant Voyages (Projet pour voyages lointains)*, 1936-37
No. 529, gouache, 11-3/4 x 9-1/2 (29.9 x 24.1)
Collection Mrs. Kay Hillman, New York (p. 178)
(will not travel to Montreal)

137. *Design for Poster for Delaunay Aperitif: "A Delaunay is good at all times." (Projet d'affiche pour l'aperitif Delaunay: "Un Delaunay est bon a toute heure.")*, c. 1937
No. 5067, gouache, 19-5/16 x 12-5/8 (49 x 32)
Collection Bibliothèque National, Paris (p. 89)

138. *Distant Voyages (Voyages lointains)*, 1936-37
gouache, 13-1/8 x 36-1/4 (34 x 92)
Collection Musée National d'Art Moderne, Paris (p. 178)

139. *Composition*, 1938
No. 85, gouache on paper, 41-3/8 x 29-3/8 (105 x 74.5)
Collection Sonia Delaunay, Paris (p. 180)

140. *First Design for King of Clubs (Premier projet pour le roi de trèfle)*, 1938
No. 628, gouache, 25-1/8 x 19-1/8 (63.7 x 48.5)
Collection Kunsthalle, Bielefeld, West Germany (p. 96)

141. *First Design for Queen of Hearts (Premier projet pour la reine de coeur)*, 1938
No. 629, gouache, 25-1/8 x 19-1/8 (63.7 x 48.5)
Collection Kunsthalle, Bielefeld, West Germany (p. 96)

142. *Rhythm No. 5 (Rythme No. 5)*, 1939
gouache, 10-3/4 x 9-1/16 (27.3 x 23)
Collection Tamar J. Cohen, New York (p. 181)

143. *Landscape at Grasse (Paysage de Grasse)*, 1942
No. 823, crayon, 11-13/16 x 8-11/16 (30 x 24.5)
Collection Sonia Delaunay, Paris (p. 91)

144. *Composition*, 1943
No. 127a, gouache, 8-3/4 x 9-1/4 (22.2 x 23.5)
Collection Tamar J. Cohen, New York (p. 181)

145. *Outline for 3rd ABC Project (Esquisse pour ABC 3ᵉ projet)*, 1947
No. 1051, gouache, 9 x 9-11/16 (22.9 x 24.6)
Collection Sonia Delaunay, Paris (p. 184)

146. *Rhythm-Color (Rythme-couleur)*, 1947
No. 1989, gouache, 9-9/16 x 8-1/16 (24.3 x 20.5)
Collection Sonia Delaunay, Paris (p. 184)

147. *Study for the Letter A (Etude pour la lettre A)*, 1947
gouache and crayon, 9-7/8 x 12-7/8 (25 x 32.7)
Collection Bibliothèque Nationale, Paris (p. 184)

148. *Composition*, 1953
No. 313, watercolor, 15 x 12-1/8 (38.1 x 30.7)
Collection The Grey Art Gallery and Study Center, New York
University Art Collection, gift of Silvia Pizitz (p. 187)

149. *Composition*, 1954
No. 133, watercolor, 7-5/16 x 9-7/16 (18.5 x 24)
Collection The Grey Art Gallery and Study Center, New York,
University Art Collection, gift of Rose Fried (p. 187)

150. *Playing Cards (Jeu de cartes)*, 1959
lithograph, 37-1/2 x 25-1/2 (95.2 x 64.7)
Issued by Altenburger und Stralsunder Spielkarten, Leinfelden, West Germany
Collection Sonia Delaunay, Paris (p. 193)

151. *King of Spades Design for Playing Cards (Roi de pique. Projet pour jeu de cartes)*, 1960
No. 1067F, gouache, 7-3/16 x 4-15/16 (18.3 x 12.5)
Collection Sonia Delaunay, Paris (p. 97)

152-157. Poetry of Words, Poetry of Colors (Poésie de mots, poésie de couleurs), 1961
31/50, portfolio of 6 serigraphs, each 25-1/2 x 19-3/4 (64.8 x 50.2) (Edition Denise René, Paris)
Collection Albright-Knox Art Gallery, gift of Seymour H. Knox (not illustrated)

158. *Rhythm-Color (Rythme-couleur)*, 1962
No. 959, gouache, 21-7/16 x 28-1/2 (54.4 x 72.3)
Private collection (p. 195)

159. *Rhythm-Color (Rythme-couleur)*, 1964
No. 1146, gouache, 30-13/16 x 22-1/4 (78 x 56.5)
Collection Sonia Delaunay, Paris (p. 198)

160. *Rhythm-Color (Rythme-couleur)*, 1964
No. 1149, gouache, 30-3/4 x 22-1/4 (78 x 56.5)
Private collection (p. 197)

161. *Design for Schwarz Album (Projet pour l'Album Schwarz)*, 1965
No. 1692, crayon, 16-9/16 x 15-3/4 (42 x 40)
Collection Sonia Delaunay, Paris (p. 199)

162. *Rhythm-Color (Rythme-couleur)*, 1965
No 1301b, gouache, 22-7/16 x 16-15/16 (57 x 43)
Collection Sonia Delaunay, Paris (p. 199)

163. *Designs for cover of book by Jacques Damase, Sonia Delaunay (Projets de couverture pour le livre de Jacques Damase, Sonia Delaunay)*, 1969
six studies in one frame,
gouache, each 12-7/16 x 8-9/16 (31.5 x 21.7)
Collection Sonia Delaunay, Paris (p. 208)

164. *Drawing (Dessin)*, c. 1970
No. 1478, ink, 7-7/8 x 5-1/2 (20 x 14)
Collection Sonia Delaunay, Paris (p. 95)

165. *Rhythm (Rythme)*, 1970
gouache, 11-3/4 x 8-1/4 (30 x 21)
Collection Jacques Damase, Paris (p. 206)

166. *Syncopated Rhythm-Color (Rythme-couleur syncopé)*, 1971
No. 1838, gouache, 18-1/8 x 16-1/8 (46 x 41)
Collection Sonia Delaunay, Paris (p. 206)

167. *Rhythm-Color (Rythme-couleur)*, 1973
No. 1892, gouache, 17-5/16 x 13-3/8 (44 x 34)
Collection Sonia Delaunay, Paris (p. 206)

168. *Drawing (Dessin)*, 1976
No. 2061, ink, 8-1/4 x 5-1/8 (21 x 13)
Collection Sonia Delaunay, Paris (p. 95)

204. *Children's Games (Jeux d'enfants)*, 1967
Aubusson tapestry, 74 x 63 (188 x 160)
Collection Etablissements Pinton, Paris (p. 210)

205. *Counterpoint (Contrepoint)*, 1967
Aubusson tapestry, 88-3/16 x 68-1/2 (224 x 174)
Collection Etablissements Pinton, Paris (p. 211)

206. *Diagonal*, 1967
Aubusson tapestry, 77-15/16 x 58-1/4 (198 x 148)
Collection Etablissements Pinton, Paris (p. 211)

207. *Finistère*, 1967
Aubusson tapestry, 70-1/16 x 76-3/4 (178 x 195)
Collection Etablissements Pinton, Paris (p. 211)

208. *Monumental II*, 1967
Aubusson tapestry, 62 x 72 (157.5 x 307)
Collection Etablissements Pinton, Paris (p. 210)

209. Rug (Tapis), 1967 (reedition of 1925 rug) 82-11/16 x 79-1/2
 (210 x 202)
Issued by Artcurial, Paris
Collection Sonia Delaunay, Paris (p. 74)

210. Plate, 1969
16/30
ceramic, diameter 12 (30.5) (Edition Jacques Damase, Paris)
Collection Tamar J. Cohen, New York (p. 98)

211. Plate, 1969
21/30
ceramic, diameter 12 (30.5) (Edition Jacques Damase, Paris)
Collection Tamar J. Cohen, New York (p. 98)

212. *Black Magic*, 1977
(after c. 1925 design)
velvet on 3-panel screen, each panel 118-1/16 x 43-5/16
 (300 x 110)
Issued by Artcurial, Paris (p. 74)

213. *Black Magic*, 1977
10/900
(after c. 1925 design)
velvet panel, 117-9/16 x 43-5/16 (298.5 x 110)
Issued by Artcurial, Paris (p. 74)

214. *Checkered (A damiers)*, 1977
221/900
wool muslin shawl, 55-1/4 x 55-1/4 (140 x 140)
Issued by Artcurial, Paris (p. 74)

215. *Checks (Damiers)*, 1977
49/900
velvet panel, 117-9/16 x 43-5/16 (298.5 x 110)
Issued by Artcurial, Paris (p. 74)

216. *Circular Rhythms (Rythmes Circulaires)*, 1977
142/900
Limoges porcelain plate, diameter 15-3/4 (40)
Issued by Artcurial, Paris (p. 98)

217. *Claridge*, 1977
281/900
fabric place mat, 13-3/4 x 17-3/4 (35 x 45)
Issued by Artcurial, Paris (p. 98)

218. *Geometric Abstraction, (Abstraction géometrique)*, 1977
100/910
fabric panel, 117-9/16 x 59-1/16 (298.5 x 150)
Issued by Artcurial, Paris (not illustrated)

219. *Harlequin (Arlequin)*, 1977
149/900
after c. 1925 design
fabric panel, 117-9/16 x 55-1/16 (298.5 x 140)
Issued by Artcurial, Paris (p. 12)

220. *Jazz*, 1977
33/900
fabric panel, 117-9/16 x 55-1/16 (298.5 x 140)
Issued by Artcurial, Paris (p. 116)

221. *Lozenges (Losanges)*, 1977
45/900
fabric panel, 117-9/16 x 59-1/16 (298.5 x 150)
Issued by Artcurial, Paris (p. 74)

222. *Rhythms (Rythmes)*, 1977
406/900
crêpe de Chine scarf, 59-1/16 x 35-7/16 (150 x 90)
Issued by Artcurial, Paris (p. 74)

223. *Signal*, 1977
252/900
tablecloth, 55-1/4 x 55-1/4 (140 x 140)
Issued by Artcurial, Paris (p. 98)

224. *Signal*, 1977
724/900
Limoges porcelain plate, diameter 11-7/16 (29)
Issued by Artcurial, Paris (p. 98)

225. *Ulysses (Ulysse)*, 1977
27/900
fabric panel, 117-9/16 x 55-1/16 (298.5 x 140)
Issued by Artcurial, Paris (p. 212)

226. *Windsor*, 1977
385/900
Limoges porcelain plate, diameter 9-7/8 (25)
Issued by Artcurial, Paris (p. 98)

227. *Carnival (Carnaval)*, 1978
297/900
Limoges porcelain plate, diameter 11-7/16 (29)
Issued by Artcurial, Paris (p. 98)

228. *The Serpent (Le serpent)*, 1978
95/900
after c. 1922 design
crêpe de Chine scarf, 74-13/16 x 35-7/16 (190 x 90)
Issued by Artcurial, Paris (p. 74)

229. *Venice (Venise)*, 1978
158/900
Limoges porcelain vase, 8-15/16 x 10-1/16 x 4-3/8
 (22.7 x 25.5 x 11)
Issued by Artcurial, Paris (p. 98)

230. *Yellow Dancer (La Danseuse jaune)*, 1978
371/900
Limoges porcelain plate, diameter 9-7/8 (25)
Issued by Artcurial, Paris (p. 98)

231. *Jazz*, 1979
rug, 59-1/16 x 86-5/8 (150 x 220)
Collection Jacques Damase, Paris (p. 99)

Top: Cat. 35. *Nude Lying on the Beach
(Nu étendu au bord de la mer)*, 1901
No. 2030, pencil, 5-15/16 x 9-1/16 (15 x 23)
Collection Patrick Raynaud, Paris

Bottom, left: Cat. 1. *Self-portrait (Autoportrait)*, c. 1904
No. 2022, sepia ink on canvas, 18-1/8 x 12-3/8 (46 x 31.5)
Collection Sonia Delaunay, Paris

Bottom, right: Cat. 36. *Aunt (Tante)*, 1904
No. 523, charcoal and chalk, 18-7/8 x 11-13/16 (48 x 30)
Collection Sonia Delaunay, Paris

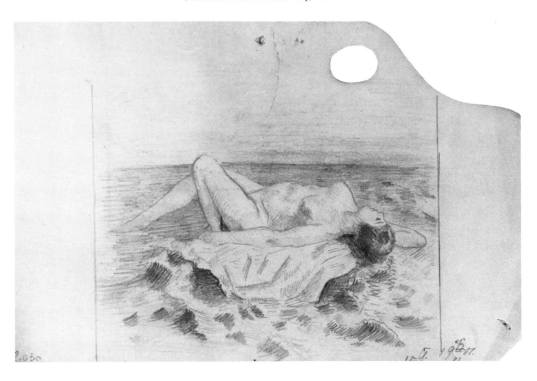

124

Top: Cat. 37. *Study, People Around a Table*
 (Etude, personnages autour d'une table), c. 1904
No. 2033, gouache, 8-11/16 x 14-9/16 (22.1 x 37)
Collection Sonia Delaunay, Paris

Bottom: Cat. 38. *Two Male Heads (Deux têtes d'hommes),* 1904
No. 2018, charcoal and chalk, 14-3/4 x 22-1/16 (37.5 x 56)
Collection Sonia Delaunay, Paris

Top: Cat. 39. *"Chez Maurice," Place Blanche,* c. 1905
No. 2031, pencil on vellum, 9-15/16 x 13-15/16 (25.3 x 35.5)
Collection Sonia Delaunay, Paris

Bottom, left: Cat. 40. *Seated Nude (Nu assis),* c. 1905
pencil on vellum, 12-3/16 x 9-7/16 (31 x 24)
Collection Sonia Delaunay, Paris

Center: Cat. 42. *Study of a Young Girl (Etude de jeune fille),* c. 1905
No. 2042, pencil, 12-3/16 x 9-7/16 (31 x 24)
Collection Sonia Delaunay, Paris

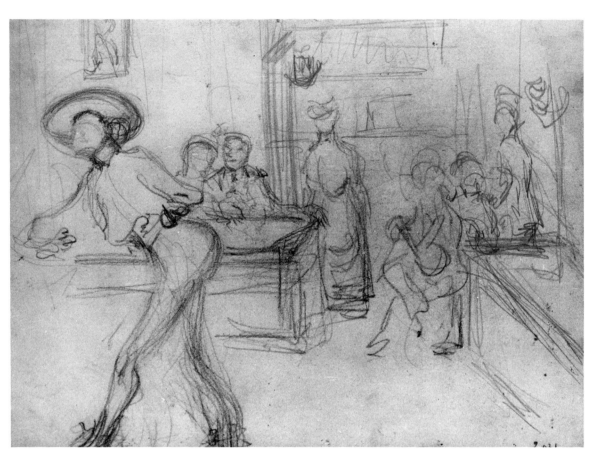

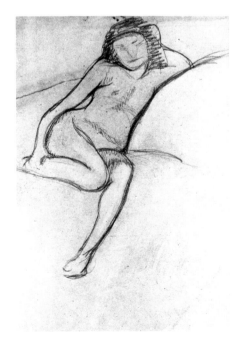 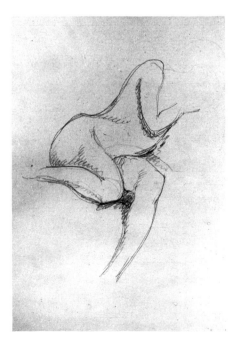 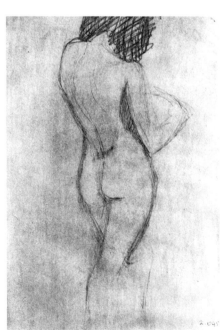

Opposite page, bottom, right: Cat. 43. *Study of nude from back*
 (Etude de nu de dos), c. 1905
No. 2045, pencil, 12-3/16 x 9-7/16 (31 x 24)
Collection Sonia Delaunay, Paris

Cat. 3. *Philomène,* 1907
oil on canvas, 16-1/8 x 13 (41 x 33)
Collection Edythe and Saul Klinow, Muttontown, New York

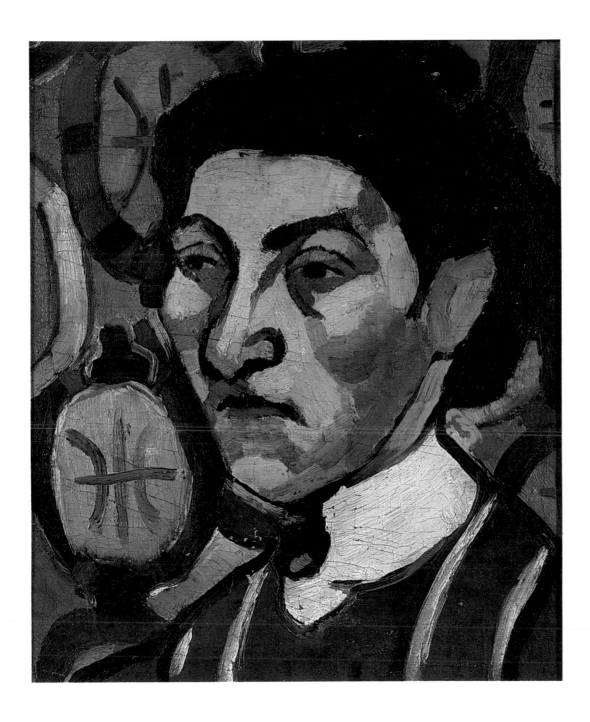

Cat. 5. *Young Finnish Woman (Jeune finlandaise)*, 1907
oil on canvas, 31-1/2 x 25-3/16 (80 x 64)
Collection Musée National d'Art Moderne, Paris

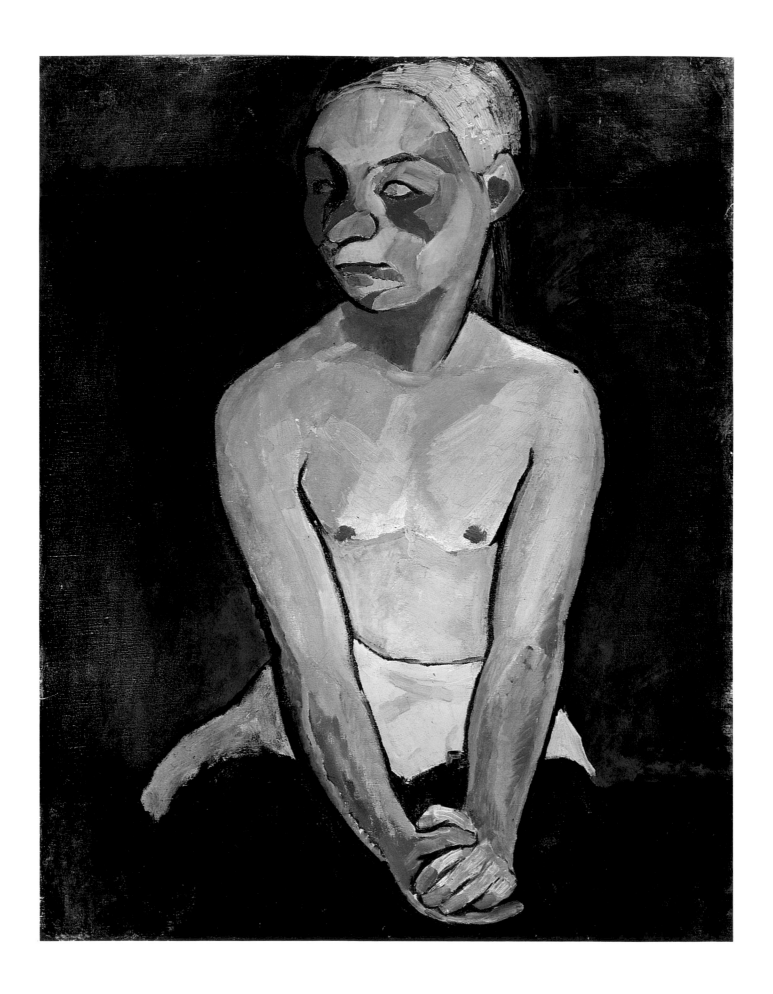

Cat. 6. *Landscape at the Water's Edge*
 (Paysage au bord de l'eau), 1908
No. 1078, oil on canvas, 29-1/8 x 36-1/4 (74 x 92)
Collection Sonia Delaunay, Paris

Cat. 7. *Portrait of Tchouiko (Portrait de Tchouiko),* 1908
No. 19, oil on canvas, 21-11/16 x 18-1/8 (55 x 46)
Collection Sonia Delaunay, Paris

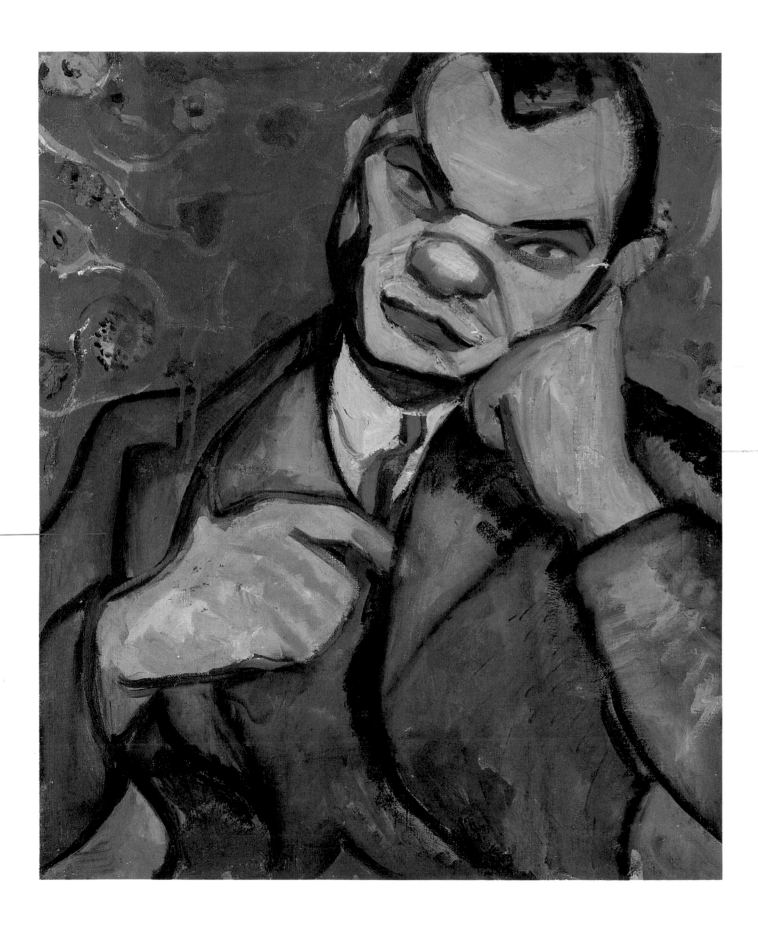

Top: Cat. 8. *Yellow Nude (Nu jaune),* 1908
No. 1405, oil on canvas, 25-5/8 x 38-5/8 (65 x 98)
Collection Jacques Damase, Paris

Bottom: Cat. 45. *Reclining Nude (Nu couché),* 1909
No. 2034, pencil on vellum, 9-7/16 x 12-3/16 (24 x 31)
Collection Sonia Delaunay, Paris

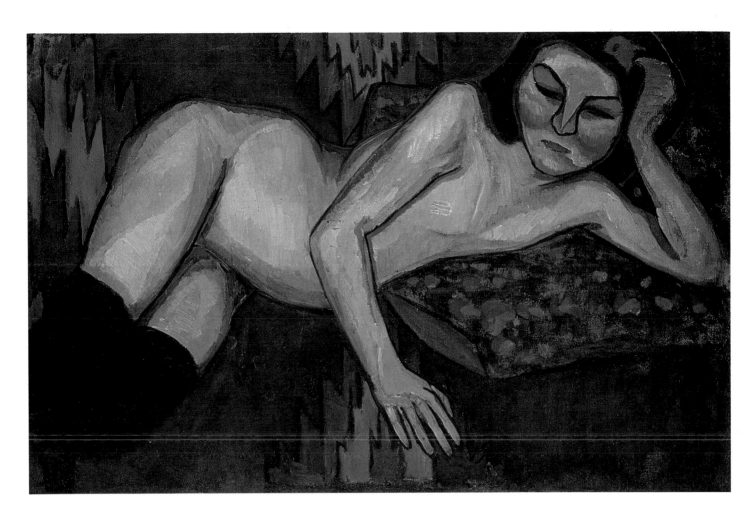

Cat. 194. Blanket (Couverture), 1911
No. 549, appliquéd fabric, 42-15/16 x 31-7/8 (109 x 81)
Collection Musée National d'Art Moderne, Paris

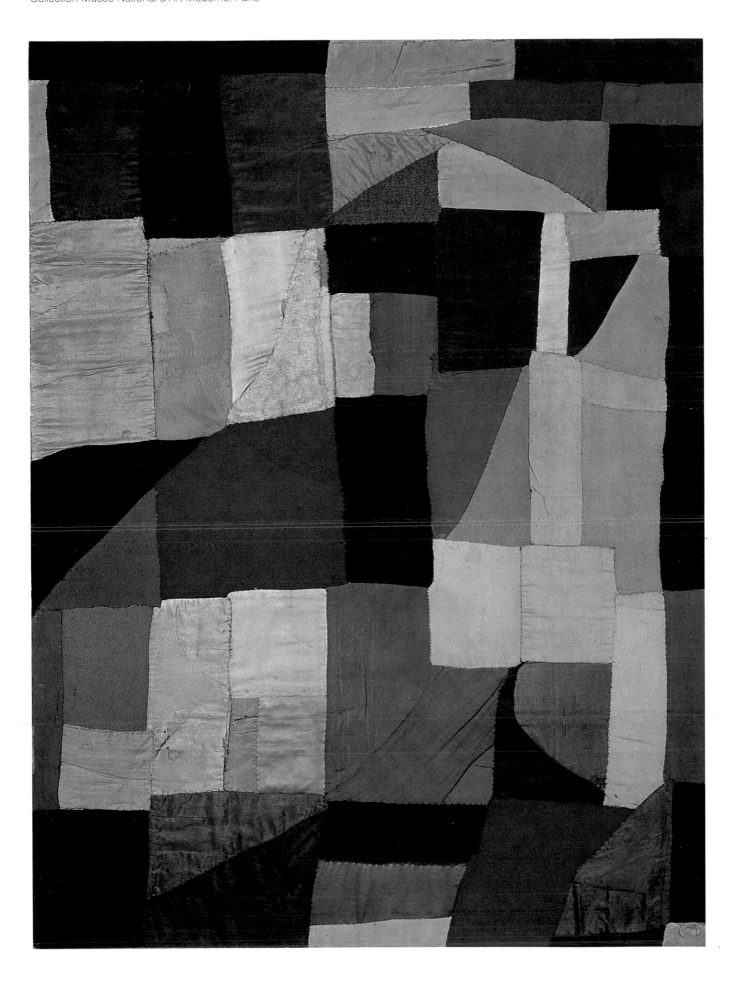

Cat. 9 *Simultaneous contrasts (Contrastes simultanés),* 1912
No. 659, oil on canvas, 17-15/16 x 21-11/16 (45.5 x 55)
Collection Musée National d'Art Moderne, Paris

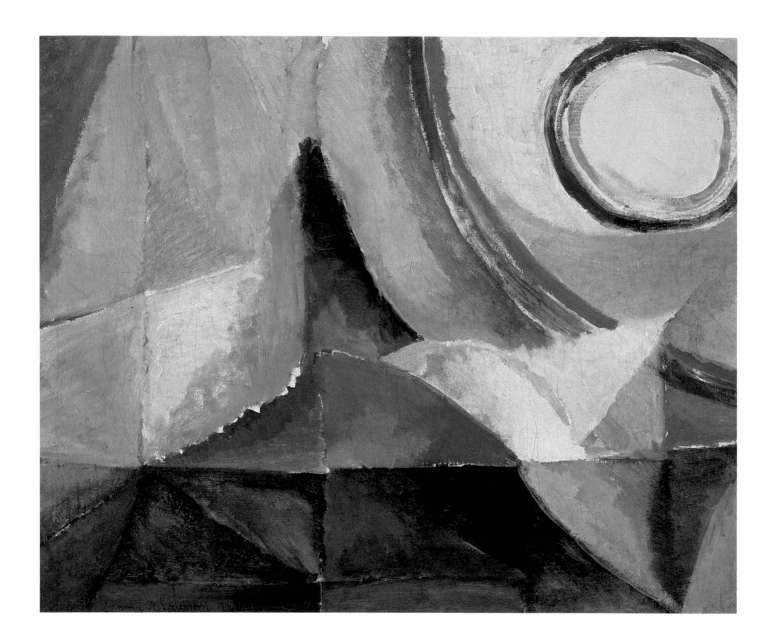

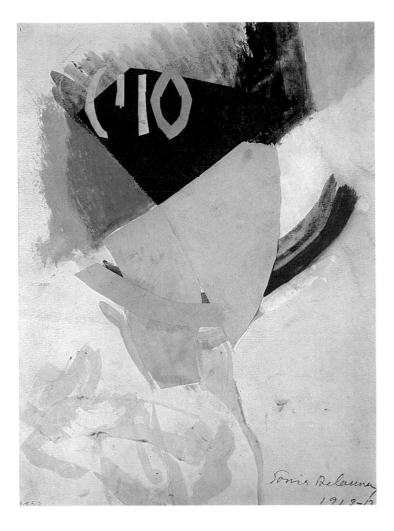

Top, left: Cat. 47. *Simultaneous contrast (Contraste simultané),* 1912-13
No. 1152, collage and gouache, 13 x 9-11/16 (33 x 24.5)
Collection Sonia Delaunay, Paris

Top, right: Cat. 53. *Studies of Light – Boulevard St. Michel (Etudes de lumière – Boulevard St. Michel),* 1913
No. 203, crayon, 5-3/16 x 5-13/16 (13.3 x 14.7)
Collection Sonia Delaunay, Paris

Bottom, left: Cat. 54. *Studies of Light – Boulevard St. Michel (Etudes de lumière – Boulevard St. Michel),* 1913
No. 205, crayon, 6-1/2 x 11 (16.5 x 27.9)
Collection Sonia Delaunay, Paris

Bottom, right: Cat. 52. *Studies of color (Etudes de couleurs),* 1913
No. 204, crayon, 6-3/8 x 6-1/8 (16.2 x 15.5)
Collection Sonia Delaunay, Paris

135

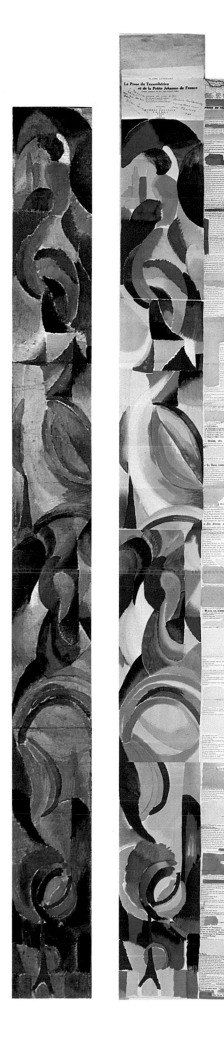

Opposite page: Cat. 51. *Simultaneous Contrasts: Poster for*
 Smirnoff Lecture (Contrastes simultanés: affiche conférence
 Smirnoff), 1913
No. 471, watercolor, 25-3/16 x 19-3/8 (64 x 49.2)
Collection Sonia Delaunay, Paris

Far left: Cat. 11. La Prose du Transsibérien et de la petite Jehanne
 de France *by Blaise Cendrars (par Blaise Cendrars),* 1913
oil on canvas, 76-1/4 x 7-1/2 (193.6 x 19)
Collection Musée National d'Art Moderne, Paris

Left, and below: Cat. 176. *La Prose du Transsibérien et de la petite*
 Jehanne de France, Text by Blaise Cendrars, 1913
64/100
pochoir and type, 78-3/4 x 14 (200 x 35.6)
(Paris: Editions des hommes nouveaux)
Collection Sonia Delaunay, Paris

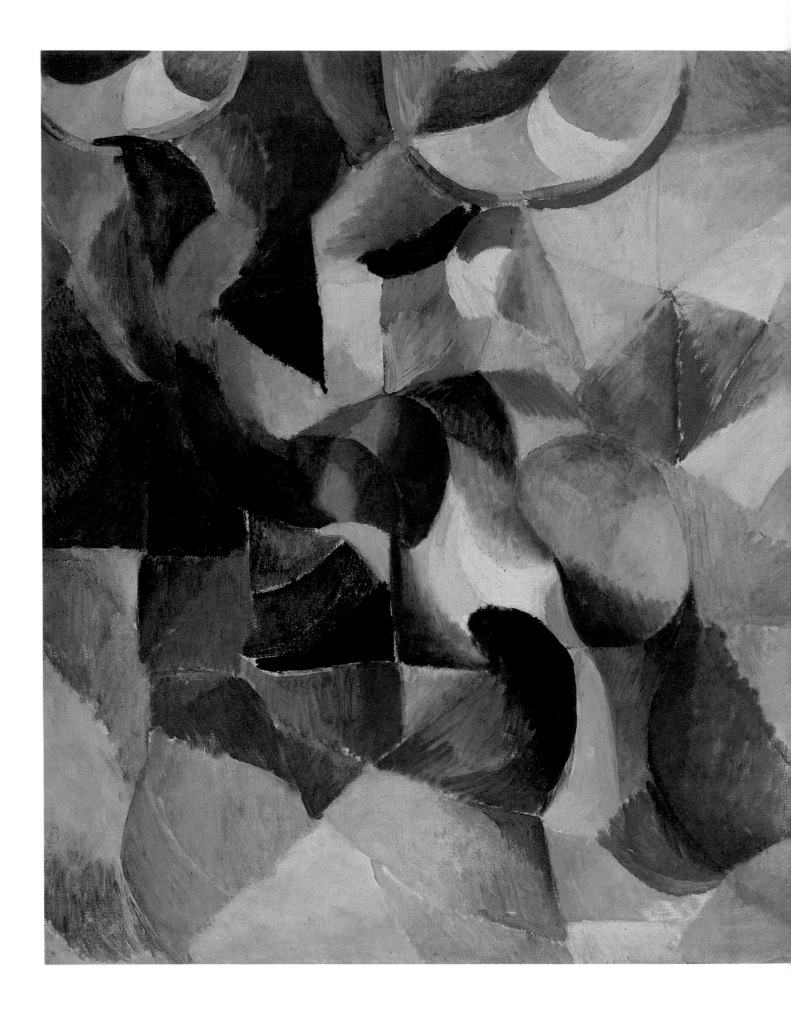

Cat. 10. *Bal Bullier (Le Bal Bullier)*, 1913
oil on canvas, 38-3/16 x 51-15/16 (97 x 132)
Collection Kunsthalle, Bielefeld, West Germany

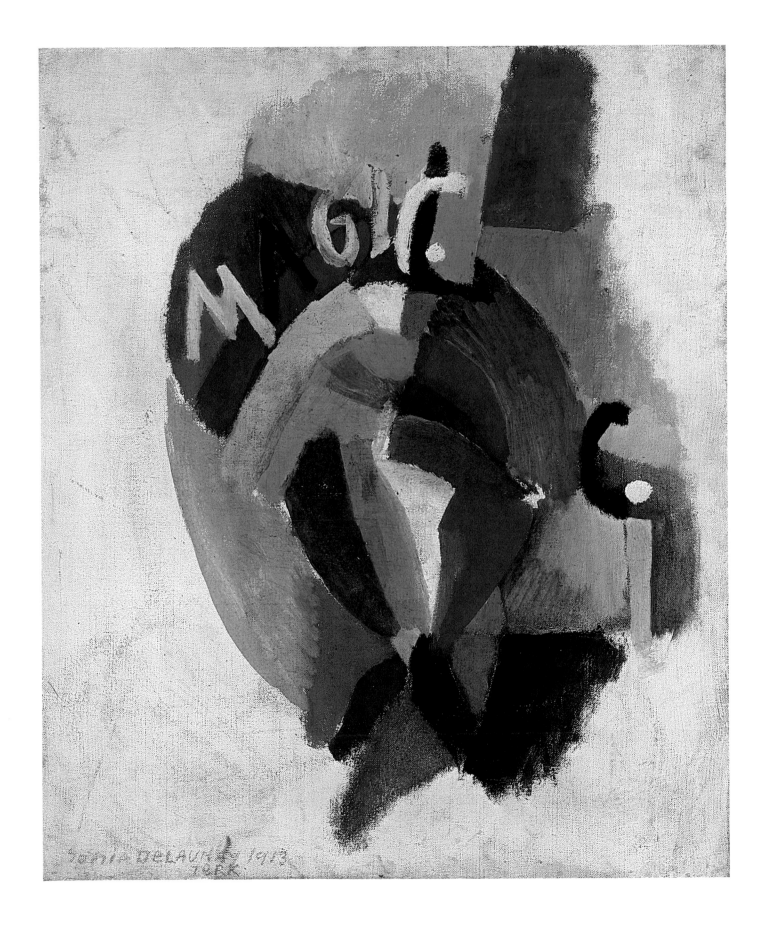

Top, left: Cat. 49. *Dancing Couple, Study for Bal Bullier*
 (Danseurs, étude pour le Bal Bullier), 1913
pastel, 11 x 7-5/8 (27.9 x 19.6)
Collection André Emmerich, New York

Top, right: Cat. 56. *Zénith,* 1913-14
No. 5031, watercolor, 7-11/16 x 9-7/8 (19.5 x 25)
Collection Sonia Delaunay, Paris

Bottom: Cat. 50. *Design for Pirelli Poster*
 (Projet d'affiche Pirelli), 1913
No. 214, pastel, 7-7/8 x 10-1/4 (19.7 x 27)
Collection Sonia Delaunay, Paris

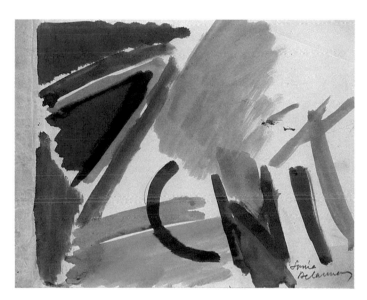

Cat. 13. *Zénith*, 1913
No. 890, oil on canvas, 12 x 14-15/16 (30.5 x 38)
Collection Sonia Delaunay, Paris

Right, top: Cat. 63. *Zénith*, 1914
No. 495A, gouache, 23-1/2 x 19-1/2 (59.7 x 49.5)
Collection Tamar J. Cohen, New York

Bottom, left: Cat. 62. *Zénith*, 1914
No. 495, gouache, 13-3/4 x 12 (34.9 x 30.5)
Collection Tamar J. Cohen, New York

Bottom, right: Cat. 55. *Zénith*, 1913-14
No. 483, crayon, 7-1/4 x 8-5/16 (18.4 x 21.7)
Collection Sonia Delaunay, Paris

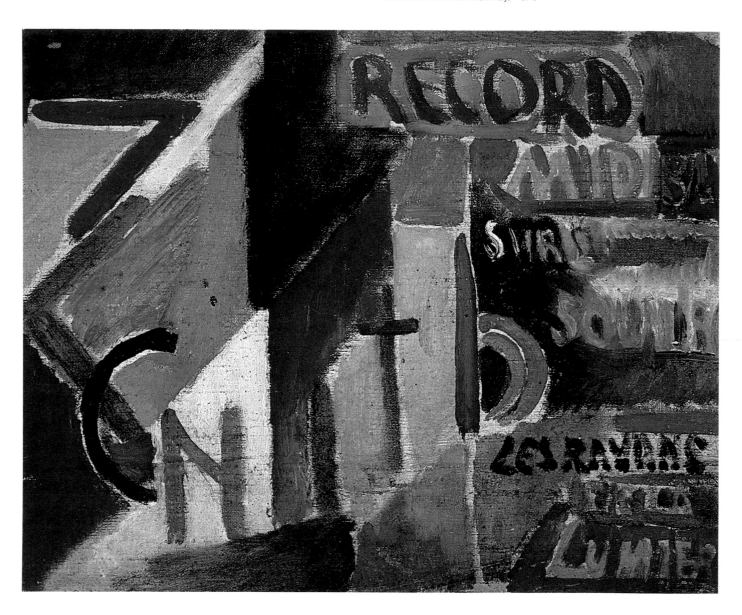

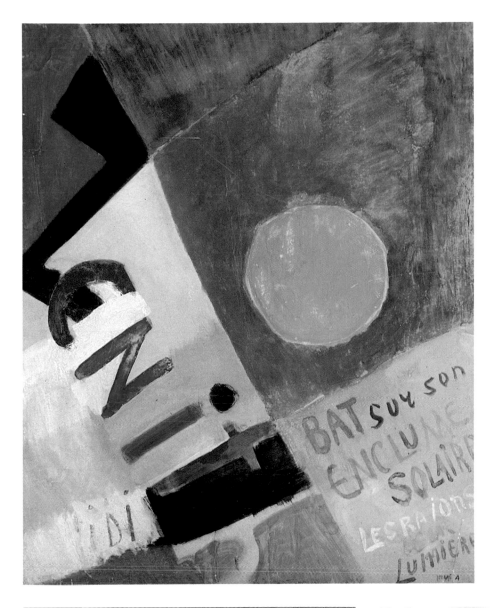

143

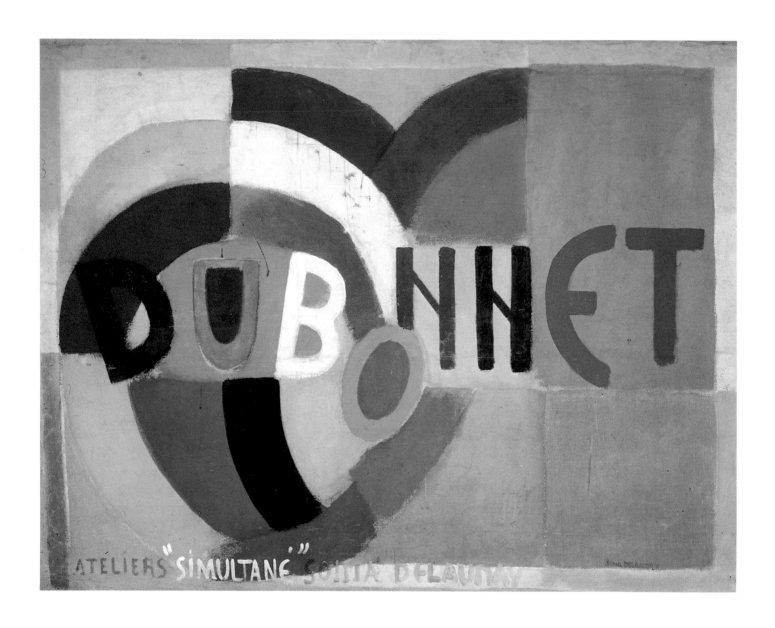

Cat. 15. *Dubonnet,* 1914
No. 797, oil on canvas, 24 x 30 (60.9 x 76.2)
Collection Tamar J. Cohen, New York

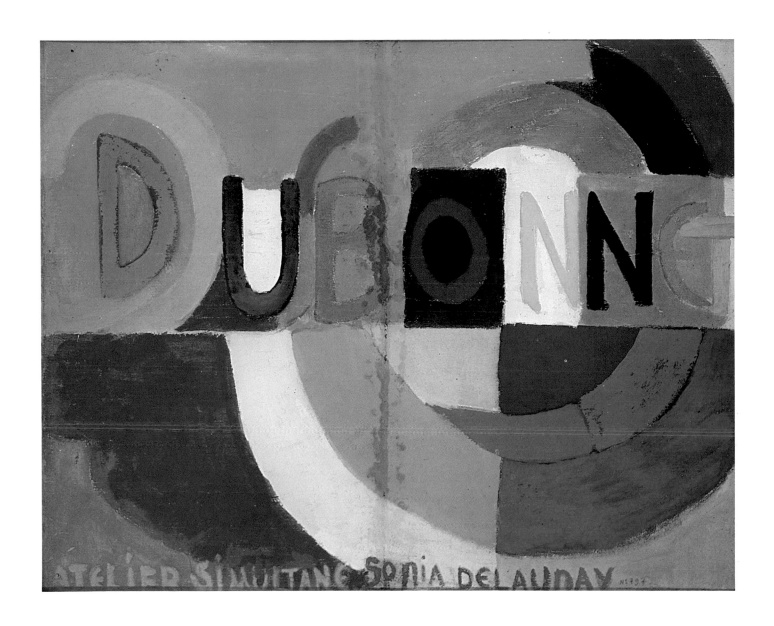

Cat. 61. *Solar Prism (Woman with parasol)*
(Prisme Solaire [Femme à l'ombrelle]), 1914
collage and crayon, 19-1/2 x 13 (49.5 x 33)
Private collection, New York

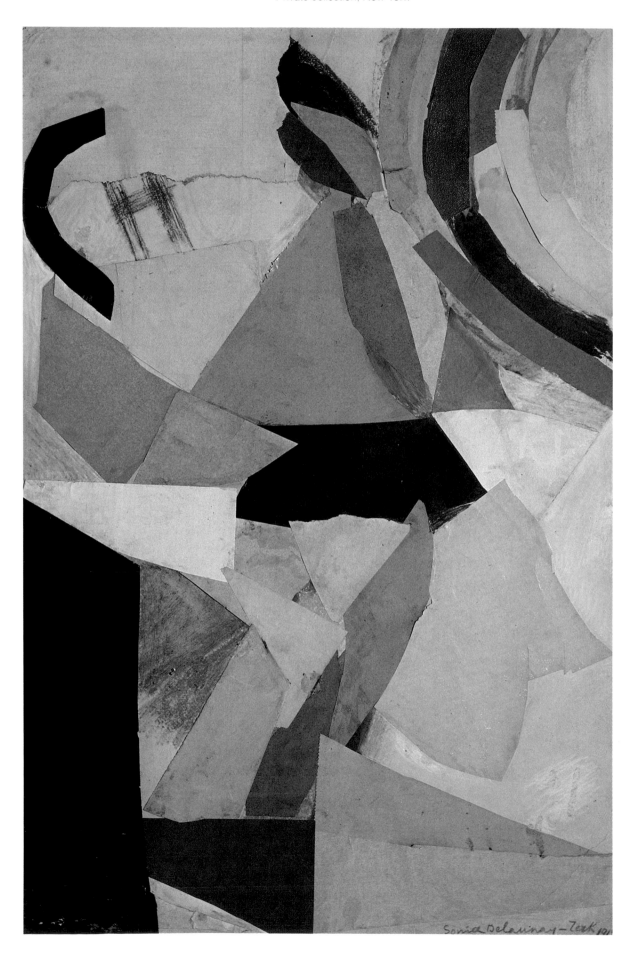

Top, left: Cat. 59. *Electric Prisms (Prismes électriques)*, 1914
No. 841, crayon, 9-5/8 x 8-1/2 (24.5 x 21.5)
Collection Sonia Delaunay, Paris

Top, right: Cat. 60. *Electric Prisms (Prismes électriques)*, 1914
No. 40, collage and crayon, 11-5/8 x 7-5/16 (29.5 x 18.5)
Collection Sonia Delaunay, Paris

Bottom: Cat. 57. *Crowd Movement, Electric Prisms
 (Mouvement de foule, prismes électriques)*, 1914
No. C409, crayon, 9-7/8 x 7-1/2 (25 x 19)
Collection Kunsthalle, Bielefeld, West Germany

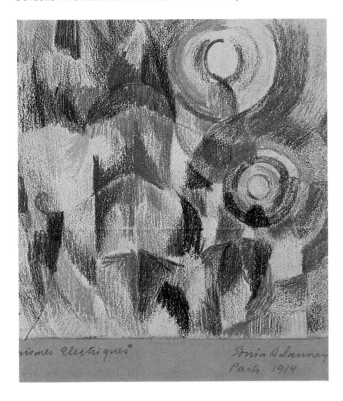

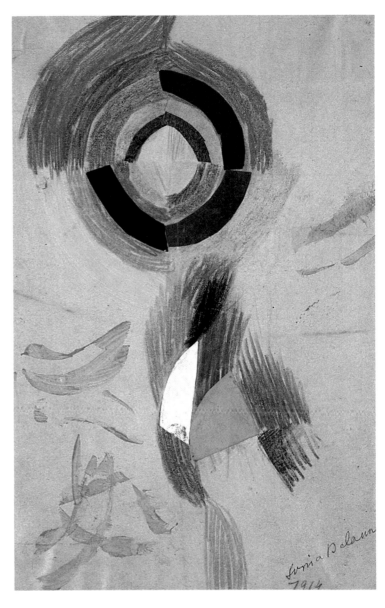

Top, left: Cat. 74. *Disk (Disque),* 1916
No. 154, sizing on paper, 10-1/2 x 8-1/16 (26.6 x 20.5)
Collection Sonia Delaunay, Paris

Top, right: Cat. 64. *Circles (Cercles),* 1915
gouache, 18-1/2 x 17 (47 x 43.2)
Collection André Emmerich, New York

Bottom: Cat. 65. *Disks (Disques),* 1915
Two works in one frame, l. to r.
 1. *Disk (Disque),* 1915
 No. 155, sizing on paper, 7-1/8 x 8-1/2 (18 x 21.5)
 2. *Disk (Disque),* 1915
 No. 153, sizing on paper, 7-3/4 x 5-11/16 (19.7 x 14.4)
Collection Sonia Delaunay, Paris

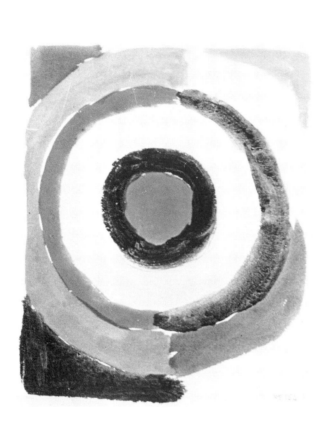

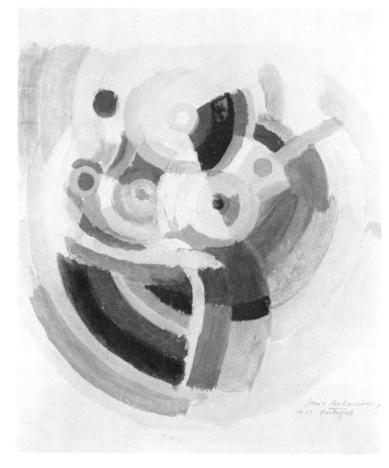

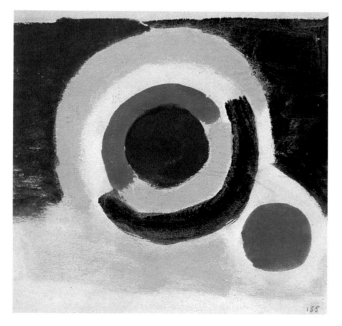

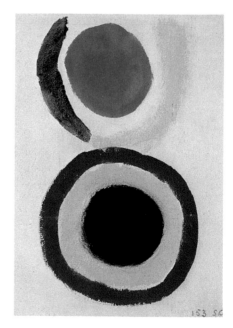

Top, left: Cat. 77. *Self-portrait (Autoportrait)*, 1916
No. 28, gouache, 11-5/8 x 8-11/16 (29.5 x 22)
Collection Sonia Delaunay, Paris

Top, right: Cat. 66. *Portuguese Toys (Jouets portugais)*, 1915
No. 467, gouache and wax on paper, 11-3/16 x 8-15/16 (28 x 22.7)
Collection Musée National d'Art Moderne, Paris

Bottom: Cat. 68. *Album, No. 1*, 1916
No. F1001, wax on paper, 9-1/8 x 9-1/4 (23 x 23.5)
Collection Arthur A. and Elaine Lustig Cohen, New York

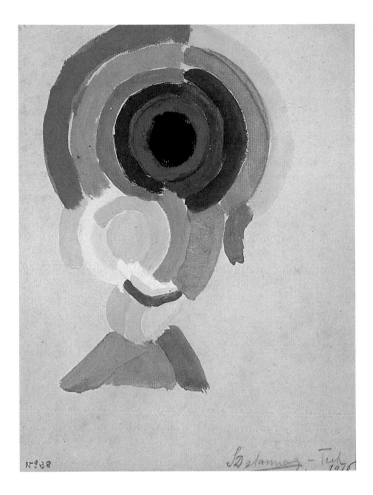

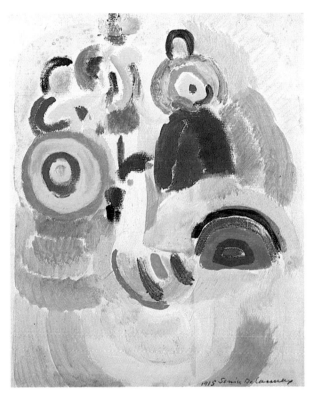

Top: Cat. 78. *Self-portrait (Autoportrait)*, 1916
No. 380, wax on paper, 13-1/4 x 19 (33.7 x 48.3)
Collection Tamar J. Cohen, New York

Bottom: Cat. 69. *Catalogue for Stockholm Exhibition — Self-portrait
and Announcement of Exhibition (Catalogue pour l'exposition de
Stockholm — Autoportrait et annonce de l'exposition)*, 1916
pochoir, 12-5/8 x 16-15/16 (32 x 43)
Collection Sonia Delaunay, Paris

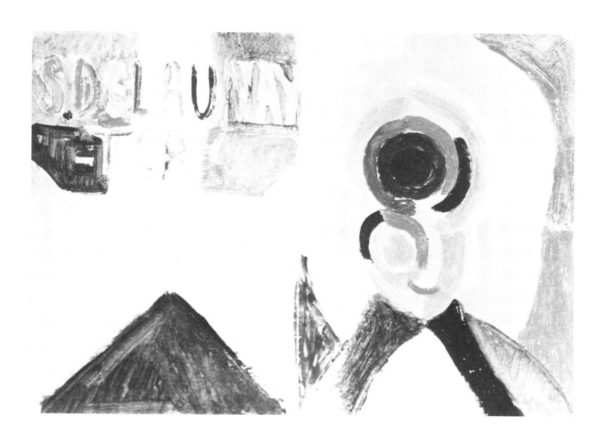

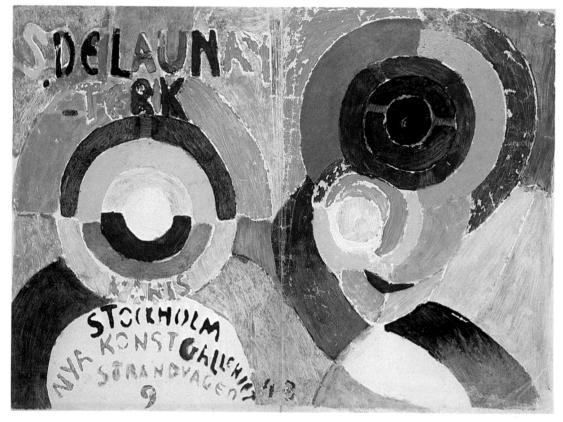

Top, left: Cat. 70. *Chocolate (Chocolat)*, 1916
No. 582, pastel, 9-3/4 x 7-3/4 (24.7 x 19.7)
Collection Arthur A. and Elaine Lustig Cohen, New York

Bottom, left: Cat. 71. *Chocolate (Chocolat)*, 1916
No. 1011, gouache, 9-1/4 x 9-1/2 (23.5 x 24.1)
Collection Mrs. Kay Hillman, New York

Top, right: Cat. 79. *Studies for the Poster "Chocolate"*
 (Etudes d'affiche "chocolat"), 1916
Three works in one frame, top to bottom:
 1. 1047A, 5-11/16 x 10-1/16 (14.5 x 25.5)
 2. 1047, 3-7/8 x 9-11/16 (10 x 25)
 3. 3-5/8 x 7-5/16 (9.7 x 18.8)
Collection Bibliothèque Nationale, Paris

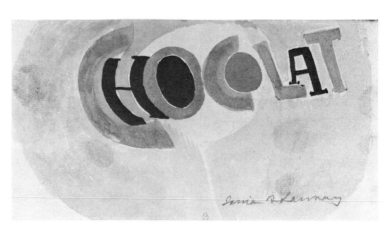

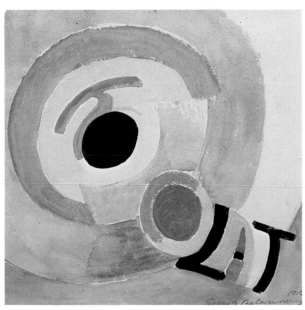

Top, left: Cat. 72. *Dancer (Danseuse)*, 1916
No. 416, watercolor and gouache on paper mounted on board,
 14-3/16 x 9-5/16 (35.8 x 23.7)
Collection Musée National d'Art Moderne, Paris

Top, right: Cat. 73. *Dancer, Second Version
 (Danseuse, deuxième version)*, 1916
No. 110, gouache, crayon and watercolor, 22-7/16 x 18-7/8
 (57.2 x 48)
Collection Albright-Knox Art Gallery, Buffalo, New York/General
 Purchase Fund

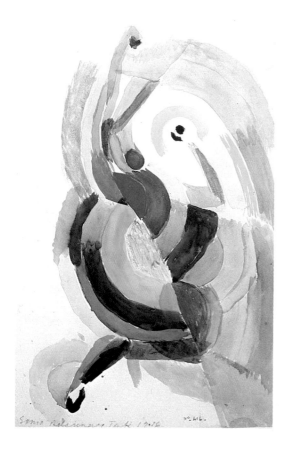

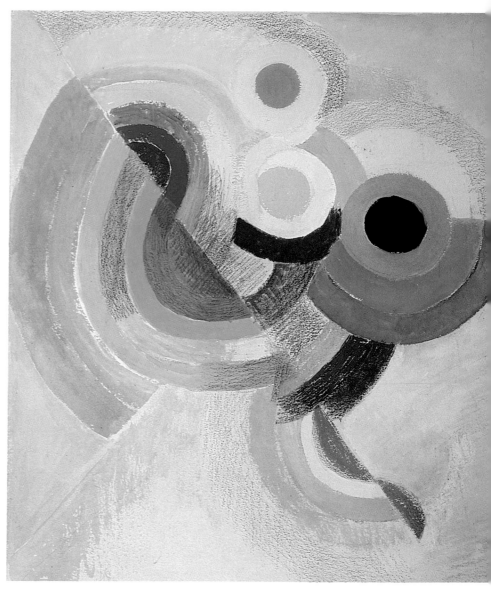

Cat. 17. *Young Girl with Pumpkin (Jeune fille au potiron),* 1916
oil on canvas, 21-1/2 x 25-1/4 (54.6 x 64.1)
Collection Leonard Hutton Galleries, New York

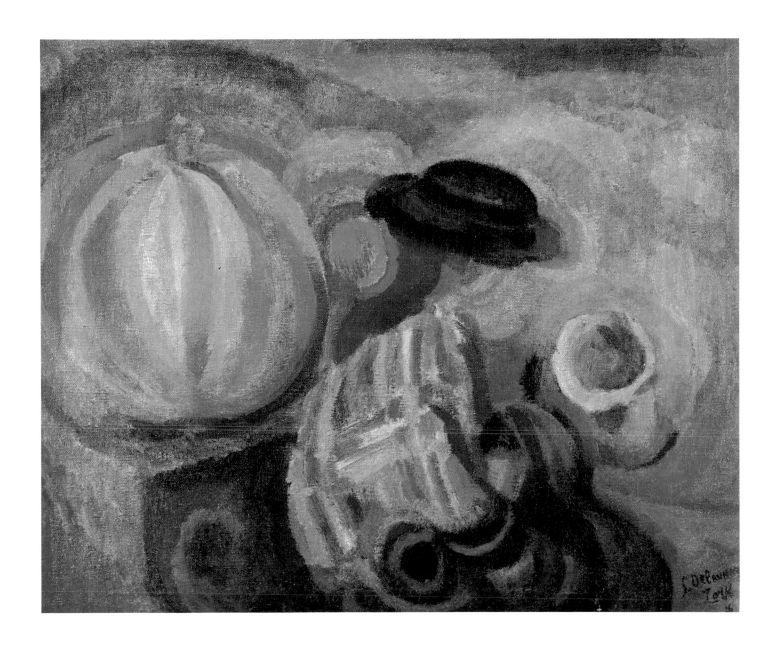

Below: Cat. 16. *Portuguese Still Life
 (Nature morte portugaise)*, 1916
No. 863, encaustic on canvas, 14-15/16 x 22-1/16 (38 x 56)
Collection Mme. Georges Pompidou, Paris

Right: Cat. 76. *Portuguese Still Life (Nature morte portugaise)*, 1916
wax on paper, mounted on board, 27-9/16 x 37-7/16 (68.5 x 95)
Collection Musée National d'Art Moderne, Paris

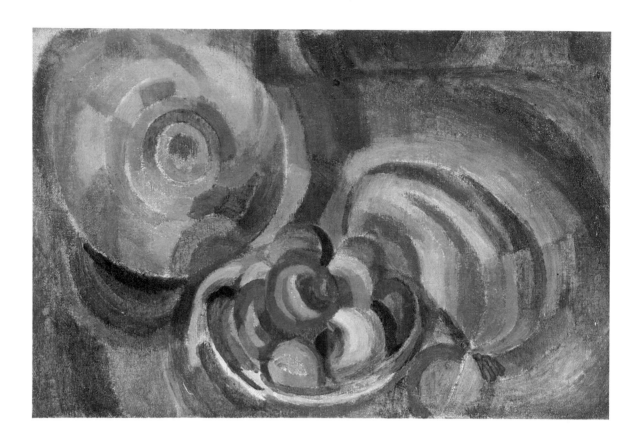

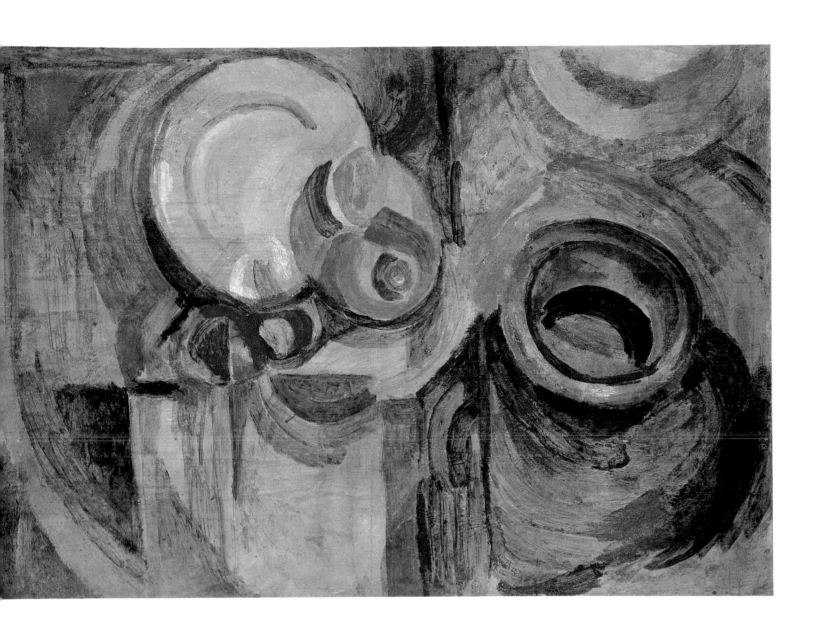

Top left: Cat. 85. *Design for fabric for* Cléopâtre *No. 1 (Projet de tissu pour* Cléopâtre *No. 1), 1918*
watercolor and ink, 4-3/4 x 13-9/16 (12 x 34.5)
Collection Mr. and Mrs. N. Lobanov-Rostovsky, London

Center, left: Cat. 86. *Design for fabric for* Cléopâtre *No. 2 (Projet de tissu pour* Cléopâtre *No. 2), 1918*
gouache and ink, 5-1/16 x 12-3/16 (12.7 x 31)
Collection Mr. and Mrs. N. Lobanov-Rostovsky, London

Bottom, left: Cat. 87. *Design for fabric for* Cléopâtre *No. 3 (Projet de tissu pour* Cléopâtre *No. 3), 1918*
gouache and ink, 4-3/4 x 12-3/16 (12 x 31)
Collection Mr. and Mrs. N. Lobanov-Rostovsky, London

Right: Cat. 82. *Costume for Cleopatra (Costume pour* Cléopâtre*), 1918*
No. 693, watercolor, 22-7/16 x 14-3/8 (57 x 36.5)
 incorrect inscription added at later date
Collection Sonia Delaunay, Paris

Top: Cat. 84. *Costumes for* Cléopâtre, Project for four shawls
 (Costumes pour Cléopâtre, *projet pour quatre châles)*, 1918
No. 754, watercolor, four works in one frame, each 12-1/4 x 3-3/4
 (31 x 9.5)
Collection Sonia Delaunay, Paris

Bottom, right: Cat. 81. *Cleopatra as Mummy (Cléopâtre comme*
 momie), 1918
No. 189, gouache, 12-7/16 x 9-5/8 (31.5 x 24.5)
Collection Sonia Delaunay, Paris

Bottom, left: Cat. 88. *Stage Design, Mummy for Screen for*
 Cléopâtre *(Projet de décors, momie pour l'écran pour* Cléopâtre*)*,
 1918
watercolor and ink, 12-5/8 x 9-5/8 (32 x 24.4)
Collection Mr. and Mrs. N. Lobanov-Rostovsky, London

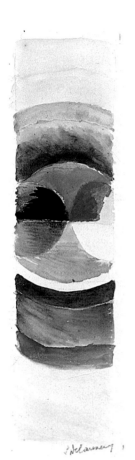
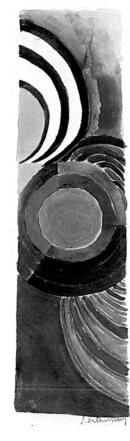
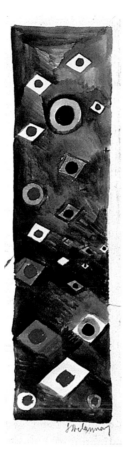
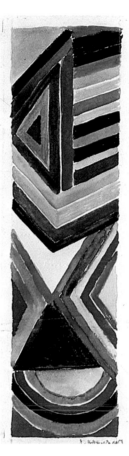

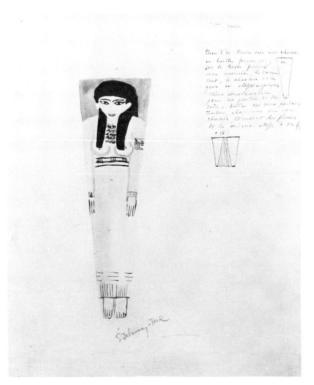
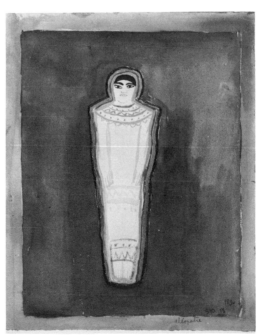

157

Top: Cat. 90. *Studies for* Cléopâtre *(Etudes pour* Cléopâtre*)*, 1918
Two works in one frame, left to right:
 1. No. 1676, ink, 9-1/2 x 6-3/4 (24 x 17)
 2. No. 1676a, watercolor, 8-1/4 x 6-1/8 (21 x 15.5)
Collection Sonia Delaunay, Paris

Bottom, left: Cat. 89. *Stage Design, Mummy for* Cléopâtre, *(Projet de décors, momie pour* Cléopâtre*)*, 1918
No. 17, gouache, watercolor and ink, 12-1/2 x 9-3/8 (31.8 x 23.8)
Collection Mr. and Mrs. N. Lobanov-Rostovsky, London

Bottom, right: Cat. 83. *Costumes for* Cléopâtre *(Costumes pour* Cléopâtre*)*, 1918
No. 68, watercolor, 10-3/4 x 20-1/8 (27.3 x 51.1)
Collection Sonia Delaunay, Paris

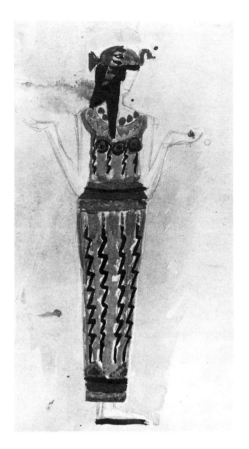

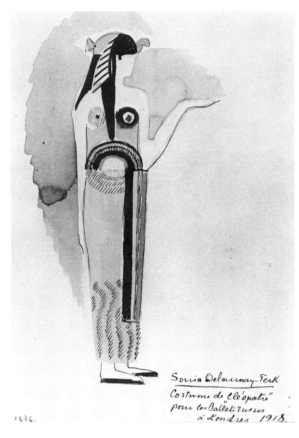

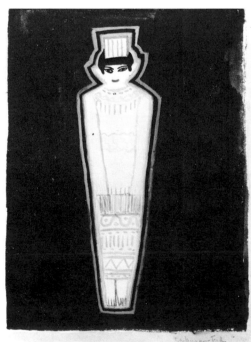

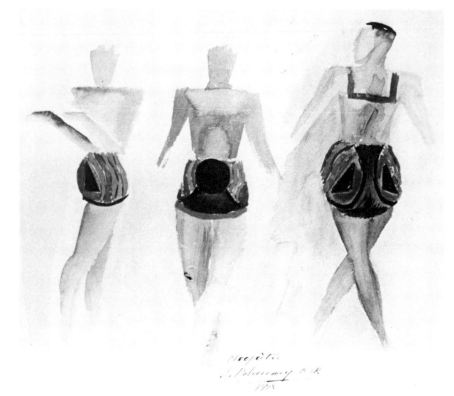

Left: Cat. 197. Costume for *Cléopâtre*, 1918
silk, sequins, beads
headdress: 22-5/8 x 14-9/16 x 12-5/8 (57.5 x 37 x 32)
dress: 45-1/16 x 18-5/16 (114.5 x 46.5)
Collection Los Angeles County Museum of Art, Museum Purchase
 with Costume Council Funds

Right: Cat. 196. Costume for *Cléopâtre, slave*, 1918
wool, silk, beads, 41 x 20 (104.1 x 50.8)
Collection Arthur A. and Elaine Lustig Cohen, New York

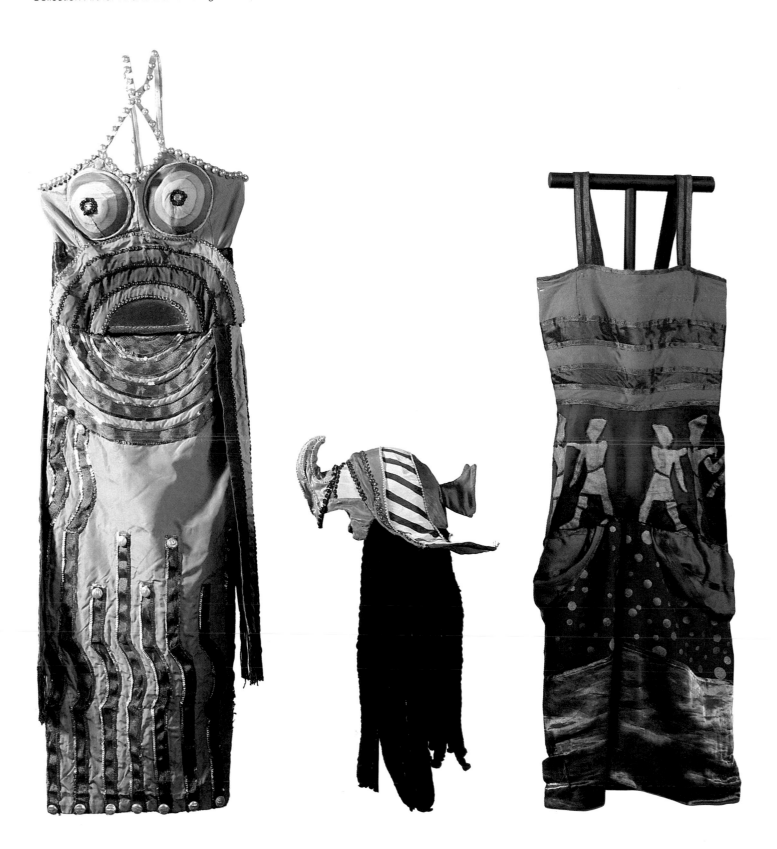

Left: Cat. 97. *Design for Female Costume for* Le Coeur à Gaz
 (Projet de costume de femme pour Le Coeur à Gaz), 1923
No. 677, watercolor, 15-7/8 x 11-7/16 (40.2 x 29)
Collection Sonia Delaunay, Paris

Right: Cat. 98. *Design for Male Costume for* Le Coeur à Gaz
 (Projet de costume d'homme pour Le Coeur à Gaz), 1923
No. 277, watercolor, 16-15/16 x 11-7/16 (43 x 29)
Collection Sonia Delaunay, Paris

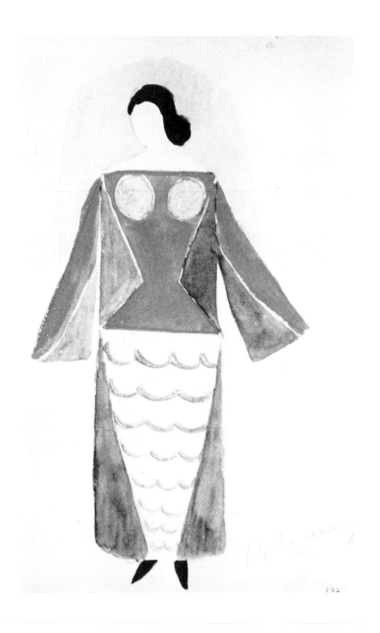

Top: Cat. 95. *Panel of Costumes (Panneau de costumes),* eight
 drawings, 1922-25
No. 1473, 24-13/16 x 60-1/4 (63 x 153)
l. to r. 1. No. 405, 1922, watercolor and china ink, 12-1/4 x 8-7/8
 (31 x 22.5)
 2. No. 518, 1925, watercolor, 12-5/8 x 9-7/8 (32 x 25)
 3. No. c, 1924, china ink and watercolor 10-5/8 x 7-1/8
 (27 x 18)
 4. No. d, 1925, watercolor, 12-5/8 x 10-1/16 (32 x 25.5)
 5. No. e, 1925, watercolor and china ink, 9-5/8 x 6-15/16
 (24.1 x 17.1)
 6. No. f, 1923, watercolor and china ink, 12-1/4 x 7-7/8
 (31 x 20)

 7. No. g, 1923, watercolor and china ink, 12-1/4 x 7-7/8
 (31 x 20)
 8. No. 804, 1922, watercolor and china ink, 12-5/8 x 9-1/16
 (32 x 23)
Collection Sonia Delaunay, Paris

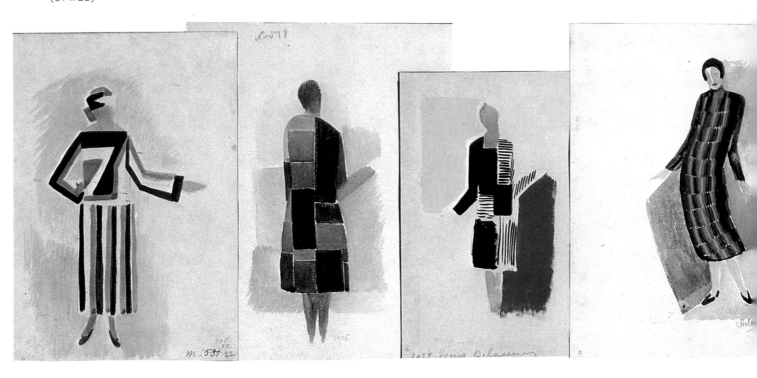

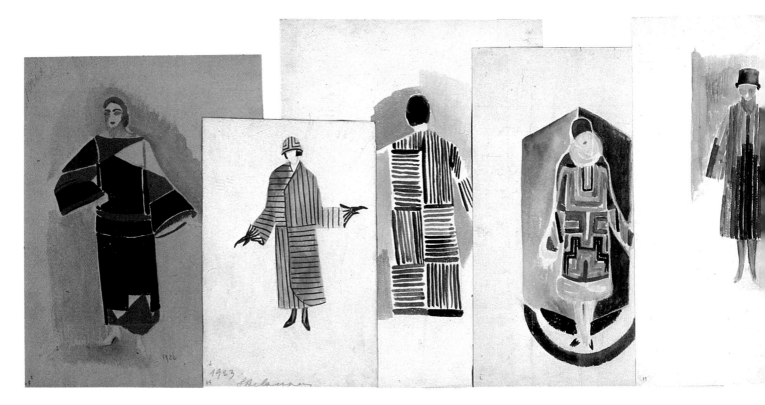

Bottom: Cat. 96. *Panel of Costumes (Panneau de costumes),*
nine drawings, 1922-26
No. 1474, 26-7/16 x 60-1/4 (62.7 x 153)
l. to r. 1. No. 63, 1922, watercolor, 12-1/4 x 8-7/8 (31 x 22.5)
 2. No. 65, 1923, watercolor, 9-7/8 x 5-15/16 (25 x 14.8)
 3. Dress, watercolor, 13-13/16 x 9-7/8 (35 x 25)
 4. Dress, No. L, watercolor, 12-5/8 x 7-1/2 (32 x 19)
 5. Dress, No. M, watercolor, 13-13/16 x 9-7/8 (35 x 25)
 6. Dress, No. N, 1926, watercolor, 13-13/16 x 9-7/8 (35 x 25)
 7. Dress, No. O, 1923, watercolor, 12-1/4 x 9-1/16 (31 x 23)

8. Dress, No. P 44, watercolor, 13-13/16 x 9-7/16 (35 x 24)
9. Dress, No. Q 523, 1923, watercolor, 12-1/4 x 9-7/8
 (31 x 25)
Collection Sonia Delaunay, Paris

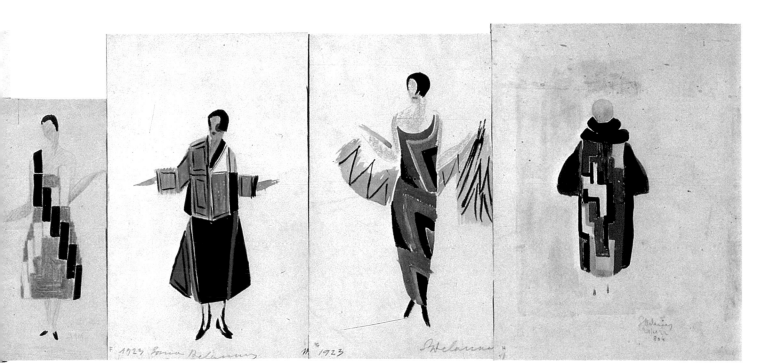

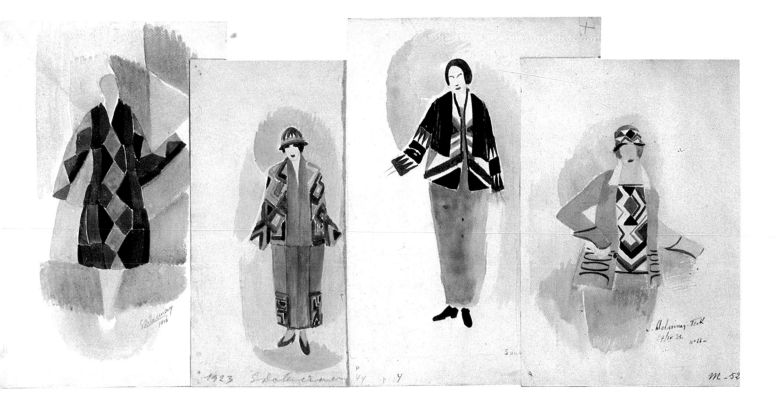

Top: Cat. 106. *Panel of Costumes (Panneau de costumes)*, seven
 drawings, 1923-26
No. 1472, 24-13/16 x 60-1/4 (63 x 153)
l. to r. 1. Dress, No. 6, watercolor and china ink, 10-5/8 x 9-7/16
 (27 x 24)
 2. Scarf & hat, 1923, watercolor, 14 x 11-3/16 (35.5 x 28.4)
 3. Dress, No. 9, 1926, watercolor, 13-13/16 x 10-1/4 (35 x 26)
 4. Costume, winter suit, No. 9, watercolor, 10-3/4 x 8-1/16
 (27.3 x 20.5)
 5. Dress, 1923, watercolor, 12-13/16 x 6-1/2 (31 x 16.4)

 6. Dress, watercolor, 13-13/16 x 9-1/16 (35 x 23)
 7. Three Dresses, Nos. 553, 554, 555, watercolor,
 13-13/16 x 20-1/8 (35 x 51)
Collection Sonia Delaunay, Paris

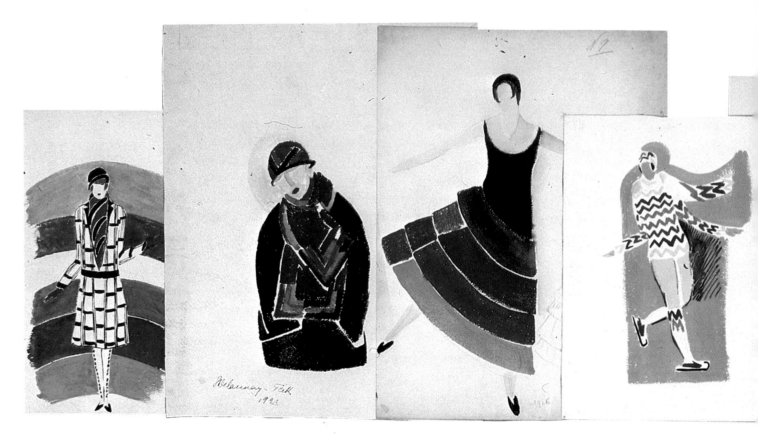

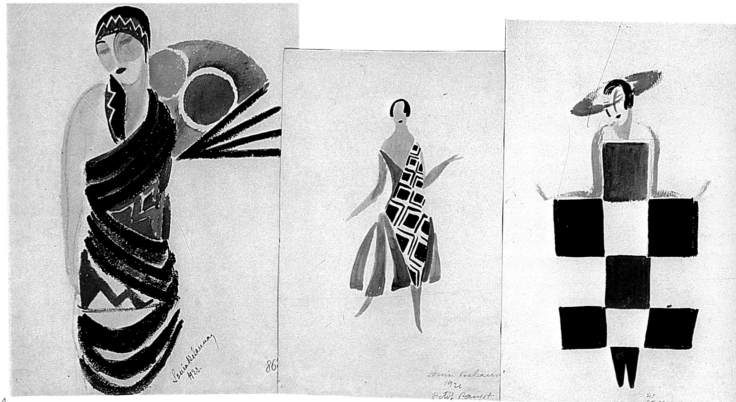

Bottom: Cat. 107. *Panel of Costumes (Panneau de costumes),*
 seven drawings, 1923-28
No. 1471, 26-7/16 x 60-1/4 (62.7 x 153)
l. to r. 1. No. 86, 1923, watercolor and china ink, 17-3/4 x 11-1/4
 (45 x 28.5)
 2. Costume for *P'tit Parigot,* No. 42, 1926, china ink,
 13 x 9-1/16 (33 x 23)
 3. Costume, No. 215, 1923, watercolor and china ink,
 14-3/16 x 9-7/8 (36 x 25)
 4. Swimsuit with balloon, No. 15, 1928, watercolor,
 10-5/8 x 8-1/4 (27 x 21)

5. Swimsuit, No. 13, watercolor, 10-5/8 x 7-7/8 (27 x 20)
6. Swimsuits, Nos. 19 & 222, 1928, watercolor, 10-5/8 x 7-7/8
 (27 x 20)
7. Swimsuit, No. 18, 1928, watercolor, 10-5/8 x 7-7/8
 (27 x 20)
Collection Sonia Delaunay, Paris

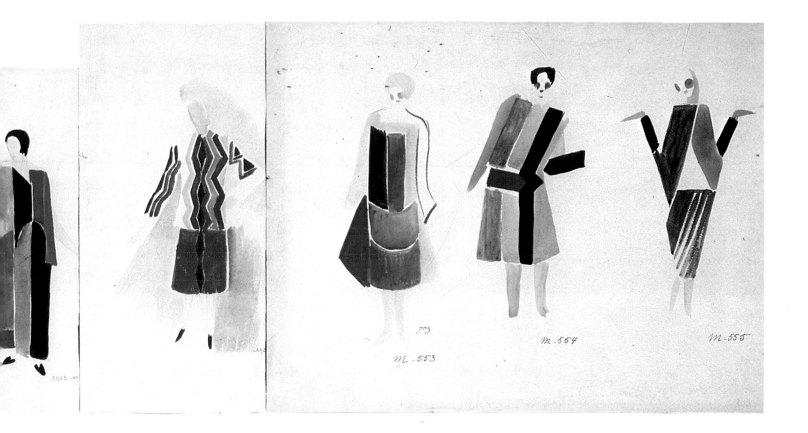

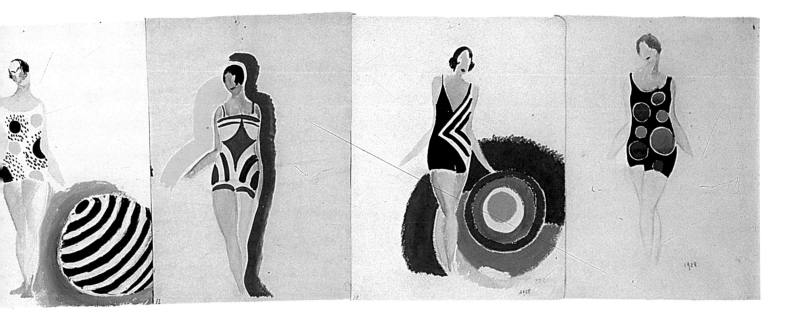

Top, left: Cat. 105. *Zaoum for* Le Coeur à Gaz, 1923
No. 699, watercolor and ink, 11-7/8 x 9-3/4 (30.2 x 24.7)
Collection The Museum of Modern Art, New York: Extended loan

Top, right: Cat. 101. *Dress-poem by Tzara (Robe-poème par Tzara),* 1923
gouache, 12 x 7-1/2 (30.5 x 19)
Collection Tamar J. Cohen, New York

Bottom: Cat. 99 *Dress (Robe),* 1923
No. 5348, china ink, 10-7/16 x 8-1/4 (26.5 x 21)
Collection Sonia Delaunay, Paris

Opposite page, left: Cat. 109. *Designs for poster for "Oja" cosmetics (Projets de publicité pour les cosmetiques "Oja"),* 1924
Two works in one frame, top to bottom:
 1. Gouache and china ink, 6-13/16 x 4-9/16 (17.5 x 11.5)
 2. No. 5108, gouache and china ink, 6-5/16 x 5-3/16 (16 x 13.2)
Collection Bibliothèque Nationale, Paris

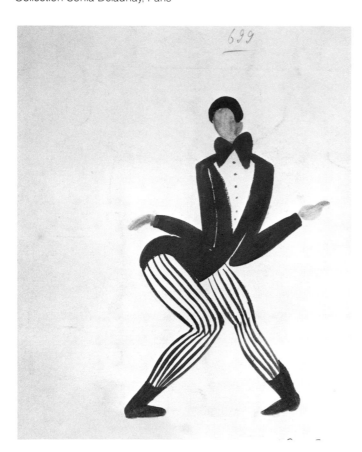

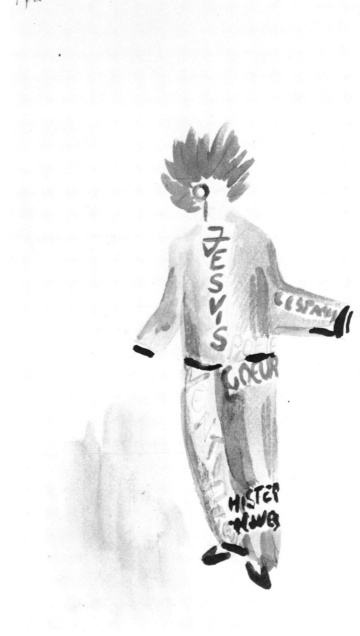

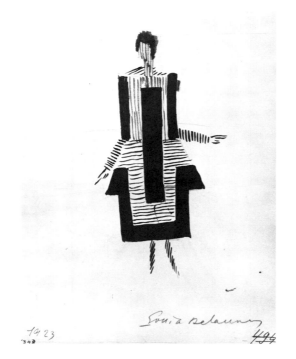

166

Top, right: Cat. 104. *Yellow Dancer for* Le Coeur à Gaz, 1923
No. 673, watercolor and ink, 14-1/8 x 11-3/8 (36 x 28)
Collection The Museum of Modern Art, New York: Extended loan

Bottom, right: Cat. 100 *Dress, Rhythm Without End (Robe, rythme sans fin),* 1923
No. 602a, china ink, 9 x 4-15/16 (22.9 x 12.6)
Collection Sonia Delaunay, Paris

Top, left: Cat. 110. *Fabric designs (Projets de tissu),* 1924.
Two works in one frame, left to right:
 1. *Fabric design (Projet de tissu),* 1924
 No. 1750a, gouache, 11-1/16 x 8-1/4 (28 x 21)
 2. *Fabric design (Projet de tissu),* 1924
 No. 1750, gouache, 11-1/16 x 8-1/4 (28 x 21)
Collection Sonia Delaunay, Paris

Bottom, left: Cat. 111. *Fabric designs (Projets de tissu),* 1924
Two works in one frame, left to right:
 1. No. 1758a, gouache, 10-5/8 x 8-1/4 (27 x 21)
 2. No. 1758, gouache, 10-5/8 x 8-1/4 (27 x 21)
Collection Sonia Delaunay, Paris

Right: Cat. 108. *Crossword Puzzle (Mots croisés),* 1924
No. 1749, gouache, 13-3/4 x 9-13/16 (35 x 25)
Collection Sonia Delaunay, Paris

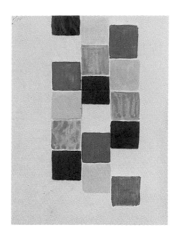
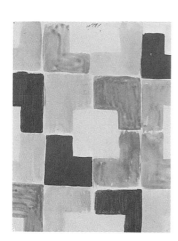
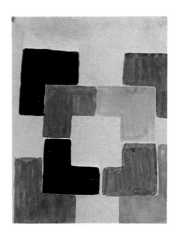
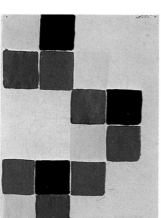
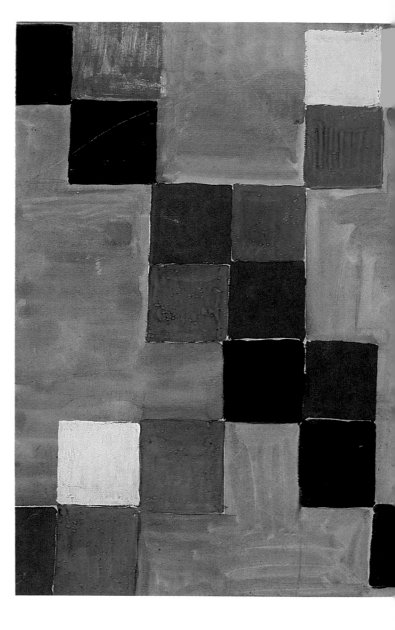

Cat. 112. *Abstract Diagonal Composition (Composition abstracte diagonale),* 1925
No. 1733, gouache, 18-15/16 x 12-9/16 (48 x 31)
Collection Arthur A. and Elaine Lustig Cohen, New York

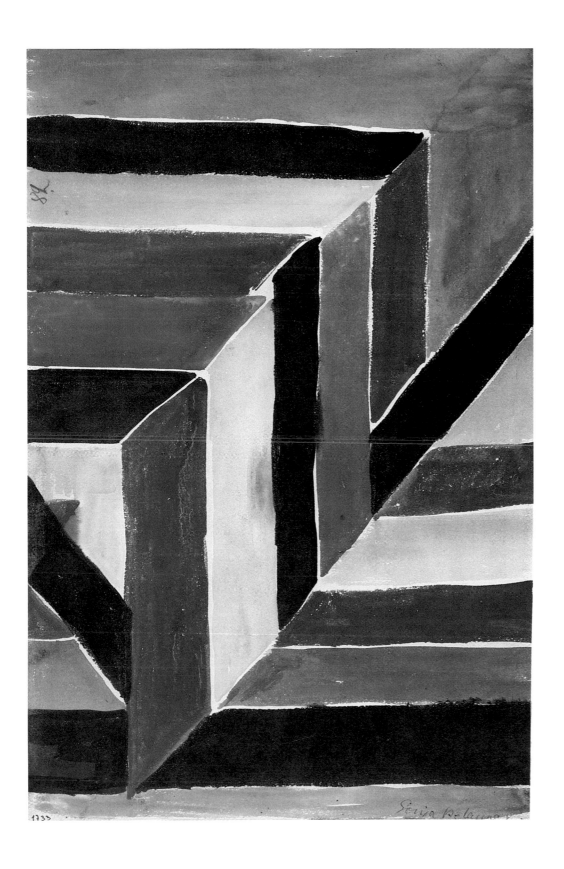

Cat. 114. *Fabric Design, Oblique Forms (Projet de tissu, obliques)*,
1925
No. 1652, gouache, 13-3/4 x 15-3/4 (35 x 40)
Collection Sonia Delaunay, Paris

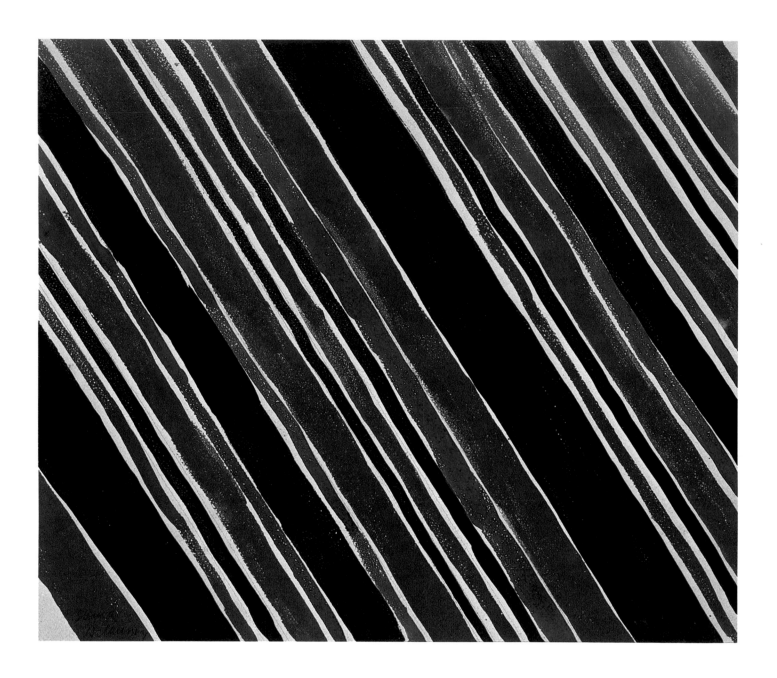

Top: Cat. 118. *Stripes (Rayures)*, 1925
No. 4901, gouache, 18-1/8 x 29-1/8 (46 x 74)
Collection Sonia Delaunay, Paris

Bottom: Cat. 115. *Fabric Sample (Echantillon de tissu)*, 1925
No. 5315, silk, 19-1/8 x 16-3/8 (48.5 x 41.5)
Collection Bibliothèque Nationale, Paris

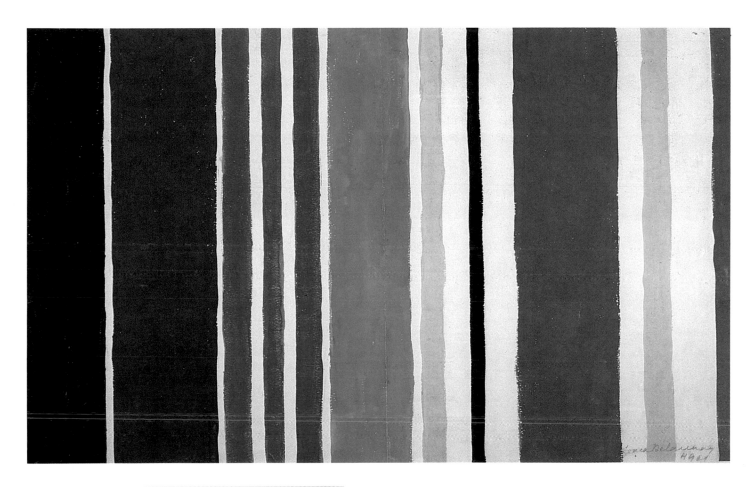

Top, right: Cat. 117. *Group of Women (Groupe de femmes)*, 1925
No. 2054, ink, 10-1/4 x 8-9/16 (26 x 21.5)
Collection Tamar J. Cohen, New York

Bottom, right: Cat. 120. *Study of Women: Decorative Motifs
 (Etudes de femmes, motifs décoratifs)*, c. 1925
No. 2057, china ink, 9-7/8 x 12-3/8 (24 x 31.5)
Collection Arthur A. and Elaine Lustig Cohen, New York

Left: Cat. 113. *Dancer in the 1920s (Danseuse années vingt)*, 1925
No. 1134, watercolor, 12-1/8 x 9-3/16 (30.8 x 23.4)
Collection Sonia Delaunay, Paris

172

Top: Cat. 123. *Design for Fabric Stripes (Projet de tissu, rayures),*
 1928
No. 1755, gouache, 5-1/2 x 17-3/4 (14 x 45)
Collection Sonia Delaunay, Paris

Bottom, left: Cat. 122. *Sketch for Fabric with Lozenge Design
 (Dessin de tissu à losanges),* 1926
No. 1150, gouache, 9-13/16 x 8-1/16 (25 x 20.5)
Collection Sonia Delaunay, Paris

Bottom, right: Cat. 119. *Study for Fabric, Checks (Etude pour
 tissu, damiers),* 1925
No. 2010, gouache on tissue, 5-15/16 x 8-1/4 (15 x 21)
Collection Sonia Delaunay, Paris

173

Top: Cat. 126. *Set Designs for Ballet* Quatre Saisons: *Spring*
(*Projets de décors pour le ballet* Quatre Saisons: *le printemps*),
1928-29
No. 667, gouache, 15-9/16 x 18-1/8 (39.5 x 46)
Collection Sonia Delaunay, Paris

Bottom: Cat. 127. *Set Designs for Ballet* Quatre Saisons: *Summer*
(*Projets de décors pour le ballet* Quatre Saisons: *l'été*),
1928-29
No. 668, gouache, 15-9/16 x 18-1/8 (39.5 x 46)
Collection Sonia Delaunay, Paris

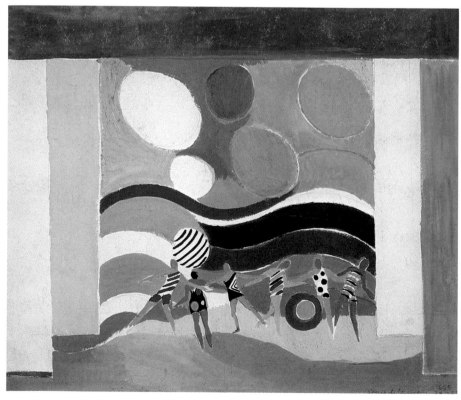

Top: Cat. 128. *Set Designs for Ballet* Quatre Saisons: *Winter*
 (Projets de décors pour le ballet Quatre Saisons: *l'hiver),* 1928-29
No. 669, gouache, 15-9/16 x 18-1/8 (39.5 x 46)
Collection Sonia Delaunay, Paris

Bottom: Cat. 129. *Set Designs for Ballet* Quatre Saisons: *Autumn*
 (Projets de décors pour le ballet Quatre Saisons: *l'automne),*
 1928-29
No. 670, gouache, 15-9/16 x 18-1/8 (39.5 x 46)
Collection Sonia Delaunay, Paris

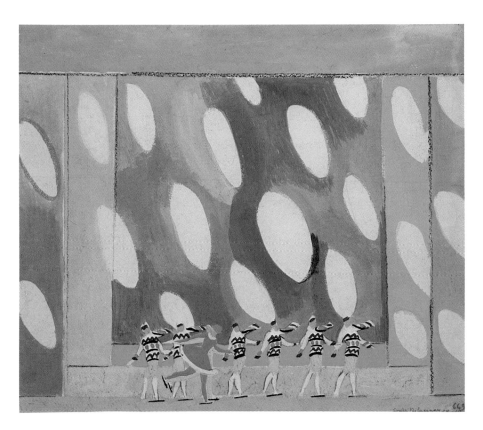

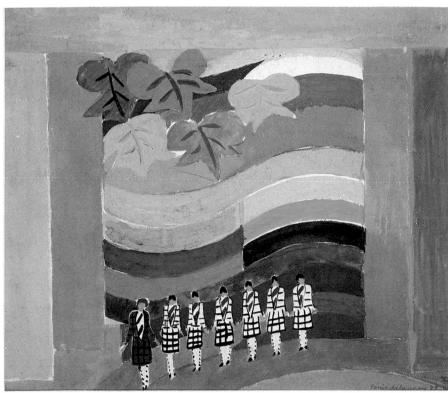

Left: Cat. 124. *Fabric Design (Projet de tissu),* 1928
No. 2058, 7-1/2 x 7-7/8 (18.1 x 19.6)
Collection Tamar J. Cohen, New York

Top, right: Cat. 130. *Graphic Research (Recherche graphique),*
 1933
No. 1439, china ink, 6-1/2 x 5-15/16 (16.5 x 15)
Collection Bibliothèque Nationale, Paris

Bottom, right: Cat. 131. *Graphic Research (Recherche
 graphique),* 1933
No. 1440, china ink, 7-1/8 x 6-1/2 (18 x 16.5)
Collection Bibliothèque Nationale, Paris

Opposite page, top: Cat. 132. *Design for Panel for the Air Pavilion:
 Airplane Motor (Projet de panneau pour le Palais de l'Air: moteur
 d'avion),* 1936
No. 701, gouache, 9-1/2 x 22-1/16 (24 x 56)
Collection Sonia Delaunay, Paris

176

Center: Cat. 133. *Design for Panel for the Air Pavilion: Control Panel (Projet de panneau pour le Palais de l'Air: tableau de bord),* 1936
No. 702, gouache, 9-1/2 x 22-1/16 (24 x 56)
Collection Sonia Delaunay, Paris

Bottom: Cat. 134. *Design for Panel for the Air Pavilion: Propeller (Projet de panneau pour le Palais de l'Air: l'hélice),* 1936
No. 703, gouache, 9-1/2 x 22-1/16 (24 x 56)
Collection Sonia Delaunay, Paris

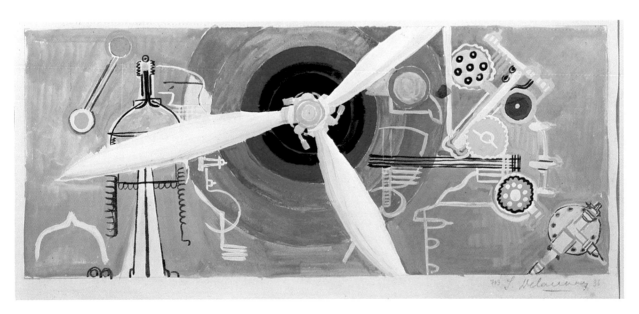

Top: Cat. 138. *Distant Voyages (Voyages lointains)*. 1936-37
gouache, 13-1/8 x 36-1/4 (34 x 92)
Collection Musée National d'Art Moderne, Paris

Bottom: Cat. 136. *Project for Distant Voyages (Projet pour voyages
 lointains),* 1936-37
No. 529, gouache, 11-3/4 x 9-1/2 (29.9 x 24.1)
Collection Mrs. Kay Hillman, New York

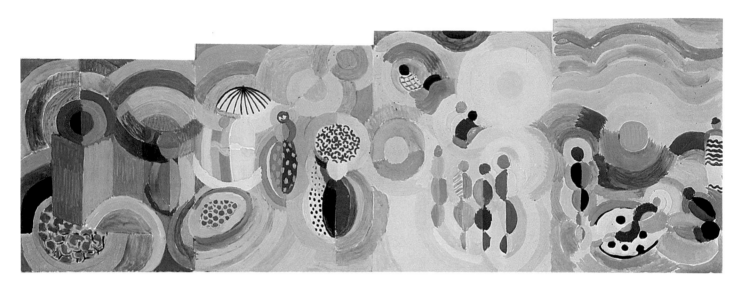

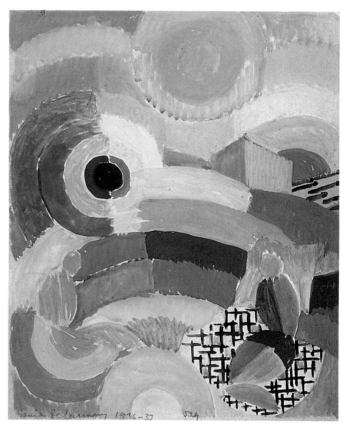

Cat. 18. *Rhythm (Rythme),* 1938
No. 123A, oil on canvas, 70-7/8 x 58-11/16 (180 x 149)
Collection Musée National d'Art Moderne, Paris

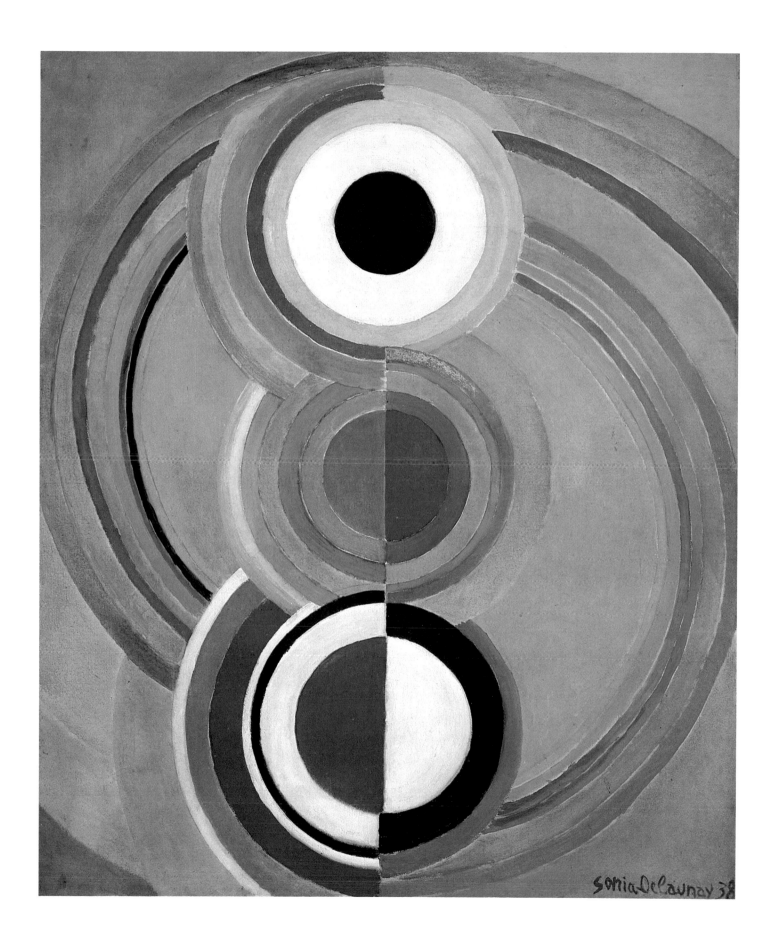

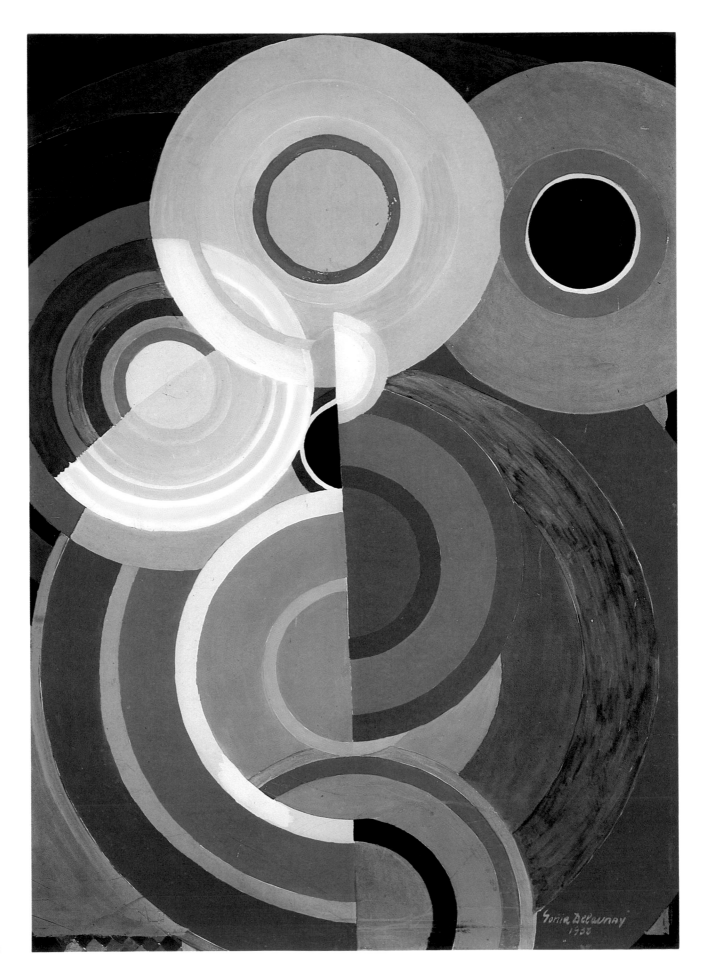

Opposite page, left: Cat. 139. *Composition,* 1938
No. 85, gouache on paper, 41-3/8 x 29-3/8 (105 x 74.5)
Collection Sonia Delaunay, Paris

Left: Cat. 142. *Rhythm No. 5 (Rythme No. 5),* 1939
gouache, 10-3/4 x 9-1/16 (27.3 x 23)
Collection Tamar J. Cohen, New York

Right: Cat. 144. *Composition,* 1943
No. 127a, gouache, 8-3/4 x 9-1/4 (22.2 x 23.5)
Collection Tamar J. Cohen, New York

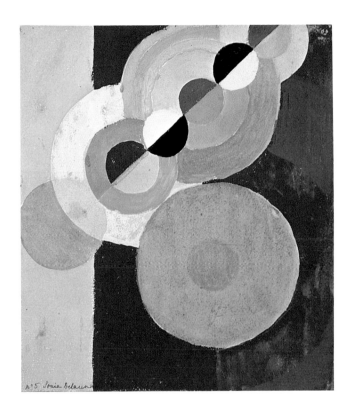

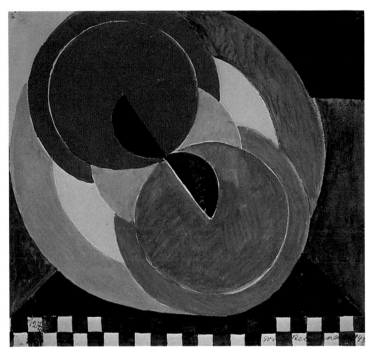

Cat. 19. *Rhythm (Rythme)*, 1945
oil on canvas, 51 x 34-7/8 (129.5 x 88.6)
Collection The Grey Art Gallery and Study Center,
New York University Art Collection,
gift of Mr. and Mrs. Myles Perrin

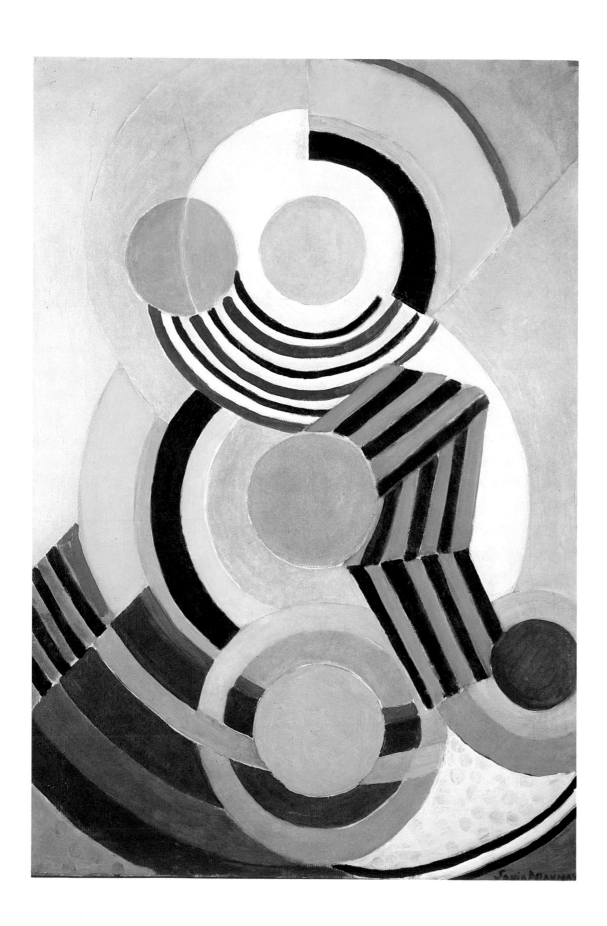

182

Cat. 20. *Rhythm (Rythme)*, 1946
oil on canvas, 69 x 59 (175.2 x 149.8)
Collection Tamar J. Cohen, New York

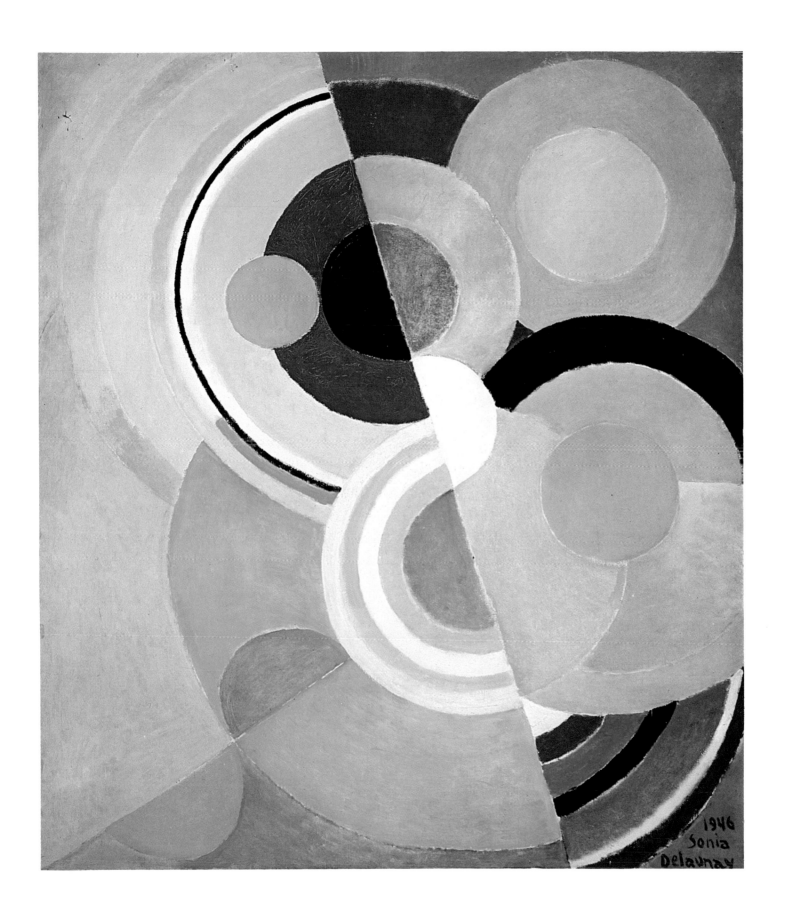

Top: Cat. 147. *Study for the Letter A (Etude pour la lettre A)*, 1947
gouache and crayon, 9-7/8 x 12-7/8 (25 x 32.7)
Collection Bibliothèque Nationale, Paris

Bottom, left: Cat. 145. *Outline for 3rd ABC Project (Esquisse pour
 ABC 3ᵉ projet)*, 1947
No. 1051, gouache, 9 x 9-11/16 (22.9 x 24.6)
Collection Sonia Delaunay, Paris

Bottom right: Cat. 146. *Rhythm-Color (Rythme-couleur)*, 1947
No. 1989, gouache, 9-9/16 x 8-1/16 (24.3 x 20.5)
Collection Sonia Delaunay, Paris

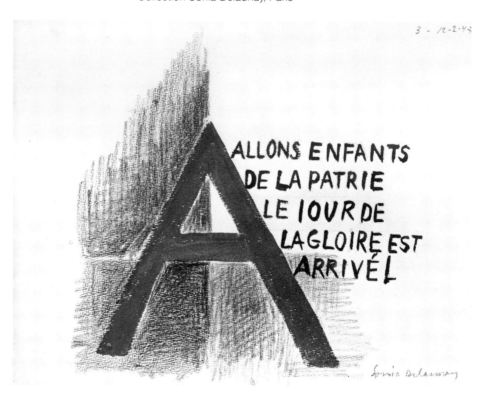

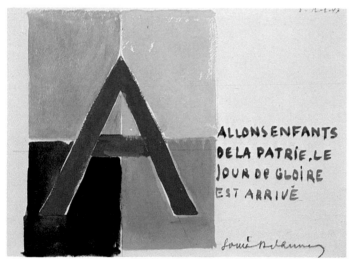

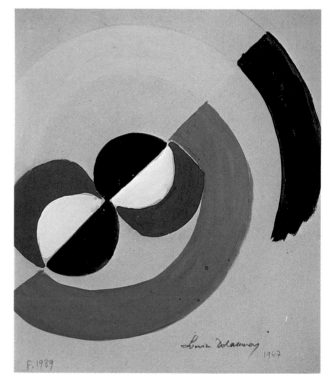

Cat. 23. *Rhythm-Color (Rythme-couleur),* 1953
No. 132, oil on canvas, 44-1/2 x 57-1/2 (113 x 146)
Collection Sonia Delaunay, Paris

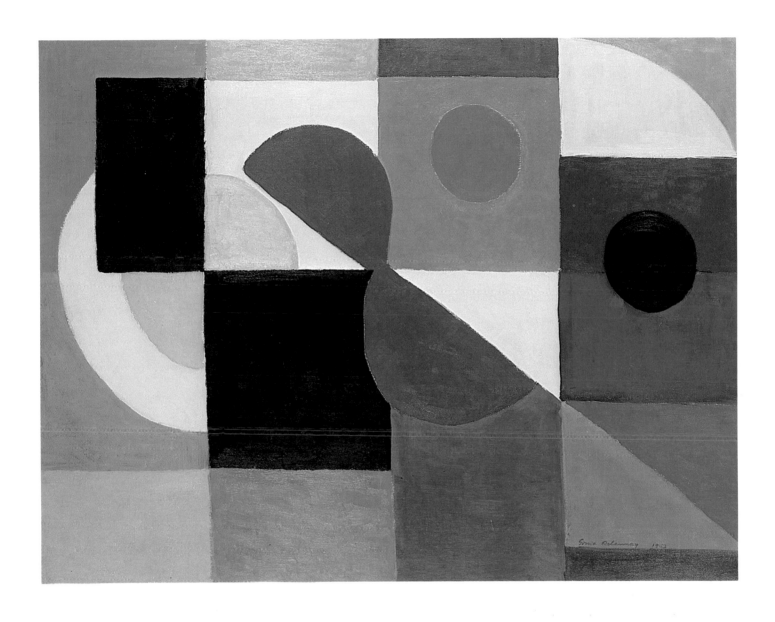

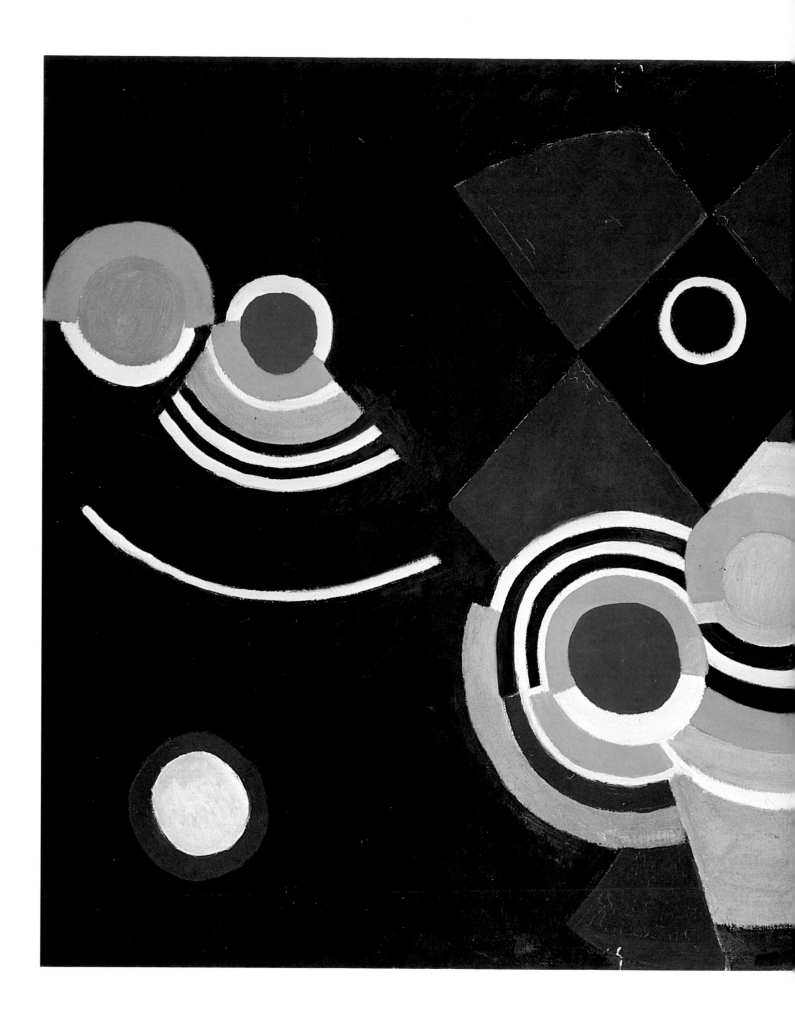

Left: Cat. 21. *Colored Rhythm (Rythme coloré)*, 1948
No. 616, oil on canvas, 40-15/16 x 57-1/8 (104 x 145)
Collection Sonia Delaunay, Paris

Top: Cat. 148. *Composition,* 1953
No. 313, watercolor, 15 x 12-1/8 (38.1 x 30.7)
Collection The Grey Art Gallery and Study Center, New York
 University Art Collection, gift of Silvia Pizitz

Bottom: Cat. 149. *Composition,* 1954
No. 133, watercolor, 7-5/16 x 9-7/16 (18.5 x 24)
Collection The Grey Art Gallery and Study Center, New York
 University Art Collection, gift of Rose Fried

187

Cat. 24. *Composition, Rhythm*
 (Composition, rythme), 1955-58
oil on canvas, 63-3/16 x 85-7/8
 (160.2 x 218.1)
Collection Musée National
 d'Art Moderne, Paris

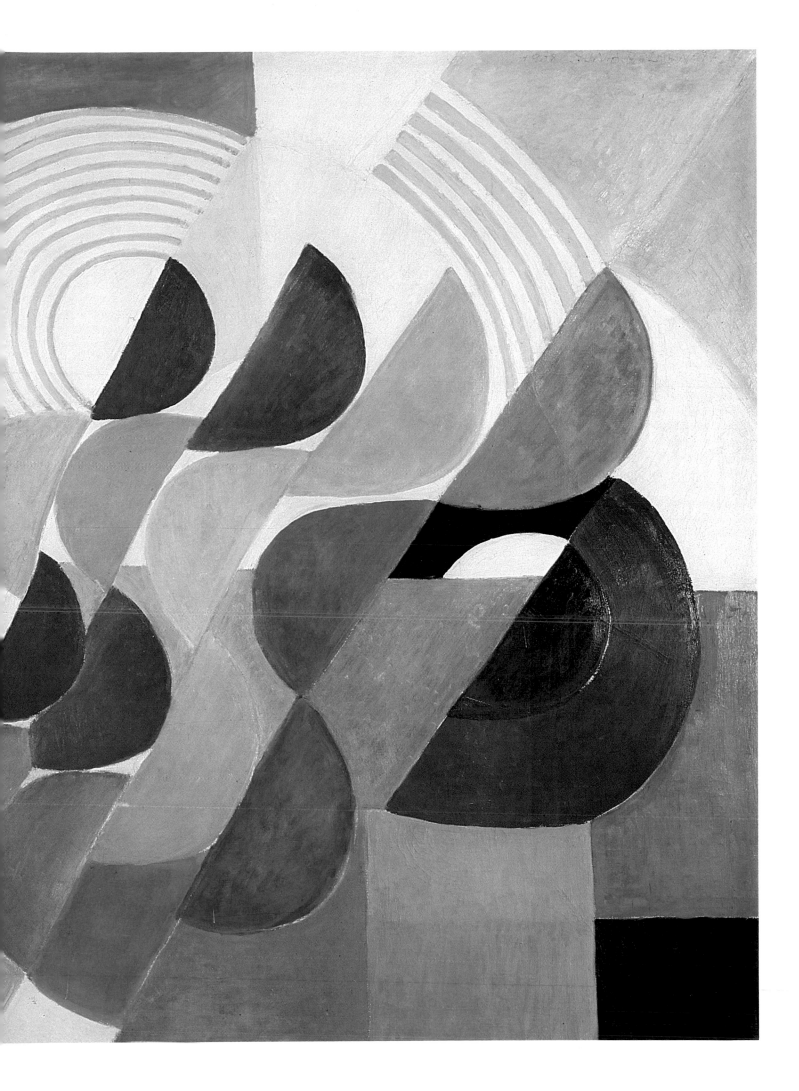

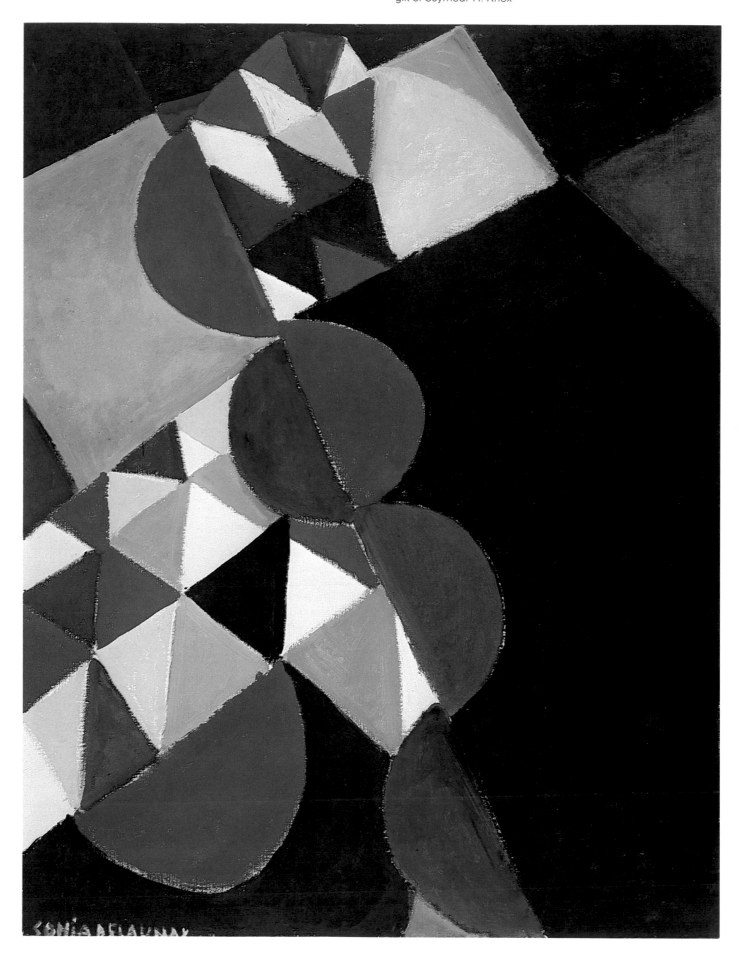

Cat. 150. *Playing Cards (Jeu de cartes)*, 1959
lithograph, 37-1/2 x 25-1/2 (95.2 x 64.7)
Issued by Altenburger und Stralsunder Spielkarten, Leinfelden,
 West Germany
Collection Sonia Delaunay, Paris

193

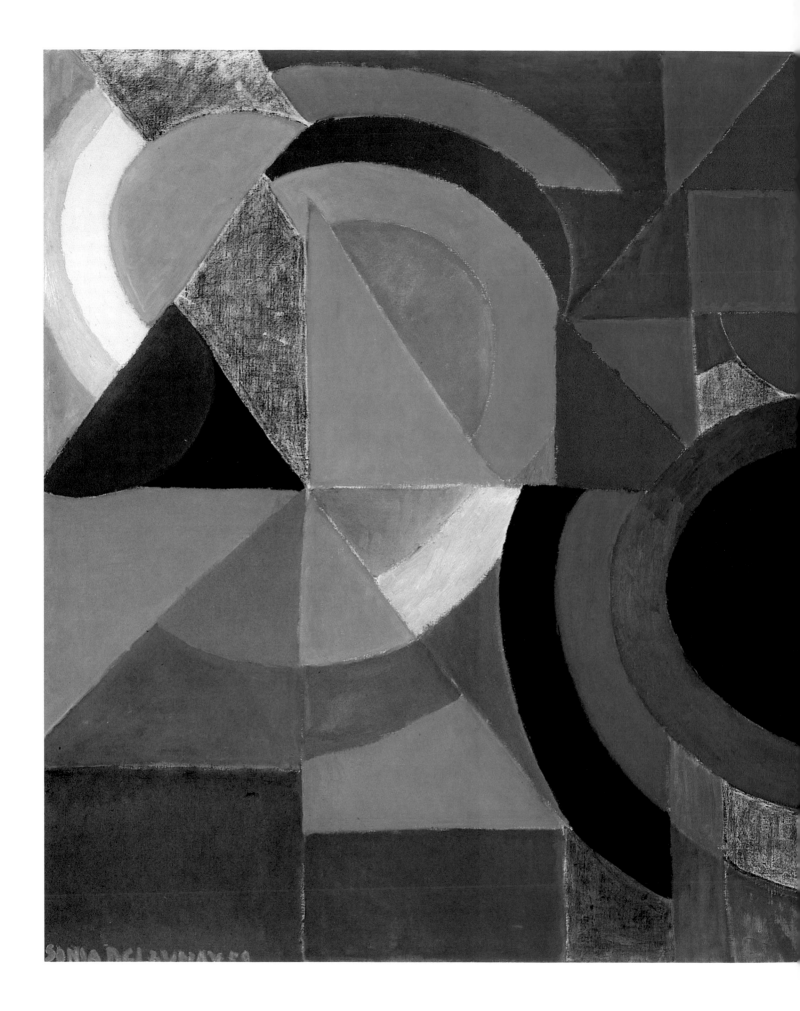

Left: Cat. 26. *Rhythm-Color (Rythme-couleur)*, 1959-60
No. 894, oil on canvas, 49 x 64 (124.5 x 162.5)
Collection Kunsthalle, Bielefeld, West Germany

Cat. 158. *Rhythm-Color (Rythme-couleur)*, 1962
No. 959, gouache 21-7/16 x 28-1/2 (54.4 x 72.3)
Private collection

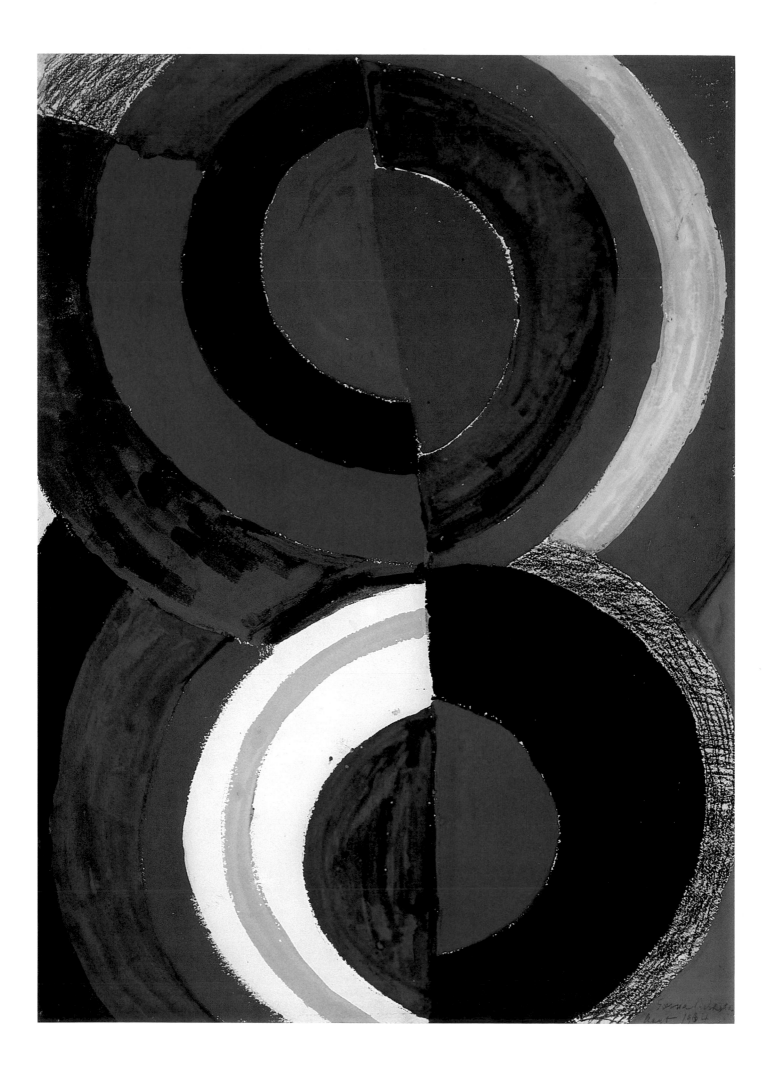

Opposite page, left: Cat. 159. *Rhythm-Color (Rythme-couleur),*
 1964
No. 1146, gouache, 30-13/16 x 22-1/4 (78 x 56.5)
Collection Sonia Delaunay, Paris

Left: Cat. 28. *Design for Stained Glass Window (Projet pour vitrail),*
 1967
gouache on panel, 45 x 13-1/2 (114.3 x 34.3)
Collection Tamar J. Cohen, New York

Top, right: Cat. 161. *Design for Schwarz Album (Projet pour
 l'Album Schwarz),* 1965
No. 1692, crayon, 16-9/16 x 15-3/4 (42 x 40)
Collection Sonia Delaunay, Paris

Bottom, right: Cat. 162. *Rhythm-Color (Rythme-couleur),* 1965
No. 130lb, gouache, 22-7/16 x 16-15/16 (57 x 43)
Collection Sonia Delaunay, Paris

199

Cat. 29. *Rhythm-Color (Rythme-couleur)*, 1967
No. 1229, oil on canvas, 78-3/4 x 59-1/16 (200 x 150)
Collection Sonia Delaunay, Paris

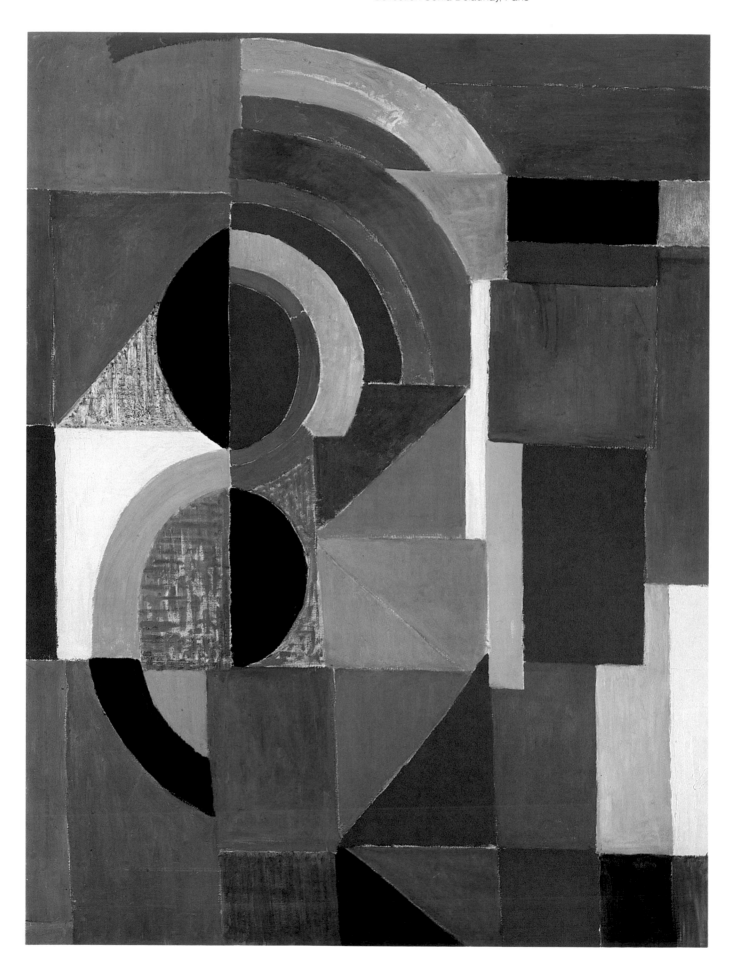

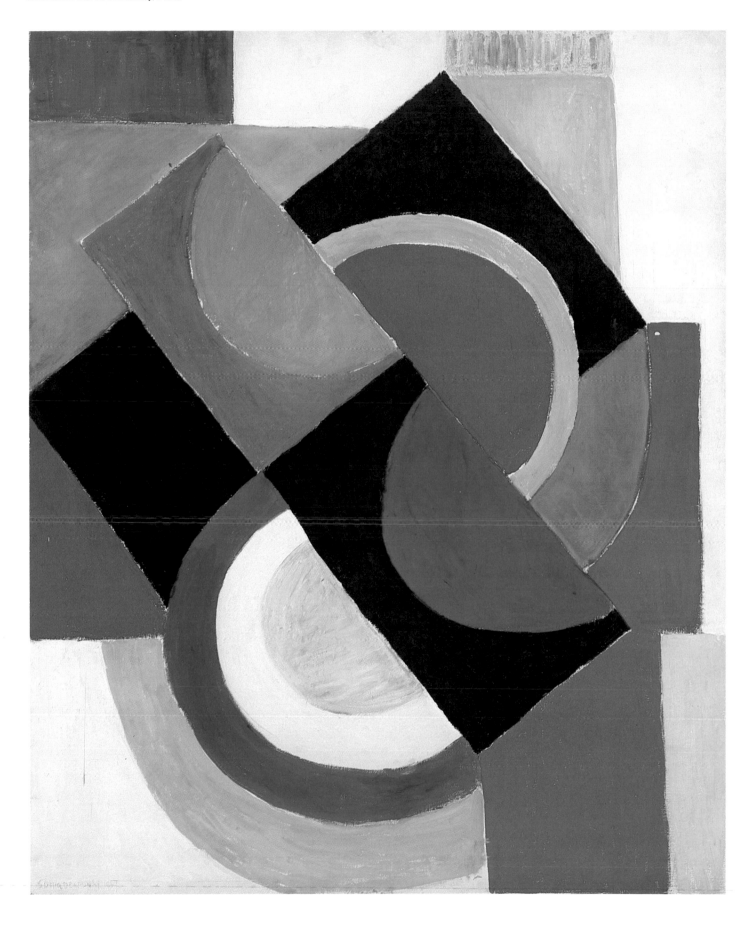

Cat. 31. *Rhythm-Color Called "Large Round Painting"*
 (Rythme-couleur dit "grand tableau rond"), 1967
No. 1541 , oil on canvas, diameter 88-5/8 (225)
Collection Sonia Delaunay, Paris

Right: Cat. 32. *Rhythm-Color (Rythme-couleur)*, 1967
No. 1554, oil on canvas, 78-3/8 x 59-1/16 (199 x 150)
Collection Sonia Delaunay, Paris

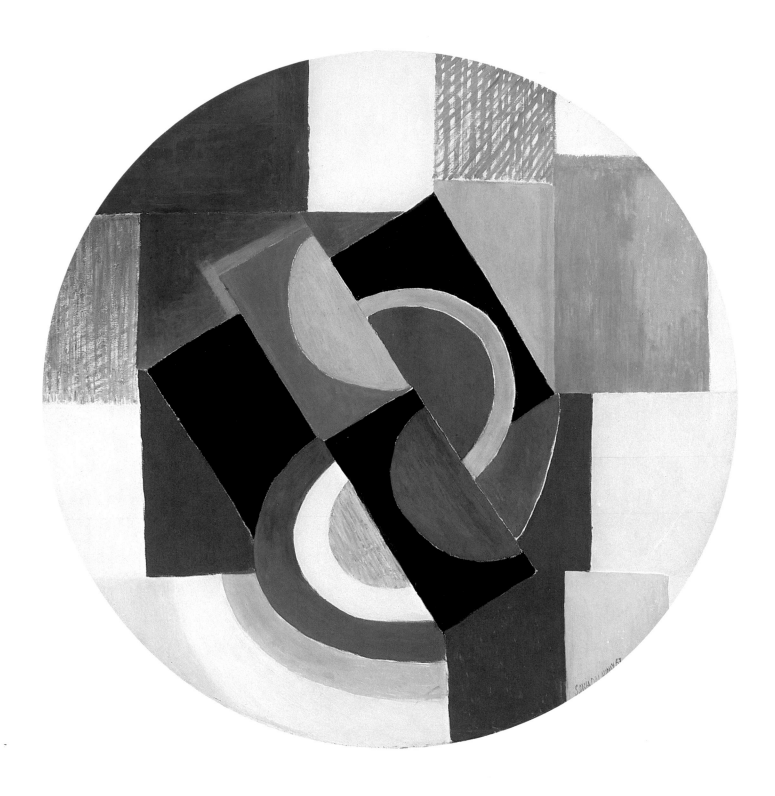

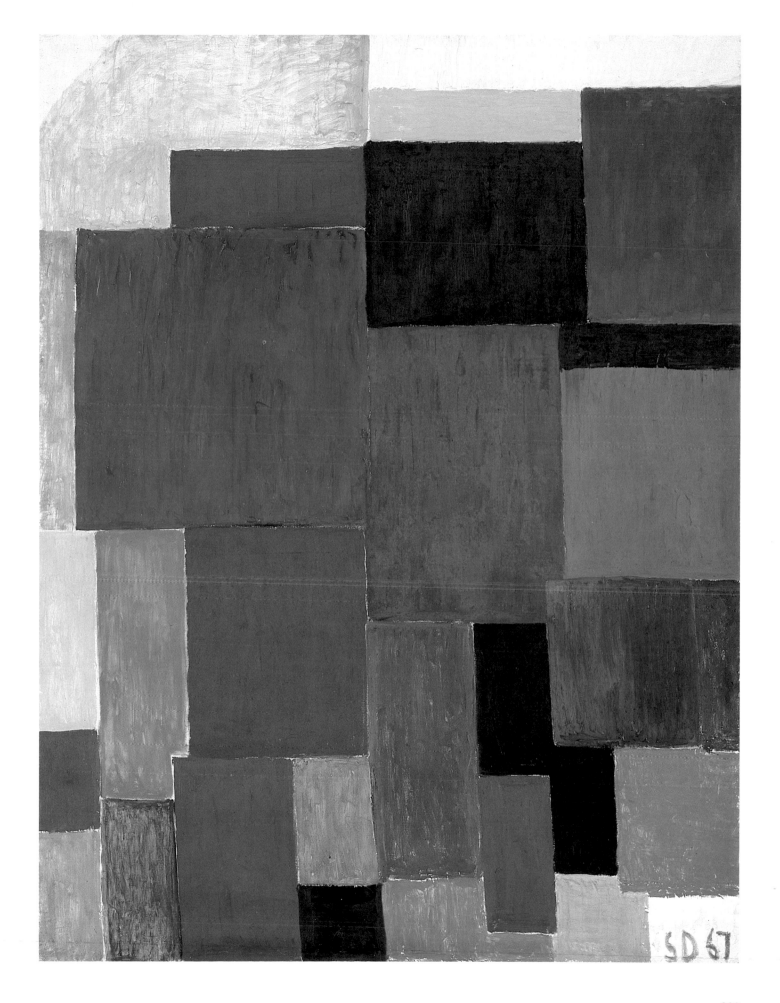

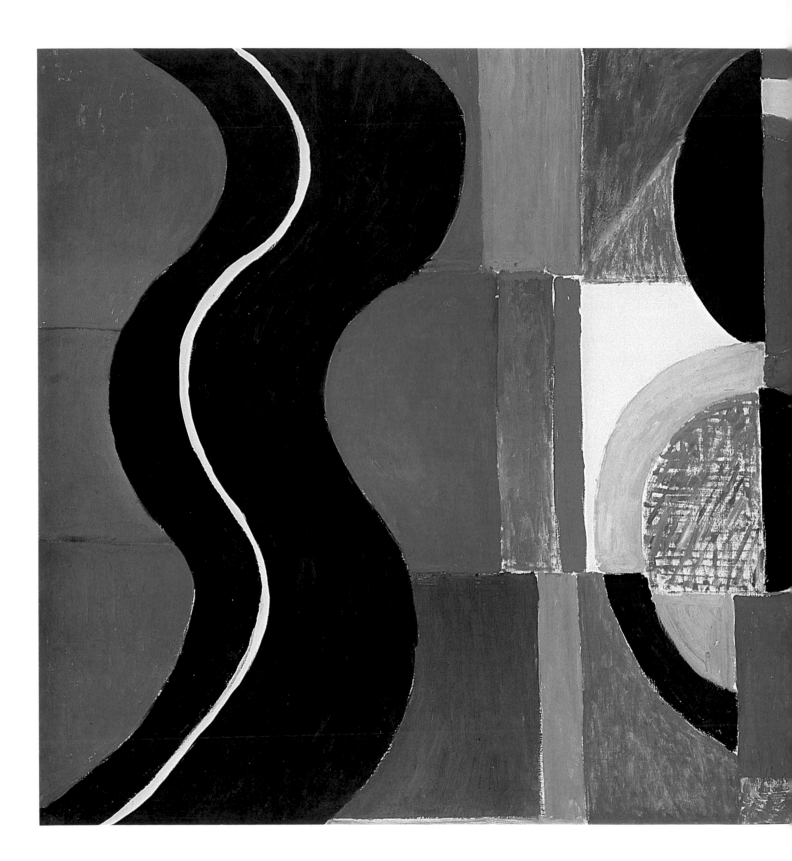

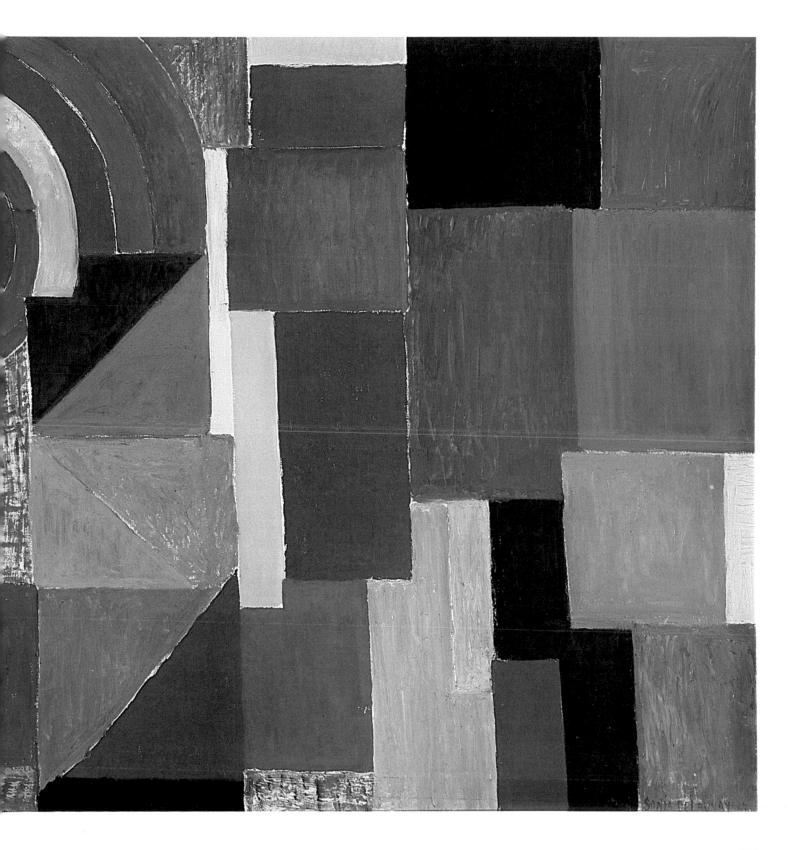

Top, left: Cat. 165. *Rhythm (Rythme)*, 1970
gouache, 11-3/4 x 8-1/4 (30 x 21)
Collection Jacques Damase, Paris

Top, right: Cat. 167. *Rhythm-Color (Rythme-couleur)*, 1973
No. 1892, gouache, 17-5/16 x 13-6/16 (44 x 34)
Collection Sonia Delaunay, Paris

Bottom: Cat. 166. *Syncopated Rhythm-Color (Rythme-couleur syncopé)*, 1971
No. 1838, gouache, 18-1/8 x 16-1/8 (46 x 41)
Collection Sonia Delaunay, Paris

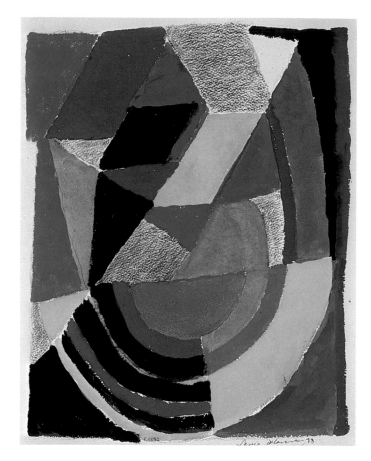

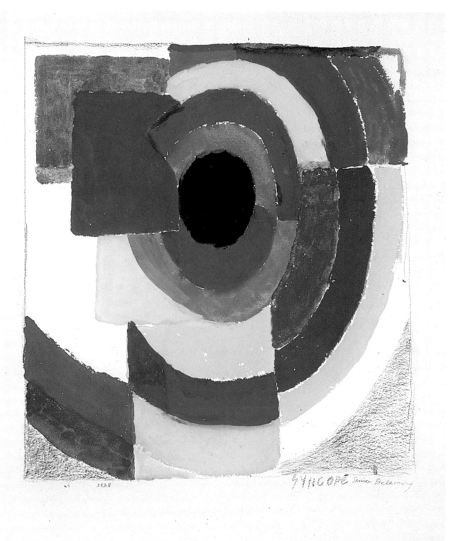

Cat. 34. *Rhythm-Color (Rythme-couleur)*, 1970
No. 1633, oil on canvas, 52-1/2 x 39-1/2 (133.4 x 100)
The National Archives of the United States, Washington, D.C.

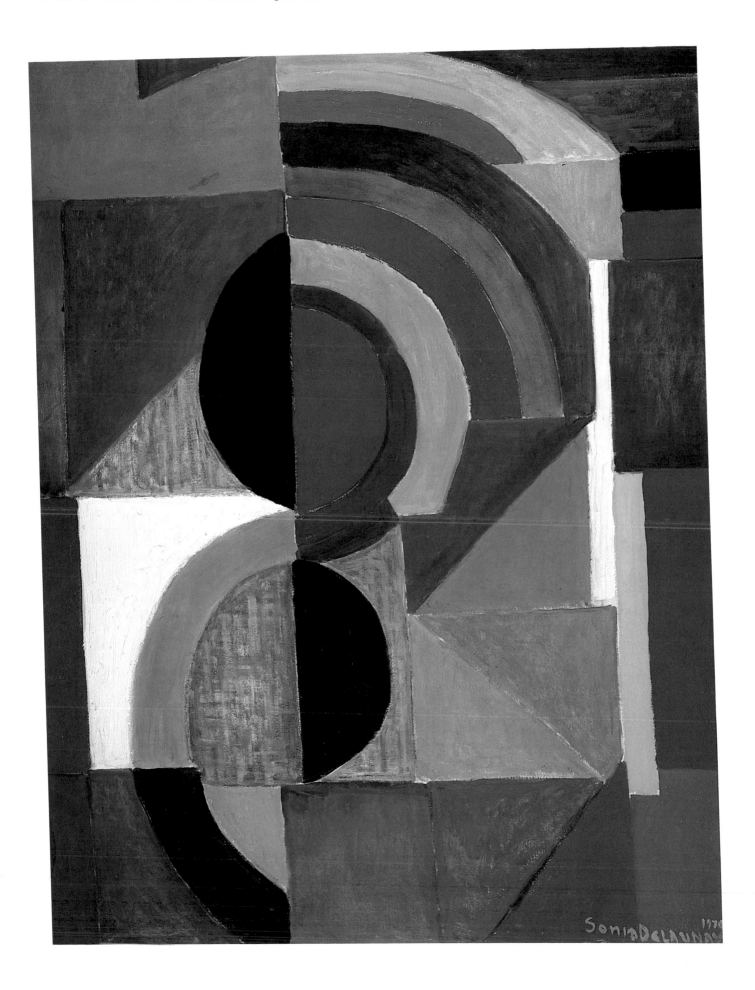

Top, right: Cat. 163. *Designs for cover of book by
 Jacques Damase, Sonia Delaunay (Projets de couverture pour le
 livre de Jacques Damase, Sonia Delaunay)*, 1969
six studies in one frame
gouache, each 12-7/16 x 8-9/16 (31.5 x 21.7)
Collection Sonia Delaunay, Paris

Top, left: Cat. 180. Bookbinding for (Reliure sur) Arthur
 Rimbaud's *Oeuvres* (Paris: Mercure de France, 1909), 1913-14
paper collage, 8-1/2 x 5-3/4 (21.5 x 14.5)
Collection Bibliothèque Nationale, Paris

Bottom: Cat. 191. Arthur Rimbaud, *Les Illuminations*, illustrated
 by Sonia Delaunay, (Paris: Editions Jacques Damase), 1973
Collection Sonia Delaunay, Paris

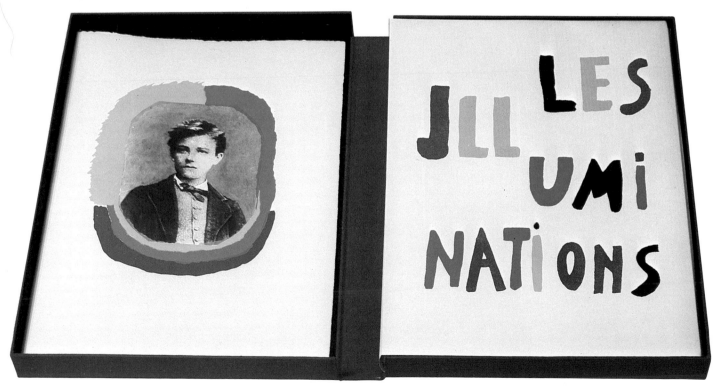

Cat. 184. Tristan Tzara, *Le Fruit Permis,* illustrated by Sonia
 Delaunay, (Paris: Editions Caractères), 1956
Collection Sonia Delaunay, Paris

Cat. 186. Sonia Delaunay and Jacques Damase, *Rythmes-couleurs,*
 (Paris: Editions Galerie Motte), 1966
Collection Sonia Delaunay, Paris

Cat. 189. Sonia Delaunay and Jacques Damase, *Robes Poèmes,*
 (Milan: Edizioni del Naviglio), 1969
Collection Sonia Delaunay, Paris

Cat. 185. Tristan Tzara, *Juste Présent,* illustrated by Sonia
 Delaunay, (Paris: Editions La Rose des vents), 1961
Collection Sonia Delaunay, Paris

Cat. 188. Sonia Delaunay, *Alphabet,* (Milan: Emme Edizioni), 1969
Collection Sonia Delaunay, Paris

Cat. 192. Tristan Tzara, *Le Coeur à Gaz,* illustrated by Sonia
 Delaunay, (Paris: Editions Jacques Damase), 1977
Collection Sonia Delaunay, Paris

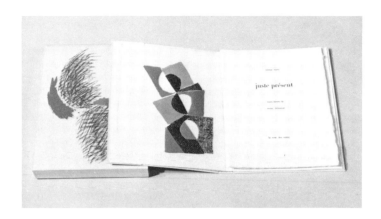

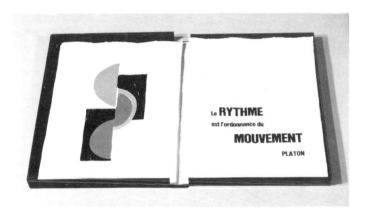

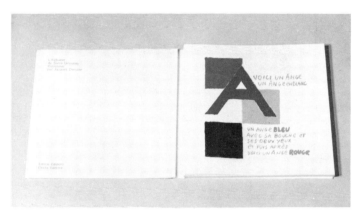

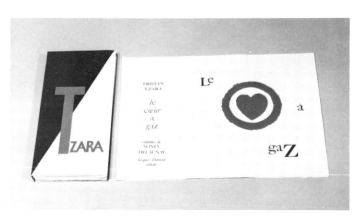

Top: Cat. 204. *Children's Games (Jeux d'enfants)*, 1967
Aubusson tapestry, 74 x 63 (188 x 160)
Collection Etablissements Pinton, Paris

Bottom: Cat. 208. *Monumental II*, 1967
Aubusson tapestry, 62 x 72 (157.5 x 307)
Collection Etablissements Pinton, Paris

Opposite page, top: Cat. 207. *Finistère*, 1967
Aubusson tapestry, 70-1/16 x 76-3/4 (178 x 195)
Collection Etablissements Pinton, Paris

Bottom, left: Cat. 205. *Counterpoint (Contrepoint)*, 1967
Aubusson tapestry, 88-3/16 x 68-1/2 (224 x 174)
Collection Etablissements Pinton, Paris

Bottom, right: Cat. 206. *Diagonal*, 1967
Aubusson tapestry, 77-15/16 x 58-1/4 (198 x 148)
Collection Etablissements Pinton, Paris

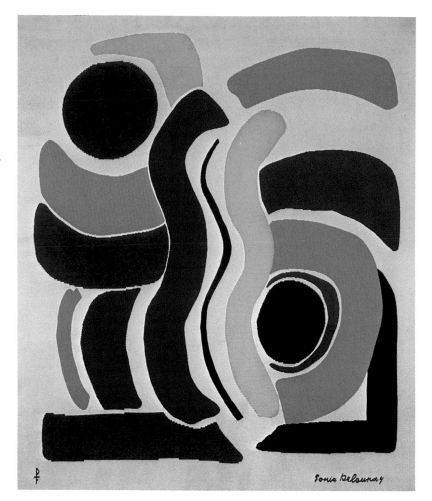

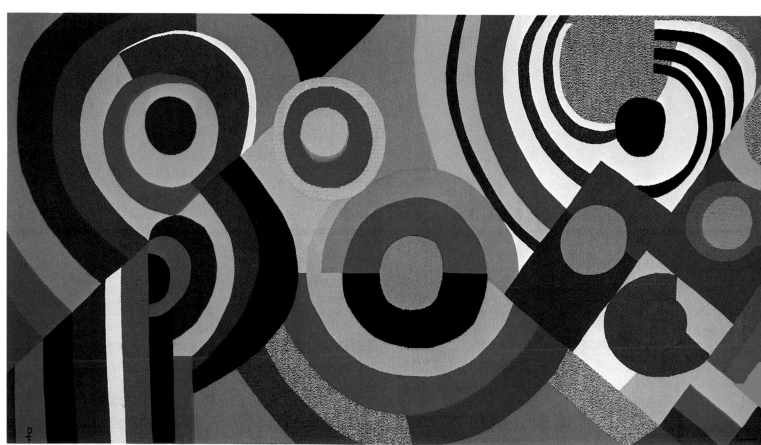

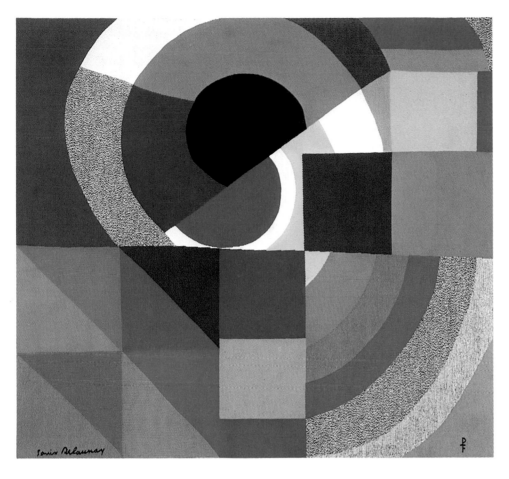

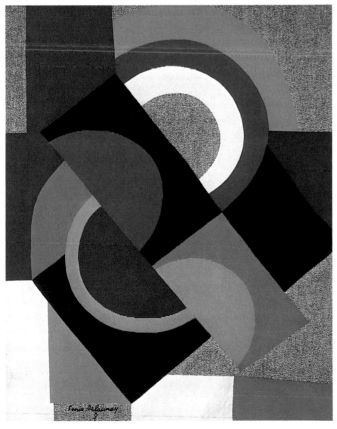

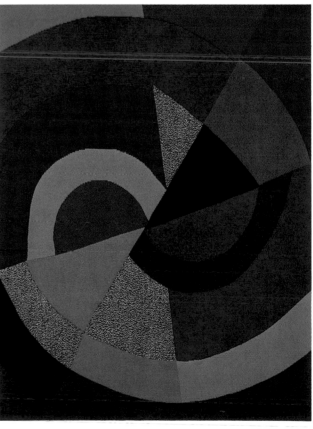

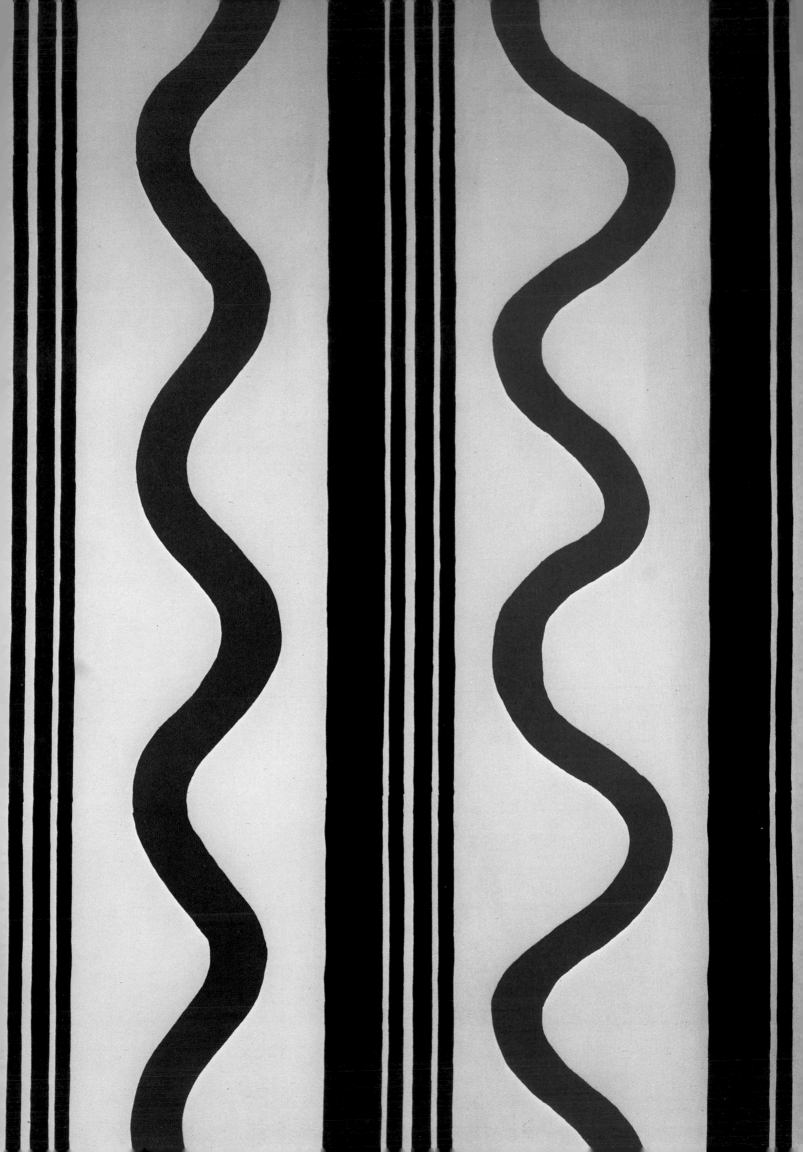

CHRONOLOGY

BY SUSAN KRANE

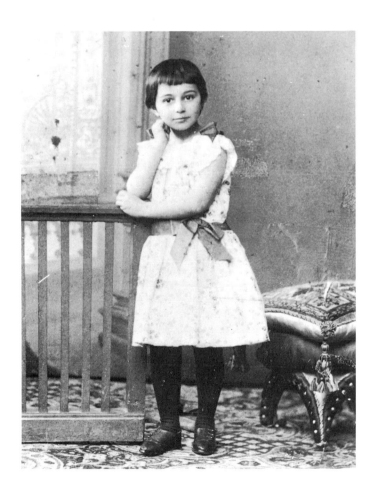

Fig. 43. *Sonia Delaunay, age 8, in St. Petersburg, 1893.*

Left: Cat. 225. *Ulysses (Ulysse),* 1977
27/900 (detail)
fabric panel, 117-9/16 x 55-1/16 (298.5 x 140)
Issued by Artcurial, Paris

1885 Born Sonia Stern on November 14 in the Ukrainian village Gradizhsk to Elie Stern, a factory worker, and Anne Terk Stern. She was the youngest of three children.

The memories of a little girl who lives in the Ukrainian plains remain as cheerfully colored memories. She goes to fetch her father at mealtime along a path dug between two snow banks three times as big as she is.

Around her, the long, low, white houses seem to be encrusted like mushrooms. Soon winter disappears and the joyous sun blazes over the horizon from end to end!

1890 Adopted by maternal uncle, Henri Terk, a wealthy lawyer in St. Petersburg. Spends youth in St. Petersburg. Vacations each summer in Finland (through 1907). Travels periodically to Switzerland, Germany and Italy. Is taught French, German and English by governesses. Becomes acquainted with art through her uncle's collection of paintings and albums of reproductions.

The husband of my aunt, who raised me, was active in the Franco-Russian exchange. He had a private town house in St. Petersburg with uniformed servants and everything — the whole works — and he had a collection of paintings from the Barbizon school. When he died he left to the relatives who raised me some large engraved albums containing many reproductions that took the place of today's photo; and since the adults' conversation interested me very little, I looked at these albums every night. They were the basis of my painting school[2]

1899 Receives first paints from the artist Max Liebermann, a friend of her uncle, when visiting Berlin. Studies drawing at *lycée.*

1903-05 Attends university in Karlsruhe, Germany, where she studies drawing with Ludwig Schmidt-Reutter. Takes anatomy classes. Is introduced to Impressionism through books.

I am attracted by pure colors. Colors from my childhood, from the Ukraine. Memories of peasant weddings in my country in which the red and green dresses decorated with many ribbons billowed in dance. Memories of an album of folk costumes brought from Sweden by my uncle[3]

213

Fig. 44. *Sonia and Wilhelm Uhde, Paris, 1908.*

1905	Moves to Paris. Lives in Latin Quarter with four Russian friends. Studies at Académie de la Palette where she meets fellow students Ozenfant, Dunoyer de Segonzac, Boussingault. Learns engraving from Rudolf Grossmann.		home, marries German critic and art dealer Wilhelm Uhde and resides at 11, Quai de Tournelle. Meets Robert Delaunay again. First one-artist exhibition at Uhde's gallery, Galerie Notre-Dame-des-Champs.
1906	Establishes studio at 9, Rue Campagne-Première.	1909	Meets Picasso, Braque and Vlaminck through Uhde. Becomes acquainted with the paintings of Henri Rousseau. Encounters Robert Delaunay again. They share artistic interests and a great admiration for Rousseau and soon develop a close friendship. Spends summer in Chaville, across the street from summer house where Delaunay is staying with his uncle.
1907	Paints figurative works in intense colors influenced by Van Gogh, Gauguin and the Fauves. Meets Robert Delaunay at Wilhelm Uhde's.		
1908	To avoid pressure from her family to return		

I could see Robert painting flowers in the garden.

Both of us were twenty-three years old when I decided not to read anymore. He knew how to observe nature. He was like a whirlwind. His eagerness for life, his aggressiveness, filled me with delight. When he left his uncle's garden, he would take me for long walks in the woods. Nine months later we were "engaged".

Back in Paris, we met every day. He took me to visit Saint-Germain-l'Auxerrois, I loved this church. We would also go to the Louvre and wander around the rooms of Egyptian art and the almost-deserted Chaldean rooms. Yes, every day I would rush from one bank of the Seine to the other to meet him[4]

1910 In spring, asks Uhde for divorce. Lives with Robert in Nantua. They marry in November and live at 3, Rue des Grands Augustins, where they maintain a studio until 1935.

1911 Son Charles born in January. Makes appliquéd crib blanket. On Sundays, artists and writers gather at Delaunays' home. Summers in Villerville.

When Charles was born in January, 1911, he had a First Empire style bed. I tucked him in with a blanket made out of scraps of material. The Russian peasants do that. Noticing the arrangement of the pieces of material my friends exclaimed: "It's cubist!" The mosaic of material was a spontaneous creation, and nothing more. I continued to use this process on other objects — some art critics have seen this as a "geometrization" of shapes and a celebration of colors which foreshadowed my works in the years to come[5]

1912 Paints first *Simultaneous Contrasts*. Designs simultaneous household objects. Becomes fascinated with newly-installed electric lights of Paris. Meets Chagall, who becomes a regular visitor. Spends summer at La Madeleine in Chevreuse Valley. Apollinaire stays with Delaunays from November to mid-December.

12, 13, 14, what rich and explosive years for Robert and me! Robert was prophesying and could not be stopped. Before the outbreak of the war, Robert had been shooting off rockets in all directions — Back on earth I had gathered the

falling sparks of the fireworks. I tended the more intimate and transient fires of everyday life, while silently continuing the important work. Robert was already dreaming of large-scale works, collaborations between painter and architect. He was aiming at monumentality and I stood behind him, also loving the vastness of it. In the sky we had rediscovered the moving principle of any work of art: the light, and the motion of color[6]

1913 Becomes close friends with Blaise Cendrars at beginning of year. Creates collage cover for Cendrars' poem *Les Pâques à New York*. In summer, creates first simultaneous clothing, worn by Delaunays to Bal Bullier.

The continuously undulating rhythm of the tango provoked my colors to move. The Bal Bullier was for me what the Moulin de la Galette had been for Degas, Renoir and Lautrec. I turned it into a painting 3.90 m. in size. It was traditional to represent a dancer frozen in a chosen position, like a snapshot. I broke away from this tradition by superimposing postures, blending light and motion and scrambling the planes[7]

Collaborates with Cendrars on illustration, type and layout of *La Prose du Transsibérien et de la Petite Jehanne de France*, (published in October). Begins series of unsolicited poster-poems (with Cendrars), collages and bookbindings. Produces poster studies of light and movement. Exhibits variety of objects at first Herbstsalon at Galerie Der Sturm, Berlin. Meets Arp. Frequents St. Cloud airport to watch planes. Spends summer at Louveciennes.

We were on the verge of new vision which, in the visual and poetical world, was going to overthrow the old conceptions. This intensive creation was such a part of our life that none of us had the urge to brag. Bragging was the key to rapid success to many of our fellow artists. But showing off and publicity were far from our minds when I was going out with my simultaneous dresses made of little pieces of assembled materials, creating sensational spots of color[8]

1914 Continues numerous poster projects for Zénith, Dubonnet, Bensdorf chocolate and studies of movement on Boulevard St. Michel. Exhibits at Salon des Indépendants.

In spring Delaunays go to Fuenterrabia, Spain for health of Charles. Remain when war is declared, spending winter and following spring in Madrid.

1915 Visits Lisbon. In summer, Delaunays move to Vila do Conde, Portugal. Share villa with Eduardo Vianna and Sam Halpert.

It was the ideal life. We could work quietly from morning to night. The villa was perched on the dunes, facing the sea with blooming cacti in the garden. I thought I was living in a fairy tale. As soon as I arrived, I fell in love with the village.

It was a world in itself. Dazzling white houses on a distant background or deep blue ocean; cods spread out everywhere to dry. On the right, a hill with a castle and a viaduct; on the plain, the countryside with hieratic women like ancient sculptures, some oxen, a great nobility in all of this. This was the first impression. Then for the details. In the dazzling sunlight, the hues of the shawls, the clothes of the women, the tanned complexions, some deep-green watermelons, their bright red core fading into pink shades. I was intoxicated with colors and started to paint right away, as did Delaunay and our Portuguese friend, Eduardo Vianna[9]

Paints flamenco singers and dancers. Decorates pottery. With Robert, Cendrars, Apollinaire, Rossiné and Portuguese artists Souza-Cardoso, Pacheco, Almada-Neguiros, plans *Corporation Nouvelle* to publish collaborative albums of poetry and art and to circulate exhibitions.

1916 Continues projects for albums. Creates simultaneous necklaces and jewelry boxes. In March, travels to Vigo, Spain. On return, is detained for several weeks on false espionage charges. Returns to Vigo in August. Moves to Valença do Minho, Portugal in September. Paints still lives, landscapes and *Market at Minho*. Produces self portraits, one of which is used for cover of catalogue for exhibition at Nya Konst Galleriet, Stockholm in April. Preliminary designs for *Homage to the Donor.*

In Valença do Minho, we were able to work on large scale in a Jesuit convent painting, the rooms which we could use were vast enough. On the facade, I painted a big composition, *Homage to the Donor.* It was a joy to rediscover the dazzling, warm and colorful everyday life of the Portugal of that time.

Nature supplied all our needs, body and soul. We could naturally apply our experiments in color, without falling into the trap of intellectualism[10]

Vacations at Monçao in winter.

1917 Continues work on *Homage to the Donor.* Loses private income as result of Russian Revolution.

The October Revolution, the end of the Tzar and the end of our income.

On the Ramblas of Barcelona, we heard the news of the Bolshevik victory. We were completely ruined, but the expectations of the Russian people made us cry with joy before we gave any thought to the effect of the ruin of the Terk family on our artistic freedom.

The Russian-Portuguese vacations are truly over. We are going to have to rejoin society and look for a way to use our discoveries in decorative art[11]

Left: Fig. 45. *The Delaunays with son Charles, in Portugal, c. 1916.*

Fig. 46. Left to right: *Robert Delaunay, Boris Kochno, Igor Stravinsky, Sonia Delaunay, Serge Diaghilev, Manuel de Falla and Barocchi in Madrid, 1918.*

Decides to market designs. Moves to Madrid. Meets Serge Diaghilev; spends evenings with members of Russian Ballet watching flamenco dancers.

1918 In Sitges, designs costumes for Diaghilev's revival of ballet *Cléopâtre* (opens in London on October 21). Diaghilev, Massine and Lopouchova stay with Delaunays. Returns to Madrid. Meets Stravinsky and de Falla. Renews acquaintance with Perret and Le Corbusier. With designers Doucet and Ziem, presents fashion show at Hotel Ritz in Madrid. Designs clothes and accessories for Spanish aristocrats; opens Casa Sonia boutique carrying lampshades, parasols, handbags and other items of simultaneous design.

Why wouldn't the bourgeoisie enjoy living in the house of a poet? I have fun with all the orders sent to the "Casa Sonia." Even when it comes to the most trivial details of fashion or interior design, I don't have the feeling I am wasting my time. It's as noble a task as painting a still life or a self portrait![12]

Corresponds with Tzara and Zurich Dadaists.

1919 Designs interior of Petit Casino in Madrid and costumes for first floor show. Exhibits at l'Associacion de Artistas Vascos with Robert and at Majestic Hall in Bilbao.

1920 Designs costumes of Aida and Amneris for production of opera *Aida* at Liceo, Barcelona.

1921 Returns to Paris, encouraged by Tzara's letters of postwar avant-garde activities. Resides at 19 Boulevard Malesherbes. Associates closely with Dadaists and Surrealists. Hosts regular gathering of artists and poets, including Breton, Aragon, Soupault, Desnos, Huidobro, Man Ray, Baron, Goll, Tzara and Bruce. Renews friendships with Gleizes, Lhote, Chagall. Exhibits Portuguese paintings at Der Sturm, Berlin.

The stalwarts of the Delaunay gang always moved together like a rugby team, at least before the break between Dadaists and Surrealists, between Tzara's advocates and the Breton clan![13]

1922 Designs interior of bookstore Au Sans Pareil
 in Neuilly. Produces first curtain-poem,
 dress-poems, vest-poems and simultaneous
 scarves. Meets Iliazd and Mayakovsky.
 Creates bookbindings for works by Tzara
 and Iliazd. Actively supports Tzara's Dada
 activities.

1923 Designs costumes for *Danseuse aux Disques*
 performed by Lizica Codreano at the
 Licorne, April 29 (music by Poulenc,
 organized by Iliazd); creates costumes for
 the *Coeur à Gaz (Gas-Operated Heart)*
 staged during the *Soirée du Coeur à Barbe
 (Evening of the Bearded Heart)* at Théâtre
 Michel.

Tzara had asked me to do costumes of his play,
Le Coeur à Gaz, and asked Georges Auric to
write the music…. The show was boycotted by
demonstrators, but we carried on for ourselves.
Tzara had organized a rehearsal in our apartment
on Boulevard Malesherbes. Everyone had
gathered there, and in this way I had the luck to
meet René Crevel. What a moving personality. He
gazed benevolently around our laboratory and
later wrote a poetic description of our vigil.
Basically, I have the feeling that only poets
understand me, understand what I always wanted
to do. My problem is that I want everyone to be a
poet![14]

Creates fashion booth at *Grand Bal Travesti-
Transmental,* held at Bal Bullier, February 23
(organized by Alliance of Russian Artists).
Textile manufacturer in Lyons commissions

fabric designs. Meets Joseph Delteil. Delaunays sell Rousseau's *La Charmeuse de Serpents* (painted for Robert's mother) on condition it be willed to the Louvre.

1924 Establishes Atelier Simultané for printing simultaneous textiles and producing clothing and accessories. Makes upholstery fabrics, embroidered and appliquéd coats, costumes for *Bal Banal*. Designs scarves and costumes paraded during recitation of Delteil's poem *La Mode Qui Vient* at gala fashion show at Hotel Claridge, May 24.

The demonstration took place at the Claridge Hotel in '24, in the presence of Marshal Foch. The costumes took people by surprise. Ball gowns? Theatrical disguises? Painted silk paradoxes, superstructures grafted on the models. While having fun, I wanted to show the variety of women's lines and the movements of their bodies. That meant abandoning the strictly classical dress. Each woman must dress according to her personality, her clothes made to complement her body. Before the inescapable reign of ready-made clothes, we were enjoying the last days of the *modèle unique*. As Crevel tells it so well, I enjoyed not just creating a dress or a scarf, but a whole new person. Thereafter, the first liberated women would be imitated by thousands of others. The ready-to-wear clothes would reclaim the conquests of the twenties and the poem-dresses would fill the streets![15]

1925 With couturier Jacques Heim, creates Boutique Simultanée for International Exhibition of Decorative Arts.

Enormous success really came after the International Exhibition of Decorative Arts, during which I decorated and animated a simultaneous shop with the help of Jacques Heim. Our booth was installed on the Alexander III bridge. The models wore my creations. Heim trusted me with the designing of fur coats. The material manufacturers began to take the bait and soon wanted to use nothing but geometrical designs. My friend, Jacques Damase, understood perfectly that for me there was no gap between my painting and my so-called decorative work and that the minor art had never been an artistic frustration but a free expansion, a conquest of new spaces. It was the application of the same research. The conception was very exciting![16]

Exhibits textiles at Salon d'Automne. Decorates Citroën B12. Publication of *Sonia Delaunay, Ses Peintures, Ses Objets, Ses Tissus Simultanés, Ses Modes* with preface by Lhote, poems by Cendrars, Delteil, Soupault and Tzara, in connection with International Exhibition.

1926 Creates costumes for René le Somptier's film, *Le P'tit Parigot;* decorative fabrics and costumes for actor Jacques Cathelin in Marcel l'Herbier's film *Le Vertige*. Meets Gropius, Breuer, Mendelsohn: designs clothing for their wives.

1927 January 27, lectures at Sorbonne on influence of painting on fashion design:

At present, fashion has become constructive, clearly influenced by painting. The construction and cut of the dress is henceforth to be conceived at the same time as its decoration. This new concept leads us logically to an invention that was patented by R. Delaunay and that was last used by me in collaboration with Maison Redfern.

It is the fabric-pattern *(tissu-patron)*.

The cut of the dress is conceived by its creator simultaneously with its decoration. Afterward, the cut and the decoration appropriate to the form is printed on the same fabric. The result is the first collaboration between the creator of the model and the creator of the fabric.

All this is conceived from the point of view of artistic conception and of the standardization to which everything in modern life tends . . ![17]

1928 Designs sets and costumes for Massine's ballet *Les Quatres Saisons* (never realized); drop curtains and tapestries for Paris premiere of Ernst Krenek's jazz opera *Jonny Spielt Auf;* costumes for actor Lucienne Bogaert in *Le Coup du 2 Décembre* (play by Bernard Zimmer).

1929 Designs furniture for play *Parce que Je T'Aime*. Costumes for performers Gabrielle Dorziat, Lucienne Bogaert, Paulette Pax; fashions for Gloria Swanson, Olga Samaroff

Top, left: Fig. 48. *Coat designed for Gloria Swanson, 1923-24.*

Top, right: Fig. 49. *Boutique Simultanée at the International Exhibition of Decorative Arts, Paris, 1925.*

Bottom, left: Fig. 50. *Press clipping advertising the Boutique Simultanée, 1925.*

Bottom, right: Fig. 51. *Design for the film* Le P'tit Parigot, *1926.*

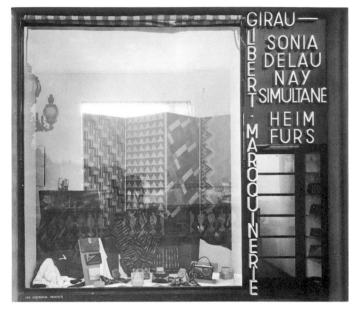

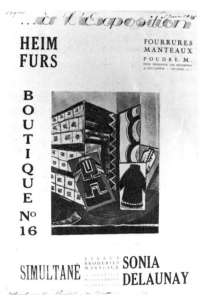

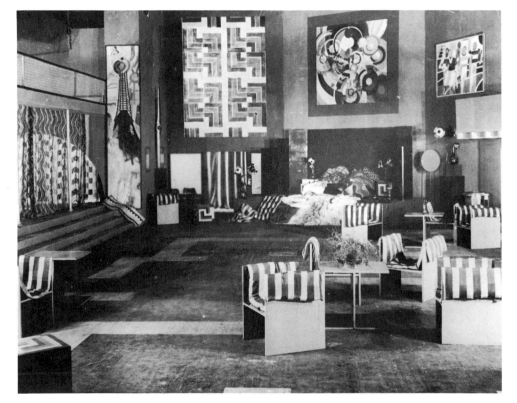

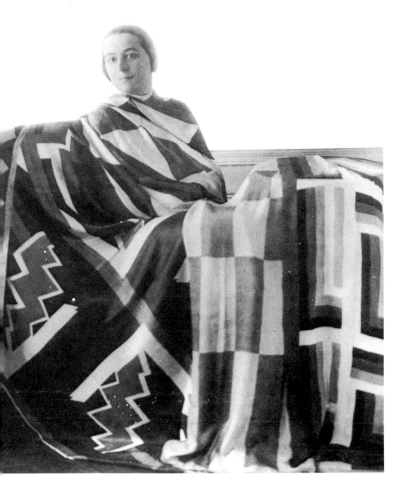

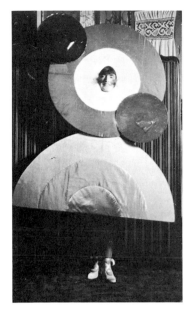

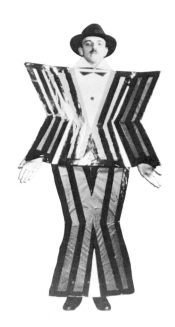

Top, left: Fig. 52. *Sonia Delaunay draped in large scarves of her own design, 1923.*

Top, center and right: Figs. 53 and 54. *Performers wearing simultaneous costumes at the Hôtel Claridge, Paris, 1923.*

Bottom: Fig. 55. *Delaunay street ensembles, Paris, 1928.*

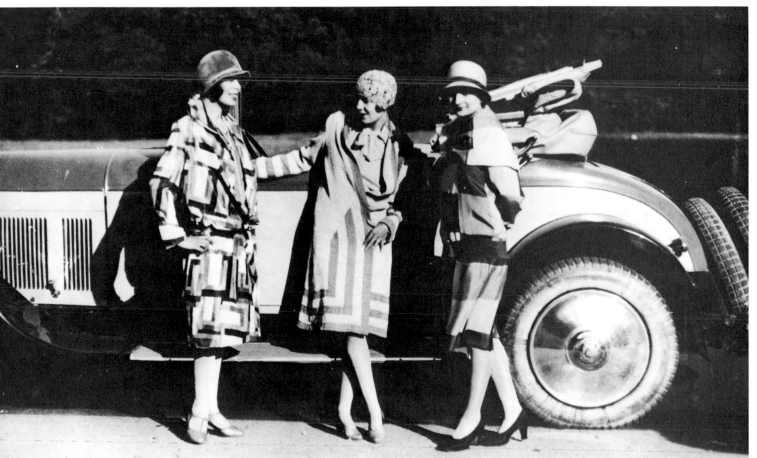

Fig. 56 *Sonia Delaunay with two assistants in her studio, c. 1933.*

Stokovsky and Nancy Cunard. Publication of *Tapis et Tissus*. Vacations with Arp and Taeuber-Arp at home of collector Jean Delhumeau on Ile d'Yeu in Brittany, then joins Tzara at Carnac.

1930 Publication of *Sonia Delaunay: Compositions, Couleurs, Idées.*

1931 Great Depression of 1929 curtails her commercial ventures. Delaunay closes Atelier Simultané and concentrates on painting. Joins *Abstraction-Création* group.

Liberated from the fabrics, I was again able to listen to Robert speak about painting from the moment we woke up. When I was running the designer boutique, I would receive my customers at Boulevard Malesherbes and Robert would leave early in the morning to work in our first studio on Rue des Grands-Augustins. United once more in pure painting, we went back to our healthy arguments. He did not scold me anymore for not having cleaned his studio for a year. I had replied that it was to fulfill his desires, since every time it was cleaned, something was misplaced and it disturbed him. We would joke about our personal little fetishes. To relax in the evening, we each had our own routine. I would collect press clippings and stick them in large albums while he would dream aloud or on paper.[18]

1932 Publishes "Les Artistes et l'Avenir de la Mode" advocating ready-to-wear fashion.

1933 Resumes daily journal which she had kept from 1902-1906.

In 1933, I spent hours of research and collaboration with Robert, fighting for abstract art. However, my life was very complex, torn apart, fragmented between the private orders that I still received from couturiers, particularly Jacques Heim, the editions of albums, publishing of articles in magazines, some projects of shop windows and posters (we were interested in electric advertising), appointments with architects, engineers and possible underwriters.[19]

1934 Publishes "De l'Art de la Devanture."

1935 Delaunays move to 16, Rue Saint Simon, where Sonia Delaunay lived until her death.

Uses garden in Neuilly as studio. With Robert, presents "mica-tube" designs at Salon de la Lumière.

Long before the Eiffel Tower was lit up by the Citroën sign, Robert was seeking a way to combine monumental mural art and electrical publicity. We constructed a booth at the Salon de la Lumière where we used mica-tube lamps. We had been in touch with inventors, engineers and innovative architects.[20]

1936 With engineer Felix Aublet, creates *Zig-zag*, a neon sculpture used as publicity poster, for Société d'Electricité de France competition; wins first prize. Robert receives commissions to decorate Air Pavilion and Railroad Pavilion for upcoming World's Fair in Paris. Works on large murals for the two pavilions with Robert and assigned team of painters in garage near Levallois.

1937 *Distant Voyages* and *Portugal* exhibited in Railroad Pavilion; *Airplane Motor, Propeller* and *Control Panel* in Air Pavilion. Receives gold medal for *Distant Voyages*. Exhibits in Salon d'Automne at invitation of Gleizes. Robert becomes ill.

1938 Creates first designs for playing cards; monumental entryway in colored cement for exhibition Art Mural. Decorates sculpture hall at Salon des Tuileries with Robert, Gleizes, Lhote and Villon. Delaunays organize Thursday afternoon meetings of art and architecture students in their home, at which Robert lectures on art.

1939 With Robert, Nelly van Doesburg, Sidès and Rambosson, organizes first *Réalités Nouvelles* exhibition at Galerie Charpentier. Outbreak of war.

The following year, at Robert's initiative, all the "inobjective" artists met at the Galerie Charpentier. It was to be the first abstract art show. We asked Fredo Sidès to be the president and Nelly van Doesburg, who always came faithfully to the dinners of the Delaunay gang, to be the secretary.

The "Salon des Réalités Nouvelles" marks the end of the Surrealist racket. They stopped setting the rules in the art circles[21]

1939-40 Delaunays travel to Auvergne, where they remain for four months, then join Arps and Magnellis in Midi. Delaunays settle in Mougins.

1941 Robert has surgery at Clermont-Ferrand. Delaunays go to Montpellier where Robert dies of cancer, October 25.

I have been thinking about what I am going to do because it is an awful feeling to be uprooted, homeless with one's belongings scattered around. I have decided to go to Lyons and organize my drawings in order not to feel my loneliness. That will keep me busy and allow me to be in touch with people. I am sure I will succeed in doing something[22]

At the Arps' invitation, joins them and Magnellis in Grasse.

1941-43 Executes series of collaborative works with Arp and Magnelli (published as lithographs in 1950); series of small gouaches. Travels to Cannes, Nice (1942).

The Arps lived in Grasse in a beautiful house surrounded with olive trees. Jean used to say that the rustling leaves foretold the coming of the Mistral even before we could feel it. The view

extended all the way to the sea. With his wife, Sophie Taeuber, Suzy and Alberto Magnelli, our little group formed an island of peace and friendship which created an atmosphere favorable for work. I made small gouaches. Alberto, his big collage series. Jean, some crumpled-up papers and marble or wooden relics. At the terrace of a cafe, we would meet the Springers and the Stahlys, we would trade our works since we were our only customers and collectors[23]

After Magnellis and Arps leave Grasse, Delaunay attempts to protect art works from bombings. Remains alone in Grasse, living in hotel and later, after Germans occupy the town, in a friend's villa.

In the morning, woken by a rifle shot at 6:45, went to the window and saw the Germans taking the Italians prisoner. It was frightening seen from above with the machine guns and shotguns. To see this German army in action when the day before there was nothing, was an amazing sight. I got up early, dressed and left at nine a.m. The halls were full of German soldiers and the hotel grounds filled with disarmed Italian trucks[24]

1944 Leaves Grasse. Stays in Toulouse for 3 months, visiting Cassou, Tzara, Fels, Uhde and the Laportes. Creates designs for International Red Cross Center.

1945 Returns to Paris in January. Dedicates energies to gaining recognition for Robert's work. Exhibits with *Art Concret* group at Galerie Drouin in June.

My *raison d'être* is to promote Robert's work, which was not fully appreciated during his life. As Delteil used to say, he disturbed too many people[25]

1946 With Carré, organizes Robert's first major retrospective. Organizes second *Réalités Nouvelles* exhibition with Sidès.

1947 Produces first studies for *Alphabet*. Meets Brancusi.

I prefer my sober life and as Eluard would say, I live in a dream but at least it is clean and optimistic.

I must think about my will. I don't want our art, to which we have devoted all our lives and placed

Fig. 57. *Sonia Delaunay and her grandson, Eric.*

above everything else, to be used for cheap materialistic yearnings. I would rather leave everything to the State[26]

1949 Assists André Farcy of Grenoble Museum with a homage to Robert, resulting in the exhibition *Les Premiers Maitres de l'Art Abstrait* at Galerie Maeght in Paris, for which she designs invitations. With Jacques Heim, designs black and white striped fabrics.

Abstract art is the beginning of the liberation of the old pictorial formula. But really new painting will begin when it is understood that color has its own life, that the infinite combinations of color have their own poetry and a poetical language much more expressive than the old style. It is a mysterious language connected with vibrations, the very life of color. In this field, the new possibilities are infinite. When this is understood, they will understand our importance in painting, mine as well as Robert's.[27]

1950 Publication of portfolio of 10 works executed by Arps, Sonia Delaunay and Magnelli in Grasse. Organizes Robert's letters and writings and gathers biographical information. Travels to Italy in the fall.

I understood why I like this period of the Florentine primitives above all, because there is rhythm in their paintings and, in later art, the descriptive aspect replaces the rhythmic one. It is really rather sad to see beautifully displayed works. It seems that the more we advance in time, the worse it gets.

I took all the books about Sienese and Florentine painting and also looked at the Byzantine ones. I wish I could understand what I like in all this and what can be useful to me. I think it is the rhythm, the construction, a richness in simplicity, a magnitude of vision. I am also interested in the transition from the Byzantine to the Renaissance.[28]

1951 With Cassou and Salles, negotiates donation of Brancusi's studio with contents to Musée National d'Art Moderne, Paris.

1953 Joins group *Espace,* founded by André Bloc. First one-artist show in Paris since 1908 at Galerie Bing, Paris.

1954 Designs mosaics, one of which is exhibited at Biot, France. Publishes "Salut Blaise Cendrars."

1955 Designs curtains and furnishings for Maison Tunisienne, Cité Universitaire, Paris. Receives Grand Prix Lissone (Italy). First one-artist exhibition in United States, Rose Fried Gallery, New York.

1956 Illustrates Tzara's *Le Fruit Permis* with four pochoirs. Resumes lithography.

1957 Designs monumental door for Berliet at Salon de l'Automobile, Parc des Expositions, Porte de Versailles, Paris.

1958 Appointed Chevalier des Arts and des Lettres. First large foreign exhibition at Kunsthalle, Bielefeld, Germany.

The theatre of color must be composed like a verse of Mallarmé, like a page of Joyce: perfect and pure juxtaposition, exact sequences, each element apportioned its correct weight with absolute rigor. Beauty resides in the power of suggestion which enables the participation of the spectator.

Beauty refuses to submit to the constraint of meaning or description.[29]

1959 Major exhibition of works of Robert and Sonia Delaunay at Musée des Beaux-Arts, Lyons.

1960 Designs deck of cards published by Deutsche Spielkarten Museum, Bielefeld.

I never have confided to anyone what I tell myself . . . this language of the private self. My diary is, in a way, the companion of my inner life. At the heart of my research as in my work concerning fashion, show business and decorative art, I have always had to progress alone. In life, I had to struggle not to let myself be fragmented or ruled by superficial individuals, snobs or schemers.[30]

1961 Publication of Tzara's *Juste Présent* illustrated with 8 color etchings by Sonia Delaunay, and an album of 6 color lithographs.

In the last phase of my life when I began to be known as a painter, Jacques Damase played a leading role. He helped to bring my work to light just as I had done for Robert from his death until his international establishment. What had I been known as until now — a decorator, a muse of Orphism, Robert Delaunay's companion. Then, I was granted "collaborator, continuator . . ." before my work was ever accepted for itself[32]

1966 Travels to London in February. Publication of *Colored Rhythms* and portfolio of 6 color etchings. Executes preliminary studies for stained glass windows for Eglise de Saux, Montpezat-de-Quercy and mosaic for Foundation Pagani, Milan. Gobelin issues 2 large tapestries after Delaunay's designs for Mobilier National.

1967 Decorates Matra B530 as part of benefit exhibition for French medical research. Major retrospective at Musée National d'Art Moderne, Paris. After 30 years hiatus, creates rugs.

1968 Designs sets and costumes for Stravinsky's *Danses Concertantes* at request of Ballet Théâtre Contemporain (presented by Ballet Théâtre d'Amiens). Executes many lithographs.

I have led three lives: one for Robert, one for my son and grandsons, a shorter one for myself. I don't regret not having given myself more attention. I really did not have the time

I had to prevent his unfinished work from being scattered around, organize retrospectives rather than sell the paintings below the price that they deserved, make donations to museums instead of surrendering unconditionally to gallery owners. Left as it is, Robert's work would have been a firework. But through it, I could perceive something else. This lifetime of work foretold to whoever could perceive it that visual art was destined to become the most important mode of expression of the future. In this domain, the essential — too long neglected for schools, styles and modes — remained to be discovered[33]

1969 In collaboration with Damase, publishes *Alphabet* and *Robes-poèmes*. Receives

1962 Galerie Denise René publishes *Poésies de Mots, Poésies de Couleurs* and exhibits Delaunay's gouaches. "Hommage à Cendrars" published in *Mercure de France*'s special edition on Cendrars.

Poetry of words
poetry of colors
the rhythm of verse
is construction
and relation of values
Poetry moves
through all
the creations of art[31]

1963 Donates 40 of Robert's works and 58 of hers to Musée National d'Art Moderne, Paris.

1964 Exhibition of donation to the state at Galerie Mollien, making Sonia Delaunay the first living woman given an exhibition at the Louvre. Exhibition of graphic work at Librairie Pierre Bérès, Paris.

1965 First major traveling exhibition of the Delaunays' work in North America, organized by National Gallery of Canada, Ottawa. Major one artist exhibition at Gimpel and Hanover Galerie, Zurich (later at Gimpel Fils, London).

Grand Prix International de'l'Art Feminin at Salon International de la Femme, Cannes. Designs three ceramic plates made in Italy.

1970 On state visit, President Pompidou presents *Rhythm-Color No. 1633,* 1969 to President Nixon. Designs poster for exhibition *Les Peintres et le Livre.* Publishes album *Avec Moi-Même* with 10 color etchings. First major showing of rugs in Paris at Galerie la Demeure.

1971 Tapestries produced by Olivier at Aubusson. First major exhibition of textiles at Musée de l'Impression sur Etoffes, Mulhouse.

1972 Raynaud produces film *Sonia Delaunay: Prises de Vues pour une Monographie.* Exhibition of tapestries made in 1971 at Corcoran Gallery of Art, Washington, D.C. and at Musée de l'Art Moderne de la Ville de Paris. Exhibition *Sonia and Robert Delaunay in Portugal and their friends Eduardo Vianna, Amadeo Souza-Cardoso, José Pacheco and José de Almada Negreiros,* Gulbenkian Foundation, Lisbon.

1973 Receives Grand Prix de la Ville de Paris. Publication of Rimbaud's *Les Illuminations* with 15 pochoirs; special edition of *XXe Siècle* on Robert and Sonia Delaunay.

1975 Receives Legion of Honor on July 15. Commissioned by UNESCO to design poster for International Women's Year. Completes cartoons of tapestries for Mobilier National. Exhibition *Hommage à Sonia Delaunay* at Musée National d'Art Moderne, Paris on occasion of her 90th birthday.

1976 Circulating exhibition of graphic works organized by Centre Georges Pompidou, Paris.

1977 Artcurial reissues textile designs, scarves, plates, shawls and tablecloths in limited, signed editions. Damase publishes Tzara's *Coeur à Gaz* illustrated with 10 lithographs. Donation of Delaunay's manuscripts, prints and drawings to Bibliothèque Nationale, Paris, where they are exhibited.

Color relations are like number relations. The birth of the painting happens in function of rhythms, that is, of abstraction.

All is done internally, I build through color. I think that a painting should be prepared in the spirit. The incubation time is therefore very long. Small size and rather free gouaches allow me to wander on the way to ultimate creation[34]

1978 Designs Christmas card for Mme. Pompidou. Retrospective of drawings and lesser known works at Artcurial.

1979 Major retrospective in Japan. Dies on December 5 in Paris.

I do not know how to define my painting. Maybe it is just as well since I am suspicious of classifications and systems. How and why define what has been torn from my own guts. Before all others, Robert had faith in me.

In my most recent research, I have had the feeling of being very close to touching what Robert had felt and what was the "solar source" of his work. I still stumble over obstacles ... But I am sure that there is, behind it all, something fundamental, which will be the basis of painting of the future.

The sun rises at midnight[35]

CHRONOLOGY FOOTNOTES

1. Sonia Delaunay, *Nous Irons Jusqu'au Soleil* (Paris: Editions Robert Laffont, 1978), p. 11.

2. Arthur A. Cohen, ed., *The New Art of Color: The Writings of Robert and Sonia Delaunay,* The Documents of 20th Century Art (New York: Viking Press, 1978), p. 223, quoted from "Interview with Sonia Delaunay (1970)"

3. Sonia Delaunay, *Nous Irons Jusqu'au Soleil,* p. 17.

4. Ibid., p. 24.

5. Ibid., p. 33.

6. Ibid., p. 45.

7. Ibid., p. 36.

8. Ibid., pp. 56-57.

9. Ibid., p. 73.

10. Ibid., pp. 74-75.

11. Ibid., p. 77.

12. Ibid., p. 80.

13. Ibid., pp. 84-85.

14. Ibid.,.p. 85.

15. Ibid., p. 93.

16. Ibid., p. 96.

17. Sonia Delaunay in Cohen, *The New Art of Color,* p. 206, quoted from "The Influence of Painting on Fashion Design." The date of this lecture given in *The New Art of Color* is incorrect.

18. Sonia Delaunay, *Nous Irons Jusqu'au Soleil,* p. 104.

19. Ibid., p. 108.

20. Ibid., p. 110.

21. Ibid., p. 120.

22. Ibid., p. 127.

23. Ibid., p. 130.

24. Ibid., p 137

25. Ibid., p. 139.

26. Ibid., p. 157.

27. Ibid., p. 169.

28. Ibid., pp. 178-79.

29. Sonia Delaunay in Cohen, *The New Art of Color,* p. 212, quoted from The Color Danced (1958)."

30. Sonia Delaunay, *Nous Irons Jusqu'au Soleil,* p. 185.

31. Cohen, *New Art of Color,* p. 213, "Text of Exhibition Catalogue (1962)."

32. Sonia Delaunay, *Nous Irons Jusqu'au Soleil,* p. 196.

33. Ibid., pp. 204-05.

34. Sonia Delaunay, "Propos de Sonia Delaunay," *Journal Artcurial* (Paris: November-December, 1977), p. 2.

35. Sonia Delaunay, *Nous Irons Jusqu'au Soleil,* p. 206.

BIBLIOGRAPHY

BY THE ARTIST

Illustrations

1913 Cendrars, Blaise. *La Prose du Transsibérien et de la Petite Jehanne de France.* Paris: Editions des Hommes Nouveaux, 1913.

1942 *10 Origin* (album of ten original lithographs by Arp, Bill, Delaunay, Domela, Kandinsky, Leuppi, Lohse, Magnelli, Taeuber-Arp and Vantongerloo). Zurich: Allianz Verlag, 1942.

1961 Tzara, Tristan. *Juste Présent.* Milan: Pagani, 1961.

1962 *Album with Six Prints.* Paris: Galerie Denise René, 1962.

 Le Poème, in Nino Frank, et al., eds. *Blaise Cendrars (1887-1961).* Paris: Mercure de France, 1962, p. 163.

1969 *L'Alphabet.* Text by Jacques Damase. Paris: Editions Emme, 1969. Eng. ed. New York: Thomas Y. Crowell, 1972.

 Robes-poèmes. Text by Jacques Damase. Milan: Edizioni del Naviglio, 1969.

1977 *Le Coeur à Gaz.* Text by Tristan Tzara. Paris: Jacques Damase Editeur, 1977. [reprint of 1923 costume sketches]

Writings

1927 "L'Influence de la Peinture sur l'Art Vestimentaire." Lecture delivered at the Sorbonne, Jan. 27, 1927.

1929 "Tapis et Tissus." *L'Art International d'Aujourd'hui no. 15.* Paris: Editions d'Art Charles Moreau, 1929.

1930 *Compositions, Couleurs, Idées.* Paris: Editions d'Art Charles Moreau, 1930.

1932 "Les Artistes et l'Avenir de la Mode." *Revue de Jacques Heim* (Paris), 1932.

1956 "Collages de Sonia et de Robert Delaunay." *XXᵉ Siècle* (Paris), n.s., no. 6, Jan. 1956, pp. 19-21.

1958 Letter to a client in *Sonia Delaunay* (exhib. cat.). Bielefeld: Städtisches Kunsthaus, 1958, pp. 7-9.

 "Robert et Sonia Delaunay, Art et Mouvement, la Couleur Dansée." *Aujourd'hui, Art et Architecture* (Boulogne-sur-Seine), vol. 3, no. 17, May 1958, pp. 42-43.

1966 Untitled text accompanying portfolio of lithographs. Milan: Galleria Schwarz, 1966.

1967 "Sonia Delaunay" in *Rétrospective Sonia Delaunay* (exhib. cat.). Paris: Musée National d'Art Moderne, 1967.

 Statement in *Six artistes à Grasse, 1940-1943* (exhib. cat.). Grasse: Société du Musée Fragonard, Musée Regional d'Art et d'Histoire, 1967.

1978 Cohen, Arthur A., ed. *The New Art of Color: The Writings of Robert and Sonia Delaunay.* The Documents of 20th Century Art. New York: Viking Press, 1978.

 Nous Irons Jusqu'au Soleil. Paris: Editions Robert Laffont, 1978.

Interviews

1970 Cohen, Arthur A. "Interview with Sonia Delaunay." [on July 22, 1970 in Paris]. Eng. trans. by Keith Cohen in Arthur A. Cohen, ed. *The New Art of Color: The Writings of Robert and Sonia Delaunay.* The Documents of 20th Century Art. New York: Viking Press, 1978.

1975 Nemser, Cindy. "Sonia Delaunay" in *Art Talk: Conversations with 12 Women Artists.* New York: Charles Scribner's Sons, 1975, pp. 34-51.

ON THE ARTIST

Books

1925 Lhote, André, ed. *Sonia Delaunay. Ses Objets. Ses Tissus Simultanés. Ses Modes.* Paris: Librairie des Arts Decoratifs, 1925.

1967 Hoog, Michel. *Robert et Sonia Delaunay.* Paris: Editions des Musées Nationaux, 1967.

1971 Damase, Jacques and Mustelier, Edouard. *Sonia Delaunay.* Paris: Galerie de Varenne, 1971.

 Damase, Jacques. *Sonia Delaunay: Rythmes et Couleurs.* Paris: Hermann, 1971. Eng. ed. *Sonia Delaunay: Rhythms and Colors.* Greenwich. Conn.: New York Graphic Society and London: Thames & Hudson, 1972.

 Sonia Delaunay: "La Terra Impareggiabile." Milan: M'Arte Edizioni, 1971.

1972 Ferreira, Paulo. *Correspondance de Quatre Artistes Portugais, Almada-Negreiros, José Pacheco, Souza-Cardoso, Eduardo Vianna avec Robert et Sonia Delaunay.* Paris: Presses Universitaires de France, 1972.

1974 Damase, Jacques, ed. *Sonia Delaunay — Robes et Gouaches Simultanées 1925 — l'Art et le Corps Rythmes — Couleurs en Mouvement.* Brussels: Jacques Damase Editeur, 1974.

1975 Cohen, Arthur A. *Sonia Delaunay.* New York: Harry N. Abrams, Inc., 1975.

1976 Damase, Jacques. *L'Hommage à Sonia Delaunay.* Paris-Brussels: Jacques Damase Editeur, 1976.

1978 Damase, Jacques. *Sonia Delaunay: Dessins Noirs et Blancs.* Paris: Jacques Damase, Artcurial Editeurs, 1978.

Selected Articles

1914 Craven, Arthur. "L'Exposition des Indépendants." *Maintenant* (Paris), special issue, Mar.-Apr. 1914, pp. 1-17.

1920 Crevel, René. "Visite à Sonia Delaunay." *La Voz de Guipúzcoa* (Bilbao), 1920.

1922 de la Serna, Ramón Gómez. "Los Trajes Poemáticos." *La Voz de Guipúzcoa* (Bilbao), 1922.

1923 de Torre, Guillermo. "El Arte Decorativo de Sonia Delaunay-Terk." *Alfar* (Montevideo), no. 35, Dec. 1923.

1924 Goll, Claire. "Simultanische Kleider." *Bilder Courier* (Berlin), Apr. 1924.

1925 Delteil, Joseph. "La Mode qui Vient à Mme. Sonia Delaunay." *Europe Almanach* (Potsdam), 1925, pp. 207-10.

 Jung-Clémenceau, Thérèse. "La Boutique Simultanée." *Les Arts Plastiques* (Paris), no. 2, May 1925, n p

1926 Benoist, Luc. "Les Tissus de Sonia Delaunay." *Art et Décoration* (Paris), vol. 50, Nov. 1926, pp. 142-45.

1927 Dormay, Marie. "Les Tissus de Sonia Delaunay." *L'Amour de l'Art* (Paris), vol. 8, Mar. 1927, pp. 97-98.

1929 Van Loon, H. "Waar Kunst en Mode Elkaar Ontmoeten." *Maandblad voor Beeldende Kunsten* (Amsterdam), vol. 6, Sept. 1929, pp. 276-81.

1950 Seuphor, Michel. "L'Orphisme." *Art d'Aujourd'hui* (Boulogne-sur-Seine), ser. 1, no. 7-8, Mar. 1950, pp. 25-26.

1952 Gindertael, R. V. "Robert Delaunay — Sonia Delaunay." *Art d'Aujourd'hui* (Boulogne-sur-Seine), ser. 3, no. 6, Aug. 1952, pp. 20-21.

Gindertael, R. V. "Pour Aider à Mieux Comprendre 'Le Passage de la Ligne': Documents Réunis par R. V. Gindertael." *Art d'Aujourd'hui* (Boulogne-sur-Seine). ser. 3. No. 6, Aug. 1952, pp. 18-22.

1956 Degand, Léon. "Sonia Delaunay et l'Exaltation Chromatique." *XXe Siècle* (Paris), n.s., no. 7, June 1956, pp. 82-85.

Vieira, José Geraldo. "Affinidades, Analogias e Coincidências." *Habitat* (São Paulo), vol. 6, no. 32, 1956. pp. 7-11.

1958 Wescher, Herta. "Eaux Vives et Sources Taries." *Cimaise* (Paris), ser. 5, no. 3, Jan.-Feb. 1958, pp. 23-31.

1959 Weelen, Guy. "Sonia Delaunay en Allemagne." *XXe Siècle* (Paris), n.s., vol. 21, no. 12, May-June 1959, pp. 12-13.

Weelen, Guy. "Robes Simultanées: Sonia Delaunay S'Amusa Longtemps à Habiller les Femmes." *L'Oeil* (Paris), no. 60, Dec. 1959, pp. 78-85.

"Aquarelle und Gouachen von 1912 bis 1958, Galerie Suzanne Bollag, Zurich." *Werk* (Winterthur), vol. 46, no. 9, Sept. 1959, p. 194.

1960 Berger, M. and Jelensky, K.A. "La Peinture Russe Moderne." *Preuves* (Paris), no. III, May 1960.

Francastel, Pierre. "Les Delaunay." *XXe Siècle* (Paris), n.s., vol. 22, no. 15, Dec. 1960, pp. 64-73.

Lassaigne, Jacques. "Robert et Sonia Delaunay." *Pensées Françaises* (Paris), no. 5, May 1960, pp. 62-66.

1961 Petzet, Heinrich. "Robert und Sonia Delaunay in der Basler Galerie d'Art Moderne." *Weltkunst* (Berlin), vol. 31, no. 16, 1961, p. 7.

Steneberg, E. "Sonia Delaunay-Terk." *Kunstwerk* (Baden-Baden), vol. 15, no. 4, Oct. 1961, pp. 22-23.

Strauss, M. "Exhibition at Brook Street Gallery." *Burlington Magazine* (London), vol. 103, no. 699, June 1961, pp. 288, 291.

1962 Lassaigne, Jacques. "Gouaches de Sonia Delaunay." *XXe Siècle* (Paris), n.s., vol. 24, no. 19, June 1962, pp. 18-19.

Ragon, Michel. "Sonia Delaunay A Fait Entrer le Cubisme dans la Mode et dans la Vie." *Arts* (Paris), no. 866, Apr. 25-May 1, 1962, p. 11.

Vincent Madeleine. "Trois Tableaux de Robert et Sonia Delaunay." *Bulletin des Musées et Monuments Lyonnais* (Lyons), vol. 3, no. 1, 1962, pp. 1-8.

Weelen, Guy. "Los Delaunay en España y Portugal." *Goya* (Madrid), no. 48, May-June 1962, pp. 420-29.

1963 d'Aubarède, G. "Sonia Delaunay Evoque des Souvenirs." *Le Jardin des Arts* (Paris), Jan. 1963, pp. 2-9.

Belloli, Carlo. "I Delaunay e la Grafica." *Pagina* (Milan), no. 2, June 1963, pp. 4-22.

Dorival, Bernard. "La Donation Delaunay." *La Revue du Louvre* (Paris), vol. 13, no. 6, Nov.-Dec. 1963, pp. 283-88.

Gindertael, R. V. "Sonia Delaunay et la Poésie Pure des Couleurs." *XXe Siècle* (Paris), n.s., vol. 25, no. 21, May 1963, pp. 43-47.

1964 Cabanne, Pierre. "Sonia Delaunay Est Depuis 50 Ans à l'Avant-Garde." *Arts* (Paris), no. 951, Feb. 26-Nov. 3, 1964, p. 8.

Mertens, Phil. "Het Ovenzicht en de Plaats van de Vlaamse

Kunst in het Europa van de Jaren Twintig." *Bulletin Musée Royale des Beaux-Arts Belgique* (Brussels), vol. 13, 1964, pp. 67-82.

Ragon, Michel. "Les Delaunay, Un Couple Fou de Couleurs" in Michel, Albin ed., *Les Vies des Grands Peintres.* Paris, 1964.

1965 Clay, Jean. "The Golden Years of Visual Jazz: Sonia Delaunay's Life and Times." *Réalités,* Eng. ed., (Paris), 1965, pp. 42-47.

Dorival, Bernard. "Robert et Sonia Delaunay." *Colóquio* (Lisbon), no. 35, Oct. 1965, pp. 8-13.

Goerg, Charles. "Les Marchés au Minho de Sonia Delaunay." *Bulletin du Musée d'Art et d'Histoire de Genève* (Geneva), vol. 13, 1965, pp. 203-13.

1965-66 Habasque, Guy. "L'Oeuvre de Robert et Sonia Delaunay." *Vie des Arts* (Montreal), no. 4, Winter 1965-1966.

1966 Hoog, Michel. "Quelques Précurseurs de l'Art d'Aujourd'hui." *Revue du Louvre* (Paris), vol. 16, no. 3, May-June 1966, pp. 165-72.

Wadia, Bettina. "Sonia Delaunay: Gimpel Fils." *Arts Review* (London), vol. XVIII, no. 2, Feb. 1966, p. 25.

"Agam, Arman, Cruz-Diez, S. Delaunay, Vasarely — 'Realités' — Leur Confie Cinq Voitures." *Connaissance des Arts* (Paris), no. 188, Oct. 1967, pp. 84-85.

1967 Armand, Louis. "Cinq Voitures de Série Personalisées par Cinq Grands Artistes Contemporains: Une Experience Louée par *Réalités* au Profit de la Fondation pour la Recherche Médicale Française." *Réalités* (Paris), Oct. 1967, pp. 82-87.

Damase, Jacques. "Sonia Delaunay: 60 Ans de Recherches et d'Innovations." *XXe Siècle* (Paris), n.s. vol. 29, no. 29, Dec. 1967, pp. 108-12.

1968 Gindertael, R. V. "Les Gouaches de Sonia Delaunay." *XXe Siècle* (Paris), n.s., vol. 30, no. 31, Dec. 1968, pp. 57-64.

Hoog, Michel. "Oeuvres Recentes de Sonia Delaunay." *Cimaise* (Paris), vol. 15, no. 88-89, Oct.-Nov. 1968, pp. 52-63.

Hoog, Michel. "Les Tissus de Sonia Delaunay au Musée des Tissus." *Bulletin des Musées et Monuments Lyonnais* (Lyons), 1968, pp. 85-93.

"Tous les Arts dans la Danse." *Connaissance des Arts* (Paris), no. 202, Dec. 1968, pp. 29,31.

1969 Boisset, Maiten. "Les Lithographies de Sonia Delaunay." *XXe Siècle* (Paris), n.s., vol. 31, no. 32, June 1969, pp. 13-14.

Lévêque, J. J "Sonia Delaunay al Naviglio, Venezia." *Le Arti* (Milan), vol. 19, no. 7-8, Aug. 1969, pp. 14-16.

Metkin, Günter. "The Delaunay's [sic] Theater" in Rischbieter, Henning, ed. *Art and the Stage in the 20th Century: Painters and Sculptors Work for the Theater.* Greenwich, Conn: New York Graphic Society, 1969, pp. 105-06.

1970 Applegate, J. "Paris: Sonia Delaunay: Galerie la Demeure." *Art International* (Lugano), vol. 14, no. 3, Mar. 1970, p. 74.

Gilioli, Emile. "Les Tapis de Sonia Delaunay." *XXe Siècle* (Paris), n.s., vol. 32, no. 34, June 1970, pp. 13-17.

1971 Dorival, Bernard. "Les Oeuvres Recentes de Sonia Delaunay." *XXe Siècle* (Paris), n.s., vol. 33, no. 36, June 1971, pp. 42-50.

Fig. 59. *Sonia Delaunay with her cat, 1950s.*

"Color and Form: 1909-1914." *Artweek* (Oakland, Calif.), vol. 2, no. 44, Dec. 18, 1971, p. 1.

1971-72 Damase, Jacques. "Sonia Delaunay, Great Lady of Abstract Art." *Art: The Journal of the Professional Artist* (U.N.E.S.C.O. France), no. 64-65, 1971-72, pp. 26-31.

1972 Cohen, Arthur A. "The Delaunays, Apollinaire and Cendrars." *Critiques 1971/72* (New York), The Cooper Union School of Art and Architecture, Fall 1972, pp. 1-16.

Ornellas, Barbara. "Portugal na Vida e na Obra de Sonia Delaunay (1915/1916). *Colóquio* (Lisbon), vol. 14, no. 8, July 1972, pp. 56-63.

Ornellas, Barbara. "L'Hommage de Lisbonne à Robert et Sonia Delaunay." *XXᵉ Siècle* (Paris), n.s., vol. 34, no. 39, Dec. 1972, pp. 101-12.

1973 Baber, Alice. "Sonia Delaunay." *Craft Horizons* (New York), vol. 33, no. 6, Dec. 1973, pp. 32-39.

Chatwin, B. "Surviving in Style." *The New York Times Magazine* (New York), Mar. 4, 1973, pp. 42-54.

Peppiatt, Michael. "Sonia Delaunay." *Art International* (Lugano), vol. 17, no. 10, Dec. 1973, pp. 18, 19, 37, 75.

"Sonia Delaunay." *Spare Rib* (London), no. 18, Dec. 1973, p. 30.

1974 Clay, Jean. "Sonia Delaunay." *Le Arti* (Milan), vol. 24, no. 1, Jan. 1974, pp. 42-48.

Mellow, James R. "When Her Husband Died She Came Into Her Own." *The New York Times* (New York), sect. 2, Jan. 27, 1974, pp. 21, 25.

Wright, Barbara. "Sonia Delaunay." *Arts Review* (London), vol. 26, no. 12, June 14, 1974, p. 363.

"Sonia Delaunay Tapestries." *Artweek* (Oakland, Calif.), vol. 5, no. 34, Oct. 12, 1974, p. 5.

1975 Baron, Jeanine. "Sonia Delaunay et Ses Amis: Maiakowski et Kandinsky." *La Croix* (Brussels), Nov. 30, 1975.

Lévêque, Jean-Jacques. "Le Siècle de Sonia Delaunay." *Les Nouvelles Littéraires* (Paris), Nov. 24, 1975.

Mazars, Pierre. "L'Art A Suivi Sonia Delaunay dans la Rue." *Le Figaro* (Paris), Nov. 25, 1975.

Michel, Jacques. "Sonia Delaunay at 90." *The Guardian* (London), Dec. 21, 1975, p. 16.

Peppiatt, Michael. "Sonia Delaunay: A Life in Color." *Art News* (New York), vol. 74, no. 3, Mar. 1975, pp. 88-91.

1976 Abadie, Daniel. "Les Inventions 'Simultanées' de Sonia Delaunay ou l'Heure Avant l'Heure." *XXᵉ Siècle* (Paris), n.s., vol. 38, no. 46, Sept. 1976, pp. 20-27.

Wierer, M. "Sonia Delaunay: Jongleur der Farbe." *Alte und Moderne Kunst* (Austria), vol. 21, no. 145, 1976, pp. 20-25.

"Sonia Delaunay: Fifty Years Not Gone By." *Domus* (Milan), no. 554, Jan. 1976, pp. 52-53.

1976-77 Lansner, Fay. "Arthur Cohen on Sonia Delaunay." *The Feminist Art Journal* (New York), vol. 5, no. 4, Winter 1976-77, pp. 5-10.

1977 Damase, Jacques. "Sonia Delaunay: un Demi-Siècle d'Avant-Garde." *Connaissance des Arts* (Paris), no. 308, Oct. 1977, pp. 80-85.

"Sonia Delaunay." *Journal Artcurial* (Paris), no. 7-8, Nov.-Dec. 1977, pp. 1-5.

1978 Giroud, Françoise. "Ahead of Her Time, in Tune with Ours." *The New York Times Magazine*, July 16, 1978, pp.54-59.

"Le Cabinet des Dessins de Sonia Delaunay." *Journal Artcurial* (Paris), no. 11, Oct. 1978, pp. 1-5.

"Le Cabinet des Dessins de Sonia Delaunay; Artcurial Paris." *L'Oeil* (Paris), no. 280, Nov. 1978, p. 66.

1979 Marter, Joan M. "Three Women Artists Married to Early Modernists: Sonia Delaunay-Terk, Sophie Taüber-Arp and Marguerite Thompson-Zorach." *Arts Magazine* (New York), vol. 54, no. 1, Sept. 1979, pp. 89-95.

Wallen, Burr. "Sonia Delaunay and Pochoir." *Arts Magazine* (New York), vol. 54, no. 1, Sept. 1979, pp. 96-102.

General Books

1942 Arp, Hans. "Essay" in Guggenheim, Peggy, ed., *Art of This Century. Objects, drawings, photographs, paintings, sculpture, collages, 1910-1942*. New York: Art of This Century, 1942.

1948 Parrot, Louis. *Blaise Cendrars*. Paris: Pierre Seghers Editeur, 1948.

1950 Gilles de la Tourette, F. *Robert Delaunay.* Paris: Charles Massin, 1950.

Seuphor, Michel. *L'Art Abstrait, Ses Origines, Ses Premiers Maîtres.* Paris: Maeght, 1950.

1957 Francastel, Pierre, ed. *Robert Delaunay: Du Cubisme à l'Art Abstrait.* Paris: S.E.V.P.E.N., 1957.

1961 Dorival, Bernard. *L'Ecole de Paris au Musée National d'Art Moderne.* Paris: Editions des Musées Nationaux, 1961.

Mackworth, Cecily. *Guillaume Apollinaire and the Cubist Life.* London: John Murray, 1961 and New York: Horizon Press, 1963.

1962 Frank, Nino et al., eds. *Blaise Cendrars (1887-1961).* Paris: Mercure de France, 1962.

1965 Sanouillet, Michel. *Dada à Paris.* Paris: Jean-Jacques Pauvert Editeur, 1965.

1966 Damase, Jacques. *Révolution Typographique Depuis Stéphane Mallarmé.* Geneva: Editions Motte, 1966.

1969 Vriesen, Gustav and Imdahl, Max. *Robert Delaunay: Light and Color.* New York: Harry N. Abrams, Inc., 1969.

1972 Breunig, LeRoy C., ed. *Apollinaire on Art: Essays and Reviews 1902-1918.* The Documents of 20th Century Art. New York: Viking Press, 1972.

t'Serstevens, A. *L'Homme que Fut Blaise Cendrars: Souvenirs.* Paris: Editions Denoël, 1972.

1976 Fanelli, G. and Fanelli, R. *Il Tessuto Moderno: Disegno Moda Architettura 1890-1940.* Florence: Nuova Valecchi Editore, 1976.

Harris, Ann Sutherland and Nochlin, Linda. *Women Artists: 1550-1950.* Los Angeles: Los Angeles County Museum of Art and New York: Alfred A. Knopf, 1976.

1978 Fine, Elsa Honig. *Women and Art.* Montclair, N.J.: Allanheld, Osmun & Co., 1978.

Levin, Gail. *Synchromism.* New York: Whitney Museum of American Art, 1978.

General Articles

1953 Wechser, Herta. "Les Collages Cubistes." *Art d'Aujourd'hui* (Boulogne-sur-Seine), ser. 4, no. 3-4, May-June 1953, pp. 33-42.

1954 Bordier, Roger. "L'Art et la Manière." *Art d'Aujourd'hui* (Boulogne-sur-Seine), ser. 5, no. 6, Sept. 1954, pp. 12-17.

"Collages." *Art d'Aujourd'hui* (Boulogne-sur-Seine), ser. 5, no. 2-3, 1954, pp. 1-41.

1955 Vigano, Vittorio. "9ème Prix International de Peinture, Lissone, 1955." *Aujourd'hui, Art et Architecture* (Boulogne-sur-Seine), no. 5, Nov. 1955, pp. 21-23.

1956 "Dix Années d'Art Contemporain." *XXe Siècle* (Paris), n.s., no. 7, June 1956, pp. 3-68.

1959 Steneberg, Eberhard. "Die Ungeduldigen: Zum Verständnis der *Ecole russe*." *Kunstwerk* (Baden-Baden), vol. 13, no. 1, Aug. 1959, pp. 3-26.

1963 Belloli, Carlo. "La Componente Visuale-Tipografica nella Poesia d'Avanguardia." *Pagina* (Milan), no. 3, Oct. 1963, pp. 5-47.

"Renouveau du Thème dans l'Art Contemporain." *XXe Siècle* (Paris), n.s., vol. 25, no. 21, May 1963, pp. 3-80.

1967 Brahammar, Gunnar. "Monumental-Original?" *Paletten* (Goteborg), no. 3, 1967, pp. 31-36.

Calvesi, Maurizio. "Futurismo e Orfismo." *L'Arte Moderna* (Milan), vol. 5, no. 43, 1967.

1977 Anderson, Susan Hiller. "The '20s Get Paris Retrospective." *The New York Times* (New York), Dec. 4, 1977.

Selected One-Artist Exhibitions

1908 Galerie Notre-Dame-des-Champs, Paris.

1916-17 Nya Konstgallerien, Stockholm. Blomquist Kunsthandel, Oslo.

1920 Libreria Mateu, Madrid.

1929 Galerie "Fermé la nuit," Paris.

1953 Galerie Bing, Paris.

1955 Rose Fried Gallery, New York. *Sonia Delaunay*. Jan. 10-Feb. 5.

1956 Galleria d'Arte Selecta, Rome.
Galleria del Naviglio, Milan.
Galleria del Cavallino, Venice.

1958 Städtisches Kunsthaus, Bielefeld. *Sonia Delaunay*. Sept. 14-Oct. 29. Catalogue, text by Gustav Vriesen and Robert Delaunay.

1959 Galerie Dr. Hans Fotscherin, Munich. *Sonia Delaunay*. June 1-25.

1960 Nora Gallery, Jerusalem.

1960-61 Galerie Hybler, Copenhagen. *Sonia Delaunay*. Dec. 1960-Jan. 1961. Catalogue, text by Gustav Vriesen.

1961 Brook Street Gallery, London. *Sonia Delaunay*. May. Catalogue, text by Jerome Mellquist.

1962 Galerie Denise René, Paris. *Sonia Delaunay*. May. Catalogue, text by Robert Delaunay and Sonia Delaunay.

Galerie le Point Cardinal, Paris.

Galleria del Cavallino, Venice.

1963 The Granville Gallery, New York.

1964 Galleria Minima, Milan. *Sonia Delaunay negli Anni Venti*. May 13-June 13. Catalogue, text by Carlo Belloli.

Galerie Bing, Paris.

Galerie Dubourg, Paris.

Librairie Pierre Beres, Paris.

1965-66 Gimpel & Hanover Galerie, Zurich. *Sonia Delaunay*. Oct. 2-30, 1965. Traveled to Gimpel Fils Ltd., London, Feb. 1-26, 1966.

1966 Galleria La Polena, Genoa. *Sonia Delaunay*. May 7-27.

Galerie Berggruen, Paris.

Galerie l'Oeil Ecoute, Lyons.

1967 Galerie d'Art Moderne, Basel. *Sonia Delaunay: Tapis*. Feb. 25-Apr. 5. Catalogue, text by Jacques Damase.

Galerie Motte, Geneva. *Sonia Delaunay, Rythmes-Couleurs*. Apr. 4-25.

Galerie Numaga, La Chaux-de-Fonds.

1967-68 Musée National d'Art Moderne, Paris. *Sonia Delaunay*. Dec. 1, 1967-Jan. 7, 1968. Catalogue, texts by Bernard Dorival and Sonia Delaunay.

1968 De Nieubourg Galleria di Ricera, Milan. *Sonia Delaunay: Tappeti*. Jan. Catalogue, text by Jacques Damase.

Galerie Denise René, Paris. *Sonia Delaunay*. Nov. Catalogue, text by Sonia Delaunay.

Galerie Cavalero, Cannes.

Galerie XXe Siècle, Paris.

Palais des Papes, Avignon. *IVe Salon International de l'Art Mural.*

Salon des Réalités Nouvelles, Paris.

1950 Akademie der Bildenden Kunste, Vienna. *Form und Gestaltung.*

Wiener Sezession, Vienna.

1951 Salon des Réalités Nouvelles, Paris.

1952 Galerie Colette Allendy, Paris.

1953 Galerie Colette Allendy, Paris. *Robert Delaunay, Sonia Delaunay, Albert Gleizes.*

Galerie Berggruen, Paris. *Maîtres de l'Art Abstrait.*

Galerie Suzanne Michel, Paris. *Groupe Evolution.*

Galleria Nazionale d'Arte Moderna, Rome. *Arte Astratta Italiana e Francese.*

Musée National d'Art Moderne, Paris. *Le Cubisme 1907-1914.*

1954 Galerie Bing, Paris. *Groupe de Grasse, Sonia Delaunay, Sophie Taeuber-Arp, Magnelli.*

College of Art, Edinburgh. *The Diaghilev Exhibition.*

1955 Gallery Delius, New York. *Great Women Artists.*

Musée Cantini, Marseille. *Premières Etapes de la Peinture Moderne.*

Musée Cantonal des Beaux-Arts, Lausanne. *Du Futurisme à l'Art Abstrait, le Mouvement dans l'Art Contemporain.*

1956 Rose Fried Gallery, New York. *International Collage Exhibition.*

Galerie H. Matarasso, Marseille. *Art Abstrait Constructif.*

Musée de Grenoble, Grenoble. *10 Ans de Peinture Française 1945-55.*

1957 Galerie Bing, Paris. *Oeuvres de Jeunesse de Robert et Sonia Delaunay; Oeuvres Recentes de Sonia Delaunay.* Nov. 29-Dec. 31.

Galerie Creuze, Paris. *50 Ans de Peinture Abstraite.*

Rose Fried Gallery, New York. *50 Works of 23 Modern Masters.*

Gimpel Fils, Ltd., London. *Autour du Cubisme.*

Musée des Beaux-Arts, Nantes. *Selection du Salon des Réalités Nouvelles.*

Musée de Rouen, Rouen. *Architecture Contemporaine, Integration des Arts.*

Salon des Réalités Nouvelles, Paris.

Stedelijk Museum, Amsterdam. *Europa 1907.*

1958 Contemporary Arts Museum, Houston. *Collage International from Picasso to the Present.*

Palais des Expositions, Charleroi. *L'Art du XXIe Siècle, Rendez-Vous de l'Avant-Garde Internationale.*

Salon des Réalités Nouvelles, Paris.

Stedelijk Museum, Amsterdam. *De Renaissance der XXen Eeuw.*

1959 Musée des Beaux-Arts, Lyons. *Robert et Sonia Delaunay.* June 24-Oct. Catalogue, introductory text by René Jullian.

Galerie Fricker, Paris. *Rythmes et Danse.*

1960 Galerie Chalette, New York. *Construction and Geometry in Painting: from Malevich to Tomorrow.* Traveled to the Contemporary Arts Center, Cincinnati; The Arts Club of Chicago; Walker Art Center, Minneapolis.

Galleria Civica d'Arte Moderna, Turin. *Robert e Sonia Delaunay.* March. Catalogue, introduction by Jacques Lassaigne; text by Guy Weelen.

Musée de Saint-Denis, Saint-Denis. *Peintres Russes de l'Ecole de Paris.*

Palazzo Barberini, Rome. *Omaggio ad Apollinaire.*

1961 Galerie d'Art Moderne, Basel. *Quelques Oeuvres de Robert Delaunay et de Sonia Delaunay.* June 26-July 10.

Galerie Suzanne Bollag, Zurich. *Contrastes II.*

Maison de la Pensée Francaise, Paris. *Les Artistes Russes de l'Ecole de Paris.*

Musée d'Art Moderne de la Ville de Paris, Paris. *Aux Sources du XXe Siècle.*

1962 Museum des 20. Jahrhunderts, Vienna.

Wallraf-Richartz Museum, Cologne. *Europäische Kunst 1912.*

1963 Kunstindustriemuseum, Copenhagen.

Palais de la Découverte, Paris. *Formes.*

1964 Galleria del Levante, Milan. *Il Contributo Russo alle Avanguardie Plastiche.*

Musée du Louvre, Galerie Mollien, Paris. *Donation Delaunay (Robert et Sonia Delaunay).* Feb. 28-Apr. 12. Catalogue, text by Jean Cassou.

Galleria Schwarz, Milan. *Groupe 1908-1928.*

Musée d'Art et d'Industrie, Saint-Etienne. *Cinquante Ans de Collages.*

Musée Rath, Geneva. *Jean Arp, Sonia Delaunay, Serge Poliakoff.*

1965 The National Gallery of Canada, Ottawa. *Robert and Sonia Delaunay.* Oct. 8-13. Catalogue, introduction by Bernard Dorival; text by Michel Hoog.

1966-67 Deutsches Spielkarten Museum, Bielefeld. *Französiche Spielkarten des XX. Jahrhunderts.*

1967 Akademie der Kunst, Berlin.

Galerie Claude Bernard, Paris. *Le Portrait.*

Galerie Denise René, Paris. *Hommage à Kassak.*

Société du Musée Fragonard, Musée Regional d'Art et d'Histoire, Grasse. *Six Artistes à Grasse, 1940-1943.*

1968 Ancienne Douane, Strasbourg. *Les Ballets Russes de Serge de Diaghilev, 1909-1929.*

Galerie Creuzevault, Paris. *Portrait d'un Portrait.*

Kunsthalle, Dusseldorf. *Dessins du XXe Siècle.*

Kunstgewerbemuseum, Zurich. *Collages 1968.*

Musée Galliera, Paris. *L'Age d'Or du Jazz.*

1969 Galerie Chauvelin, Paris. *Aspects de l'Avant-Garde Russe 1905-25.*

Galerie du Fleuve, Paris. *Oeuvres Graphiques de Tapies, Soulages, Friedlaender, Sonia Delaunay.*

Musée des Monuments Nationaux, Paris. *Les Maîtres Contemporains du Vitrail.*

Galerie de Varenne, Paris. *Sonia et Robert Delaunay et le Théâtre.*

1970 Carnegie Institute, Pittsburgh. *Pittsburgh International.*

Galerie Alice Pauli, Lausanne. *Jeunesse et Presence.*

Galerie Denise René, Paris. *Les Pionniers de l'Art Abstrait.*

Musée des Tapisseries, Aix-en-Provence. *Tapisseries de Matisse à Mathieu.*

1971-72 Leonard Hutton Galleries, New York. *Russian Avant-Garde.*

Calouste Gulbenkian Foundation Gallery, Lisbon. *Sonia e Robert Delaunay em Portugal, e os seus amigos Eduardo Vianna, Amadeo de Souza-Cardoso, José Pacheco, José de Almada Negreiros.* Apr.-May. Catalogue, texts by Paulo Ferreira and Fernando Pernes.

1972 Wallraf-Richartz Museum, Cologne. *Worte Werden Bilder.*

Musée des Beaux-Arts, Nancy. *Sonia Delaunay, Robert Delaunay.* June-Sept. Catalogue, preface by Michel Hoog; introduction by Simon Guillame.

1974 Nationalgalerie, Berlin. *Hommage à Schoenberg.*

1976 Los Angeles County Museum of Art, Los Angeles. *Women Artists 1550-1950.*

Musée de l'Abbaye Sainte-Croix, Les Sables d'Olonne. *Vos papiers, svp: le Papier dans l'Art Contemporain.*

Musée des Arts Decoratifs, Paris. *Cinquantenaire de l'Exposition 1925.*

Salon de Mai, Paris.

Victoria and Albert Museum, London. *Fashion 1900-1939.*

1977 Centre Georges Pompidou, Paris. *Paris-New York.*

Kettle's Yard, Cambridge. *Simultaneity.*

Kunsthalle, Recklinghausen. *Fliegen ein Traum.*

Musée de Tesse, Le Mans. *Diaghilev.*

Städtisches Kunsthalle, Dusseldorf. *Vom Licht zur Farbe.*

1977-78 Centre Culturel du Marais, Paris. *Diaghilev et les Ballets Russes.*

1978 Centre Georges Pompidou, Paris. *Paris-Berlin.*

Grand Palais, Paris. *Cubisme: Salon des Indépendants.*

Musée d'Art Moderne de la Ville de Paris, Paris. *Abstraction-Création.*

The Museum of Fine Arts, Houston. *Art and the Alphabet.*

Salon de Mai, Paris.

Whitney Museum of American Art, New York. *Synchromism and American Color Abstraction 1910-1925.*

1979 Centre Georges Pompidou, Paris, *Paris-Moscou.*

Grand Palais, Paris. *L'Or des Années Folles: 90e Salon des Indépendants.*

Moderne Galerie Bottrop, Bottrop. *Sonia Delaunay, Vieira da Silva, Bridget Riley.*

Musée d'Art et d'Industrie, Saint-Etienne. *L'Art dans les Années 30 en France.*

Salon de Mai, Paris.

Mrs. Rachel Adler, New York
Arthur A. and Elaine Lustig Cohen, New York
Tamar J. Cohen, New York
Jacques Damase, Paris
Sonia Delaunay, Paris
André Emmerich, New York
Mrs. Kay Hillman, New York
Edythe and Saul Klinow, Muttontown, New York
Mr. and Mrs. N. Lobanov-Rostovsky, London
Mme. Georges Pompidou, Paris
Patrick Raynaud, Paris
Mr. and Mrs. Henry M. Reed, Montclair, New Jersey
Private Collections

Albright-Knox Art Gallery, Buffalo, New York
Bibliothèque Nationale, Paris
The Grey Art Gallery and Study Center, New York University, New York
Kunsthalle, Bielefeld, West Germany
Los Angeles County Museum of Art, Los Angeles
Mississippi Museum of Art, Jackson, Mississippi
Musée National d'Art Moderne, Paris
Museum of Art, Rhode Island School of Design, Providence, Rhode Island
The Museum of Modern Art, New York
The National Archives of the United States, Washington, D.C.
Union Française des Arts du Costume, Paris

Artcurial, Paris
Leonard Hutton Galleries, New York
Etablissements Pinton, Paris

Fig. 60. *Sonia Delaunay, Paris, 1974.*

CREDITS

The organizers of the exhibition wish to thank the libraries, museums and private collections for permitting the reproduction of works in their collections. Photographs were supplied by owners or custodians of the works of art except for the following:

COLOR

Harry N. Abrams, Inc., New York: Cat. nos. 5, 12, 13, 20, 21, 28, 49, 51, 61, 102, 132, 136, 176, 194, 208. Fig. nos. 27, 40.

J. Ph. Charbonnier, Pictorial Crandall, Paris. Courtesy *Réalités:* Fig. no. 41.

The National Museum of Modern Art, Tokyo: Cat. nos. 7, 8, 9, 11, 16, 18, 22, 23, 29, 30, 31, 32, 33, 47, 50, 54, 56, 59, 60, 65, 69, 76, 77, 82, 84, 95, 96, 106, 107, 108, 122, 123, 126, 127, 128, 129, 139, 145, 146, 151, 159, 161, 163, 166, 167, 180, 191, 204, 205, 206, 207.

Phototech Studio, Buffalo, New York: Cat. nos. 25, 52, 174 (front cover), 175 (back cover).

Runco Photo Studios Inc., Buffalo, New York: Cat. nos. 3, 6, 19, 24, 27, 62, 66, 71, 73, 75, 85, 86, 87, 111, 112, 115, 133, 134, 138, 142, 148, 193, 196, 197, 198, 199, 200, 201, 202, 203, 209, 210, 211, 212, 213, 214, 215, 216, 217, 219, 220, 221, 222, 224, 225, 226, 227, 228, 229, 230. Fig. no. 9.

Sidney Waintrob, Bud Waintrob Collection, New York: Frontispiece.

BLACK AND WHITE

Harry N. Abrams, Inc., New York: Fig. nos. 3, 4, 6, 10, 14, 16, 17, 18, 21, 22, 24, 25, 28, 29, 30, 31, 32, 33, 34, 36, 37, 38, 43, 44, 45, 46, 47, 49, 51, 52, 53, 54, 55.

Artcurial, Paris: Fig. no. 42.

Collection of the artist: Fig. nos. 48, 50, 56, 59.

Elaine Lustig Cohen, New York: Fig. no. 58.

André Emmerich Gallery, New York: Fig. no. 60.

Etienne Hubert, Paris: Cat. no. 113.

H. Philipp, Paris: Fig. no. 20.

Phototech Studio, Buffalo, New York: Cat. nos. 1, 4, 37, 48, 53, 55, 74, 78, 83, 91, 97, 98, 100, 121, 162, 165, 184, 185, 186, 187, 188, 189, 192, 195.

Eric Pollitzer, Garden City Park, New York: Cat. nos. 67, 80.

Nathan Rabin, New York: Cat. no. 101.

Runco Photo Studios Inc., Buffalo, New York: Cat. nos. 36, 41, 70, 88, 89, 99, 116, 117, 120, 124, 158, 177, 182. Fig. nos. 5, 11, 15.

John D. Schiff, New York: Cat. no. 149.

Charles Uht, New York: Cat. no. 64.

Marc Vaux, Paris: Cat. nos. 2, 44, 58.

Wölbing-van Dyck, Bielefeld, West Germany: Fig. no. 57.

8,000 copies of this catalogue, edited by Josephine Novak and designed by Sandra T. Ticen, have been typeset in Helvetica Light by Thorner-Sidney Type Services and printed on 100 lb. Wedgewood Dull by Thorner-Sidney Press, Buffalo, New York, on the occasion of the exhibition *Sonia Delaunay: A Retrospective,* March 1980.